SELF
PORTRAIT

Published in Great Britain by
National Portrait Gallery Publications,
National Portrait Gallery,
St Martin's Place,
London WC2H 0HE
www.npg.org.uk/publications

To accompany the exhibition SELF
PORTRAIT: Renaissance to Contemporary
held at the National Portrait Gallery, London,
England from 20 October 2005 to 29 January
2006 and at the Art Gallery of New South
Wales, Sydney, 17 February to 14 May 2006

For a complete catalogue of current
publications, please write to the National
Portrait Gallery at the address above, or visit
our website at www.npg.org.uk/publications

ISBN-13: 978-1-85514-356-2 Hardback
ISBN-10: 1-855-14-356-9 Hardback

ISBN-13: 978-1-85514-357-9 Paperback
ISBN-10: 1-855-14-357-7 Paperback

A catalogue record for this book is available
from the British Library.

Publishing Manager: Celia Joicey
Project Manager: Johanna Stephenson
Picture Researcher: Kate Phillimore
Production Manager: Ruth Müller-Wirth
Design: Atelier Works
Printed in Italy

Sponsored in London by

Published in Australia in 2006 (edition
exclusive to exhibition venue) by
Art Gallery of New South Wales
Art Gallery Road
The Domain, Sydney
NSW 2000 Australia
www.artgallery.nsw.gov.au

Art Gallery of New South Wales
Cataloguing-in-publication data

Bond, Anthony
SELF PORTRAIT: Renaissance to
Contemporary / Anthony Bond and Joanna
Woodall ; with essays by T.J. Clark, Ludmilla
Jordanova and Joseph Leo Koerner.

Catalogue of an exhibition held at the National
Portrait Gallery, London, England, 20 October
2005 to 29 January 2006 and the Art Gallery
of New South Wales, Sydney, 17 February to
14 May 2006.
Includes bibliographic references and index.

ISBN 0 7347 6377 8 Paperback (Aust.)

1. Self-portraits -- Exhibitions. 2. Artists --
Portraits -- Exhibitions. 3. Portrait painting --
Exhibitions. I. Woodall, Joanna. II. Art Gallery
of New South Wales. III. National Portrait
Gallery (Great Britain) IV. Title

757

Sponsored in Sydney by

Overleaf Marlene Dumas, *This evil is banal*
(cat.54, detail)

SELF PORTRAIT

Renaissance to Contemporary

Anthony Bond and Joanna Woodall
With essays by T.J. Clark, Ludmilla Jordanova and Joseph Leo Koerner

National Portrait Gallery, London
Art Gallery of New South Wales, Sydney

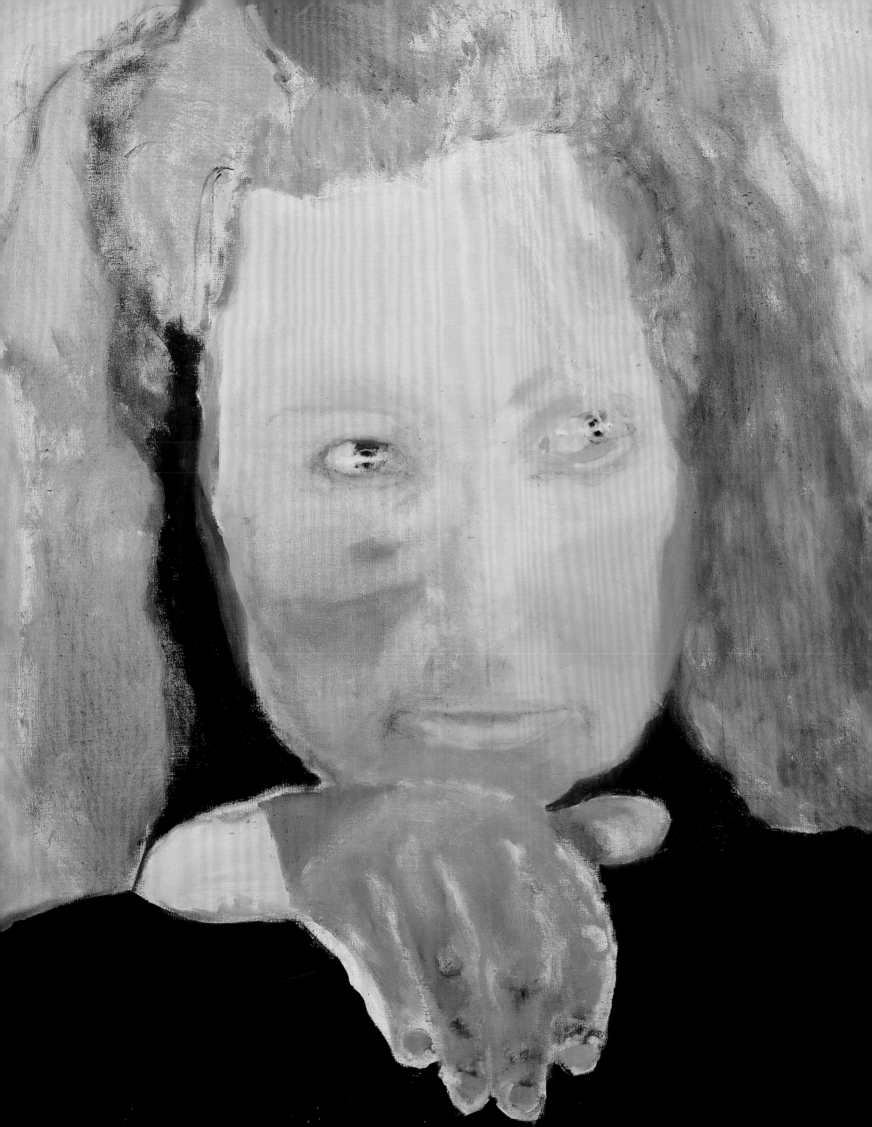

CONTENTS

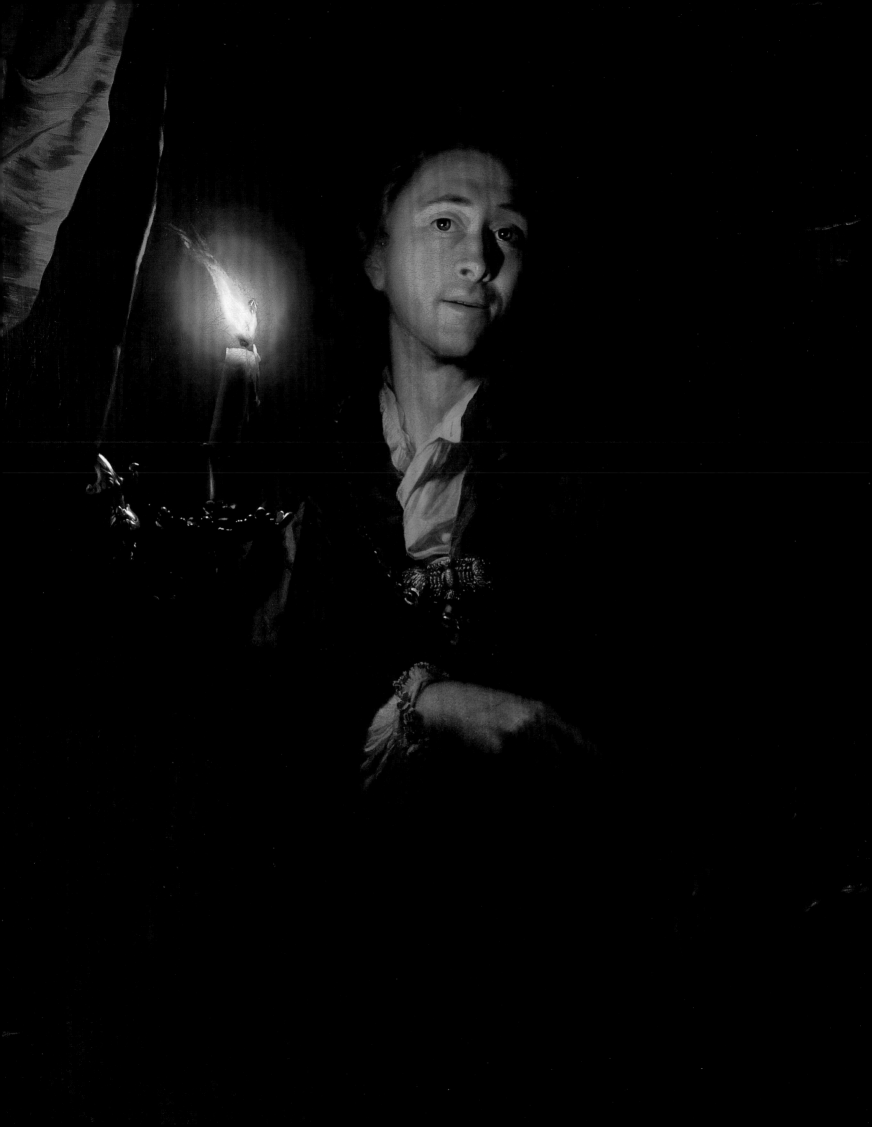

DIRECTORS' FOREWORD

Self-consciousness can be part of daily ritual. Looking in the mirror to adjust clothing, apply make-up or shave, may be taken for granted, yet introspection sometimes seeps in. Even the banal reminder of seeing one's own face prompts contemplation of what we like or dislike about ourselves. The image reminds us that the self reflected back is the one we have to work with, the one that is on offer.

This encounter with questions of consciousness is renewed when looking at an artist's self-portrait. The personal questions of our own are magnified and made public through the studied gaze of the painter. And the fascination that a self-portrait holds is increased with the degree of empathy we have with a particular artist, seemingly crossing time to offer insight into their life, studio or surroundings. A self-portrait painting may also suggest a more critical framework for an understanding of the artist and their role.

Self-portraiture developed as a means of demonstrating skill, as an indicator of an emergent professional status of the artist alongside philosophers and writers, while many self portraits were created as symbolic of the imminence of death or the presence of vanitas. Creativity and the concept of artistic freedom are frequently implied. Self-portraits range from the single figure of the artist to a doubling with a model, wife or muse. Others position the artist next to patrons, family or friends – setting out their social place – or explore allegorical themes or the fracturing of the image in the modern period. Although the self-portrait in painted form might appear less fashionable in recent years, the power of the best remains undiminished and can be seen within a wider context in which artists' examination of questions of identity through self-image remains a compelling contemporary theme. The self-portrait endures.

Concepts for exhibitions are sometimes wonderfully simple. In this case the idea was proposed by Anthony Bond and Joanna Woodall, and from that the project was initiated. Their enthusiasm for self-portraits, although potentially satisfied by a number of books exploring the subject, had not been matched by any larger scale attempt to bring artists' own images together from across periods and places within the tradition of Western painting. There seemed no obvious reason why an exhibition had not been attempted before, other than the innate difficulty of borrowing some famous paintings: these being works which are now fêted within the collections and cities where they reside. The National Portrait Gallery, itself the owner of many self-portrait paintings, had the advantage of being an institution for which thinking about this aspect of portraiture is close to its heart.

The project had a defining parameter of examining self-portrait paintings in oils, and this developed as one of the arguments of the exhibition – about the particular importance of the technology of oil paint to the development of this genre of work – as well as a

Fig.1 **Godfried Schalken (1643–1700)**
Self-portrait, 1694
Oil on canvas, 1100 x 890 mm (43 x 35")
Royal Pump Rooms, Leamington Spa

limitation that helped the processes of selection. Nevertheless, the work of the curators in researching and developing the initial list, and of the project team in London and Sydney in following it through with alternate choices, has been prodigious. The project was taken forward by the interest and encouragement of a number of scholars, several of whom came together for a colloquium in April 2004 at the National Portrait Gallery in London. Their interest and input encouraged us greatly.

Once the idea was being developed, it was important to gain the cooperation of the Uffizi Gallery in Florence. The so-called Vasari Corridor is the most notable and famous collection of self-portraits in the world, originating in an interest of Cosimo de' Medici in the sixteenth century and becoming institutionalised into a system of invitation by which an elite of artists would be invited to submit their work. In the event the Uffizi has made an extraordinarily generous offer of seven early works, which form an essential part of the exhibition, and we are especially grateful to the Soporindentza, Annamaria Petrioli Tofani for her support. We also worked in partnership with the National Gallery, London, as it was developing an important exhibition on the formation of the image of the artist in the Romantic period. The National Gallery's agreement for a generous group of works to be lent to the exhibition is much appreciated, together with the personal support of its director, Charles Saumarez Smith. The development of a complementary exhibition by the Museum of Contemporary Art in Sydney has also offered another level of engagement for audiences in Australia in 2006.

All museum directors and exhibition curators hope for the most complete selection possible, but we knew that some famous self-portraits were always going to be impossible to obtain. The painted self-portraits by Albrecht Dürer are so celebrated, and also on panel, that it was never likely that they could travel. Equally celebrated works such as Titian's few self-portraits, Jacques-Louis David's self-portrait with the swollen cheek and Gauguin's self-portrait with the yellow crucifixion are now regarded by their museum owners as part of the permanent display that cannot be offered on loan. In some cases the timing of other exhibitions, such as the Goya exhibition in Madrid and Paris, the Edvard Munch self-portraits exhibition in Oslo and London and the survey of Alice Neel's work in Washington, were clashes that could not be avoided. Wherever possible suitable comparative illustrations have been included in the catalogue.

We are very proud of the selection of nearly sixty works that has been achieved – with some variations for London and Sydney. We hope that it will not only excite large numbers of visitors but also encourage much further research to be undertaken over the years to come.

We wish to acknowledge the central position in this project of Joanna Woodall of the Courtauld Institute and Anthony Bond, Head Curator of International Art at the Art Gallery of New South Wales and to thank them for all of their hard work over three and a half years. The special contribution of Sophie Clark, Exhibitions Manager, as well as that of Kathleen Soriano and Howard Smith, Head and Temporary Head of Exhibitions and Collections, and Rosie Wilson, Exhibitions Assistant, at the National Portrait Gallery, Anne Flanagan, General Manager, Exhibitions and Building, Erica Drew, Senior Exhibitions Manager, Ursula Prunster, Curator Special Projects and Senior Coordinator Public Programs and Anne Douglas, Research Assistant, at the Art Gallery of New South Wales, deserves very special mention; they have offered creative and managerial insights at every turn, helping to refine and accomplish the project in its best form. This catalogue has been developed under the leadership of Celia Joicey, Publishing Manager, with the key contributions of Johanna Stephenson as Project Manager, Atelier Works for design and Ruth Müller-Wirth as Production Manager in London. The special educational collaboration of Liz Rideal, Education Manager at the National Portrait Gallery and Brian Ladd, Head of Public Programs at the Art Gallery of New South Wales, has been particularly important. There are many others who have made outstanding contributions, and acknowledgements to them and others who have made the project possible are printed on p.208.

Channel 4 Television has provided sponsorship for the London exhibition, as well as connections to its own programmes on self-portraiture, written and presented by Matthew Collings. We are most grateful for this support.

JPMorgan is the sponsor of the exhibition in Sydney and we are equally grateful for their support.

We would like to give special thanks to the authors in this catalogue, who have so enthusiastically joined in with the project: T.J. Clark, Ludmilla Jordanova and Joseph Leo Koerner. The living artists deserve our special thanks: Georg Baselitz, Marlene Dumas, Richard Hamilton, Lucian Freud, Leon Kossoff, Gerhard Richter, Jenny Saville, and especially Chuck Close, who created a new self-portrait with this exhibition in mind.

Finally, we wish to thank all the museums and private collectors who have lent so generously to the exhibition. We have been enormously gratified by the enthusiasm and support that we have received throughout the formation of the project.

Edmund Capon
Director
Art Gallery of New South Wales, Sydney

Sandy Nairne
Director
National Portrait Gallery, London

SPONSORS' FOREWORDS

Channel 4 is delighted to support SELF PORTRAIT: Renaissance to Contemporary, which traces Western traditions of self-portraiture from the Renaissance to the present day. Our involvement stems partly from the relationship between this major new book and exhibition and our television series on self-portraiture, presented by Matt Collings. It is also a natural progression from a highly successful collaboration between Channel 4 and the National Portrait Gallery on 'Self Portrait UK', a project which invited people across the country to create their own self-portraits, culminating in two television series and a national touring exhibition of over eighty works.

As a publicly owned public service broadcaster, Channel 4 is required to be innovative, experimental and diverse in its output. These are qualities that we aim to explore in our arts programming, as in everything we do. We act as a patron of the arts and artists, commissioning new work and providing a platform for new talent. We seek to open up the creative processes of artists and performers for the benefit of viewers. We aim to surprise, provoke and stimulate; to use television, not just as a medium for reporting the arts, but as an artistic medium in is own right.

Kevin Lygo
Director of Television
Channel 4

JPMorgan is proud to partner with the Art Gallery of New South Wales in bringing to Australia SELF PORTRAIT: Renaissance to Contemporary, direct from the National Portrait Gallery in London. This exceptional selection of self-portraits includes a wonderful mix of works from artists over the last 500 years.

Motivated by Anthony Bond and Joanna Woodall's enthusiasm for self-portraits, this exhibition demonstrates the artists' extraordinary ability of self expression and awareness with influence eliminating the divide of the ages.

JPMorgan has a strong tradition as patron to the arts. Commencing in 1959, the success of our collection is unparalleled, and the adventurous spirit that sparked our first acquisitions is as strong as ever. At JPMorgan, art is enjoyed not just for its aesthetic appeal, but also for its socio-educational values.

In this context, JPMorgan trusts this exhibition will enlighten and inspire, providing valuable cultural and historical insight for us all to enjoy.

Rob Priestley
Managing Director
Senior Country Officer
JPMorgan Australia & New Zealand

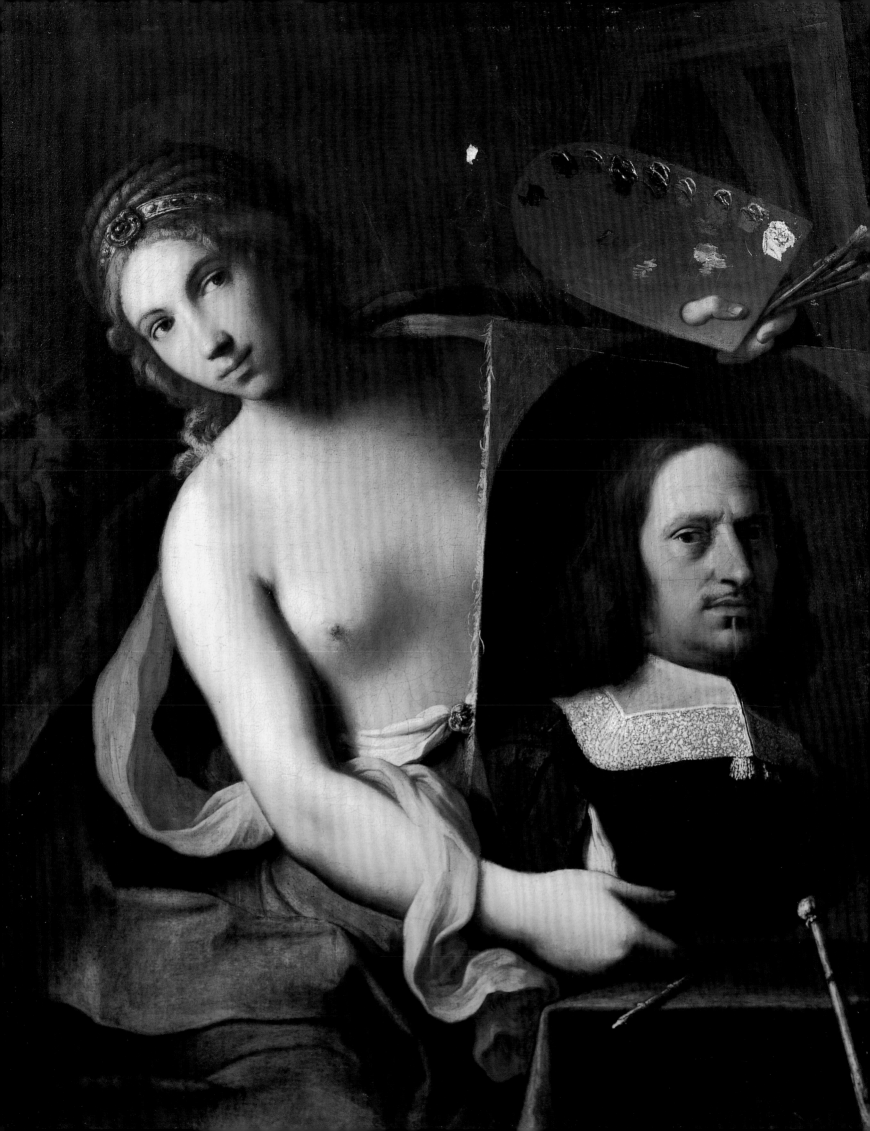

PREFACE

This exhibition explores how Western artists have used naturalistic likeness in oil to represent themselves over a period of five centuries, from the institution of the medium in the fifteenth century to the pluralism of the present day. The initial idea came from Anthony Bond, who was captivated by the intense outward gaze that is a consistent feature of self-portraiture from Van Eyck to Warhol. This look is, to be sure, the practical consequence of self-scrutiny in a mirror, the self-portraitist's essential tool of reflection even beyond the advent of photography. However, pictures in which the gaze is veiled or deflected reveal this stare as an artistic choice, a self-conscious sign of self-portraiture. Self-portraiture's gaze character-ises the artist as a 'seer' in possession of a vision that is both directed externally – at the world, at other people, at one's own outward appearance – and a source of insight.

The decision to include only self-portraits in oil provides focus within a category that numbers thousands of images, and emphasises a set of qualities specific to that medium and the genre. The mirror-like gloss and perceived transparency of illusionistic painting in oils dramatises the relationship between the images of themselves that artists observed in mirrors and the perfect paintings that they produced. At the same time, the material substance of oil paint, and the way it can be visibly manipulated and reworked, can highlight the transformation of a body of materials into an illusion of spirit or consciousness as a dynamic, ongoing process. A kind of equivalence can therefore be seen between 'painterly' handling and the creative process of the subject represented. By making embodied artistry (in the figure of the painter and the way that it is painted) the very subject of representation, self-portraiture thus challenges the reduction of portraiture to the reproduction of a physical likeness.

The penetrating gaze of self-portraiture, often emanating from a single eye situated at the core of the work, can be understood as a metaphor for the artist's creative power. Historically, self-portraiture has spoken of the painter's claims to virtue, a word derived from the Latin *vir* (man) and originally connoting manliness, manhood, strength, vigour, courage, excellence. This enduring quality, assumed to link Man with God, justified fame, commemoration and a noble title in the social world, and promised immortality in heaven. It distinguished named, honourable subjects worthy of permanent representation from the anonymous, transient, ignoble multitude.

In their assertion of virtue, artists sat alongside other established and aspirant elites that claimed to be worthy of honour and representation in the form of an individualised likeness. From this perspective, artists were as much subjects of elite portraiture as the source of representations of the creative subject. For example, when in the 1520s and 1530s the humanist cleric Paolo Giovio set up his 'Museum' of some four hundred portraits in his villa at Lake Como, images of artists joined those of poets and philosophers, as well as military commanders, kings, emperors and popes, enriching the series of 'famous men' that had been amassed over centuries. Such collections were described in Latin as *De Viris Illustribus*, a hint that the mirror-like brilliance of early portraiture in oils was related to the radiant virtue of their subjects. A collection such as Giovio's brought the heroic virtue that had justified Petrarch's selection of Roman military and political leaders in the later fourteenth century into a

Opposite Giovanni Domenico Cerrini, *Allegory of Painting* (fig.12, detail)

more diverse present, enlarging the definition of virtue beyond the inheritance of noble blood. In particular, the figure of the artist came to stand for values that facilitated change, such as genius, originality and insight. Such 'individualistic' qualities were, paradoxically, proving valuable to Europe's burgeoning courts and increasingly complex urban economies.

One purpose of representing these celebrities – then as now – was to provide desirable models for emulation and, altogether, a kind of history and geography constructed through recognised images, names and biographical data. The multiples facilitated by print technology and later by photography helped to familiarise people with these constellations of stars. Identification and characterisation of such figures were achieved partly through comparison with prior authoritative models or exemplars that positioned the named subject within a lineage or genealogy of types or personae, starting with Pliny's account of the major figures in Greek art. Many court painters, for example, were characterised by reference to Apelles, whose outstanding knowledge, skill and urbanity had made him the favoured artist of Alexander the Great. On the other hand, Pieter van Laer, who painted itinerants and beggars in seventeenth-century Rome, had a classical model in Piraeicus, who attained glory, appreciation and high prices with pictures of low life in the fourth century BC. The proliferation of different types of artistic personae in the sixteenth and especially the early seventeenth century was justified by this variety of antique models, and the possibility that virtue could be hidden in unlikely places. After all, the Greek philosopher Socrates was extraordinarily ugly, yet immensely wise, and Christ himself had been a humble, itinerant carpenter. Caravaggio is the founding example of the 'alternative' artist who later came to dominate the conception of painting as a mark of progress, but figures such as Van Laer, Rosa and the later Rembrandt demonstrate that he was not alone in challenging the relationship between the performance of gentlemanly virtue and artistic value.

The relationship to authoritative predecessors could be acknowledged or dramatised through physical likeness, as in a family resemblance. Genealogies of likeness, in the form of iconographic types and compositional formats, persisted over generations and it is one of the reasons for the surprising continuity of metaphors for the artist across the generations that can be seen in this exhibition. We can trace the gentleman, the bohemian, the performer through the centuries. Although many 'sons' tried not just to imitate but to surpass their symbolic 'fathers', emulation was typically a conservative process. Paradoxically, it placed artists – and their representations – within an essentially aristocratic system of value in which creativity was associated with the passing on of virtue. Yet by holding up a mirror to reflect upon established authority, the technique could also be critical. For example, in its resemblance to Manet's *Olympia*, Suzanne Valadon's modernist self-portrait entitled *The Blue Room* (cat.40) not only pays homage to a revered master but also transfers the authority of the upright artist to the unruly body of the reclining model.

The deployment of the artist as an exemplar of different kinds of virtue involves representation but not necessarily self-portraiture. For example, the collection formed from the late sixteenth century by the Accademia di San Luca in Rome included not only self-portraits such as the Lavinia Fontana included here (cat.5), but also portraits of artists by other artists. Copies and reproductions of self-portraits also undermine the connection that we often assume between authorship and confrontation with an authentic self-image. Even the famous Gallery of self-portraits now in the Uffizi in Florence, which is fundamental to our exhibition, was based on a collection of *uomini illustri* formed by Cosimo I de' Medici (1519–74) that included likenesses, but not necessarily self-portraits, of early Renaissance masters. The Medici collection of self-portraits proper was begun by the humanist collector and cardinal Leopoldo de' Medici (1617–75), who died leaving drawings, coins, books, specimens of natural history and about seven hundred paintings, of which about a tenth were self-portraits. Leopoldo's nephew, Cosimo III, Grand Duke of Tuscany (1642–1723), continued to form the collection, which was moved to a special gallery in the Uffizi (fig.2) and by 1714 comprised 186 works. The collection, which continues to be augmented today, was crucial to the establishment of self-portraiture as a distinct category or genre, separate from portraits of artists by other artists.

Self-portraiture constitutes the painter as an exemplary subject of particular interest because it seems to conflate the roles of creator 'behind' the work of art, subject 'within' and viewer 'before' it – taking the place of the artist's reflection in the mirror. If the artist and his work (in the form of his portrait) are understood as one and the same, the distinctive virtue or value claimed by the artist is invested in this object, which can thus, as the anthropologist Alfred Gell has argued, act like a person, a surrogate for the artist. And if the viewer in front of a self-portrait is imagined not only to occupy the position in which the artist worked (as is the case with any picture) but also to take the place of the artist's mirror image, this figure is brought into the ambit of artistic agency in an explicit and particular way: as a second self or alter ego of the creative subject. Beyond the image in the mirror we can also imagine the artist engaging with the world at large. So by collapsing the distinctions between the painter and the painting, the artist and the viewer, the mirror and the world, self-portraiture can be used to constitute the artist as a sovereign individual: everything is ultimately subject to the creative ego.

However, if we pay attention to these distinctions they become a means of acknowledging the part played by others in the constitution of this exemplary subject. In particular, noticing the fiction of the displacement of the mirror by the framed painting engenders self-consciousness about the identification between the viewer and the painter. By physically and visually 'occupying the place' of the artist, viewers can imagine themselves to exceed the boundary between self and other, between personal, interiorised, embodied experience and the knowledge of others (and ourselves) gained through our apprehension of the way they (and we) look from the outside. The eyes that 'meet' in the mirror/canvas seem to brush the different subjectivities of artist and spectator against one another.

This dialogue between self and other in the discourse of the 'modern' subject is a fundamental concern of the exhibition. Many of the works we have chosen construct ideas of selfhood and creativity through explicit interactions between the artist and tangible figures such as the model, wife, teacher, patrons, connoisseurs and friends, or personifications such as Love and Death. Through the metaphor of the mirror, fundamental not only to self-portraiture but to the medium of oil, the painting itself can be understood as an alter ego, a means of negotiating subjectivity

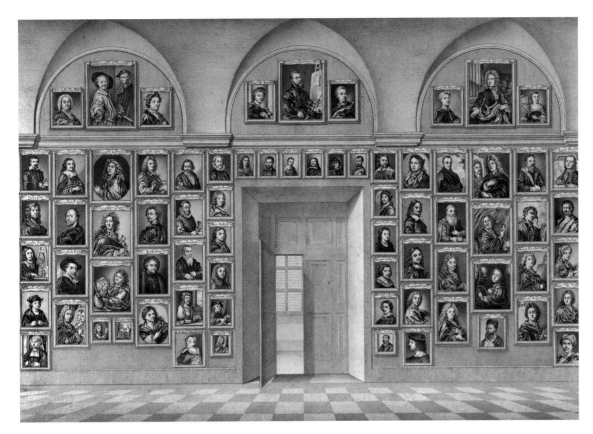

Fig.2
Medici Gallery of Self-portraits
at the Uffizi showing the
painters of the northern
European Schools
Pen drawing,
386 x 560mm (15 x 22")
Nationalbibliotheke, Vienna

through interaction with desired (or reviled) doubles and replicas of ourselves. At this moment of technological change, which faces us with unending replicas and clones, we may even question the stability and authenticity of the 'original': the self from which the copy – the mimetic representation – is supposedly drawn.

The exhibition itself results from a series of creative dialogues. The first of these was between Anthony Bond, a museum curator with a contemporary focus and Joanna Woodall, an historian of early modern art with a special interest in portraiture, realism and desire. Rather than divide the exhibition into period responsibilities we have worked jointly across the entire selection and interrogated each other's assumptions. This has proved to be a profoundly rewarding process in which two different ways of looking, evident in our respective catalogue essays, have informed each other and, we hope, made something new.

While the foundations of the project were laid by this curatorial collaboration, it was Sandy Nairne who invited us to bring the exhibition to the National Portrait Gallery in a collaboration with the Art Gallery of New South Wales. Sandy and his team contributed another dimension of intellectual rigour and practical resolution to the project; discussions with this group have been essential in clarifying ideas and sharpening the selection process. One of the contributors behind the scenes has been Joanna Woods-Marsden, whose groundbreaking work on the self-portrait in the Italian Renaissance was a key text for the curators. Joanna also contributed to a colloquium of scholars who generously gave us a day of their time to be our first audience and to interrogate our ideas. This colloquium at the National Portrait Gallery in April 2004 was enormously influential in the final shaping of the exhibition and the input of these scholars, including Joseph Leo Koerner and Ludmilla Jordanova, is evident in this book and associated public programme.

A further creative partnership has been between Joanna Woodall and the students at the Courtauld Institute of Art taking her MA special option for 2004–5 on concepts of the artist in early modern visual culture. This course was as much of a learning experience for the teacher as for the students, whose significant contribution to the project is most evident in the catalogue entries for the earlier works in the exhibition.

Assembling this exhibition has been an ambitious task. It would have been impossible without the Uffizi's generous agreement to our request for no fewer than seven paintings from its celebrated collection of self-portraits. It is fitting that the Uffizi collection, which has played such an important part in the establishment of the self-portrait as a distinctive category, should have such a strong presence in this exhibition. We are also heartened by the enthusiasm with which so many curators and museum directors have met our proposals and we would particularly like to thank all those who have helped to make this exhibition a reality.

Anthony Bond
Art Gallery of New South Wales

Joanna Woodall
Courtauld Institute of Art, University of London

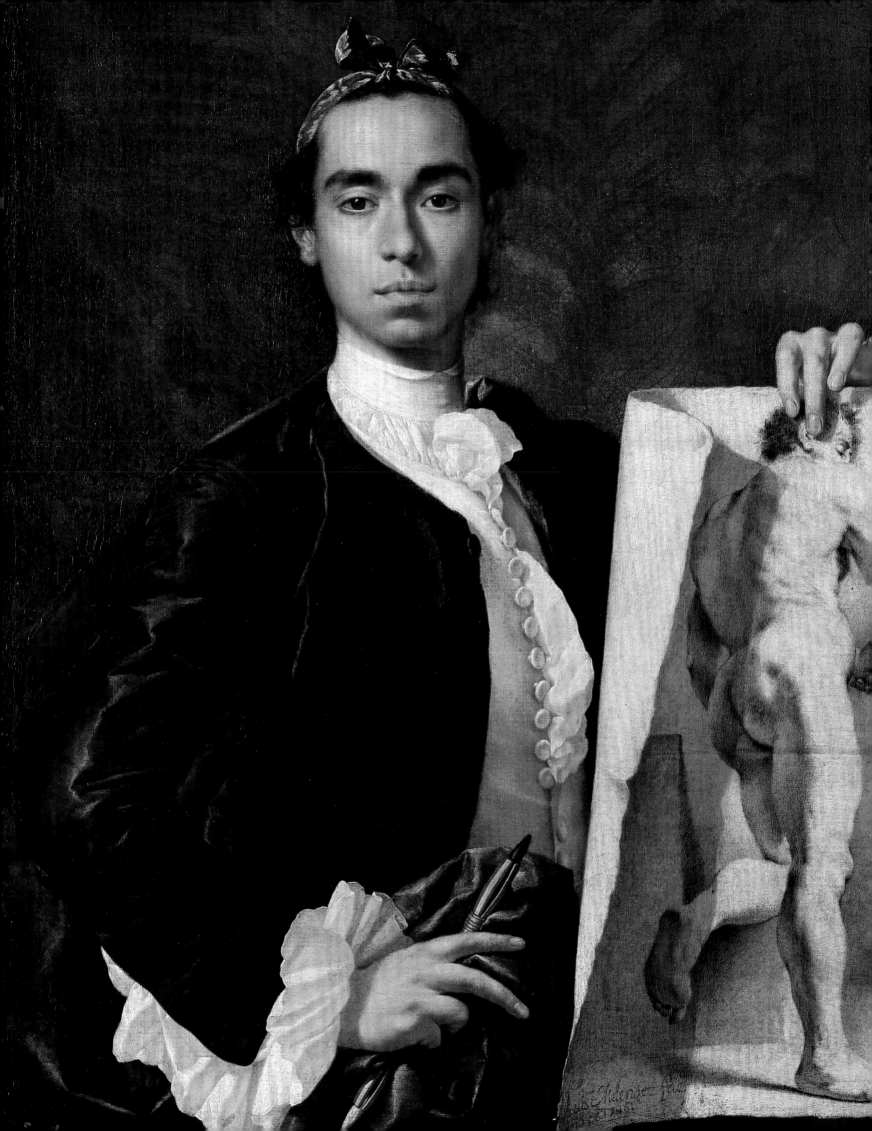

'EVERY PAINTER PAINTS HIMSELF': SELF-PORTRAITURE AND CREATIVITY

Joanna Woodall

On the altar wall of the Sistine Chapel in Rome, near the centre of Michelangelo's *Last Judgement*, there is a figure of Saint Bartholomew, flayed alive for his Christian faith (fig.3). His head, twisted round on a powerful, classical body, looks up towards Christ and the Virgin Mary in desire for salvation. While his right hand brandishes a knife, the left proffers his pelt towards damnation. Viewers soon recognised the features of Michelangelo himself in the grotesque, blind mask borne by flaccid skin. Yet Michelangelo's name also evokes an heroic concept of the artist dramatised by the ideal figure of St Bartholomew: a quasi-divine being whose emulation of perfect forms requires severance from the deficiencies and uncertainties of material, sensory experience.[1] He has violently cut away the membrane of palpable, individual appearance as a superficial, lifeless distortion, a sacrifice to the essential character within.

There is no place for naturalistic likeness in this understanding of artistic creativity. Confinement to the named, particular body implies impotence and death rather than the power to live on through creation or reproduction. How can such an all-too human body represent the divine soul of the creator? Faithful imitation of God's creation must be an abstract endeavour realised through and located in the artist's inborn artistic intelligence and capacity to design or invent.[2] Giorgio Vasari's hugely influential *Lives of the Painters, Sculptors and Architects* of 1568 claimed that Michelangelo never painted portraits 'because he hated drawing any living subject unless it were of exceptional beauty'.[3] In 1544 Michelangelo himself had noted that he had no interest in representing the Medici dukes 'as nature had formed and composed them', but preferred to accord them such grandeur that, in a thousand years, no-one thought to ask whether they had actually looked like the image he had given them.[4] We are faced with an absolute opposition between the true artist's interiorised, abstract creativity and standard portraiture's fidelity to the variety and specificity of nature.

This is at odds with Leon Battista Alberti, who in his groundbreaking treatise *On Painting* of 1435 (first printed 1540) had recognised the 'truly divine power' of naturalistic painting to recall to life an absent or dead person, 'as they say of friendship'. Alberti saw creativity in painting's lifelikeness, a recognition that produced great admiration for painters with the capacity to engender this animation.[5] For Michelangelo, on the other hand, painting bore transparent witness to the artist's personal and quasi-divine capacity to create *ideal* faces and bodies that expressed the vital, enduring character of the subject. In the justification of a self-generating, self-sustaining individual, a direct, personal relationship with an omnipotent God was preferred to imitation of divine creation manifest in fertile Nature. In this view, naturalistic self-portraiture as a means of figuring artistic creativity is a contradiction in terms.

Yet Michelangelo voiced the adage 'every painter paints himself', a Renaissance formulation of the recognisably modern belief that all works of art are invested with the presence of their author, in effect a kind of oblique self-portrait.[6] His long life (1475–1564) also witnessed a proliferation of conventional self-portraiture both in courts and in cities, some revealing ambitions comparable to that of the master himself. In Dürer's *Self-portrait* of 1500

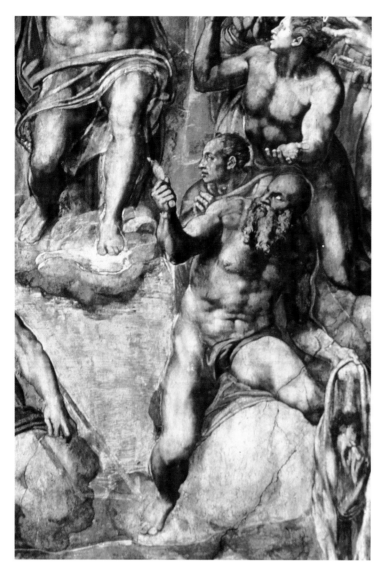

Fig.3
**Michelangelo Buonarroti
(1475–1564)**
St Bartholomew from
The Last Judgement, 1534–41
Fresco, detail from altar wall,
Sistine Chapel, Vatican

(fig.36) the consummate artist's portrayal is aligned with the True Image of Christ and his painting constitutes everything down to the hairs on the head. Joseph Koerner has seen this work as inaugurating a new era of discourse in which creative figures, unlike ordinary people, possess self-contained power and freedom of action analogous to gods. For him, Dürer's self-portraits go beyond appearance and status to give access to an interior self and reflect on the underlying idea of painting itself: 'What they say is *art is an image of its maker.*'[7] This is reminiscent and worthy of Michelangelo, but Dürer asserts himself through an intimate, physical engagement with material creation, rather than by abstracting himself from an imperfect world. Koerner pinpoints this contact in the fingering of the fur, a gesture at once intensely sensual and pointing to the hidden heart of the named, honorific subject.

Michelangelo and Dürer both exemplify 'the rise of the sovereign individual' as a presumed foundation of modernity. They certainly demonstrate the significant role of the artist in our society as a figure through which we contemplate and negotiate different accounts of subjectivity.[8] They point to the relationship between an abstract mind or spirit and physical embodiment as fundamental terms of reference in this ongoing discussion. Painting, conceived as an engagement between a creative human subject and nature in the form of materials derived from minerals, animals and plants, is a substantial metaphor for this relationship. Painted self-portraits pose the issues acutely by representing the artist as an enduring and creative subject through a physical likeness that is, in turn, the product of an engagement between 'mind' and 'matter'.[9]

While it is not certain that the earliest picture in the exhibition, a work of 1433 by the Flemish artist Jan van Eyck (cat.1), is a self-portrait, it realises the necessary conditions. Historically, self-portraiture deploys material technology and artfulness to create lifelikeness, characterises the named subject as an artist and employs the mirror as both a practical device and a metaphor for self-reflection. Van Eyck was credited with inventing the technology of oil painting and his *Portrait of a Man* demonstrates the perfection to which he brought it.[10] By exploiting the medium's potential to recreate the effects of light reflected from different surfaces, he produced an extraordinary illusion of a minutely observed and acutely observing human presence, epitomised by the direct gaze. The original viewers of this picture were offered fresh knowledge of divine creation in the form of a particular human being. Van Eyck was a celebrated court painter and he combined his unparalleled ability to create a living likeness with an unprecedented degree of self-reference. In *Portrait of a Man*, his personal motto '*Als ich kan*' connects the name of the artist *(ich/Eyck)* with both the unique prowess evident in his painting (As only *I* can) and a proper Christian humility (As I can, but not as I would).[11]

MIRROR IMAGES

In 1503 two Venetian glassmakers claimed that they were the only ones to know 'the secret of making mirrors of crystalline glass, a most valuable and singular thing … unknown throughout the world, except for one house in Germany, and one in Flanders, who sell their mirrors at excessive prices'.[12] The German house was in Dürer's home town of Nuremberg, and it seems that he had access to one of these precious instruments, giving rise to a new kind of self-image

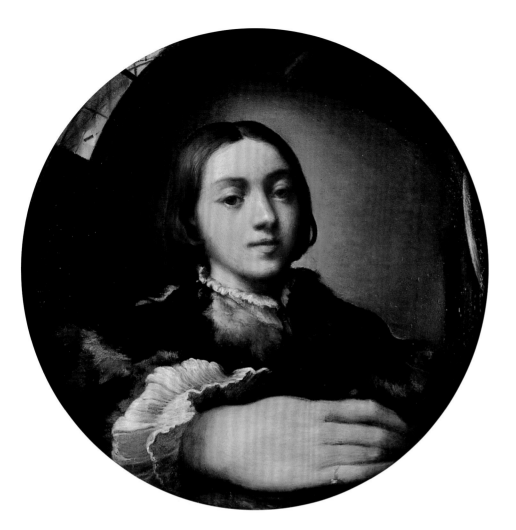

Fig.4
Parmigianino (Girolamo Francesco Maria Mazzoli) (1503–40)
Self-portrait, c.1524
Oil on wood half-sphere, diam. 244mm (9½")
Kunsthistorisches Museum, Vienna

that in sixteenth-century Venice was called simply a 'portrait made in the mirror'.[13] The precise observation and polish of Van Eyck's oil painting also evokes such a perfect mirror – provoking a mid-sixteenth-century admirer of his work to exclaim that 'it seems that everything is alive and emerging from the panel. They are mirrors, they are mirrors, no! They are not paintings.'[14] Despite the intriguing reference to Flemish production of flat mirrors, Van Eyck is assumed to have used a curved blown-glass mirror similar to the one depicted in his *Arnolfini Portrait* (1434; National Gallery, London) or that recreated by Parmigianino in his virtuoso self-portrait nearly a century later (fig.4). Unlike Parmigianino, though, Van Eyck minimised the distortion of the mirror to fashion a naturalistic ideal, rather than mimicking it to dramatise the roles of head and hand in the creation of a painting.[15]

At the defining moment of self-portraiture (whether we attribute this to Van Eyck or to Dürer) the mirror was invested with metaphorical and magical significance. It was regarded as a manifestation of the omniscience and love radiated forth by the perfect earthly prince, the saints, Christ and especially the Virgin Mary, the 'Mirror without Stain'. In their reference to the mirror, self-portraits both reflected and partook of the virtue ascribed to these shining examples, helping to establish artists in turn as powerful models for emulation. Because the mirror image was both a reflection and an inversion of the original model, metaphorical mirrors had also long been used to figure the human subject's progress towards divine perfection through contemplation of his or her imperfections.[16] In the thirteenth century, for example, the Dominican Jacopo de Voragine, in one of his popular sermons on the titles and virtues of the Virgin Mary, had urged:

> as all things are reflected from a mirror, so in the blessed Virgin, as in the mirror of God, ought all to see their impurities and spots, and purify and correct them, for the proud, beholding her humility see their blemishes, the avaricious see theirs in her poverty, the lovers of pleasure theirs in her virginity.[17]

The legend that the Apostle Luke had painted the Virgin and Child articulated the particular importance of the mirror as a means of self-perfection for artists. Saint Luke became the favoured patron of both the painters' guilds and some of the academies established from the mid-sixteenth century.[18] Many artists depicted the theme, in which the Virgin and Child are understood as the mirror image of God's blinding beauty: different and yet the same. Such pictures define the artist's self-realisation in terms of devout engagement with nature as the incarnation of divine creation. The Virgin and Child provided, then, a form of nature – and a Christian figure for Painting – that although an inversion was not a gross distortion of divine perfection. This was the model or 'other' through which the living artist and his art could approach the ideal by imitation.[19]

Some of the proper self-portraits depicting artists at work that appear from around 1550, such as Alessandro Allori's of c.1555 (cat.3) or Sofonisba Anguissola's of 1556 (cat.4), engage with these ideas. By boldly placing herself in the position of St Luke, Anguissola characterised herself as divinely inspired to paint and motivated not

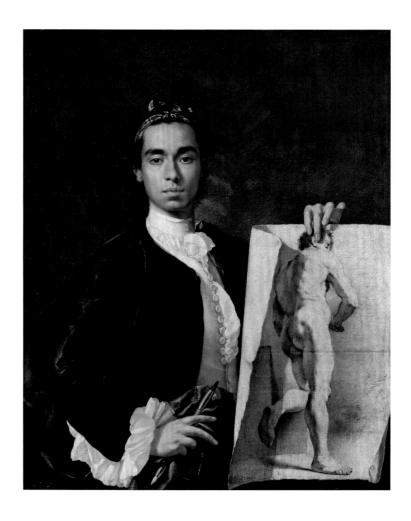

Fig.5
Luis Meléndez
(1716–80)
Self-portrait Holding
an Academic Study, 1746
Oil on canvas, 461 x 380mm
(18 x 15")
Musée du Louvre, Paris

Fig.6
Titian (Tiziano Vecelli)
(*c.*1487–1576)
*Self-portrait, c.*1550–62
Oil on canvas, 960 x 750mm
(37¾ x 29½")
Staatliche Museen,
Gemäldegalerie, Berlin

by money but by devotion to the sacred, completed subject
represented by the Virgin and Child. Her outward glance conflates
her own reflection in a mirror with both her virtuous model and the
living world. The young Alessandro Allori is actually transfigured by
devout contemplation of the Virgin in and as a mirror. His clothes
have an azure hue as though imbued with a reflection of Virgin blue
and the gentle face, shaped and smoothed as if by radiant light, bears
a meditative expression reminiscent of that attributed to Mary in her
knowledge of Christ's impending fate.

In such uses of the mirror we can recognise a distinction
between the exterior and interior self and a dynamic concept of
selfhood still familiar to us today. In a mirror we can see our faults,
but God is also accessible 'through a glass darkly'.[20] Progress
towards perfection involves an ongoing dialectic between external
experience and the shadowy depths visible through self-reflection,
until we reach the blinding light. Self-portraits are supposed to bear
witness to the artist's autonomy,[21] but in fact very often include other
figures – friends and patrons, lover, wife, child, teacher, student,
model – which can be understood as mirror images or alter egos
contributing to the constitution of the artist as a perfect subject.
In Anthony van Dyck's self-portrait with Endymion Porter of *c.*1635
(cat.12) the artist is shown in a complementary relationship to a
'middle man' with the power to progress his standing at the court
of the sovereign, Charles I. United by the rock, the ineffable
substratum on which they rest their hands, Porter's brilliant, silvery,
substantial surface is a mirror-inversion of the artist's mysterious,
melancholic black depths.

THE CANVAS ON THE EASEL

The other side of the mirror of virtue, leading to loving engagement
and ultimate union with divine perfection, is the mirror of vanity,
which transfixes the subject into absorption and annihilation.
Self-portraiture's reference to the mirror thus dramatised and
internalised a complementary distinction between progress towards
an enduring, honorific identity and a self-deceptive narcissism
ending in abjection and death. In this way the misleading mirror
of vanity has the potential to face the material self with a grotesque
emptiness, even menace. The enticing pool of self-reflection in
which we have placed our trust seduces us into a petrifying prospect,
a canvas that is irreversibly just sacking, rather than the material
support of life.

Giovanni Baglione's 1642 *Life of Caravaggio* records that as a
young man, 'he made some small pictures of himself drawn from
the mirror. The first was a Bacchus with some bunches of various
kinds of grapes, painted with great care but a little dry in style.'[22]
In his *Self-portrait as the Sick Bacchus* (fig.13) Caravaggio juxtaposed
face and body, in the guise of a nature-god, to intensely observed
pieces of fruit. The wondrous lifelikeness of the fleshy peaches and
glassy grapes on the tombstone-like table stages the creation of a
naturalistic, sensual illusion from inert material, and the ailing face
of Bacchus/the artist suspends him between eternal, fertile life and
a blank and barren death. Centuries later, the single narcissus that
flowers in Christian Schad's *Self-portrait* of 1927 (cat.42)
acknowledges the painter's naked, objectified and scarred partner
and 'model' as a morbid mirror image. Here, loving, creative

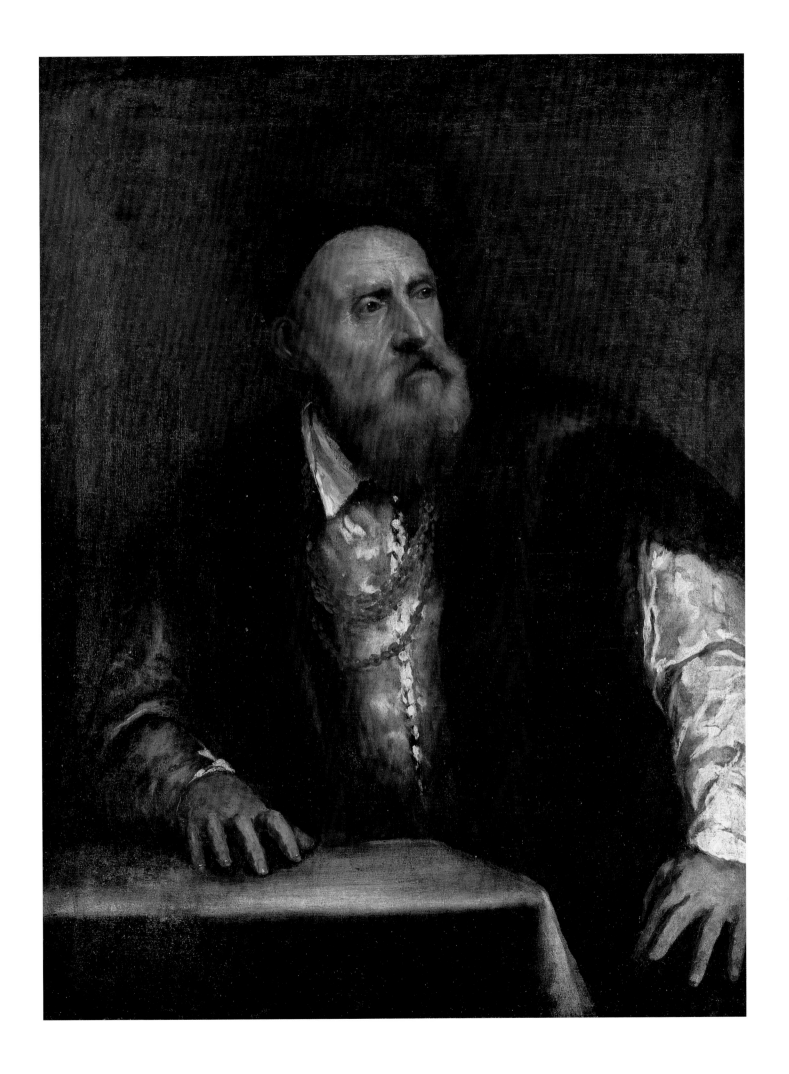

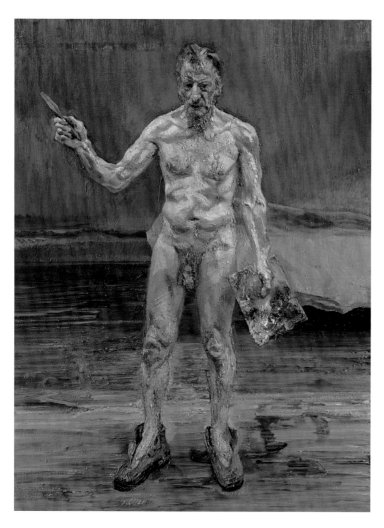

Fig.7
Lucian Freud
(b.1922)
Painter Working. Reflection, 1993
Oil on canvas, 1016 x 819mm
(40 x 32¼")
Private Collection

intercourse seems to have slipped into self-serving exploitation. In Hans Thoma's Romantic *Self-portrait with Love and Death* of 1875 (cat.31) the artist, poised between a plump young cupid and the bony frame of a skeleton, is oriented towards a threshold of representation that is at once a mirror and the canvas. The mirror is typically juxtaposed to a canvas during the practical production of a self-portrait, and a stretcher or panel borne on an easel becomes a defining feature of self-portraiture from the mid-sixteenth century onwards. The word easel derives from the German for 'donkey' or 'ass',[23] linking this apparatus with the base, load-bearing animal that bore the incarnate Christ. In Annibale Carracci's *Self-portrait on an Easel in a Workshop* of *c*.1605 (cat.6) the lowly placement of the painted canvas on a strangely two-legged easel produces a travesty of the absent, honorific image of the artist. Yet in the central eye, placed like a navel in this humble rearrangement of ideal reality, we inescapably see life.

At the beginning of the century in which Descartes articulated a radical mind–body dualism, violent physical severance is located at the heart of a melancholic, histrionic, yet formidable creator.[24] Just before he died in 1610, Carracci's contemporary Caravaggio is believed to have given his own face to a decapitated head, the dishevelled giant Goliath overwhelmed by a luminous youth (fig.47). Cristofano Allori soon followed suit with his *Judith with the Head of Holofernes* bearing the features of the painter and his feminine lover (cat.7). In the Biblical text Judith kills the enemy commander Holofernes by seducing him and then severing his head. In the picture the head, though disembodied, blind, agonised, remains unmistakably alive, held up by a gorgeously attired beauty in the position usually taken by the artist. From one perspective, deceitful Painting, representing the material world, has risen from her abjection to make the mirror-glass cut absolute, inverting the immortal subject in a grotesque mask and assuming his rightful place. From another, the painting is true to the human condition, miraculously and sadly suspended, in representation, between eternal life and absolute death, the mirror's promise of perfection and the blank material canvas propped up by the wooden easel.

PAINTING IN OIL

Viewers who knew nothing of photographs, and much more than most of us about how pictures were made, appreciated the immense art involved in creating a perfect mirror from earthy materials. Forty years after the death of Rembrandt, for example, a Dutch authority judged a master of high finish, Adriaen van der Werff (1659–1722), to be the greatest star in the whole artistic firmament of the Netherlands (cat.21).[25] In Spain in 1746, however, the ambitious young Luis Meléndez (1716–80) felt compelled to demonstrate his artistic wit, invention and scope to prospective clients and the Academy by balancing his beautifully portrayed face with a perspective drawing of a male nude, perfectly realised in oils (fig.5). The naturalistic vision of coffee-coloured complexion and white ruffled shirt unfurls into a display of academic thought and skill on the cream paper. To our eyes, the naked body, depicted from behind and below, also hints that this artist is essentially motivated by physical desire.

Even in the twentieth century, when progressive art had largely abandoned the power of illusion to photography, there are self-portraits in oil that continue to explore Alberti's belief in lifelikeness as a creative form. Stanley Spencer, for example, produced a *Self-portrait* in 1913 or 1914 (fig.57) whose miraculous technical proficiency, frontality and naturalism are immediately reminiscent of Dürer's *Self-portrait* of 1500 (fig.36). Yet rather than bearing witness to (a) divine creation, Spencer's painting speaks directly of the sensory and sensual power and presence of the painter through the substance of the paint and the way in which the bronzed face with its assertive gaze, projecting nose and succulent lips is set erect upon the exposed, pale column of the neck. Christian Schad, both a painter and a photographer, refines illusionistic naturalism into a second skin, a transparent sheath to contain and yet reveal the hairy body, while still allowing the head to emerge as the locus of raw power (cat.42).[26] In Schad's painting there is also a diaphanous, folding membrane between the anonymous, industrial landscape that lies behind and the supposedly 'private', 'individual' concerns that are foregrounded. The artist is a subject divided and repressed, yet at the same time revealed and empowered, by the capacity artfully to cultivate a delicate screen of naturalistic illusion distinct from the animal body and an alien world.

Exploitation of oil paint's capacity not only to produce a brilliant likeness but also to mark its own substantial presence dates from mid-sixteenth-century Venice.[27] Because oil could be reworked, it could mark the process or progress of creating an image. In coming closer to the working drawing and sketch, painting was understood to signify the 'hand' of the artist, not in the sense of manual labour but rather as instrument or gesture: the active realisation of a personal vision or inspiration through a particular process and manner.[28] This new way of thinking about painting is evident in Titian's freely painted and seemingly spontaneous *Self-portrait* of *c*.1550–62 (fig.6), where the artfully averted gaze both denies the formative role of the mirror and implies the existence of another person beyond the frame. The glass has in effect been broken, but the mirror has not been destroyed. An embodied viewer, who stands in the very place occupied by the original artist and actively participates in the completion of the subject, now undertakes the creative role of the other.

The identification of this 'rough' form of oil painting not only with an active, bodily engagement with nature but with life itself is now taken for granted, although its full history remains to be written. Looking at Lucian Freud's *Painter Working. Reflection* of 1993 (fig.7), for example, the artist asks us to interpret the marks of paint in terms of living flesh: 'I want paint to work as flesh … my portraits to be of the people, not like them. Not having a look of the sitter, being them … As far as I am concerned the paint is the person. I want it to work for me just as flesh does.'[29] Flesh is, of course, also dead meat and, in reality, the lifelike reflection will disappear when the living subject is no longer physically there to look. In the very way that it is painted, this picture of the naked, aged artist produces 'life' in the juxtaposition of the idea of an ongoing, creative process with the temporary material reality of the body. The boots are indicative of a journey but also, like feet of clay, make the material foundations of existence – and representation – explicit.

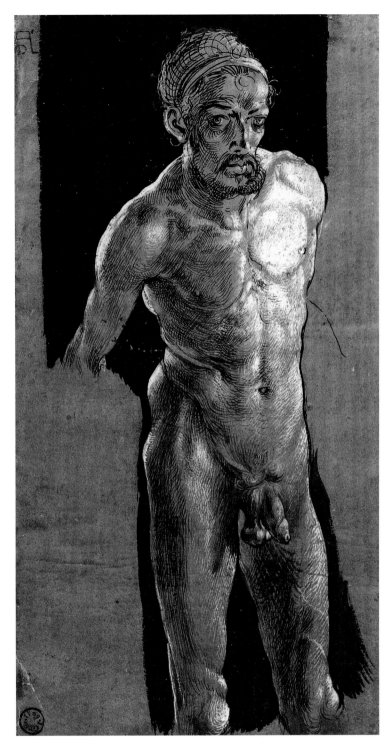

Fig.8
**Albrecht Dürer
(1471–1528)**
*Nude Self-portrait, c.*1503–5
Pen and wash, 290 x 150mm
(11½ x 6")
Schlossmuseum, Weimar

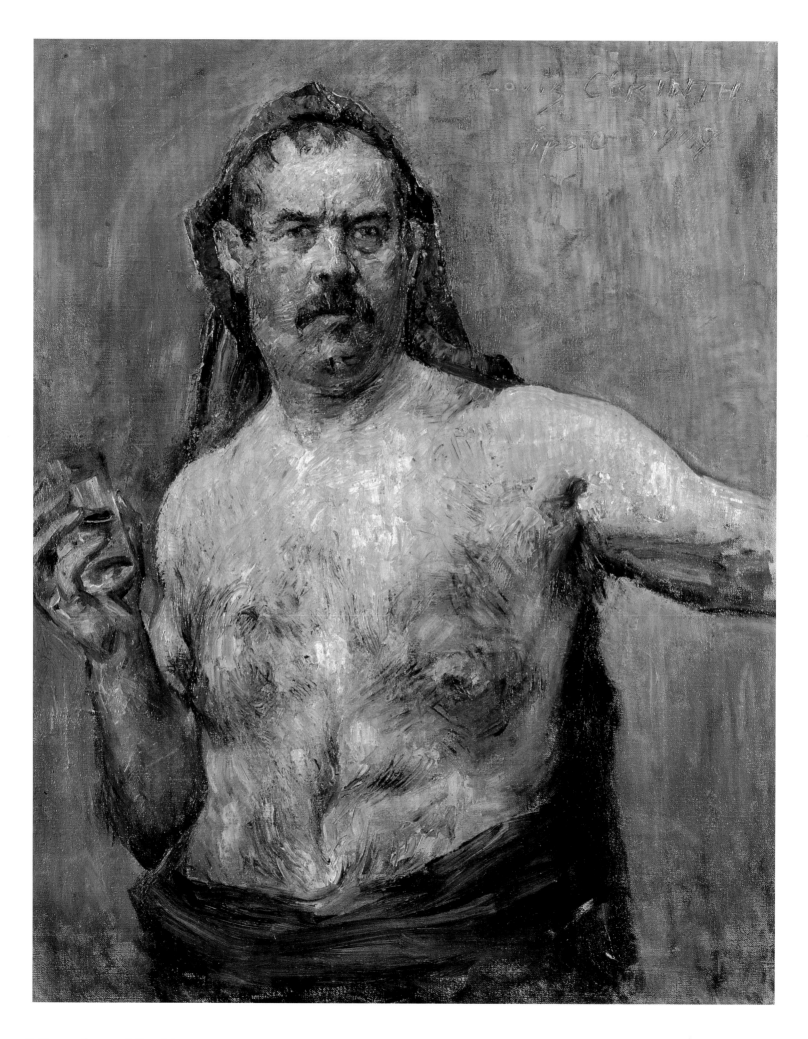

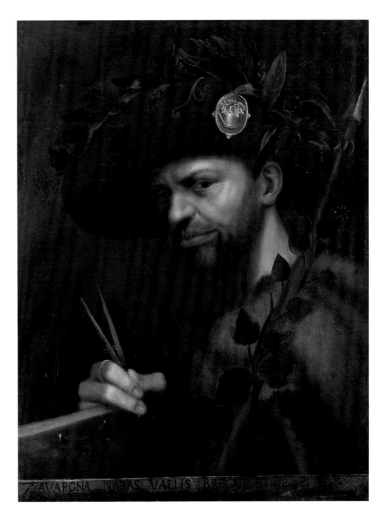

Fig.9
**Lovis Corinth
(1858–1925)**
Self-portrait with Glass, 1907
Oil on canvas, 1000 x 800mm
(39⅜ x 31½ ")
National Gallery, Prague

Fig.10
**Giovanni Paolo Lomazzo
(1538–1600)**
*Self-portrait, c.*1568
Oil on canvas, 430 x 550mm
(17 x 21⅝")
Pinacoteca di Brera, Milan

THE MASCULINE BODY

The etymological relationship between the words *genitals, genius, ingenious* and *generation* establishes a connection between the male sexual organs and creative powers, alongside the negative, confessional view of them as grotesque agents of disease and carnal lust, posing a threat to reason and even life itself.[30] Insistence on embodiment as a condition of, as well as a mortal threat to, masculine creativity can be traced right back to Dürer's naked self-portrait of *c.*1503–5 (fig.8) and Joseph Koerner suggests that this kind of image should be understood in terms of the 'Renaissance recuperation of the whole body' as a site of significance.[31] This was the source of the anxieties and debates about what *kind* of body is worthy of attention: naturalistic or ideal.

One potent masculine body that held great appeal for male artists in the Renaissance and far beyond was that of Hercules, the half-divine hero who repeatedly laboured to overcome evil and death. He was thus compelled to make a choice between (mirrors of) Virtue and Vice, rather than recognising their similarity and difference. Faced with two alluring women/landscapes, he preferred the lonely, rocky path to fame to the sunny pastures of desire.[32] Hercules' validation of heroic works and physical power as signs of and steps towards divine virtue provided an abstract, self-aggrandising model for both sovereigns and elite artists, but his human side – his rugged character and temptation to sensuality – also presented an animalistic vision of the masculine subject, quite distinct from the smoothly crafted gentleman. In Lovis Corinth's *Self-portrait with Glass* of 1907 (fig.9), for example, the cowl-like garment, hairy slab

of a body and fierce expression are irresistibly reminiscent of Hercules wrapped in the pelt of the strangled Nemean lion. In contrast to St Bartholomew's attainment of immortality by sloughing off the natural skin, Hercules' body is clothed or disguised in the hide of a powerful creature. Mimetic magic infuses plain matter with a vigorous, sensual, natural life that takes death head-on. At the same time, the body is shrouded in inert, empty material, the skin of a beast.[33] Corinth becomes recognisable as both a creative force and a canvas-bearing easel or 'ass', the inane material support of a lifelike illusion.

In Goya's *Self-portrait at 69 Years* (fig.18), the force of painting's living body seems to have split and broken through the blank canvas, as if defiantly furling back the collar like the tops of Freud's boots.[34] By comparison, Courbet's prostrate, blind and blooded *Portrait of the Artist called The Wounded Man* of 1844–54 (cat.29) acknowledges the place of death and annihilation as a condition of embodiment and representation. Both pictures rely on a connection between the material canvas and an illusion of immortal life.

Corinth's unconventional artist can be interpreted as the archetypal bohemian. His Dionysian creativity, inspired and physically driven to ecstatic, unruly outpouring by alcohol, music and sexual desire, is recognisably romantic, although the identification between the artist and Bacchus has a much longer history.[35] In addition to Caravaggio's *Sick Bacchus* (fig.13), for example, a self-portrait of about 1568 by the Milanese artist, poet and art theorist Giovanni Paolo Lomazzo (fig.10) shows him adopting an alternative name and disguising himself as the god of wine. The

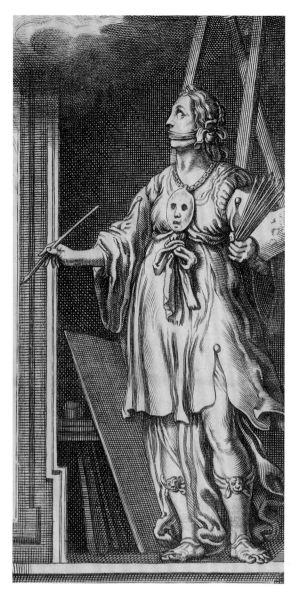

Fig.11
**Cesare Ripa (Giovanni Campani)
(1560?–1623?)**
Detail of *Pittura* from
title page of *Iconologia of
uytbeeldingen des verstands....
translated from the Italian by
Dirck Dietersz. Pers*, Amsterdam,
1603
Engraving
British Library, London

picture was apparently made to commemorate Lomazzo's position of authority in a literary academy whose gentlemanly members assumed the nicknames, vernacular dialect and proximity to nature of vine tenders.[36] In these two pictures, identification with Bacchus did not necessarily involve a commitment to 'rough' painting: although the figure of Lomazzo/Bacchus/Vine Tender is physically 'hairy', the *manner* of painting adheres to the tradition of mirror-like naturalism. Rough painting can well express a Dionysian outpouring, because of the legibility of gesture and process. However, as a figure of mystery, continuous change and theatrical deceit, Bacchus was equally well-placed to be figured – in painting and in the creative subject's persona – by miraculous transformations between base matter and lifelike illusions.

THE ARTIST AS A WOMAN

Western concepts of the artist have involved a distinction, and often an opposition, between an active, interiorised process of engendering life and an externalised, physical 'nature'. This way of conceiving creation is related to the dominant pre-modern theory of sexual reproduction, in which the man was believed to plant a 'seed', while the woman contributed the material environment in which this potential for new life was developed.[37] The feminine body encased the precious, implicitly masculine kernel of creativity within. Divine creativity was veiled or masked by the natural world in a similar way. Nature, gendered feminine, could be regarded negatively, as the base, imperfect material that screened and obscured the God within, the skin – the empty canvas – cast off by Michelangelo's St Bartholomew. It could also be regarded more positively, as the means of bringing forth or manifesting divine creation in a form accessible to human perception. In this ideal, Nature was understood in Christian thought as a mirror in which human beings could approach God through contemplation, imitation and reflection. The vision of perfect nature was given feminine form in the Virgin Mary, the Mirror without Stain and the Christian personification of painting. The Virgin Mother, impregnated directly by God, represented the justification and completion of nature by bearing and nurturing a (masculine) humanity that, while humble, infantile and embodied, was also immortal and divine.

Women artists, when they managed to gain access to representation, negotiated these gendered terms of reference in immensely inventive ways. Anguissola's self-portrait (cat.4) not only alludes to St Luke but also plays on the commonality between the female painter and the Virgin Mary as a virtuous form of nature and painting, negating the distinction between the miracle of creation and its material realisation. Both Anguissola and her emulator, Lavinia Fontana (cat.5) inscribed the title 'Virgin' on their self-portraits, thereby claiming perfectly to imitate – both in their paintings and in their behaviour as elite female painters – virtuous feminine nature.[38] Some four centuries later, the Mexican Frida Kahlo painted a self-portrait directly onto a mirror, deftly conflating the material support with the source of the illusion (cat.44). Painted wooden flowers frame the face, like a folk image of the Virgin in a flower garland. This small, seemingly unassuming work asserts the power of 'feminine' and 'marginal' creative forms.

Because abstract concepts were gendered feminine in Latin and Greek, humanists represented allegorical personifications such as

'Painting' as a woman. Certainly the picture itself, conceived as both a material object (a canvas) and a manifestation of divine beauty (a mirror), is conventionally gendered feminine, whereas the miraculous transformation of matter into living nature is generally attributed to the implicitly masculine artist 'behind' the work. I want to suggest here, however, that the aphorism 'every painter paints himself' implies that paintings were seen as *physically invested* in various ways with the presence of their author, rather than being simply surfaces generated by the design and genius of a hidden, abstract agent. The saying originally meant that there was a *bodily resemblance* between the figures in a painting and the physique of the artist, and the development of languages of personal manner, style and connoisseurship from the mid-sixteenth century assumed that the artist not only stood *behind* the work, at its origin, but was also visibly present *in it*, in the personal realisation of the conception and the handling of the paint.[39] The clearest instance of the presence of the artist in the work is self-portraiture, where the lifelikeness, there for all to see, is of *both* the model and the painter, the object of representation and the creative subject.

This makes it impossible to visualise the idea of Painting within the bounds of the conventionally feminine because a picture manifests not only 'beauty' or 'nature' but also the agency of the artist.[40] The Christian personification of Painting was, after all, not the Virgin alone but the Virgin displaying the Christ Child, a masculine incarnation of divine agency. In Cesare Ripa's *Iconologia*, a hugely influential dictionary of concepts in visual form first published in 1593, the figure of Pittura is described as a beautiful woman but, with its brushes and palette, it has the tools of the active painter. The figure is also a thinly veiled court artist, dressed in a lustrous garment, with the golden neck-chain and pendant traditionally awarded by the royal patron. This medallion hanging over the beating heart depicts, however, not the conventional head of a sovereign but a mask, the external 'feminine' face that petrifies, disguises and deceives yet also characterises and animates the living subject (fig.11).[41] Ripa advised that mute Pittura should have the word IMITATIO inscribed on her forehead, thus placing the *agent* in a mimetic relationship with an authoritative model similar to that of 'feminine' nature's reflection of God. Her dishevelled hair, associated with the Neoplatonic idea of poetic frenzy, located creativity in an active, irrational state understandable as both divine and hysterical. No wonder Pittura's garment was of changing colours and some artists identified with the chameleon god Bacchus![42]

Women artists exploited the identification of the painter with painting to characterise themselves as creative beings. The idea at the heart of Artemisia Gentileschi's self-portrait of 1638–9 (cat.14), for example, is simply to take Ripa's allegorical figure literally: if Pittura can be represented as a woman, then a specific woman can conceivably be portrayed as Pittura. While Ripa's figure is a composite of symbolic attributes, Gentileschi's brilliant invention fully integrates the painter as agent with the painting as product, the inspired and physical aspects of art. At the end of the eighteenth century, Elisabeth Vigée-Lebrun still invoked the Virgin Mary in representing herself as an infinitely desirable, natural beauty, the perfect other (cat.27). However, she also used the lessons of Pittura to imbue this 'feminine' nature with active 'masculine' agency. The forthright, flower-bedecked figure that teasingly confronts the

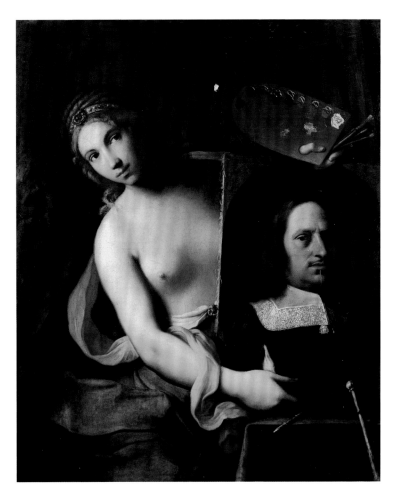

Fig.12
**Giovanni Domenico Cerrini
(1609–81)**
*Allegory of Painting, c.*1639
Oil on canvas, 1290 x 1080mm
(50¾x 42½")
Pinacoteca Nazionale, Bologna

viewer has implicitly assumed an inherent capacity to create. With a smiling, unflinching gaze she has taken the brushes in hand. At their very tips, touches of rose and sky-blue paint place the worldly body and a trace of heaven within the artist's scope and render the gorgeous surface the site of significance.[43]

Painting has historically been deeply reliant on gendered oppositions to naturalise, and challenge, patriarchal regimes of significance. Individual sovereignty, as a form of masculinity, has involved both desire for and hatred of a contrasting, implicitly feminine position. But painting's ultimate task, to face death by generating life in and through matter, entails an erotic union between these different terms.[44] As women make the tools of the divine agent their own, it also becomes possible to see, long before the potter Grayson Perry publicly assumed a feminine alter ego, male artists identifying with the 'feminine' character of Painting. In Pierre Bonnard's *Self-portrait* of *c*.1938–40 (cat.45), produced when the artist was in his early seventies, a feminine form of interiority is displayed by situating the artist in an intimate domestic space, in front of a dressing-room mirror, his hands apparently engaged with his own body. Behind the figure, pressing it into view, is a cruciform frame that could be a door or the back of a canvas. The effacement of individual features, the absence of self-portraiture's characteristic penetrating gaze and the vivid pastel palette replace individual self-assertion with absorption into the matter of (the) painting.

This picture is unusual in its feminine iconography and aesthetic but, as every painter paints himself, more conventionally masculine figures cannot avoid becoming intimately mixed up with supposedly feminine aspects of painting (fig.12). Even the heroic Corinth can embrace a feminine body (cat.36). By framing their 'selves' as subjects/objects of admiration, emulation, exploration, even fear, artists visualise themselves in the 'feminine' mirrors of virtue and vice, making use of the 'feminine' canvas or material that contains both the threat of death and the potential for life. In all self-portraiture the 'internal' character or spirit that imbues the figure with life is understood to be visible *in* – not through – a representa-tion that is bodily first because it is perceived as a likeness and secondly because it is physically made of paint. Inseparable from this pictorial articulation of 'true' life and creativity are performance, deceit, transformation – conventionally feminine forms of behaviour.

In the end, we know that while these gendered tropes are immensely and inescapably significant, we are all – men and women – ultimately in the same boat: sailing in fear and hope towards the horizon. The final terms of reference are not masculinity and femininity, but life and death.[45] For example, Jenny Saville's *Juncture* of 1994 (cat.57) explores from a feminist perspective boundaries that concern everyone. The figure of the artist is simultaneously intensely personal and a nameless other: faceless and sexless, the head crushed into a body and back-turned into something that is atonce a living being and a desolate landscape, a mirror image and a material canvas, flesh and paint. Contained by a rigid frame and pressed up hard against the transparent yet impenetrable plane of representation, the matter of subjectivity is squashed out of shape and yet still recognisable as a reflection – a compelling likeness – of our own position facing the image.

I warmly thank Joseph Koerner, Sandy Nairne and Rose Marie San Juan for their acute and constructive criticism, which has improved this essay immeasurably. I am also most grateful to Johanna Stephenson for her sensitivity and professionalism as an editor.

1 In the first engraving of the *Last Judgement* (1562), Michelangelo's name is inscribed immediately beneath the skin. Marcia B. Hall, *After Raphael. Painting in Central Italy in the Sixteenth Century* (Cambridge University Press, Cambridge, 1999), pp.133–4. The skin was first published as a self-portrait in Francesco La Cava, *Il volto di Michelangelo scoperto ne Giudizio Finale. Un dramma psicologico in un ritratto simbolico* (Zanichelli, Bologna, 1925); see also W.G. Avigdor Poseq, 'Michelangelo's Self-Portrait on the Flayed Skin of Saint Bartholomew', *Gazette des Beaux-Arts* 124 (July – August 1994), pp.1–13; cf. Leo Steinberg, 'The Line of Fate in Michelangelo's Painting', *Critical Inquiry* 6, no.3 (spring 1980), pp.411–54, who argues that the fresco represents the moment at which it is decided whether the skin will be saved to re-clothe the subject as an individual on the Last Day, or left to rot; B. Barnes, 'Skin, Bones and Dust. Self-Portraits in Michelangelo's *Last Judgement*', *Sixteenth Century Journal* 35, no.4 (2004), pp.969–86. See also Claudia Benthien, *Skin: on the cultural border between the self and the world*, trans. Thomas Dunlap (Columbia University Press, New York, 2002), p.96. Didier Anzieu, *The Skin Ego*, trans. Chris Turner (Yale University Press, London and New Haven, 1989).
2 Emison 2004, pp.6–7.
3 Vasari (ed. Milanesi) 1906, VII, p.272: 'aborira il fare somigliare il vivo, se non era d'infinita bullezza'. Édouard Pommier, *Théories du Portrait. De la Renaissance aux Lumières* (Paris, Éditions Gallimard, 1998), p.137.
4 Niccolò Martelli to 'Rugasso, servitor del S. Oratio de Farnese', Florence, 28 July 1544, in *Il primo libro delle lettere di Niccolò Martelli* (Florence, 1546), fol.49; Pommier 1998, p.137; Lorne Campbell, *Renaissance Portraits. European Portrait-Painting in the 14th, 15th and 16th Centuries* (Yale University Press, New Haven and London, 1990), pp.1–2.
5 Cecil Grayson, *Leon Battista Alberti, On Painting and On Sculpture. The Latin Texts of De Pictura and De Statua*, edited with translations, introduction and notes ... (Phaidon, London, 1972), pp.60, 61, Book II, p.25: '*Nam habet ea quidem in se vim admodum divinam non modo ut quod de amicitia dicunt, absentes pictura praesentes esse faciat, verum etiam defunctos longa post saecula viventium exhibeat, ut summa cum artificis admiratione ac visentium voluptae cognoscantur*'.
6 Asked why a cow was the most successful part of a picture he was shown, Michelangelo's cutting response was 'Every painter paints himself well' ('Ogni pittore ritrae se medesima bene'). Vasari (ed. Milanesi) 1906, VII, p.280. Leonardo described automimesis as a *defect* of paintings in which the expressions and physiognomies of the depicted figures actually resembled those of the artist. Zöllner 1992, pp.137–59, esp. pp.143–5; Kemp 1976, pp.311–23; Wittkower and Wittkower 1963, pp.93–4.
7 Koerner 1993, p.55.
8 Cf. Stoichita 1997, pp.198–267 and *passim*.
9 Berger 2000, pp.119–135 for a discussion and critique of these beliefs.
10 Smith 2004, p.38.

11 The Latin inscription on the lower edge meaning 'Jan van Eyck made me, 21 October 1433' underlines the named artist's authority over the subject as simultaneously its fabricator and a truthful witness. Lorne Campbell, 'Portrait of a Man (Self Portrait?)', *National Gallery Catalogues: The Fifteenth Century Netherlandish Paintings* (National Gallery Publications, London, 1998), p.214.
12 Melchior-Bonnet 2001, p.18, citing Germaine Rose-Villequey, *Verres et verriers en Lorraine au début des temps moderns* (PUF, Paris, 1972), p.62. Brown 2000, p.48.
13 J. Fletcher, '"Fatto al specchi": Venetian Renaissance Artists in Self Portraiture', *Fenway Court: Imaging the Self in Renaissance Italy* (Isabella Stewart Gardner Museum, Boston, 1990–1), pp.45–60. Elsewhere during this period, self-portraits were commonly described as 'a portrait of the artist by himself'; the term *self-portrait* becomes established in English in the early nineteenth century. Erin Griffey, *The Artist's roles: searching for self-portraiture in the seventeenth century Netherlands* (Ph.D. thesis, University of London (Courtauld Institute of Art, 2001), pp.27–8, 30, 38. Ernst van de Wetering, 'The multiple functions of Rembrandt's Self-Portraits' in White and Buvelot 1999, pp.17–19.
14 *Karel van Mander. The lives of the illustrious Netherlandish and German painters*, vols 1– 6, ed. Hessel Miedema (Davaco, Doornspijk, 1994–9): I, no.63 (fol. 201r): '... *Want t'schijnt dat hier al leeft, en uyt de Tafel rijst./T'sijn spieghels, spieghels zijnt, neen t'zijn geen Tafereelen*'. Latin inscriptions relating to the Virgin in *The Ghent Altarpiece* (1432; St Bavo's Cathedral, Ghent), *The Madonna of Canon van der Paele* (1436; Musée Communal des Beaux-Arts, Bruges) and *The Virgin and Child in a Church* (1437; Staatliche Kunstsammlungen, Dresden) describe her as the brightness of the light, the unspotted mirror of the power of God and the image of His goodness (cf. Vulgate Bible, I Wisdom 7:29, II Wisdom 7:26). Elisabeth Dhanens, *Hubert and Jan van Eyck* (Tabard Press, New York, 1980), pp.106–7, 218, 377, 383, 385.
15 National Gallery, London.
16 Melchior-Bonnet 2001, pp.105–11; cf. Marin 1995, p.205 and *passim*. H.Schwartz, 'The Mirror in Art', *Art Quarterly* 15 (spring 1952), pp.96–118; Schwartz 1959, pp.90–105; Brown 2000, pp.45–55.
17 Ernest Cushing Richardson, *Materials for a Life of Jacopo de Varagine* (H.W. Wilson Company, New York, 1935), vol.2, p.66.
18 Gisela Kraut, *Lucas Malt die Madonna: Zugnisse zum künstlerischen Selbstverständnis in der Malerei* (Wernersche Verlagsgesellschaft, Worms, 1986), pp.10–12. In some cities north of the Alps (e.g. Aachen), both painters and mirror-makers were members of the guild of St Luke (Brown 2000, p.47 n.58).
19 Cf. Taussig 1993, pp.44–7 and *passim*.
20 I Corinthians 13:12.
21 Koerner 1993, p.9.
22 Giovanni Baglione, *Le Vite de'pittori,scultori et architecti* ... (Rome, 1642; facsimile edn V. Mariani, Rome, 1935, p.136), trans. in Catherine Puglisi, *Caravaggio* (Phaidon, London, 1998), p.414.
23 Ernest Klein. *A Comprehensive Etymological Dictionary of the English Language*. (Elsevier, Amsterdam, 1971), p.495; Old High German: *Esil*; Latin: *asinus*; Italian: *cavaletto*. The metaphor is similar to 'clothes horse'.
24 Sigmund Freud, 'Mourning and Melancholia' in *The Freud Reader*, ed. Peter Gay (W.W. Norton and Company, New York and London, 1989), pp.584–9; Wittkower and Wittkower 1963, pp.102–8: 'The Saturnine Temperament'.
25 Arnold Houbraken, *De Groote Schouburgh der Nederlantsche Konstchilders en Schilderessen* (3 vols, Amsterdam 1718–21, repr. Leiter-Nypels, Maastricht, 1953), vol.3, pp.387–8, 400.
26 Gell 1998.
27 Maria-Isabel Pousão-Smith, *Concepts of Brushwork in the Northern and Southern Netherlands in the seventeenth century* (Ph.D. thesis, University of London [Courtauld Institute of Art], 1998), pp.97–9; Gridley McKim-Smith, 'Writing and painting in the Age of Velasquez', in G. McKim-Smith *et al.*, *Examining Velazquez* (Yale University Press, New Haven and London, 1988), pp.1–33, esp. 1–2, 15–33; Ernst van de Wetering, 'Rembrandt's Manner: Technique in the Service of Illusion', in Christopher Brown *et al.*, *Rembrandt: The Master and his Workshop* (exh. cat., National Gallery, London, 1991–2), pp.16–22; see also Joseph Koerner, 'Factura', *Res* 36 (autumn 1999), pp.5–19; H. Damisch, 'The underneaths of painting', trans. F. Pacteau and S. Bann, *Word and Image* 1, no.2 (1985), pp.197–209.
28 J. Woodall, 'Drawing in Colour', in *Peter Paul Rubens. A Touch of Brilliance* (exh. cat., The Hermitage Rooms, Courtauld Institute of Art, London, 2003).
29 William Feaver, 'Lucian Freud: Life into Art' in W. Feaver, *Lucian Freud* (exh. cat., Tate, London, 2002), p.33: 'For me the painting *is* the person'.
30 Klein 1971 (see note 23), pp.648, 794. See also Koerner 1993, p.246; Geoffrey H. Hartman, 'Toward Literary History', in *Beyond Formalism: Literary Essays 1958–1970* (New Haven and London, Yale University Press, 1970), p.373 n.18; Otto Rank, *Art and Artist: Creative Urge and Personality Development* (W.W. Norton and Company, London and New York 1989 [c.1932]), pp.19–20, 45.
31 Koerner 1993, p.244.
32 R. Wittkower, 'Chance.Time and Virtue', *Journal of the Warburg and Courtauld Institutes* 1 (1937–8), pp.313–21; J. Siegel, 'Virtù in and since the Renaissance', first published in *Dictionary of the History of Ideas* (New York, Charles Scribner's Sons, 1973–4), vol. 4, pp.476–85. The basic iconographic study is E. Panofsky, *Herkules am Scheidewege und andere antike Bildstoffe in der neueren Kunst*, ed. F. Saxl, Warburg Library Studies 18 (Warburg Library, Leipzig, 1930). In Cesare Ripa, *Iconologia, overo Descrittione d'Imagini delle Virtv, Vitij, Affetti, Passioni humane, Corpi celesti, Mondo e sue parti* (Padua, Pietro Paolo Tozzi, 1611), pp.537–8, 'Heroic Virtue' takes the form of Hercules in the lion-skin with his club and apples.
33 Gell 1998, pp.99–102, 104–6. The statue of *The Seated Scribe* from Sakkara (Egypt, c.2620–2350 BC) in the Musée du Louvre, Paris, shows the use of one's own apparel as a kind of easel. The figure, naked to the waist, sits cross-legged with his skirt stretching tightly across his knees to create a firm surface on which to rest his tablet. An anonymous twelfth-century manuscript from St Catherine's monastery, Mount Sinai, juxtaposes mirror, easel and skin, showing an illuminator of manuscripts (generally made of parchment) with a small, angled mirror attached to his podium. This reflected the sun onto the work in progress, but would also have enabled the artist to see his own face. On the history of the easel: http://www.xylemdesign.com/default.asp.z
34 See also Carel Fabritius, *Self-Portrait* (c.1645; Museum Boymans-van Beuningen, Rotterdam).
35 The work of Rubens, for example, is currently being reconsidered in relation to Bacchic concepts of creativity. R. Stephan-Maaser, *Mythos und Lebenswelt. Studien zum 'Trunkenen Silen' von Peter Paul Rubens* (Lit, Münster, 1992); Svetlana Alpers, *The Making of Rubens* (Yale University Press, New Haven and London, 1995); Lucy Davis, *The Bacchic Paintings of Peter Paul Rubens* (Ph.D. thesis, London University [Courtauld Institute of Art], 2003). On traditions of Bacchic creativity, ibid. pp.41–97. On Bacchic ecstacy and divine furor: 'Marsilio Ficino to Peregrino Agli "de divino furore"', *The Letters of Marsilio Ficino* (Shepheard-Walwyn, London, 1975), 7 vols: I, p. 42; P. P. Bober, 'Appropriation Contexts: décor, Furor Bacchicus, Convivium', *Antiquity and its interpreters*, eds Alina Payne, Anne Kuttner and Rebekah Smick (Cambridge University Press, Cambridge 2000), pp.231–8.
36 James B. Lynch, 'Giovanni Paolo Lomazzo's Self-Portrait in the Brera', *Gazette des Beaux- Arts* 64 (1964), pp.189–97; Adrienne von Lates, 'Caravaggio's peaches and academic puns', *Word and Image* 11, no 1. (January–March 1995), pp.55–60.
37 F.H. Jacobs, 'Woman's capacity to create. The unusual case of Sofonisba Anguissola', *Renaissance Quarterly* 47, no. 1 (spring 1994), pp.74–101; Prudence Allen, *The Concept of Woman: The Aristotelian Revolution, 750 BC – AD 1250* (Eden Press, Montreal 1985), p.91: 'The female always provides the material, the male that which fashions the material into shape ...' (Aristotle, *Generation of Animals*, trans. and ed. A.L. Peck [Harvard University Press, Cambridge, MA, and William Heinemann Ltd, London, 1943], 785a 20). See further Allen 1985 (see note 37), pp.89–101.
38 Gunter Schweikhart, 'Boccaccio's De Claris Mulieribus und die Selbstdarstellungen von Malerinnen im 16.Jahrhundert', in Winner 1992, pp.113–27. Whitney Chadwick, *Women, Art and Society* (3rd edn Thames & Hudson, London, 2002), p.32 for Iaia of Kyzikos who, according to Pliny the Elder, outdid her male contemporaries in portraits of women and rapid work, whilst remaining *perpetua virgo*.
39 Kemp 1976, pp.311–12, 314–15; Zöllner 1992, pp.139–45. Cf. the Aristotelian idea that a male child's resemblance to his father resulted from a 'victory' of the male seed over the resistance of feminine matter (Allen 1985, [see note 37], pp.95, 101–3). On connoisseurship and subjectivity, E. Honig, 'The beholder as work of art: A study in the location of value in seventeenth century Flemish painting', *Nederlands Kunsthistorisch Jaarboek* 46 (1995), pp.253–93.
40 Gell 1998, pp.17–19, 23, 33.
41 Gombrich, 1982, esp. p.111. Cf. Derrida 1993, pp.72–3; Deleuze and Guattari 1988, pp.167–91.
42 Ripa 1611, pp.429–30.
43 Cf. Mary D. Sheriff, *The Exceptional Woman. Elisabeth Vigée-Lebrun and the Cultural Politics of Art* (University of Chicago Press, Chicago and London, 1996), pp.180–220.
44 Georges Bataille, *Eroticism*, trans. from the French by Mary Balwood (Marion Boyars, London and New York, 1987), pp.12 –19, 55–62.
45 Cf. Marin 1995, p.213.

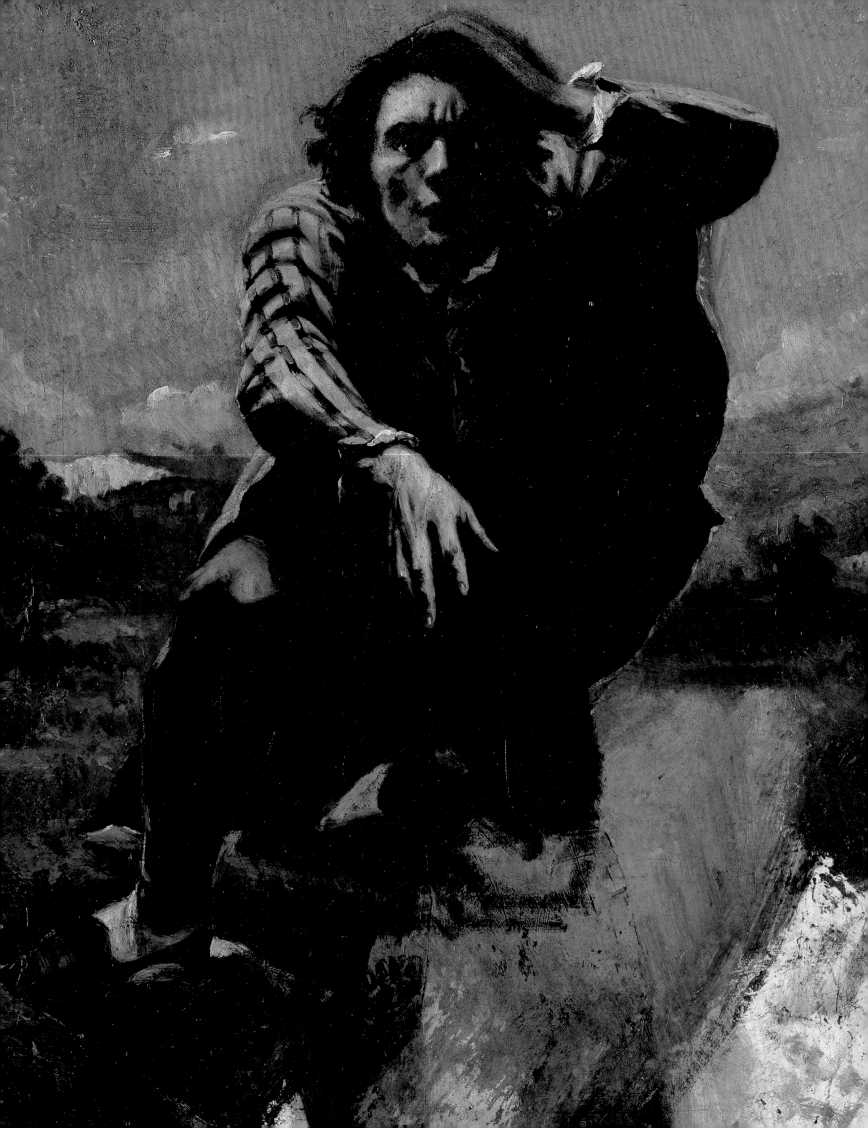

PERFORMING THE SELF?

Anthony Bond

This exhibition demonstrates the unique properties of self-portraits which transcend mere stylistic development, revealing an extraordinary recurrence of certain artistic strategies across five hundred years of Western art history. The works all share the physical circumstances of material dependence on the mirror in the studio. In spite of the changing social and philosophical contexts the artists also share certain subjective needs that inform the way the paintings are structured.

Artists express a strong desire to communicate with posterity, often going to great lengths to convey their layered personal and social circumstances to establish their identity and their status as creative artists. However, the best self-portraits are far more than personal memorials. Many artists draw each successive spectator into an intimate exchange, and through this exchange they ensure their immortality in the hearts and minds of others. It is the continuity of common themes and encounters that has informed the selection of the exhibition and the themes explored in this catalogue. The sense of urgency that often produces the compelling nature of the self-portrait image has its roots in the Renaissance. From the late fifteenth century artists had acquired both the status and the technical means to create this new genre that permits an intimate exchange between artist and viewer. For these artists it was not only the immortality of their superficial appearance that concerned them, but the very particular way they wanted to be remembered. They wished to establish their social context and to present themselves as embodying a powerful presence that would be encountered by generations of future beholders.

Since its origins in the Renaissance the genre of self-portraiture entailed many often contradictory aims: to project the artist as a significant member of the intellectual elite, rather than as an artisan, and yet also somehow capture the moment of creation as proof positive that I, the artist, made this transformation of base matter into the likeness of a gentleman. There is a commonly held view that any portrait should attempt to reveal the true character and the complex identity that lies behind the appearance of the sitter. This is always a problematic assumption, and even more so when the sitter is the artist, but it is a challenge that has become an obsession for many artists. Being human, artists may wish to present the image they want us to have of them, or indeed to create the ideal to which they aspire. These issues are dealt with in other parts of this book, but my chief interest will be to consider self-portraits as representations of artistic creativity. The immediacy of the creative act is captured in the mirror and translated onto the canvas, to be empathetically encountered by future beholders who stand in the place of the artist before the painting.

There are three distinct ways in which the idea of creativity can be represented in a self-portrait. The most direct of these is to paint oneself in front of the easel with brush in hand (and we include a number of examples here). Then there is the trace of the artist's hand, the signature brushwork that proclaims originality and individuality, acting as evidence of the artist's touch. In known self-portraits we do not need to be experts in identification to read this signature: it is sufficient that we appreciate the handling of the paint as evidence of the artist's prior presence in front of the canvas. This

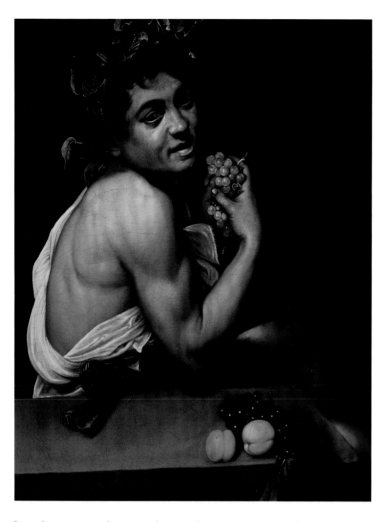

Fig.13
Michelangelo Merisi da Caravaggio
(1571–1610)
Self-portrait as the Sick Bacchus,
*c.*1593–4
Oil on canvas,
670 x 530mm (26⅜ x 21")
Galleria Borghese, Rome

literal trace provides us with an indirect contact with the artist that is more immanent than any image alone. Finally, there are allegories of creativity, for example Dionysian inspiration, most notably evident in Caravaggio's *Self-portrait as the Sick Bacchus* (c.1593–4; fig.13) and the modern equivalent of the bohemian artist with glass or cigarette in hand. Female procreativity or male fertility may also be associated with the act of artistic creation.

When artists show themselves in the studio they provide us with a privileged insight into the structure of all self-portraits. In these compositions we can see the set-up that applies to the genre as a whole. In order to paint his own likeness the artist must be able to look into a mirror. While it is possible that they could memorise their image and reproduce it later, this is not how most artists undertake the process. The mirror is usually placed to one side of the artist with the canvas on the easel at right angles to it and in easy reach of the artist's brush. So the artist stands or sits in a tightly configured triangular space compressed between mirror and canvas. As a result the painted image often appears to extend beyond the frame of the painting just as its reflection will have done beyond the mirror.

When we look at a self-portrait we occupy the same space before the canvas as the artist did to paint the image. While this is also true of all paintings, in the case of the self-portrait it is particularly poignant: we find ourselves looking back into the eyes of the artist, just as they gazed into their own reflection in the mirror. In this way the canvas replaces the mirror spatially and the viewer is caught up in a close exchange with the artist. The intimate nature of many self-portraits ensures that the viewer stands at approximately arm's

length from the canvas in order to view them. This spatial relationship supports the tendency for the viewer to identify with the artist as the trace of the artist's hand is brought into sharp focus.

The self-portrait of Johannes Gumpp (1646; cat.19) makes this prismatic configuration explicit. The artist is seen from the back, standing in the same plane as the spectator. The mirror is shown to his left and the painting he is working on hangs on the right. The Gumpp is also notable for the way it engages the viewer in a paradoxical hierarchy of representations of the real. Almost half the painting is occupied by the back view of the artist working in the studio; his black cloak forms a large triangular area in the lower centre of the composition, as it were a void at the bottom margin of the painting. It also acts as an arrow to point up the composition to where the action takes place. By making his own body our point of entry to the composition Johannes Gumpp underlines the role of the spectator as second beholder, standing in the place of the artist, the first beholder.

There is a subtle progression in the three images of Gumpp presented here. The cloaked figure is the largest, yet it is virtually an unrelieved black space with the exception of the white collar separating black hair from black cloak. To the left is Gumpp's reflection in the mirror, facing the black figure. However, the figure does not seem to be facing the mirror: he turns to look at the painting which hangs on the right, a little lower than the mirror. The mirror image thus represents his memory of what he saw before he turned to the canvas. The painted portrait is just a little brighter and more present than the mirrored image, and, although it is the same face

Fig.14
Gustave Courbet
(1819–77)
The Man Made Mad with Fear
(The Desperate Man), c.1843–4
Oil on paper mounted on
canvas, 610 x 914mm (24 x 36")
Nasjonalgalleriet, Oslo

captured at the same moment, instead of looking back at the artist it completes the cycle by looking over his creator's shoulder at the spectator.

The figure of the artist that is the closest to the viewer (the one in the cloak, brush in hand) must have been painted from imagination unless he had a very complicated set of mirrors in the studio, which may partly explain why it is the least defined of the three. The mirror, presumably a memory in the representation, is slightly shaded; the painted portrait that is the focus of the artist's gaze is the brightest of the three. Thus we have a clever representation of various states of consciousness: imagination, memory and immanent perception. It could equally be a demonstration of the artist's skill appearing to create an image brighter than life itself. The picture is an extraordinary study of the experiential consequence of the set-up necessary for any self-portrait.

The intensity of this implied circling of the gaze, including that of the spectator, in self-portraits supports Michael Fried's speculations on the 'quasi corporeal merger' that he finds at work in the self-portraits of Courbet.[1] Fried finds that in bringing the figure very close to the surface and providing various compositional strategies the painter attempts to break down the boundary that separates the world in the image and the world on our side of the canvas. Courbet's *Wounded Man* (1844–54; cat.29) seems to be slipping out of the picture at the bottom of the frame as if the lower part of his body were continuing into our space before the canvas. This apparent movement out of the picture plane brings us so close to the image of the painter that we come to empathise with him to the point of a

close identification. I would suggest that, contrary to Fried's view, this is not specific to Courbet but applies in some degree to self-portraiture in general. I suspect that this is an important factor in many self-portraits: they do not simply communicate an experience of the artist; rather, their true purpose may be the projection of the idea of selfhood from the artist to the viewer.

Courbet's most dramatically claustrophobic self-portraits underscore the climax of a process in which the perceived boundaries between representation and reality are put under pressure. In *The Man Made Mad with Fear* (c.1843–4; fig.14) the artist seems to be leaping out of the canvas in which his virtual presence is entrapped. Remarkably, the painted surface breaks down into an unresolved scumble just where the cliff edge or void should be. This is, of course, just an unfinished canvas that reveals a partly erased underpainting – or is it? In many self-portraits Courbet deliberately plays with this possibility of an imaginary passage between the painted space and the world on our side of the frame. In *The Burial at Ornans* (1849–50; Musée d'Orsay, Paris), for example, the open grave just appears at the lower edge of the canvas, providing a point of passage between our world of consciousness and the imaginary world beyond. The dark figure of Gumpp performs a similar function in his self-portrait, and in many of the paintings of Cézanne there is a loosening of the painted structure at the lower edge that seems to facilitate a kind of entry to the composition. Consciously or unconsciously, therefore, the fragmented edge of the void in *Man Made Mad with Fear* may well represent such a passage. Courbet was after all a master of the rapidly rendered rock face and it would have

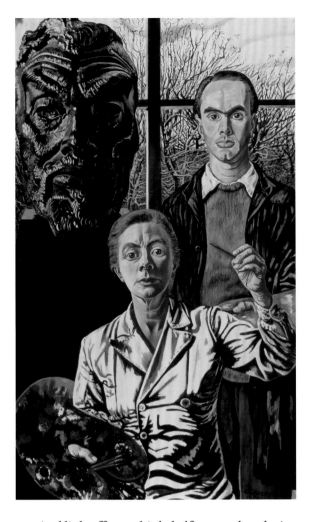

Fig.15
**Diego Velázquez de Silva
(1599–1660)**
Las Meninas, 1656–7
Oil on canvas, 1050 x 910mm
(4⅜ x 36")
Museo del Prado, Madrid

Fig.16
**Charley Toorop
(1891–1955)**
Three Generations, 1941–50
Oil on canvas, 2000 x 1210mm
(78¾x 47⅝")
Museum Boijmans Van
Beuningen, Rotterdam

required little effort on his behalf to complete the image. He may, on the other hand, have frightened himself by imagining his own extreme existential terror and simply abandoned the project. In either case we can share the sense of panic it embodies.

The Spanish sculptor Juan Muñoz illustrated this experience for me when he gave me his interpretation of the composition of *Las Meninas* by Velázquez (1656–7; fig.15), one of the great self-portraits of all time and one of the most complex in terms of its engagement of the viewer in a reciprocal and self-conscious exchange of the gaze.[2] Muñoz talked of the cycle of glances and of the king and queen who must have stood just where we stand in order to be reflected in the rear mirror and painted by the artist who glances out at them (and us). He also raised the question of the notional and problematic giant mirror that would have needed to be positioned where we stood, in place of the subject, so that the artist could see himself making the painting, as well as the scene behind his back where we see the reflection of the missing king, queen and courtier in the doorway. It was then that Juan so pointedly evoked the existential terror to be found in the Courbet when he said: 'Now we go to have a real Spanish lunch, but they stay; and that is the terror of Spanish painting!'

In some of the most direct self-portraits where artists represent themselves as engrossed in the process of capturing their image in a mirror positioned at right angles to the pictorial plane, strange things may also be happening. In the case of Alessandro Allori's charming and gentle self-portrait (*c*.1555; cat.3) he shows himself gazing down and to his left, presumably at a mirror that must be on our side of the picture plane. Allori paints himself in the act of applying paint to an invisible surface abutting the edge of the actual canvas and at right angles to it. The mirror and the pictorial surface seem hinged at this point, and in this way the artist makes explicit the notional hinge between the real and the represented. In this kind of image the artist captures the moment of creation, showing himself with the tools of his trade in hand. Even in the most apparently conventional self-portraits, where the head and shoulders are framed and the head is inclined to one side as if glancing into the mirror, we experience a kind of complicity not common to other genres of painting. This is the case with Vincent van Gogh (1888; cat.34), Sassoferrato (*c*.1650; cat.20), Sabine Lepsius (1885; cat.33) and many others in this exhibition. Because we know that this is a self-portrait our reading of the image is conditioned to the presence of the mirror, and this may be reinforced by other clues. The eyes of the artist purport to be meeting their own gaze in the mirror, the surface of the canvas becoming one with the surface of the mirror. The viewer then seems to look into a mirrored surface and, instead of his own reflection, sees the face and intense gaze of the artist returned. This most authentic moment of connection between artist and beholder, bound in an empathetic exchange, is also the strangest of deceptions.

A most compelling example of this is a self-portrait by Charley Toorop, *Three Generations* (1941–50; fig.16). This painting is an example of the dynastic self-portrait in which the artist is depicted surrounded by family: here Toorop is overlooked by her son and the gigantic bronze head of her father, both also artists. Here the artist

Fig.17
**Sofonisba Anguissola
(1530s–1625)**
*Self-portrait with Bernardino
Campi*, 1550
Oil on canvas, 1110 x 1095mm
(43¾x 43⅛")
Pinacoteca Nazionale, Sienna

Fig.18
**Francisco de Goya
(1746–1828)**
Self-portrait at 69 Years, 1815
Oil on canvas, 460 x 540mm
(18 x 21¼")
Royal Academy of San
Fernando, Madrid

also deliberately introduces the conceit of the mirror. She paints herself gazing directly into the mirror, with paintbrush poised to dab a spot of colour onto the canvas that replicates the plane of the glass. The mirror and canvas are directly substituted, so that the paint, dab by dab, could potentially obliterate both the reflected image and the viewer.

This idea is taken to its conceptual conclusion by Richard Hamilton in his *Four Self-portraits* (1990; cat.56). Each of the four panels shows a different viewpoint, making an oblique reference to Cubism. Here many layers of deception are at play. Hamilton has painted apparently expressive gestures on to a pane of glass through which his reflection is seen as if partly erased by paint. This image irresistibly brings to mind Henri-Georges Clouzot's film *Mystère* (1956), in which Picasso is photographed painting on to a sheet of transparent material, or Hans Namuth's film of Jackson Pollock painting on to a sheet of glass between him and the camera. The glass sheet can be seen as a substitute for Toorop's mirror. But Hamilton has worked with photography rather than a mirror, enabling him to rephotograph the overpainted portrait and then paint again. In the four panels the same apparently spontaneous gestures have been meticulously recreated, so that at first it is not clear which is a photograph and which is a painted copy.

Here, as in the painting by Johannes Gumpp, we are invited to explore many layers of representation or a hierarchy of authenticity. Hamilton takes the illusory nature of painting to an extreme, thereby exposing the mechanisms that condition our reading of the images and making us very aware of the structure of our looking. Although

he is playing with painting and photography in a way that suggests a postmodern context, such deliberate strategies have long been employed by artists to produce, from the outset, a self-consciousness on the part of the viewer, particularly in looking at a self-portrait. Take Sofonisba Anguissola's witty self-portrait (1550; fig.17), for example. Here she shows herself being painted by her master, Bernardino Campi, who stands in front of a large canvas where Sofonsiba's completed image has taken shape. His hand with the maulstick (a rod used to steady the brush hand of the painter) rests gently on her breast where in all modesty it should never have been in life. The image of Sofonisba is slightly more prominent than that of Campi. She paints herself half a head higher than Campi in the composition and, although both figures turn to face us, her features are more brightly lit and framed by the open white collar of her blouse. She looks back at us with a trace of a smile. In acknowledging her master as having created her she clearly and playfully surpasses him. Her smile, directed at us, makes us feel complicit with the artist in an intimate and revealing personal moment.

Oil paint as a medium has an intimate connection with the self-portrait. The framed oil painting with its glossy surface has an affinity with the framed mirror that no other medium can quite replicate. There is also the advantage of oil paint's material bulk that so readily holds the trace of the hand and the structure of the image. Far from having a distancing effect, this evidence of manufacture makes us all the more susceptible to the sensuous quality of the medium and its material property of organic oiliness that is so

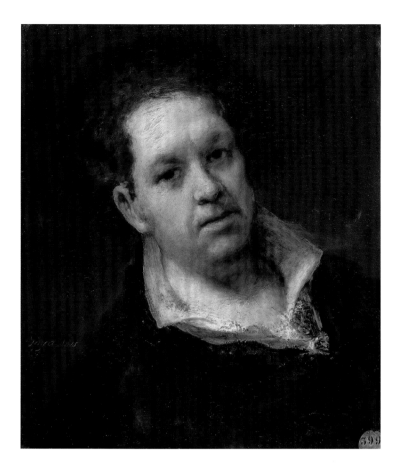

compatible with the representation of flesh. At another level, oil painting exemplifies the metaphorical transformation that occurs when an artist takes earth (pigment) and creates the image of a subject with a spiritual dimension.

In the sixteenth century the Catholic Church was struggling with religious practices that the Protestants regarded as idolatrous. Established pilgrimage routes in Northern Italy, particularly in the vicinity of Florence and Pisa, connected sites where revered icons were housed. The attraction of these particular icons rested on their reputation of having been miraculously generated, by a saint or by the Virgin Mary.[3] This attribution naturally necessitated the absence of detectable identity or personal touch. The trace of the artist's hand in many paintings after the Renaissance, and the acknowledgement of the artistic process testified by the brushmark, by contrast manifestly denied the possibility of the miraculous and affirmed human creativity. Paradoxically, it is this emphasis on materiality and authorship that has separated most painting since the sixteenth century from the ontological communion that applies to the medieval icon.[4] The new emphasis is paradoxical because the trace of the artist's hand is also indexical and tactile: we may not touch it with our hand or lip like the medieval pilgrim, but we seem to touch with the mind's eye.[5]

The way the paint is handled very often tells us more about the character of the artist or the art-historical context of the work than iconography would. For example, in his 1973 self-portrait *Mannlicher Akt – Fingermalerei* (cat.52) Georg Baselitz created his own likeness by smearing oil paint onto the canvas with his fingers – perhaps the most extreme example possible of the hand of the artist as a trace of his literal presence.

In Pierre Bonnard's 1938–40 *Self-portrait* (cat.45) the artist represents himself as self-absorbed. He is viewed as if from behind, reflected in the dressing-room mirror; yet he does not look into the mirror to meet our gaze, but rather down at his hands, concentrating on some small domestic task. He is wedged awkwardly between what is often taken to be the reverse of a canvas, but it could equally be the panelling of a door. Either way, the effect is to press his image up close to the surface. Bonnard uses strong colour here – ultramarine, yellow gold articulated by black and white – surprisingly harmonised into an atmospheric likeness. His strong, open brushwork and broken colour push the structure of representation to the point of collapse, yet we can still read this as a credible likeness. It could be argued that because he looks modestly away and avoids our gaze he is avoiding self-revelation, yet the manner of his working supports another interpretation: he may be reticent, shy and a very private person, but the vigorous brushwork suggests that the artist behind this reticence is very much in charge.

Sidney Nolan uses strong colour – red, yellow and blue with slashes of black – for his far from flattering *Self-portrait* of 1943 (cat.47). This is even less an imitation of appearance than Bonnard's, yet the material quality of the work and the way the paint is applied speak volumes about the man behind the image. When he painted it Nolan was an army conscript stationed in the bleak Wimmera landscape; a year later he deserted and became a man on the run. Conflict is written all over this painting: Ripolin (household enamel paint) is defiantly slashed across rough hessian sacking; the primary colours across his forehead look like war-paint and the palette and brushes are held up like a shield and a bunch of spears. The background is an intense, blood red broken by black and yellow forms representing his paintings in the studio. The background – like the stretcher bars/panelling in the Bonnard – force the subject up against the pictorial plane. This use of material and the manner of its application vividly express the artist's internal state at the time. The flattened space and blocked-out composition can be seen as a statement about modernism translated imperfectly into the Australian context, but fitting perfectly with the narrative about Nolan and his place in the world at that time. Australia was relatively isolated during the Second World War, and those experiments in modernism that did continue were typically skewed by what Ian Burn has referred to as 'creative misreadings'.[6]

The quality of the paint and the way it is applied can also stand in for qualities of the thing to be represented. Through his bodily experience the artist searches for a kind of equivalence between perceived qualities in nature and his own technique – not an imitation, but rather a way to evoke a particular response that is in some degree parallel to our experience of the thing itself. Lucian Freud, for example, makes much of his brushwork, to the point where it seems almost independent from the contours he is trying to describe. But it is because of this that we are compelled to resolve the image in the mind's eye, and are drawn into an uncomfortable complicity as our eye follows the tip of the brush as it 'feels' the flesh of the sitter.

This uneasy relationship between paint, gesture and subject is a particularly important factor when artists wish to draw our attention

Fig.19
Yves Klein
(1928–62)
Leap into the Void, 1960
Gelatin silver print
(by Harry Schunk)
Metropolitan Museum of Art,
New York

to the tension between mind and body. The starched white ruff separating head from body in so much sixteenth- and seventeenth-century portraiture is an accidental metaphor for the separation of the subject as a thinking being from the body. By contrast, in many of the paintings in this exhibition the fleshiness of the body is represented, either directly or through the metaphor of soft fabric against flesh, as it were augmenting it as a second skin. An open-necked shirt may reveal the throat and chest, hinting at movement across the boundary between the body's interior and exterior (see, for example, Goya's *Self-portrait at 69 Years*, 1815; fig.18).

Allegorical representation of creativity often supports the material evidence of creativity registered in the brushwork. The artist may wish to be seen as a member of a creative dynasty, like Charley Toorop, or claim status as father or mother to demonstrate creative powers, or even show themselves in the company of a creative muse. In his self-portrait with Patricia Preece, his second wife (1937; cat.43), Stanley Spencer challenges social convention with a strikingly intimate depiction of his private world, a bohemian gesture echoing the tradition of Dionysian inspiration exemplified by Lomazzo or Caravaggio's self-portraits as Bacchus (figs 10, 13). Even when an artist's self-portrait seems to be the result of a genuine moment of self-regard or self-interrogation, it is invariably a kind of performance. In many cases, such as Caravaggio's *Self-portrait as the Sick Bacchus*, the role-playing is overt. With Johannes Gumpp (cat.19), what appears to be a literal representation of the artist is in reality a complicated and conscious fabrication: it is virtually impossible not to self-consciously construct your own image.

In every self-portrait we discover individuals who wish to portray not just likenesses or even inner worlds, but concrete facts about who they were, what they could achieve and how they fitted in to the world around them. These things can in no way be conveyed by physical likeness alone. The existence of the painted image identifies the artist as the creator who can be judged as much by the quality of the painting and the trace of his hand as by the characterisation we suppose to be embedded in a portrait. In this exhibition we have included only oil paintings because of the centrality of the medium to the Renaissance tradition that gave shape to the genre. In the mid-twentieth century, however, the urgent need of the artist to communicate creativity to an audience found other means of expression. Performance art, and in particular the performing body, is founded on enacting similar definitions of the creative force to those we have already examined, such as the relationship of mind and body of the artist and the spectator as collaborator. Performance artists Marina Abramovic and Mike Parr explored the limits of the body and the mind's capacity to control it in their works of the 1970s. Parr literally put his endurance to the test when he held his finger in a flame for as long as he could bear it. Abramovic and her partner Ulay performed many endurance works in which the end of the performance came when their bodies could no longer obey the commands of the mind. These extreme performances were also enacted before audiences whose own endurance was severely tested, and in this way the work of art became a mutual or empathetic experience of artist and viewer.

A more poetic performance of artistic creativity occurred in 1960 when Yves Klein leapt from a second–storey window in Paris. He called this performance *Leap into the Void*: Harry Schunk's

photographs of Klein's enactment reveal just how brilliantly he expressed his transcendent aspiration (fig.19). The images show Klein's body launched into space, giving every indication that he is defying gravity; his face perfectly expresses the passionate desire of a man to be free from material constraints. He was a practising Rosicrucian and his life's work closely followed the spiritual aspirations of his faith: he believed that through spiritual exercise, humanity could help bring on the age of the immaterial, hence his constant visualisation of the void. Setting the spiritual concerns aside, Klein here enacts all our dreams of flying, however we wish to interpret them.

Like every other self-portrait, Yves Klein's performance reflects not just the artist but also something of each individual viewer. Intense moments of shared humanity between artists and spectators are often separated by centuries, yet they are experienced as immanent. It is this living presence of the artist through such shared moments that provides the most significant form of immortality through art. Unlike monuments, these compressed and urgent communications come alive for every viewer because they are remade through our own image of selfhood and the wonder of being.

1 Fried 1990, especially 'The structure of beholding', pp.29ff.
2 There has been a great deal written about this work, and in particular about the relationship of the viewer to the missing subject of the artist's painting, most notably Foucault 1970. See also Alpers 1983.
3 In a presentation at the University of Sydney in 2003 Megan Holmes described these icons and their mystical attribution. Her research was to be published as 'The Elusive Origins of the Cult of the Annunziata in Florence', in *The Miraculous Image in Late Medieval and Renaissance Culture*, eds E. Thunø and G. Wolf (Rome, Analecta Romana Instituti Danici in collaboration with L'Erma di Bretschneider, 2004).

4 The icon illustrates the truest example of a religious picture as defined by Hans-Georg Gadamer (*Truth and Method* [New York, Continuum, 1975], p.126): 'Only the religious picture shows the full ontological power of the picture.... Thus the meaning of the religious picture is an exemplary one. In it we can see without doubt that a picture is not a copy of a copied being, but is in ontological communion with what is copied.'
5 'Touching with the eye' is a phrase Marcel Duchamp used, but it has currency in surrealist thinking more generally, e.g. Georges Bataille's *Story of the Eye* (1928; English edn Urizen, New York, 1977).
6 Ian Burn, 'The re-appropriation of influence', in *From the Southern Cross* (exh. cat. for the Biennale of Sydney, ABC Sydney, 1988).

Overleaf Michelangelo Merisi da Caravaggio, *Self-portrait as the Sick Bacchus* (fig.13, detail)

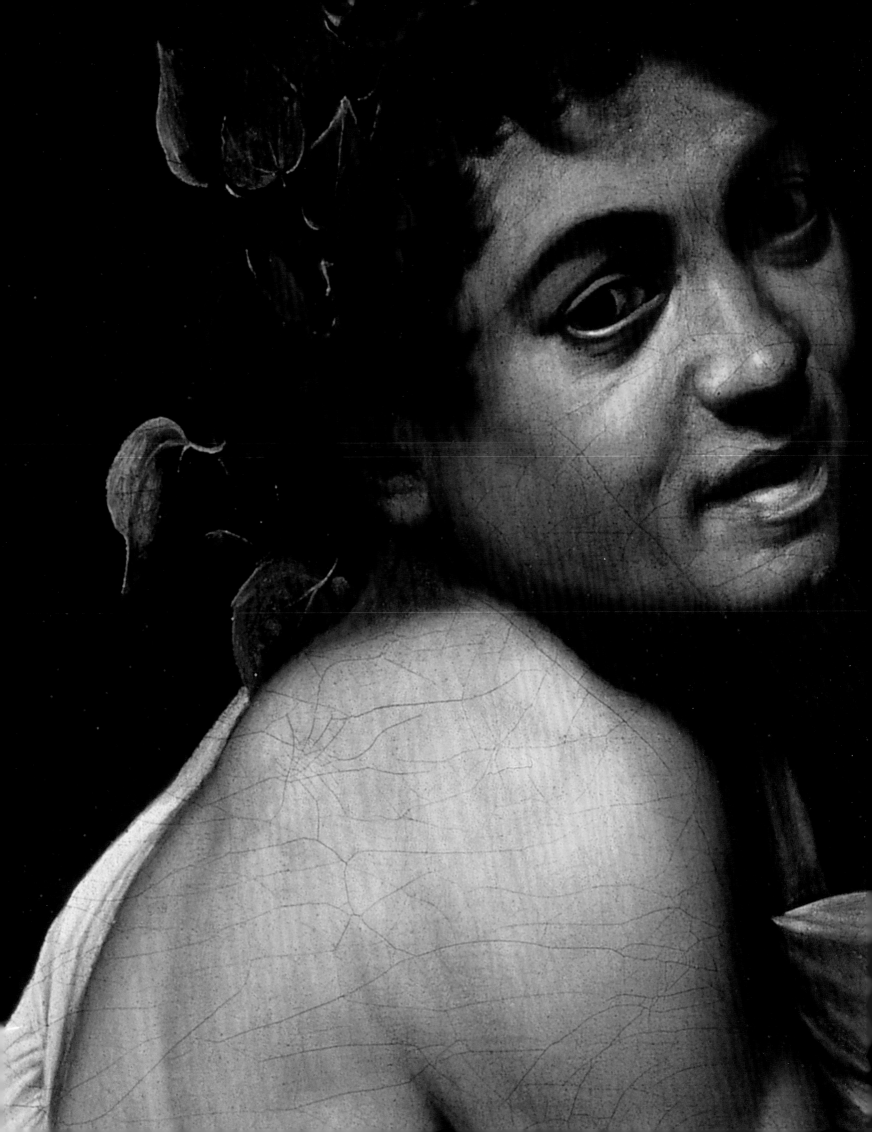

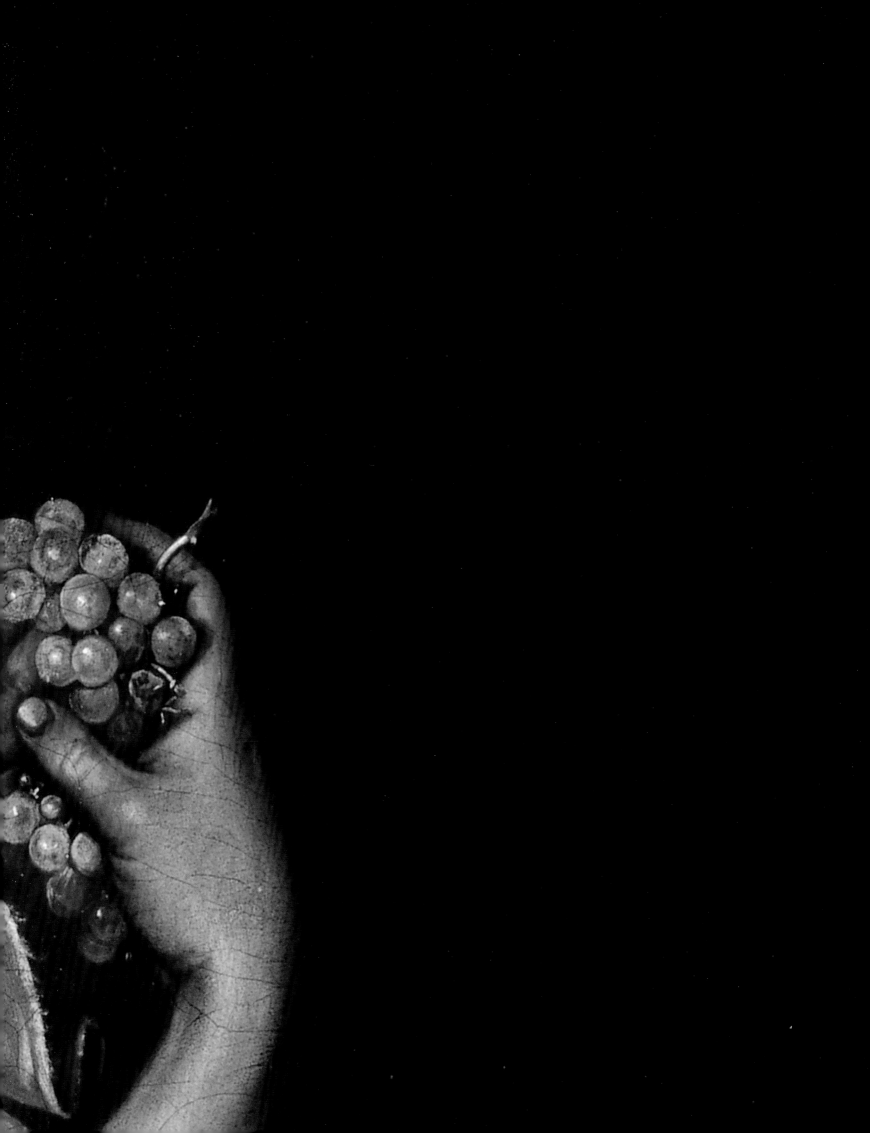

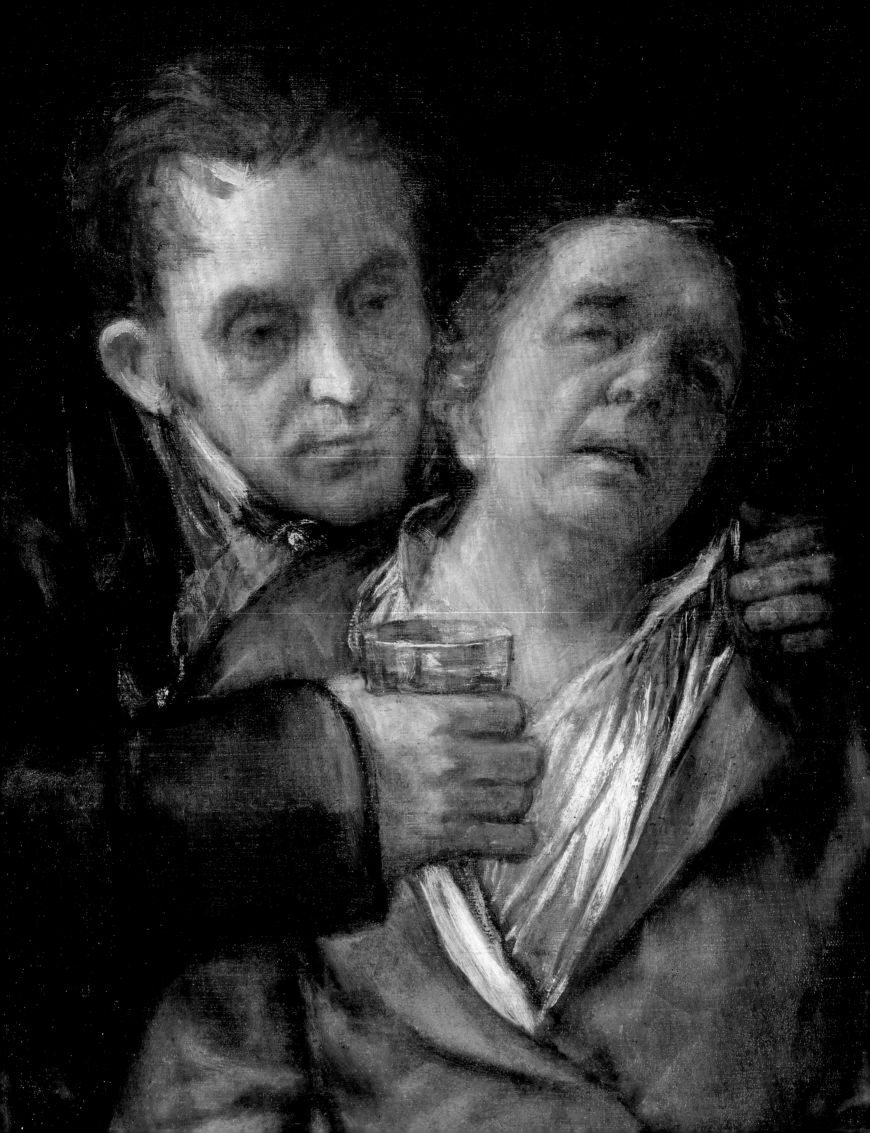

THE BODY OF THE ARTIST

Ludmilla Jordanova

The body of the artist is necessarily present in a self-portrait. When making self-portraits, a combination of manual dexterity, artistic skill and visual intelligence is required. In cultures that are curious about artists, attribute special powers to them, and place high value on a limited number of works of art, self-portraits are bound to acquire a certain aura. For many viewers self-portraits have a directness, a special capacity to offer privileged insight into artistic character.[1] Given the privileged place of oil painting in Western traditions, and the preoccupation with personality, genius and creativity, it is hardly surprising that there is a huge amount of interest in the self-portraits of great artists such as Titian, Dürer, Rembrandt, Poussin, Goya, David and van Gogh. To bring together many influential and fascinating self-portraits in oils is to offer one particular overview of painting over the last five hundred years, the period in which ideas such as 'art' and 'genius' were continually debated, modified and contested.

When artists portrayed themselves they mobilised their distinctive skills. A self-portrait might therefore be seen as a sample of work, a declaration of achievement, an occasion for showing off, a distinctive kind of display that has its own neat completeness by virtue of the artist and the sitter being one and the same. Self-portraits display both the body of the artist and their array of skills. They are a special kind of conceit, in which the artist's body is somehow arranged so that it is not shown doing what it actually is doing. There are only a few well-known exceptions where artists show themselves in the very act of painting the self-portrait in question, in which case their back is generally turned. While a wide range of devices is used to display the body, they must either acknowledge that an exhibition is involved or deny it by deploying a pose that ignores the viewer. Once this type of picture starts to circulate, to be talked about and gradually to become a part of the oeuvre of many artists, it is used to probe artistic identity and the relationships between artists. Self-portraits allow their makers to explore artistic traditions, the influence of masters and forbears, links with patrons, fellow artists, family and friends. Thus self-portraits participate in conversations about art and artists, about their roles in wider worlds. Certainly they can be intimate, introspective, confessional, but they are also calling cards, statements about patronage, ambition, traditions, national identity, gender and age. It is precisely because they deploy the skills and forms of intelligence artists most value that viewers must recognise how self-portraits are carefully wrought to produce certain effects and responses. If they appear to offer glimpses of the inner person, it is because the artist has made it precisely to give that impression. It follows that the more imaginative and virtuosic they are, the more effective makers will be in exploring and playing with their own images. They do so furthermore in the idioms of their own time, drawing on earlier motifs as they touch them directly.

Thus it seems to me to be quite untrue that 'self-portraiture is a singular, in-turned art'.[2] Rather, self-portraits are generally made with the express intention of presenting the artist to an audience. The nature and composition of that audience varies from case to case. Mostly self-portraits address viewers, sometimes through their gaze and sometimes with their bodily stance, especially the

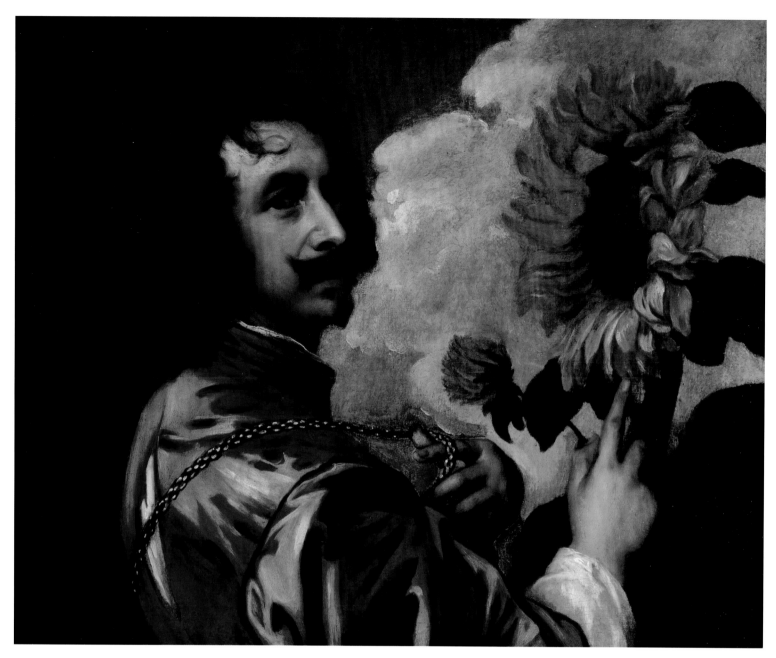

Fig.20
Anthony van Dyck
(1599–1641)
*Self-portrait with a Sunflower, c.*1633
Oil on canvas, 584 x 730mm
(23 x 28¾")
Private Collection

Fig.21
Francisco de Goya
(1746–1828)
Self-portrait with Dr Arrieta, 1820
Oil on canvas, 1156 x 800mm
(45½ x 31⅛")
Minneapolis Institute
of Arts, Minnesota

positioning of the hands. In addition, the ways in which self-portraits evoke and converse with one another indicate just how 'out-turned' the genre is. It is dangerous and misguided to take self-portraits and closely related portraits of family members and fellow artists and use them to move as it were *inside* the individual who produced them. The alternative is to pay attention to the contexts in which self-portraits are made, used and displayed. Studies of self-portraiture have the potential to enlarge our understanding of artistic processes, artistic identity and the settings in which art was practised.

Interpreting self-portraits requires an elaborate historical sense. Such images are made in the artists' here and now – necessarily a complex swirl of forces, including their aspirations and anxieties about competition, whether actual or imagined, strategies for creating and advancing a 'reputation', as well as their immediate domestic and social relationships, geographical location and economic needs. They are also produced out of artists' senses of visual models to be emulated, revered forbears, influential teachers and masters. In other words, artists themselves often have a vivid awareness, that can be termed 'historical', of what has gone before, and in making it manifest, as many did in their self-portraits, they speak to contemporaries about their debts and their filiations and lay down deposits for future generations to examine.

One story that is told about broad historical changes over the last five hundred years concerns the growth of individualism. Whether the emphasis is on property, rights, social and political organisations, consumerism, psychology or the emotions, there is a sense that introspection, a preoccupation with the self and the affirmation of individual autonomy have grown markedly over that time.[3] At first sight the history of self-portraiture fits comfortably with this account; indeed it might be taken to offer evidence for and confirmation of it. When a relatively small number of oil paintings are taken to represent the entire genre, it can certainly seem compelling to place them in such a context. To evoke such a story is too easy: it neglects the complexity and diversity of self-portraits themselves. Some challenging choices need to be made about how self-portraits are to be explained. It is desirable that historians are explicit about how the genre is to be defined, and about the large historical patterns, models of change and forms of periodisation that work best with the available evidence. While there were autonomous self-portraits before 1500, they are much more common from the sixteenth century onwards. Thereafter, simple historical shifts are difficult to discern and this is partly because self-portraits themselves manifest such diversity in terms of medium, composition and scale that it is worth thinking afresh about how and why artists depict themselves.

Many self-portraits also include other figures. Rubens, for example, painted himself alone, with friends and with his wives. Several of van Dyck's self-portraits include associates, and these in no way detract from the bravura of his depictions of himself alone. His self-portrait with a sunflower and gold chain from around 1633 (fig.20) is particularly notable by virtue of the insistent symbolism and declaratory pose. These are not isolated examples: many of those who produced powerful images of themselves alone also portrayed themselves with family members, as Zoffany, Vigée-Lebrun and Stanley Spencer did, with allegorical figures as Angelica Kauffmann and Hans Thoma did, or with some significant other, as Goya did

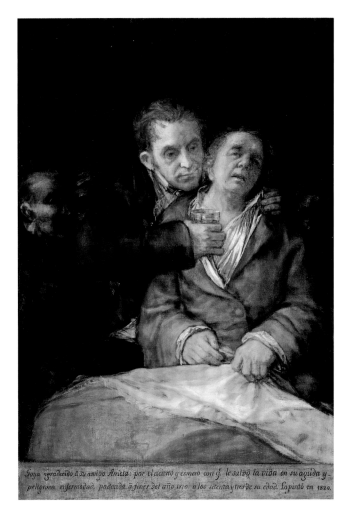

Goya agradecido á su amigo Arrieta: por el acierto y esmero con q. le salvó la vida en su aguda y peligrosa enfermedad, padecida á fines del año 1819, a los setenta y tres de su edad. Lo pintó en 1820.

when he showed himself being tended by the doctor who saved his life in 1819 (fig.21).[4]

One of the most striking features of the genre is that at the moment it is impossible to know its size and scope. Indeed, this may remain elusive: works have been destroyed and many artists' names are scarcely remembered by posterity. Furthermore, there are problems of attribution when the provenance is incomplete or absent or when no other likenesses are available for comparison. Full-face portraits with an intense gaze of an unknown (male) sitter are particularly likely to attract speculation about whether they are self-portraits. So it is perfectly possible to say that there is a category of portraits where the artist is depicting her or himself, but it is not possible to know either what proportion of artists undertook one or more self-portraits, or how many works come into this category. The titles given to such works are significant. Some are called 'portrait of the artist', others are given titles: 'The Wounded Man', 'La chambre bleue', 'La Reproduction Interdite', for example. Of course titles should be treated with some scepticism, and it is vital to know when and by whom they were devised. While it can be no more than a hunch, I suspect the majority of artists from the early eighteenth century onwards made a self-portrait at one time or another. Since most books on self-portraiture reproduce a limited number of images, it is productive to consider less well-known examples and to note the range of media involved. In any case up to the early twentieth century the great oil self-portraits were largely known through prints by those who could not see them at first hand.

Since there are so many self-portraits and they are visually so

Fig.22
**Jean-Baptiste-Siméon Chardin
(1699–1779)**
Self-portrait wearing Glasses, 1788
Pastel on blue paper over
canvas stretcher, 407 x 325mm
(16 x 12¾")
Musée du Louvre, Paris

Fig.23
**Barbara Hepworth
(1903–75)**
Self-portrait, 1950
Oil and pencil on board,
305 x 267mm (12 x 10½")
National Portrait Gallery, London

diverse, it is important to consider whether any recurrent patterns can be discerned. As in portraiture more generally, two points need to be borne in mind. First, the genre depends on viewers recognising not only gestures, poses and expressions but also the meanings of items such as hats, clothes, jewellery and books. In practice these visual invitations do not always work, but the intention is surely legibility. There are repeated poses and motifs, such as standing in front of an easel, staring out, leaning on a ledge, wearing a hat or cap, holding a palette, giving a sideways glance, and so on. Second, since there are an infinite number of ways in which portraits can be individualised, the variety, the nuances and inflections that distinguish them demand careful attention.

The most systematic way of giving self-portraits such attention is by the conventional method of comparison. Many artists produced numerous self-portraits over their lives and comparing these with one another, together with any models or templates that they draw upon, is a first step. Lovis Corinth has become one of the best-known examples of what might be seen as a compulsion to return regularly to self-portraiture. Where an artist worked in more than one medium, as Rembrandt did, there are further comparisons to be made.[5] Switches between media can produce arresting results, as when Chardin late in life produced pastel self-portraits (fig.22), and the sculptor Barbara Hepworth used oil and pencil on board in 1950 to produce an apparently simple depiction of herself (fig.23).[6] There are some other striking examples where the self-portrait is not in the medium with which the artist is primarily associated: Poussin's unkempt drawing from around 1630, Raeburn's 1792 medallion,

Gauguin's 1889 self-portrait jug.[7] Self-portraits should certainly be compared with portraits of the artist by others. There have been intense artistic networks – Gauguin, Cézanne, van Gogh and Carrière, for example – that produced an elaborate array of portraits and self-portraits that can usefully be considered together.[8] Since many self-portraitists were portrait painters, numerous further sets of comparisons are available. Because artists never exist in social isolation, their depictions of family, friends, patrons and other sitters may be systematically compared with self-portraits. However tempting, it is always a mistake to view self-portraits in isolation: multiple comparisons help to break down some of the myth-making around them. Inevitably self-portraits have been treated as testifying to individual struggles, private pain, deep angst and prodigious talent because these are familiar tropes when it comes to telling artists' lives, themes that have long had a grip on biographers, art historians, patrons and viewers, as well as on artists themselves.

Becoming aware of the aura that has been created around self-portraiture as a genre and some exponents of it in particular, and treating it critically, is an important step in paying self-portraits the attention they deserve. They reveal a very great deal about artistic identity, which may be defined as the sense of themselves that artists have, and are able or willing to reveal, in relation both to earlier art and artists and to their contemporaries. It is their artistic personality, which is necessarily a composite, as it is externalised in their work. In fact the term 'personality' is somewhat misleading – identity is as much as about groups, and the ideas associated with them, such as nations, religious communities, families, regions, classes and so on,

Barbara Hepworth

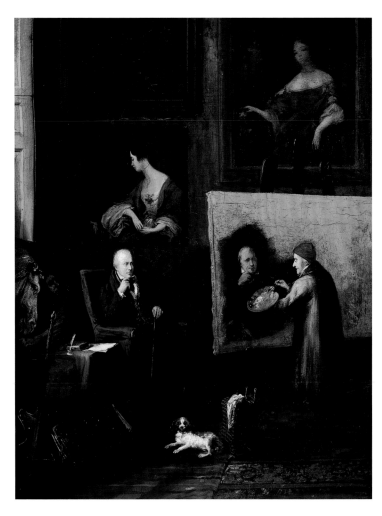

Fig.24
James Northcote
(1746–1831)
or possibly attributed to
John Cawse
(1779–1862)
Portrait of James Northcote
Painting Sir Walter Scott, 1828
Oil on canvas, 717 x 544mm
(28¼ x 21½")
Royal Albert Memorial
Museum, Exeter

Fig.25
T.A. Dean after
Titian (Tiziano Vecelli)
(c.1487–1576)
Frontispiece to Northcote's
biography of Titian, 1830
Engraving, 78 x 65mm
(3 x 2½")
Print collection, National
Portrait Gallery, London

as it is about individuals. Many factors produce such identity: they pertain to the historical, material circumstances of individual artists, to their specific characters, to the people who surround them, to institutions and also to chance. In this category of art, interpreters are moving from the unconscious, through biography, to major historical forces. Of just one thing we can be sure – self-portraits do not tell viewers what their makers were *really* like. But if they speak to artistic identity, as I believe they do, then a more rounded picture will result if they are both compared meticulously with other works of art, such as depictions of fellow artists, patrons, and close associates, and understood in broad historical terms.

It helps to think of making art as a particular type of work and to recognise that there is a complex history of those jobs we now join together under the title 'artist'. Artists, furthermore, do *physical* work, and by that token their representations of their own bodies are highly significant. A large proportion of portraits refer in one way or another to the status, achievements or occupation of the sitter. None does so more directly than a self-portrait, even when the accoutrements of art are absent – hence it is particularly revealing to study portraits (and self-portraits) of the full range of such jobs, as well as of those closely related to art such as collectors and connoisseurs, and to remember that engravers, sculptors, architects, doctors, and scientists also made self-portraits.[9] The connections between biography and autobiography and portraiture and self-portraiture are also worth pursuing: they serve to reinforce the point that self-portraits are generally fully integrated into the fabric of social and cultural life.

In his extraordinary self-portrait of 1828 (fig.24), which is also a portrait of Sir Walter Scott, James Northcote wears what was identified by contemporaries as a 'Titian cap'. By this period many prints were in circulation showing Titian in such a cap: Northcote used one as the frontispiece to his two-volume biography of Titian published in 1830 (fig.25). It shows Titian in profile, wearing something that is between a turban and a cap, and bears a close resemblance to earlier prints entitled 'Titian and his Mistress'. In Northcote's book the print is described as being 'from an Original Drawing by himself in the possession of Sir Richard Colt Hoare Bart. & formerly in the Collection of King Charles Ist'.[10] There is ample evidence that monarchs, like many connoisseurs and collectors, valued self-portraits by painters they particularly esteemed. Before he came to the throne, Charles had persuaded Rubens to paint a self-portrait for him, and many of the most revered self-portraits have been in Royal collections.[11] Northcote's paintings and writings reveal his historic debts. He was an avid self-portraitist throughout his life, whose image is in the Uffizi collection, as is that of his master, Sir Joshua Reynolds, whose biography he also wrote. When Northcote depicted himself, it was invariably in profile, as Titian had done in the gaunt, stately self-portrait in the Prado. Reynolds, by contrast, deployed a much wider visual repertoire and was surely quite knowing, or should we say downright manipulative, in making associations with old masters such as Michelangelo and Rembrandt (see cat.22). He was equally knowing in placing his self-portraits with relatives, friends, institutions and patrons. After his death his niece gave 'the best self-portrait he ever painted of himself' from

in an elaborate landscape, painted in 1782 using enamel on Wedgwood biscuit earthenware, is a striking example.[15] Salvator Rosa (cat.18)and Vigée-Lebrun (cat.27)chose dramatic skies. Gainsborough depicted himself, his family and his daughters outside.[16] Such selection processes are, of course, present in all portrait painting, when choices typically involve negotiations between several interested parties. In the majority of self-portraits the degree of authorial control is exceptionally high, hence the degree of significance that can be attributed to the results is correspondingly high.

Certain parts of the body, head, face and especially eyes, together with the hands, carry enhanced significance. When Joshua Reynolds chose, in his early self-portrait from around 1747 (cat.22), to place one hand over his eyes, which are then in shadow, it was an extraordinarily bold move. The painting suggests the capacity to see into the far distance even as he is in the act of painting, as the palette and maulstick in the other hand indicate. But in raising his left hand in this way Reynolds drew attention to it, as well as to his eyes; viewers inexorably think about the sense of sight, in all its metaphorical richness, and the active gestures of both hands give the whole body a sense of energy. Clear sightedness was accorded a high prestige during the Enlightenment; 'I see' still means 'I *understand*'. The intriguing comparison with George Richmond's similar pose in his youthful undated self-portrait in the Fitzwilliam Museum, Cambridge, is worth pursuing.[17] The presence of glasses can, in a similar manner, insist that viewers reflect upon the nature of vision. In the cases of Chardin (fig.22) and Therbusch (cat.25), they draw our gaze to the head. Hats also function in this way. Rembrandt plays outrageously with headgear, and it can hardly be coincidental that in his self-portraits Joseph Wright of Derby was mostly either dressed in seventeenth-century costume or wearing an elaborate hat. Richard Cosway, a fervent admirer of Rubens, was also fond of fancy dress when depicting himself and his wife.[18]

While hats can be playful, visually pleasurable, suggesting other times and other artists, as Vigée-Lebrun does when she pays homage to Rubens (fig.27) in her *Self-portrait in a Straw Hat* (cat.27), they also serve as visual markers or tags associated with the most important part of the body. James Northcote's cap is not especially attractive and certainly does not suggest playfulness. Rather it makes a claim – 'I am like Titian, associate me with him'. The claim is made through both the body – his profile and aged look closely resemble Titian's in the prints mentioned earlier – and through an item – the cap – that already bore Titian's name in Northcote's time.[19]

For one artist to claim to be 'like' another is deceptively complex and slippery. It may be that Northcote's emulation of Titian took on greater plausibility in old age. By the late 1820s he had been an active painter for six decades, and his reputation as a gossip and as a writer was extensive. Having depicted an impressive array of leading figures – Henry Fuseli, Edward Jenner, Edmund Kean and William Godwin, for example – it is hardly surprising that, in the face of Sir Thomas Lawrence's stunning success, Northcote was staking a distinctive claim. Lawrence, who had little appetite for self-portraiture, had painted Scott for the Royal Collection; Northcote, in casting his body in the Titian mode, alongside Scott's familiar seated figure in a work commissioned by a member of the court (fig.24), asserted his own status as, quite literally, 'old master'.[20]

around 1788 (fig.26) to the Prince Regent with whom he had been on friendly terms.[12] From the time he was young Reynolds paid careful attention to his own image; the self-portraits were just one aspect of what is often referred to as 'self-fashioning'.[13] By contrast, his most vociferous critic, William Blake, who produced only a small number of portraits, rarely depicted himself and when he did it was in profile, using spare lines.[14]

These differences in self-portraiture practices are significant, since by the second half of the eighteenth century the special status of self-portraits was widely understood within artistic and collecting communities. Despite this, it is sometimes claimed that artists simply used themselves as models, as the figure that comes most readily to hand. This approach turns at least a proportion of self-portraits into practical expediencies, part of the everyday life of artists. Where there is direct evidence to corroborate such claims, they are certainly worth pursuing, but very few human beings have been uninterested in how they look and are represented, and when the means of representation lie at the very core of an individual's identity, it seems implausible that they would treat depicting themselves casually or as mere practical expediency. Artists' claims about utility may mask concerns about appearing self-regarding. Furthermore, the content of many self-portraits indicates a careful, fully aware autobiographical attention. In most cases artists either place themselves inside or against an unspecific background. Thus when an open-air setting is selected, it is hardly likely to be a casual matter: rather, it results from a knowing choice. George Stubbs's *Self-portrait on a White Hunter* (Lady Lever Art Gallery, Port Sunlight), set

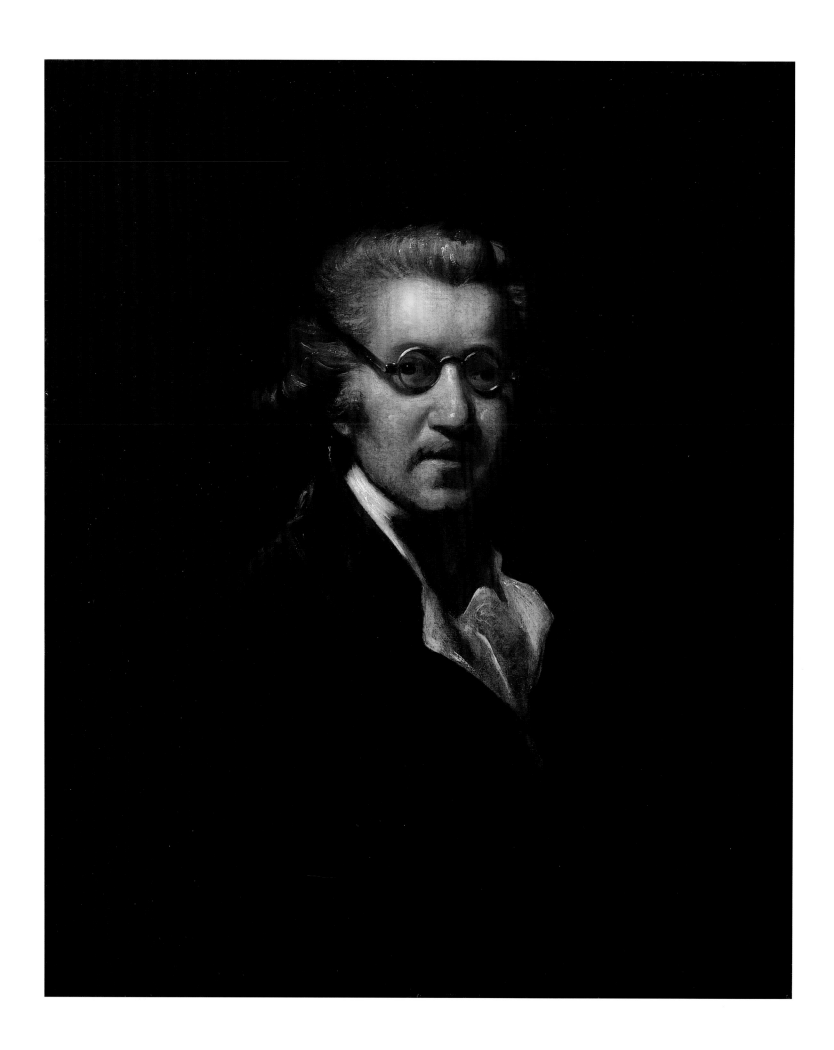

The Body of the Artist

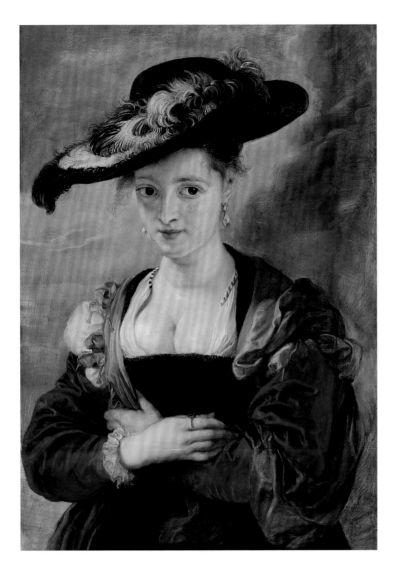

Fig.26
Joshua Reynolds
(1723–92)
Self-portrait, 1788
Oil on canvas, 762 x 638mm
(30 x 25⅛")
Dulwich Picture Gallery

Fig.27
Peter Paul Rubens
(1577–1640)
Le Chapeau de Paille, c.1622–5
Oil on oak, 790 x 546mm
(31⅛ x 21½")
National Gallery, London

This case illustrates a more general and in some ways potentially troubling point. Each self-portrait possesses dense particularities: it is rarely possible to 'read' it using only the visual evidence, however immediate it may seem on the surface. Many self-portraits trade, I would suggest quite deliberately, on being simple, available, direct, unmediated. Viewers beware! When Vigée-Lebrun depicts herself in a way that evokes Rubens, what is she in fact doing? The comparison in question is with a portrait that is probably of Rubens' future sister-in-law – although at the time it was believed to represent Rubens's wife. It is evident that Vigée is an artist, since she holds a palette; but her clothes hardly suggest work. In this case the likeness between her and Rubens is both abstract, that is, concerned with artistry, and sensuously embodied in the painting style and the body depicted. Her décolletage reveals the curves of her left breast. In presenting herself in this way she is offering herself up as an object of desire, as is corroborated by contemporary comments. She is, as in the self-portraits where she embraces her daughter, drawing attention not just to herself as a woman artist, but to her femininity. In the Louvre self-portrait of 1789, in which there are no references to her occupation, her choice of costume, headdress and colour range are quite different, but the assertions of her own womanliness are no less emphatic. [21]

If routinely seen as suites and in comparison with both carefully selected portraits by the same hand and with the exemplars they evoke and are in conversation with, self-portraits can move beyond privileged glimpses into artistic consciousness and become a special type of document. They may be thought of as working documents; taken as a body, they speak to a constellation of jobs, they *are* the work, upon which they also offer a commentary. Self-portraits constitute a particular type of commentary in that they generally engage with the *history* of art. Audiences are becoming familiar with the ways in which subsequent generations of painters returned to Raphael, Titian and Rembrandt in their self-portraits. This is one type of history. Another may be found in the Pissarro family, who produced portraits and self-portraits over three generations from Camille (fig.28) to Orovida (fig.29). They painted themselves, each other, family members and other artists who were important to them – Camille depicted Cézanne in 1874 and kept the slightly unfinished portrait until his death. Orovida, his granddaughter, portrayed herself in 1913 – she was painted by her father Lucien the same year – and in 1953. Camille depicted his wife, and his son Lucien, in a rare use of pastel, and also in prints and chalk. Lucian portrayed his mother in 1923. Camille's self-portrait etching from around 1890, dense and intense as it is, evokes Rembrandt, whereas his pastel portrait of his son looking recognisably like an 'artist', of 1883, evokes Degas. Orovida's two self-portraits in the Ashmolean use the same pose forty years apart, but could not be more different. The first (1913; fig.29) is infused with her father's techniques and choice of palette, whereas the second (1953) is deeper hued, and has been described as 'sombre'. [22]

The case of the Pissarro family, where there is also extensive archival material, provides exceptionally rich evidence for the history of art in general and for the history of portraiture and self-portraiture in particular. While such a case may be unusual in spanning a number of generations, family relationships and artistic associations and in the wealth of documentary material that survives, it does

Fig.28
Camille Pissarro
(1830–1903)
*Self-portrait, c.*1890
Etching, 185 x 177mm (7¼ x 7")
Ashmolean Museum, Oxford

Fig.29
Orovida Pissarro
(1893–1968)
Self-portrait, 1913
Oil on canvas, 395 x 320mm
(15½ x 12⅝")
Ashmolean Museum, Oxford

illustrate quite vividly how self-portraiture and portraiture can be understood to be embedded in historically specific artistic practices and networks. Following through such dense clusters of portraits and self-portraits has the capacity to yield a variety of insights, including about the choice of medium. They indicate the possibility of a thoroughly historical approach to self-portraiture, in which the nature of visual reasoning would play a central role. Earlier on I suggested the importance of artists' visual intelligence for self-portraiture. Visual intelligence refers to the mental processing that is required for any work of art to be produced – a process in which intellect, emotions, instincts and unconscious responses are blended. These processes cannot be isolated from the environment, that is to say, from the contexts, including the histories, in which those who work as artists exist. It is the job of artists to transform their knowledge, experience and skills into material objects and in each genre they do so in a distinctive and historically specific manner.

A full history of self-portraiture remains to be written – I acknowledge that such an account may be difficult if not impossible to produce. What matters is that in viewing groups of self-portraits in oils, the contexts out of which they have been drawn are not neglected. The place to start in thinking about these contexts is the body of the artist that laboured to make them, the body that mediates between the world and the works. A genre that appears at first sight to be highly individual may turn out to be the most deeply social of them all, and that is why it should never be seen in isolation but imagined in deep conversation with other works of art, with texts, with social processes, with 'manufacturing' and 'industry'.

1 For a range of approaches to self-portraiture see Shearer West, *Portraiture* (Oxford University Press, Oxford, 2004), chap. 7; Bell 2000; Brooke 1994; Rideal 2001; Woods-Marsden 1998; Derrida 1993.

2 Julian Bell, 'Introduction' in Bell 2000, pp.5–10, quotation from p.5.

3 See e.g. C.B. Macpherson, *The Political Theory of Possessive Individualism* (Clarendon Press, Oxford, 1962); Roy Porter (ed.), *Rewriting the Self: Histories from the Renaissance to the Present* (Routledge, London and New York, 1997); Charles Taylor, *Sources of the Self: The Making of Modern Identity* (Cambridge University Press, Cambridge, 1989); Michael Mascuch, *Origins of the Individualist Self: Autobiography and Self-Identity in England, 1591–1791* (Stanford University Press, Stanford, CA, 1996).

4 J. Ciofalo, *The Self-Portraits of Francisco Goya* (Cambridge University Press, Cambridge and New York, 2001).

5 White and Buvelot 1999; cf. Elizabeth Jennings, 'Rembrandt's Late Self-portraits' in *New Collected Poems* (Carcanet, Manchester, 2002), p.105.

6 In the National Portrait Gallery, London. See also *Barbara Hepworth: A Pictorial Autobiography* (Tate Gallery, London, 1993; first published 1985), esp. the explanatory note by Alan Bowness, Hepworth's son-in-law, on the genesis and history of this 'autobiography'. The self-portrait is reproduced on p.59.

7 The Poussin drawing (c.1630) is in the British Museum, London, and is reproduced in Bell 2000, p.148; Raeburn's self-portrait medallion (1792) is reproduced in Brooke 1994, p.80; Gauguin's self-portrait jug (1889) is also illustrated in Bell 2000, p.319, and in D. Silverman, *Van Gogh and Gauguin: The Search for Sacred Art* (New York, Farrar, Straus and Giroux, 2000), p.34.

8 Silverman explores the intricate relationship between van Gogh and Gauguin: see esp. chap. 1, 'Self-portraits', and figs 3, 4, 7, 54. On Cézanne see Mary Tompkins Lewis, *Cézanne* (London, Phaidon, 2000), esp. her discussion on pp.237–40 and 244–6 and pls 2, 15, 28, 33, 107, 114, 115, 135, 142, 145, 146, 147, 148, 149, 151, 163, 173. On Carrière see *Eugene Carrière 1849–1906* (Musées de Strasbourg, Strasbourg, 1996), cats 3, 11, 17, 41, 52, 53, 55, 56, 67, 119.

9 The Hope Collection of portrait prints in the Ashmolean Museum, Oxford, which is organised by sitters' occupation, reveals this point. For an introduction to the collection see Richard Sharp, *Portrait Prints from the Hope Collection* (Ashmolean Museum, Oxford, 1997).

10 I was able to view prints entitled 'Titian and his Mistress' at the Clark Art Institute, Williamstown, MA, and would like to thank the staff there for their help; James Northcote, *Life of Titian*, 2 vols (Colburn & Bentley, London, 1830).

11 The Rubens self-portrait in the exhibition (cat.9) is a version of the self-portrait that Charles commissioned when he was Prince of Wales. On self-portraits in the Royal Collection see O. Millar, *The Queen's Pictures* (Weidenfeld & Nicolson and BBC, London, 1997), pp.32, 35, 38, 56, 100, 130.

12 Millar 1997, p.130; see also D. Mannings, *Sir Joshua Reynolds: A Complete Catalogue of His Paintings* (Yale University Press, New Haven and London, 2000), vol.1 (text), p.51, vol.2 (images), p.569.

13 The notion of 'self-fashioning' is generally associated with Stephen Greenblatt, *Renaissance Self-fashioning: From More to Shakespeare* (Chicago University Press, Chicago, 1980).

14 G. Keynes, *The Complete Portraiture of William & Catherine Blake*, with an essay and an iconography (Trianon Press, London, 1977).

15 Brooke 1994, p.86 and pl.10.

16 See, for example, M. Rosenthal and M. Myrone (eds), *Gainsborough* (Tate, London, 2002), p.57 (*Self-portrait Sketching*, pencil on paper, British Museum, London), pp.60–1 (*Portrait of the Artist with his Wife and Daughter*, oil on canvas, National Gallery, London), pp.74–5 (*Self-portrait*, oil on canvas, National Portrait Gallery, London), pp.184–5 (*The Painter's Daughters with a Cat*, oil on canvas, National Gallery, London); and John Hayes, *Thomas Gainsborough* (Tate, London, 1980), pp.81–2 (*Gainsborough's Daughters, Margaret and Mary Chasing a Butterfly*, oil on canvas, National Gallery, London), see also pp.48–9, 78–9.

17 On Richmond, see R. Lister, *George Richmond: A Critical Biography* (Robin Garton Limited, London, 1981), and pls xxxiii, xxxv and xxxviii for other self-portraits by him. In all cases Richmond depicts only head and shoulders, while Reynolds shows the upper body.

18 See, for example, the etching in Brooke 1994, p.74; S. Lloyd, *Richard and Maria Cosway: Regency Artists of Taste and Fashion* (Scottish National Portrait Gallery, Edinburgh, 1995); Gerald Barnett, *Richard and Maria Cosway: A Biography* (Westcountry Books, Tiverton, 1995).

19 W. Hazlitt, *Conversations of James Northcote Esq. R.A.* (Hutchinson, London, 1952), p.11, which describes Northcote making a self-portrait, and links his 'green velvet-cap' with him looking 'very like Titian'. The Prado self-portrait by Titian is reproduced in Bell 2000, p.97.

20 I list other portraits by James Northcote in the collections of the National Portrait Gallery, London. Lawrence's portrait of Scott was painted 1821–6 and remains in the Royal Collection. See Kenneth Garlick, *Sir Thomas Lawrence: A Complete Catalogue of Oil Paintings* (Phaidon, Oxford, 1989); Alex Potts, *Sir Francis Chantrey 1781–1841* (National Portrait Gallery, London, 1980), p.21; Francis Russell, *Portraits of Sir Walter Scott: A Study of Romantic Portraiture* (printed for the author by White Brothers, London, 1987).

21 Brooke 1994, p.88 and pl.11; Angelica Goodden, *The Sweetness of Life: A biography of Elisabeth Louise Vigée-Lebrun* (André Deutsch, London, 1997); Siân Evans (trans.), *The Memoirs of Elisabeth Vigée-Le Brun* (Camden, London, 1989).

22 Camille Pissarro's portrait of Cézanne is in the National Gallery, London. All the other works mentioned by the Pissarros are in the Ashmolean Museum, Oxford. For information on the paintings see *The Ashmolean Complete Illustrated Catalogue of Paintings* (Oxford, 2004), and pp.175–6 for information about the two Orovida self-portraits. The comment about the second one being 'sombre' is on p.176. See also Anne Thorold and Kristen Erickson, *Camille Pissarro and his Family: The Pissarro Collection in the Ashmolean Museum* (Ashmolean Museum, Oxford, 1993); A. Thorold, *Artists, Writers, Politics: Camille Pissarro and his friends* (Ashmolean Museum Oxford, 1980); A. Thorold (ed.), *Letters of Lucien to Camille Pissarro, 1883–1903* (Cambridge University Press, Cambridge, 1993).

THE LOOK OF SELF-PORTRAITURE

T.J. Clark

This essay is an attempt to come to terms with the special circumstances of looking in self-portraiture – the peculiar business of attending to oneself – and the distinctive sort of looking out at *us* that seems to issue from those circumstances. The descriptions I offer apply to many self-portraits, I believe, and may reveal some basic presuppositions of the genre; but they were generated in the first place by a confrontation with an extreme, and in a sense untypical, example of the breed: Jacques-Louis David's *Self-portrait* of 1794 (fig.30). The painting was done in prison, in the months immediately after the fall of the Robespierre regime. David had been one of the regime's leading actors. He had every reason to expect a sentence of death – which in the end he was spared, probably because of his artistic preeminence.[1]

To begin with the look. If we take the basic fiction of this kind of self-portraiture seriously – the notion, I mean, that what we are looking at is what the painter saw in the mirror – then it follows that the look of self-portraiture must be a very specific one: the look, we could say, of someone looking at him or herself looking. The trouble is that where we put an end to the last part of the preceding sentence can only be decided by pure fiat. The sentence is designed to go on for ever: 'The look of someone looking at him or herself looking at the look he or she has when it is a matter of looking not just at anything, at something else, but back to the place from which one is looking ...'. Would that do better? Is that what self-portraiture is about? Simple questions in self-portraiture open regularly onto infinite dialectical regress. And is not one of the things we admire in self-portraits precisely the effort to represent this kind of dialectical

vertigo? Isn't this what David is concentrating on?

Well, yes and no. The look in the picture does seem to be meant to be complicated, as if it issued from some process of inquiry; but it is also meant to be businesslike. There may be some epistemological anxiety about, but we are surely not supposed to take the subject as overwhelmed by it – his look is poised, cool and craftsmanlike, the look of a professional. (These last are class attributes as well as professional ones, and the look of self-portraiture is shot through with signs of class and gender. It is the look of mastery: of containment, detachment, distance, *sang froid*, self-possession. It comes out of an aristocratic matrix. The fact that the look seems to have come into being, or taken on a certain consistency, at the moment of Mannerism may not be beside the point.) Perhaps in the end, for all its coolness, this is a look that intends to break through the surface to some truth within. But we cannot be sure, and it is part of self-portraiture that we should not be; maybe the point or effect of the mirror is to let the look deal strictly with appearances. The look in self-portraiture never stops oscillating between these two possibilities, these two kinds of reading. The oscillation is what the look *is*. On the one hand Rembrandt (fig.31), on the other Sir Joshua Reynolds (fig.32, cat.22). But are we so sure, on reflection, who is on the one hand and the other? Are not both of them on both? Is there not pathos even to Reynolds's professionalism? We accept the hand shading the eye as a sign of technical steadying and control on the artist's part; but inevitably it seems partly a gesture of defence, a way of keeping the full intensity of the world at bay.

The problems already have us by the throat. Let me try to restate

Fig.30
Jacques-Louis David
(1748–1825)
Self-portrait, 1794
Oil on canvas, 810 x 640mm
(32 x 25")
Musée du Louvre, Paris

Fig.31
Rembrandt
(Harmensz van Rijn)
(1606–69)
Self-portrait, 1669
Oil on wood, 860 x 705mm
(33⅞ x 27¾")
National Gallery, London

them in less intractable form. For a start, we could ask if the painter of a self-portrait is normally taken to be a privileged witness to what he is looking at. (For reasons that will emerge in a moment, the masculine pronoun turns out to be the least offensive choice in this case.) If so, what kind of privilege is it? Presumably it would be stretching things to say that a self-portraitist does not have *some* special knowledge of – or access to – what he is like. But it does not follow that he is necessarily a good judge of what he *looks* like. And he may be exactly the wrong person to tell us or show us how his self – if we mean by that a certain continuity of character and attitude to things – is manifest on the outside, in the way he presents what is visible to others. This might be opaque to him, and in any case not open to inspection in a mirror; it might be something he (happily) took for granted and in a sense positively avoided observing in everyday life, whereas the rest of us had been doing the observing like mad, as part of our ordinary dealings with him. We would be better portraitists of him, if we had the skills, than he will ever be; there are plenty of pairs of portraits and self-portraits that seem to prove the point.

So what does a portraitist think he is doing looking in the mirror in the first place? Everyone knows the game is risky. Jean-Jacques Rousseau is trotting out a platitude when he associates self-portraiture with Narcissus. The language in general does much the same thing. Self-regard, for example, is not a neutral term in common usage, and shades off quickly into *amour propre*. Looking too hard at oneself is embarrassing. Even self-consciousness is an equivocal concept (more so in English than French): some contexts make it a high and difficult attainment, and others an unfortunate condition linked with adolescence and bad skin. Self-portraits are partly made, I think, against this background of suspicion, and the look in them has to signify, before all else, that the painter cast a cold eye on his subject matter as opposed to a warm one. Hence there emerged a whole deeply conventional repertoire of poses and expressions meant to prove the point: casual, momentary, disabused, warts-and-all, professional, pessimistic, would-be Nietzschean; all of them determined not to be self-absorbed or self-regarding, or not in ways to which viewers could condescend. (This is one of the reasons why the set-up in self-portraiture that has the painter 'looking back' at himself over his shoulder becomes such a favourite [see figs 33, 34]. It looks so much like a pose struck *en passant*, for no more than a moment, before the painter turned back to what he was really interested in – in other words, the canvas.)

This kind of scepticism towards self-portraiture is not, I think, just something I have worked up for the occasion: it seems to be built into the very language of self-scrutiny, and to have had effects on painters' practice. All the same, there is a sense in which it leaves our most deeply held prejudices untouched. Say what you will, nothing is ever quite going to budge us from the conviction that a self-portraitist *is* privileged and does look back at us from a special place. I can ironise about *amour propre* until I am blue in the face; put me back in front of a Rembrandt and the circuitry is largely intact. What is it then that we cannot escape from?

First of all, there does not seem to be an exit from the situation *we* are put in as viewers of a self-portrait: we cannot entirely escape from

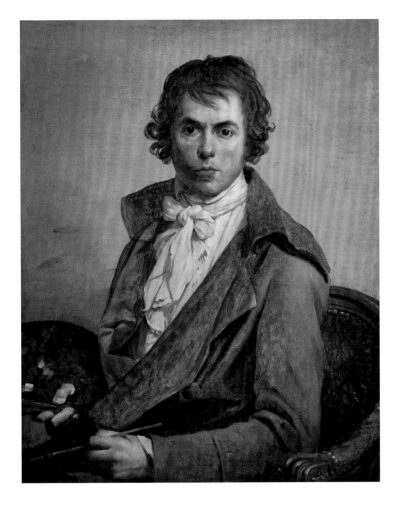

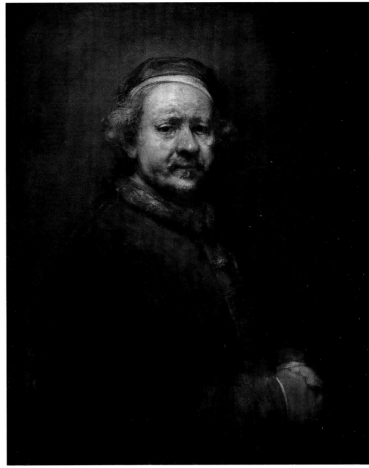

ourselves, and the invitation to double and project that entity or location or condition – the game thrives on the ontology hereabouts being so slippery – on to the image in front of us. This is a powerful constraint, a real generator of readings. The beholder of David's self-portrait, say, is put in that place (but is it a place at all, exactly?) from which, or in which, it is imagined, the depicting got done; and this not metaphorically – after all, the beholder is used to that – but literally. Not that the 'literally' here is at all to be trusted, or even meant to be: we are not physically in any such place, and on one level we know it. It is just that in order to get on any kind of terms with a self-portrait we have to accept that our eyes are roughly where the painter's once were, and not only eyes but mind. 'We' (the word is always to be understood in scarequotes in this essay, but now it had better wear them with pride) are meant to assume – to *resume* – the position of consciousness whose outside is there on the canvas. That outside is not just the evidence for the position, it is its product; and the cast of mind on show is not general – not an invitation to any and every projection on our part – but specific. What we are shown is consciousness directed to that exotic entity, its own outside, its 'appearance'. And is not that where and how *our* consciousness is directed? Cannot we duplicate as viewers those very movements of seeing or mind that are pictured and that led to the picturing? All viewing of paintings is a kind of complicity, no doubt. Not all of it involves this kind of haunting.

These are structures, I believe, that can resist all sorts of scepticism. Many philosophers – most notably David Hume in the *Treatise of Human Nature* – have called into question the self's

identity, or simplicity, or continuity through time. And in front of a Rembrandt we are free – maybe we are encouraged – to half-remember the sceptics' arguments. We can go on taking the movements of seeing and mind to add up finally to a singularity, or we can revel in their unravelling. We can have the self or its negation: intimacy can disperse into otherness, unity into multiplicity, soul into matter, 'what we meant' into the 'free play of the signifier'. Any movement will do as long as it is we who do it. They are all part of the same fiction, the same 'figure of reading or of understanding'.[2]

My imagery in the last couple of paragraphs has been of coercion, as if I thought the game we had been inveigled into playing was one with actual costs and deficits, which it would be good not to run up. The reader may be wondering what I think the costs are. Is the account of self and self-knowledge I see in these pictures' set-ups strong enough to count as coercive? Have we been sold any very particular bill of goods?

I think we have – which is not to say that I see any other better bills on offer for the time being. The items are three. We have been sold a certain metaphysics of spatiality – a picture of the self as having insides and outsides, and being somewhere. We have acquiesced in an equation of seeing with knowing and vice-versa, one that is built deep into our accounts of the world: Paul de Man calls it 'the fundamental metaphor of understanding as seeing'.[3] And we have given in to the great argument of self-portraiture, that a clear and fundamental distinction can be drawn between seeing and representing. I shall speak to the first two items straight away.

What does it mean, would be my question, to say that in the

Fig.32
Joshua Reynolds
(1723–92)
Self-portrait, c.1747–9
Oil on canvas, 635 x 743mm
(25 x 29¼")
National Portrait Gallery, London

Fig.33
Anthony van Dyck
(1599–1641)
Self-portrait, c.1613
Oil on canvas, 430 x 325 mm
(16⅞ x 12¾")
Gemäldegalerie, Vienna

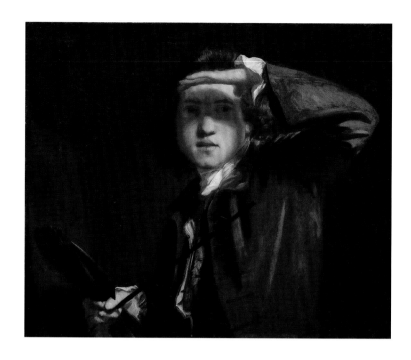

David we are looking at a self's outside, or at a body with a self inside it? We are looking at a body. A 'self' is a way of describing it. Obviously we may want to specify all manner of things about that self, but why necessarily its *location*? And yet, of course, the movement to spatialise the self runs deep, and seems bound up, at least lately, with the effort to articulate what is special and irreducible in any one person's take on the world. Perhaps it is true, to quote the philosopher Charles Taylor, that 'the modern conception of a unified personality may not be possible' without a 'space of disclosure … considered to be *inside*, in the mind'.[4] 'We may want to judge this in the end as fanciful a view as the ones which preceded it, but this doesn't dispense us from understanding the process of self-transformation which was partly constituted in this shift.'

It may even be that the 'movement of interiorization' Taylor is talking about captures something about selfhood that is basic and ineradicable; it does not sound good to eradicate it: we all know the claptrap of anti-individualism when we hear it. Nonetheless, I intend to stick to my guns. The movement in question seems impoverishing to me, and certainly it has come to stand in the way of capturing or even addressing various other dimensions to what it might mean to have or be a self. It may or may not be true, for example, that 'the Dinka language … compels its speakers to integrate the moral and physical attributes of persons together within the physical matrix of the human body'.[5] 'Compels' is a difficult word here. Anthropologists disagree. But in any case the point the anthropologist is making can stand *a contrario*: our language, in contrast to the Dinkas', invites its speakers to think of persons and bodies separately. Likewise, it may or may not be useful to think of selfhood as a code of sorts, a kind of performance or negotiation, and therefore to put our stress on the self's belonging to social practice. The language for this exists, of course; the language but not the discourse: no context of practice, that is – no proper language-games – of the kind that would truly extend and intensify the syntax and lexicon of the self and oblige them to draw on their full resources. So we simply do not know if the alternative models and metaphors of self could have purchase on new particulars or not; for what happens when they are tried is that the attempt to state them is infiltrated, not to say recaptured, by the very spacing and siding of self they see as the enemy. 'We are never fully ourselves in our utterances. What we make or say is always somewhat alien to us, never wholly ours, as we ourselves are not wholly ours … We are *outside* ourselves, and that "outsidedness" … creates the tragedy of expression' (Gary Morson interpreting Mikhail Bakhtin).[6] Either this, or bloodless abstraction: 'A self is a repertoire of behavior appropriate to a different set of contingencies.' 'The self is the code that makes sense out of almost all the individual's activities and provides a basis for organising them' (Erving Goffman).[7] The notion of code turns out in practice too thin to provoke much more than vague assent. Goffman's multiplication of particular social scenarios, which is where the real interest of his work is to be found, does not ultimately help. When it comes time to pin back the description of activities and contingencies to the concept of self, the concept stays largely uninflected by its excursions.

Neither Goffman nor Morson is brought on here as an easy

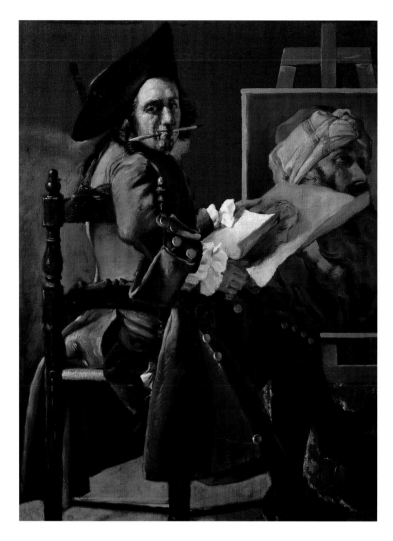

Fig.34
Pierre Subleyras
(1699–1749)
*Self-portrait, c.*1746
Oil on canvas,
1250 x 990mm (49 x 39")
Gemäldegalerie, Vienna

target: in a sense they are the least easy of the bunch. Morson in particular is working out of a rich tradition, and often profits from it. The quotes are there to show what it means to swim against the tide.

The model of inside and outside would not have the kind of hold on us it has if it were not bound up with the second item on my bill of goods, the equation of seeing and understanding. This takes me back to the painter's look. The type of self-portrait I am interested in, of which David's is a strong case, is out to show not just the likeness of a person who happens to be the artist – there are admittedly plenty of portraits with no higher ambition – but the activity of self-scrutiny. It wants to get down the physical 'look' of examining one's own face – in a mirror, most likely, though the mechanics of the transaction may be stressed or not – and the connection between this looking and the attendant movement of totalisation which is (what verb will do here?) *possessing* a self, or coming to consciousness of oneself as one.

Self-portraiture thrives on the further premise that *seeing*, in this connection, is uniquely privileged: we are being shown someone seeing the thing he or she understands best, or, at least, in a way nobody else could. And the understanding the self has of itself *is too a kind of seeing*; or shall we say, it is a process that can only be properly imagined after the model of seeing: that is, as a discrete, continuous, immediate proceeding from a centre: a movement out, as of some Will, but at the same time a stillness and receptivity, as of some Eye to which the world comes. Of course there is more to understanding the self than just seeing – self-portraits never tire of producing that piety – but the more is more of the same. Understanding is a seeing of the mind: a vector or trajectory of some kind, starting, so to speak, from an inch or two behind the eye, at the space or point which *is* our identity, and going out to the image in the mirror. And the fact that the model of seeing is thus generalised *to mind* reflects back prestige on seeing itself. People may say there is more to understanding the self than seeing, but they are not painters or epistemologists. Perhaps if they just looked hard enough ...

This picture of the world is powerful. David's self-portrait shows us someone under its spell, I think, and part of the reason we respond to it so readily is that we know, as the saying goes, where the painter is coming from: we come from the same place. I have been arguing, and no doubt demonstrating, that it takes a lot of painful mental gymnastics to imagine, even roughly, what an alternative picture would be. It goes against the grain. What would it be like, for instance, to think of the self as a thing without sides? Sides as opposed to what? Moments? Deployments? Different kinds of outwardness with no inwardness to match? Places, aspects, modes, numbers (-dividual and in-dividual), forms of ownership (one is not always self-possessed), kinds of texture or consistency? And even if a *painter* will not be inclined to do without the notion of the self as known spatially, then are there other conceivable relations in space besides those turning on 'in' versus 'out'? Do the various places of knowledge in the case of self have to be divided – by a partition which is all the more absolute for being at one and the same time so grossly, self-evidently material (in *here*, on the other side of *that*) and so entirely a matter of mind? '*Il me suffit ... de rentrer au dedans de moi.*' '*Consultons la lumière intérieure*' ('It is enough for me to go back inside myself.' 'Let us consult the interior light').[8] To which Diderot replies: '*Je ne sais si vous pouvez dire que l'âme soit dans le corps, ni de*

quel côté elle est' ('I do not know if you can say that the soul is in the body, or on what side of the body it is').[9] Put 'self' for 'soul' in the Diderot sentence, and his question still nags at some basic presuppositions.

Suppose the stitching that normally holds seeing and understanding together in our view of things were to come undone. Where would that leave the look of self-portraiture? Nobody for the moment is out to deny that looking at one's face in a mirror *is* a form of self-knowledge. On the contrary, let us posit it as an ordinary and adequate one, with the emphasis on the ordinary; one among several or many, none of them distinct or immutable, none exactly trustworthy. We might choose to give up talking altogether about looking *in general*, or try to, and opt for ways of speaking in which looking is tied close to circumstances: *this* looking, constituted in any one case by a great pattern of contingencies: by mirrors and maulsticks and eyeshades, for certain, but also by the ways in which looking at a given moment is constituted by language – vaunted, doubted, distinguished from other mental operations, idealised, materialised, made subject to social constraints and permissions, and so on. It might be possible as a result to pose the question of identity in a new way – to rescue it from the one mode of cognition (the privileged 'visual') and have it be scattered among the modes of mask, place, sign, name, lineage, affiliation, performance, language-game. Under this rubric all forms of self-knowledge, looking included, would be 'insufficient' (it is the dream of a *sufficiency* of self to self, with looking as the means to that sufficiency, that strikes me as self-portraiture's most deadly fiction). All of them would be external, in the sense of being always renegotiated in the public realm; maybe all of them would be open to description in materialist terms; and no doubt they would still be caught up in some version of Charles Taylor's 'movement of interiorization'. Inside, outside; fragmentary, unitary; authentic or made up for the occasion; something acted out, something one has or is: the structures are not going to be dislodged merely by multiplying the materials they are called on to organise. What might be thinkable, though – and here finally is my apology for pluralism – is a version of self-portraiture in which seeing would be pictured *as itself a form of representation*, not a proceeding somehow exempt from that circuit, or prior to it, or capable of breaking through it from one side to the other. That would lead to, and issue from, very different looks and poses from the ones we have.

1 For a full treatment of the painting see T.J. Clark, 'Gross David with the Swoln Cheek: An Essay on Self-Portraiture', in M. Roth (ed.), *Rediscovering History: Culture, Politics, and the Psyche* (Stanford University Press, Stanford, CA, 1994).

2 Paul de Man, 'Autobiography As De-Facement', in Paul de Man, *The Rhetoric of Romanticism* (Columbia University Press, New York, 1984), p.70: 'Autobiography, then, is not a genre or a mode, but a figure of reading or of understanding that occurs, to some degree, in all texts. The autobiographical moment happens as an alignment between the two subjects involved in the process of reading in which they determine each other by mutual reflexive substitution ... This specular structure is interiorized in a text in which the author declares himself the subject of his own understanding, but this merely makes explicit the wider claim to authorship that takes place whenever a text is stated to be *by* someone and assumed to be understandable to the extent that this is the case.' One way of putting my question about David's self-portrait would be to say that I am interested in whether it ends up being *by* someone – and understandable to the extent that this is the case.

3 Paul de Man, *Allegories of Reading* (Yale University Press, New Haven and London, 1979), p.600 n.5.

4 This and the following quote from Charles Taylor, 'The Person', in Michael Carrithers, Steven Collins and Steven Lukes (eds), *The Category of the Person: Anthropology, philosophy, history* (Cambridge University Press, Cambridge, 1985), p.277. Compare Charles Taylor, *Sources of the Self: The Making of the Modern Identity* (Harvard University Press, Cambridge, MA, 1989).

5 Godfrey Lienhardt, 'Self: Public, private. Some African representations', in Carrithers *et al.*, 1985, p.150.

6 Gary Morson, 'Who speaks for Bakhtin? A dialogic introduction', *Critical Inquiry* 10, no.2 (December 1983), p.242. Morson is fully aware of the pitfalls here: this statement of Bakhtin's case is put in the mouth of one of two speakers, and is immediately disputed by the other, who 'sees no tragedy' and wants a Bakhtin of Vygotsky's 'empirical and scientific' frame of mind.

7 Erving Goffman, *The Presentation of Self in Everyday Life* (New York, 1959), quoted in Martin Hollis, 'Of masks and men', in Carrithers *et al.*, 1985, p.227.

6 Jean-Jacques Rousseau, 'Profession de Foï', *Oeuvres Complètes*, (Paris, 1959) vol.4, p.569. One main purpose of de Man's chapter on the *Profession* is to demonstrate how the text in practice cannot (or anyway does not) sustain the opposition of inner and outer on which its epistemology ostensibly depends.

SELF-PORTRAITURE DIRECT AND OBLIQUE

Joseph Leo Koerner

It is an arresting spectacle, all these makers gazing out of the things they made, all these fabricated products having little more to do than to exhibit their producer, as if in person. A portrait likeness, even when it is not of the painter, can appeal to viewers directly, activating in them instinctive responses to faces faced their way. With self-portraits, the painted look that hails me has a special intimacy, since it derives from an encounter not of strangers but of self with self. Those painted eyes regard me so directly because (of course) at the moment of their depiction, they were fixed on the mirrored image of themselves. Theirs had been a restless struggle simultaneously to see and to submit themselves to sight. Intruding belatedly on this knotty game, I can imagine that I, and not the one beholding us, am its fugitive centre. The arresting spectacle results: all these portraitists eyeing me alone professionally; a portrait gallery whose single focus seems to be the self.

Historians today tend to demystify self-portraiture. Where the laity feel they glimpse human *universals* (man as a creature capable of reflecting on himself; consciousness as that backward turn), the learnèd discern *contingency*: the artist-likeness as accident of one craft tradition. Self-portraits, historians insist, were a quirky means by which a profession (painting), as practised in one time and place (Europe from about 1500 until recently), sought to advance its standing in society. And where, confounding a narrow location, there seem to exist parallels in other traditions – the self-portraits of literati painters in early modern China, for example, where social advancement seems not the main objective – we are asked to understand these locally, as well. Inscribing their identity on the things they made, artists (we are taught) do not address us directly, but instead launch their person into the vagrant social life of things.

To be sure, like any artistic practise, self-portraiture has served diverse purposes. Artists have painted their likenesses variously to climb the social ladder, to practice and/or to advertise their skills, to master (on the model of themselves) a repertoire of facial expressions, to gloss their intentions and aspirations, and to transmit to posterity a sort of frontispiece for their oeuvre (personified, oeuvres become *distributed persons*, linking all material products and traces back to agent who made them).[1] The painter and illuminator Joris Hoefnagel travelled with a portrait of himself and his wife; accompanied by that effigy, and able to be compared with it, he could show off his skill to clients.[2] The attention to one's own person that self-portraiture requires can serve intensely private aims, as well, say, as a physical and moral hygiene ('care of self'), or as narcissism extended into professional practice. Multiple purposes place self-portraiture in divergent histories. Hoefnagel's sample belongs more to the story of portraiture than to stories about an emergent modern self. And although expressive of post-medieval subjectivity, Albrecht Dürer's self-portraits make the most sense within histories of the trademark and of copyright.[3] This German master's remarkable series of painted and sketched likenesses form a subset of his larger endeavour, carried out in monograms, dates and autobiographical inscriptions, to link his products to his person – and this for an artist who, in his prints, uncoupled these.

And yet: while it may have served multiple and often contradictory purposes, self-portraiture does evidence inherent

capabilities both of the human subject and of painting as a craft. In 1435, at the beginnings of the European portrait tradition, Leon Battista Alberti praised the painter's art for its ability to animate. 'Painting', Alberti states, 'contains a divine force which not only makes absent men present, as friendship is said to do, but moreover makes the dead seem almost alive.'[4] In self-portraiture (of which Alberti was a precocious practitioner), the sitter animates himself, and not only through the lifelike effigy he crafts, but also in the crafting evidenced by the effigy, since that is also *of* his person. Max Beckman's self-portraits meld the forceful look of the artist (as a man of strength) with a forceful way of painting. The artist's tuxedo, which can indicate his worldly status, becomes at once a garb of mourning for the world and a reference to the signature black of Beckman's personal style (fig.35). At once the icon and the index of their creator, self-portraits attach what, in other artefacts, seems radically distinct. In them, products become the direct image and imprint of their producer while simultaneously personality itself becomes an artefact. In them, *homo faber*, distinct from all other creatures due to his productive, toolmaking capabilities, becomes one with the instruments that define him.

In spite of its various aims, then, we fancy we know what self-portraiture ultimately does. More so than in any other area of artistic production, its purpose seems direct and self-evident, to the extent that such purpose gets transferred to *all* artistic productions as ultimately their aim, as well. Self-portraits, we suppose, exhibit the artist to us, both as that person there before us, who regards us with a directness that confirms our acquaintance with his or her aims, *and* as the person who showed themselves in this and no other way, who posed, composed, and painted thus. And is this not what, for centuries now, we have come to believe art itself does: reveal the artist? Artists – so the standard model goes – communicate their experience, culture, and person in their works. Every Matisse, Beckman or Dürer indexes its maker. Their self-portraits simply personify that ubiquitous indication.

Not all products of human making can indicate their maker in such an explicit way. And very few indeed can reduce themselves to nothing but this indication. A hammer can be given a personal form: its maker can sign the product, or even decorate it somewhere with a likeness of him- or herself. However, these idiosyncrasies would not bear on the hammer's purpose, or if they did, the object would not function as the tool it is. Similarly, dentists are especially appreciated for their skill, yet how many patients would want such work permanently and sensibly to advertise the individuality of their dentist?

That paintings since the Renaissance routinely do just that is usually attributed to their functional autonomy. Self-sufficient, their only purpose would be the 'purely disinterested liking' which, according to Immanuel Kant, is the essence of aesthetic experience.[5] Self-portraits merely reify the autonomy that had been achieved for art objects generally. Isolated physically by a frame, and deposited on a portable support so that it functions independently of its setting, the post-medieval likeness not only resembles a person. In its freedom and mobility, it behaves like a person.[6] Painting seems destined to have become self-portrait painting. And yet, at around the time of the earliest painted self-portraits, this medium was dismissed as especially unrepresentative of the human capacity to create. When Nicolas of Cusa, writing in 1450, sought to exemplify

the originary power of the soul, he specifically rejected the instance of painting, since it produced no new entities. Cusanus's spokesperson for genuine creativity, and thus for the divine character of the soul, was instead a spoonmaker:

> Whereas a painter derives prototypes from things he seeks to reproduce, I who brings forth wooden spoons and bowls and pots from clay do not do this. For I do not imitate the form of any natural thing. The forms of the spoons, bowls, and pots arise only through human art. For that reason, my art consists more of bringing-about than of imitating created forms, and in that it stands much closer to divine art.[7]

In the person of the spoonmaker, Cusanus disqualifies painters from true creation. Their products reproduce things that exist without their agency. And since, according to this philosopher's Neoplatonic model, reality itself is the likeness of a prototype existing in a higher realm, crafted effigies will be third-order entities: images of images of ideas.

The spoonmaker as exemplary creator demonstrates the historical contingency of self-portraiture. Cusanus admired the products of contemporary Netherlandish painters. Responsive to the new level of realism achieved by masters such as Jan van Eyck and Rogier van der Weyden, this theologian also had a precocious grasp of the metaphorical value of self-portraiture. His tract *On the Vision of God* contains an extended comparison between fabricated icons of Christ and artists' depictions of themselves.[8] And yet, refusing to regard painting as exemplary of man's creative potential, he would never have predicted what self-portraiture would become. It was precisely its characteristic as *image* rather than *object* that enabled it to represent man as maker.

Fifty years after Cusanus gave the spoonmaker a voice, Dürer turned his own likeness into the inevitable emblem of human creativity. An egoistic document of ego, his 1500 likeness exemplifies everything we imagine self-portraiture to be (fig.36). But what exactly does this painting document? The event in the life of a particular person? Imagine that, in 1500 Anno Domini (the nestled monogram 'AD' doubles as that great division in time), Dürer observed his reflection in a mirror. In that auspicious year, and coincidentally – the Latin explains – in his own twenty-eighth year, when men were believed to reach the peak of their physical perfection, Dürer must have worked to make his mirror image similarly propitious and complete. He held himself rigidly in place (his fidgeting fingers animate the struggle) so that the reflection observed 'out there' in the mirror *looked like* how the body itself *felt*, physically, within the act of looking, from within *its* front and centre. Thus positioned, Dürer then proceeded to *depict* that reflection in oil paint on panel, in a time-consuming technique handled with unique diligence and skill, with the result that both images, the mirrored and the crafted one, collapse back into the person they document. The inscription glosses this. It proclaims that the artist fashioned his likeness with '*propriis coloribus*', a phrase meaning 'eternal' and 'permanent' colours, as well as colours that are Dürer's own. Consubstantial with what it represents, paint returns us from the image to the prototype and (by the perfection achieved by art) from that prototype to the Platonic idea.[9]

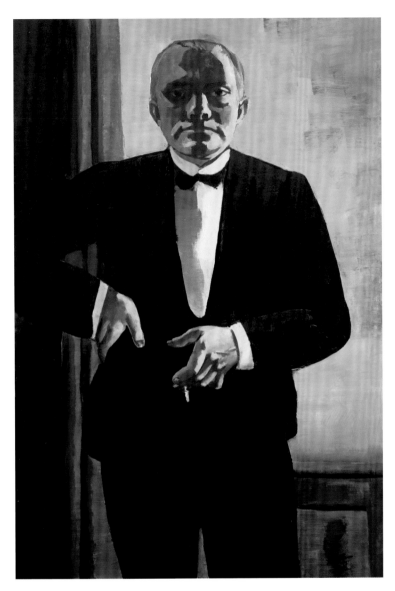

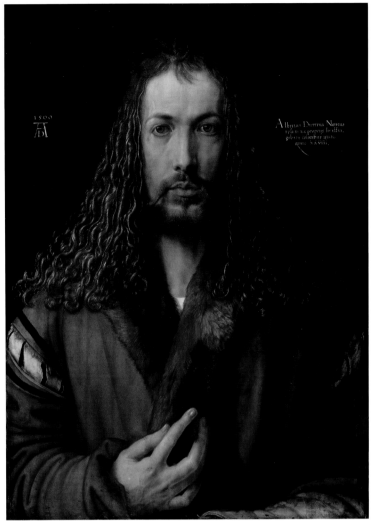

Fig.36
Albrecht Dürer
(1471–1528)
Self-portrait, 1500
Oil on panel, 670 x 490mm
(26⅜ x 19¼")
Alte Pinakothek, Munich

Fig.35
Max Beckmann
(1884–1950)
Self-portrait in Tuxedo, 1929
Oil on canvas, 1396 x 955mm
(55 x 37⅝")
Busch-Reisinger Museum,
Harvard University,
Cambridge, MA

Fig.37
Albrecht Dürer
(1471–1528)
Self-portrait at 13, 1484
Silverpoint, 275 x 196mm
(11 x 7¾")
Graphische Sammlung
Albertina, Vienna

The self-portrait is an ideal ego-document. It is also, simultaneously, the document of an 'ego-ideal'. In it, one feels that the artist offers himself *to* himself as his highest standard: thus should a man look, the beautiful likeness testifies, and thus should he act, with talent and discipline, making things as perfect as this. Dürer's makes the beauty of his person become the beauty that his person makes. His admirable golden locks are admirable, too, in the calligraphic lines that render them and that only he could paint; his shapely hand, displayed at the picture's base, measures perfectly his handicraft, which makes products that seem precisely *not* handmade but naturally or miraculously generated.

Psychoanalysis distinguishes between the 'ego ideal' and an 'ideal ego'.[10] The 'ideal ego' designates the ego's primordial perception of itself as perfect; in an illusion of grandeur (the story goes), His Majesty the Child takes himself as his own ideal. However, harsh reality, parental criticism and self-criticism force the ego to abandon itself and form a different ideal towards which to aspire. This new standard, the 'ego ideal', amalgamates from others (from the parents and the social world) an image of what the subject would *like* to be but is not, or better: what the subject would like to be in order to retrieve what it once was, namely the now-forsaken ideal ego. Narcissism thus gets retained by shifting its perspective. Note that the ideal ego turns into the ego ideal by becoming a genuine *image* of the ego. As a concept, narcissism draws from the ancient myth the conceit of self-love occurring accidentally by way of a mirrored likeness. The ideal-ego places before the subject a *picture* of what it wants to be.

And as if to bolster the modern psycho-historian's own ego ideal, Dürer documents even this mysterious formation. In his first self-portrait we see him age thirteen, learning to draw by sketching a likeness of himself (fig.37). 'This I fashioned after myself out of a mirror in the year 1484 when I was still a child,' he boasts in an autograph inscription added in the 1520s. The artist's earliest surviving work, this image documents his becoming an image-maker. In the first instance it documented this to his father. Albrecht the Elder, we learn from the artist's family chronicle, intended his son to be a goldsmith like himself. But by 1486 – presumably because of virtuoso performances such as this – he let the boy switch to the painter's trade.[11] In the final instance, the image documents to future admirers that, at bottom, all Dürer's products, and the miraculous resemblance his images bear to their prototype, derived immediately from his person, without any external master or model, and without prior training except for the exercise here on display. In the unique case of Dürer – this Opus One suggests – His Majesty the Child continues to reign.

The artist could take himself as his own ego ideal because, in strict psychoanalytical terms, his ideal was already an image, a visual representation. The 1484 *Self-portrait* inaugurated Dürer's oeuvre in the form of a likeness of the author at the very outset of his career. And, more amazingly, it inaugurated the modern idea of an artist's – any artist's – oeuvre, since prior to 1484, products were not emphatically categorised according to who made them. In that earliest self-portrait, then, Dürer's self is shown to be, from the start, invested in the images he made, and all these images, all these

Fig.38
**Niklaus Manuel Deutsch
(1484–1530)**
*Picture of Airborne Witch, c.*1513
Pen and ink on coloured
ground, 309 x 209mm (12 x 8")
Öffentliche Kunstsammlung,
Kupferstichkabinett, Basel

things, therefore become distributions of himself. As in this drawing, so too in the 1500 likeness, the ideal embodied is more an image than an empirical person. Dürer modelled his likeness after icons of Christ; he even modified his own physical features and proportions to fit this model. Modern commentators have generally understood this gesture as proposing an analogy between the persons of Christ and Dürer, or as likening 'God the artificer' to the artist in his divinity.[12] In my view, the painting synthesises two types of images: on the one hand, the true image of Christ made 'not by human hands' (for example the miraculous stain on St Veronica's cloth); on the other hand, the self-portrait painting as perfect icon and index of its maker, since everything you see is a relic of his well-trained hand.[13] In sync with the sitter's *en face* posture and penetrating gaze, and on the model of the true icon of Christ, Dürer's likeness proposes itself as the direct, unmediated emanation of person into product.

The painting thus attests to sameness, to the mimetic identity of the ego and its ideal, of image and prototype, of artefact and maker, of an historical document and the information it imparts. Treating the artist as the ideal object, it makes him into an aesthetic, ethical and cultural standard, which is precisely what Dürer became for younger masters who came under his influence.[14] Yet when we turn to the self-portraits of Dürer's followers, quite a different picture unfolds. These objects thrust themselves on us the moment we consider his model status for other artists of his time. One humorous example is a drawing from *c.*1513 of an airborne witch by the Swiss painter, playwright, and mercenary soldier Niklaus

Manuel Deutsch (fig.38).[15] At first glance, the sheet seems anything but a likeness of self. It presents to its (presumably) male viewer something radically separate from him: a nude woman harnessed in decorative chains. If her body and costume allure, her flight ought to terrify for it indicates a devilish pact. Witches were believed to be powerless in themselves. Conjured by her fiery potion, and secretly linked to her through a carnal embrace implied by her flight but not shown, some demon will have to have enabled her 'transvection' (as such motion was called), as well as her *maleficium* – her ability to charm or harm her victim. A seductive enemy, Manuel's witch seems already to have achieved her goal. She bears in her hand a death's head. Dangling from its upper jaw, a little tag initialled 'NMD' identifies the skull as Manuel's. Here, then, a self-portrait *in malo*: the artist's visage and his professional and corporate insignia inside an evil plot.

One characteristic of this ego document is that identities become fickle. Labelled with the artist's initials and wearing a hat with his badge, the skull would seem to signal that the witch has conquered him. Perhaps her spectacle of availability and submission had seduced then murdered him. Her hair, an attribute of her desirability, chimes with the forms of her evil potion. The skull's feathered beret evokes the artist's own rakish egoism that could have precipitated his fall. Elsewhere in his oeuvre Manuel portrays himself as a Swiss mercenary and boasts of his intimacy with prostitutes and death. But it is also possible to read the skull as not yet Manuel's. Anonymous because stripped of its face, it might be an instrument of imitative magic, where harm comes by way of an

Fig.39
Albrecht Dürer
(1471–1528)
*Nemesis, c.*1501–2
Engraving, 329 x 229 mm
(13 x 9")
British Museum London
(1895-9-15-346)

Fig.40
Hans Baldung Grien
(*c.*1480–1545)
Bewitched Stable Groom, 1544–5
Woodcut, 330 x 197mm
(13 x 7¾")
British Museum, London

Fig.41
Albrecht Dürer
(1471–1528)
Large Horse, 1505
Engraving, 167 x 119mm
(6⅝ x 4⅝")
British Museum, London

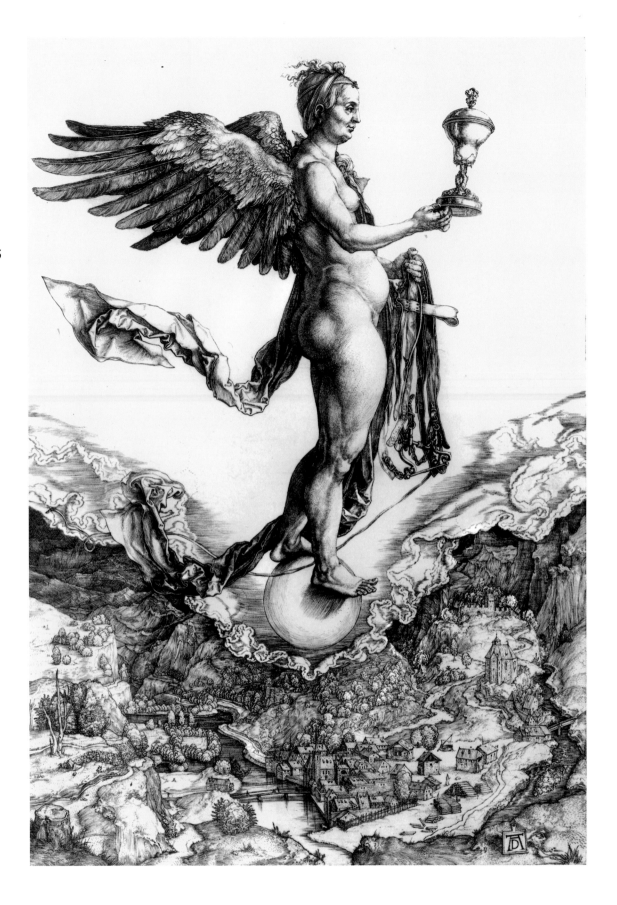

effigy. In that case, Manuel's putative self-portrait was crafted by the witch, who hopes to use it against him, just as she now casts her spell on the picture's viewer. Tangled in a conspiracy of everything antagonistic to it, the ego disappears, leaving behind objects of erotic infatuation and terror, powers that arouse in order to castrate.

At one level, the sketch imagines that the ego's overthrow was by means of a trance: the witch either performs, or has already performed, erotic magic on and/or through the artist. At another level the sketch itself performs an analogous sorcery on its viewer through the erotic charge that Manuel himself gives it. Placing his initials under the skull and at the base of his sheet, the artist likens his art to that of the witch. For beyond the pleasures and pains elicited by the image of a woman and a corpse, the drawing proposes itself as the object of visual desire and repulsion. Note how the witch's hair and her malignant vapours together evidence Manuel's calligraphic mastery. The brownish-orange prepared ground amplifies the sorcery of those black and white lines rather as Dürer, in his 1500 picture, let his marvellously painted hair and beard stand forth from darkness. And although the comparison between that ideal self-portrait and this malignant one seems far-fetched, a work by Dürer is in fact the rival Other of Manuel's drawing.

Dürer's *Nemesis* exerted a huge influence on German and Swiss artists of the period (fig.39). The second largest engraving in Dürer's oeuvre, this work, dating from around 1501, translates into the printed medium a message underlying the 1500 *Self-portrait*. Goddess of temperance, Nemesis rewards those who remain within her measure and punishes those who stray beyond. Dürer obeys her

in the way he best can, by drafting a temperate image of temperance. *Proportion*, controlling the goddess's corporeal form, and linear *perspective*, plotting the landscape's ordered recession into distance, are the two chief instruments by which the artist gives his products a proper *aesthetic* measure. Dürer thus proclaims his desires and his products to be bridled and bound within the compass of the ego. If in his self-portraits he obeyed the maxim 'know thyself', here he obeys the other Delphic injunction: 'nothing in extremes'.

Manuel travesties this ideal. In place of the goddess of measure, he installs a prostitute-witch whose bridle itself has turned into an erotic fetish. In place of the harness and goblet of temperance he offers the rewards of sex and death. In place of an ethical and an aesthetic balance between ego and world, he returns both poles, the subject and the object, to their traumatic kernel where they are both annihilated. And in place of Dürerian egoism he evidences self-love's evil twin, aggression. Note that the travesty of Dürer's ego ideal is itself fuelled by an ego. In making the sketch, Manuel poses as an aggressive rival to an artistic father-figure. As we have seen, Dürer proposed his artistry *and* his own image as an ego-ideal; inheriting that proposal, later masters simultaneously identified with, and sought aggressively to negate, that (as it were) Oedipal rival. The rivalry may be political as well as artistic, since the landscape under Dürer's *Nemesis* may depict the valley where German forces under Emperor Maximilian were defeated by the Swiss.[16] It is striking how the crudest travesties of the engraving were made by the two Swiss soldier-artists: Manuel of Bern and his more flamboyant contemporary Urs Graf of Zurich, who made a drawing of Dürer's

Nemesis as an army prostitute holding an enema. In any case, Manuel's airborne witch shows us how an ego document can be turned upon itself.

Such a reversal is not unique to this drawing. The work of Hans Baldung Grien, Dürer's most gifted disciple, abounds in self-portraits *in malo*. His last surviving work, conventionally titled *Bewitched Stable Groom* (fig.40), gathers on the planes that make up space the principle antagonists of his art: at the right, a witch, embodiment of woman as Other; at the rear, a wild horse, emblem of libidinal desire; and on the ground, a corpse. These paradigmatic 'others' conspire against three 'ego' documents: Baldung's coat of arms, his monogram, and, in the corpse, his portrait likeness in extreme foreshortening. This swan song of Renaissance art negates what Dürer's self-portraits had founded. Where Dürer took himself as his own ideal, thus constituting the stable identities of ego and object, Baldung throws back on the world the disorder of which his own being is composed. Baldung's horse stands in a specific rivalry, being based on Dürer's *Large Horse* engraving of 1505 (fig.41).[17] For Dürer, the bridled and mastered horse, symbol of disciplined desire, had been another vehicle for demonstrating the ethical and aesthetic value of proportion. In Baldung, the horse has thrown the artist to the ground and looks back at us malignantly. The visual figure – or trope – of a backward turn is crucial here. Enacted by a devilish mare, it coincides with the animal's perverse display of her anus or vulva. Since antiquity, the desire-inducing efflux of mares in heat – called *hippomanes* or 'horse madness' – were believed to be collected by witches and used in magic.[18] The turn contrasts absolutely with the view we have of the artist laid flat on his back.

In its formal and semantic obliquity, Baldung's self-portrait overturns the standard models of both portraiture and self. Toppled by the Others it seeks to control, the ego is pictured in its negation, as that thing lying there. At the same time the picture itself – the image that rises in place of self-portraiture – stands directly opposite us, the viewer, not as the object of our gaze but as an active subject who, fixing its evil eye on us, threatens to topple us as well. The obverse of Dürer's Christomorphic likeness, this also reverses the optimism of the modern era that the panel, with its proud date of 1500, self-consciously inaugurates. Baldung's woodcut is not unique. It belongs to a counter-tradition within the history of self-portraiture. The difficulty of tracing this line lies partly in the fact that evidence for it will be, by nature, oblique, masked, or otherwise concealed. The 1500 *Self-portrait* already contains the seeds of this development. The artist's left hand, painted from a mirror and therefore perceived by the viewer to be his right hand, turns towards the physical person in Dürer's image. A gesture of self-reference, the hand's movement is also an exploration of the person's material – even carnal – nature. The tips of Dürer's fingers probe the quiddity of the body in the animal fur that adorns it. Mocked by his friends as 'the hairy, bearded painter',[19] Dürer, in other self-portraits, reflects on his own corporeality in more explicitly critical ways. In a sketch (now in Bremen) presumably made for his doctor, he points to the seat of his disease, a 'yellow spot' in the area of the spleen. More spectacularly, in his *Nude Self-portrait* in Weimar (fig.8; dating from the period of his work on the idealised figures of Adam and Eve), he considers his own frame as physically abject, anticipating modern artists such as

Fig.42
**Hieronymus Bosch
(*c*.1450–1516)**
*The Trees Have Ears and
the Field Has Eyes*, *c*.1510
Pen and ink, 202 x 127mm
(8 x 5")
Kupferstichkabinett, Berlin

Fig.43
**Hieronymus Bosch
(*c*.1450–1516)**
The Pedlar, closed state of
The Hay Wain, *c*.1500
Oil on panel, 1400 x 1000mm
(55 x 39⅜")
Museo del Prado, Madrid

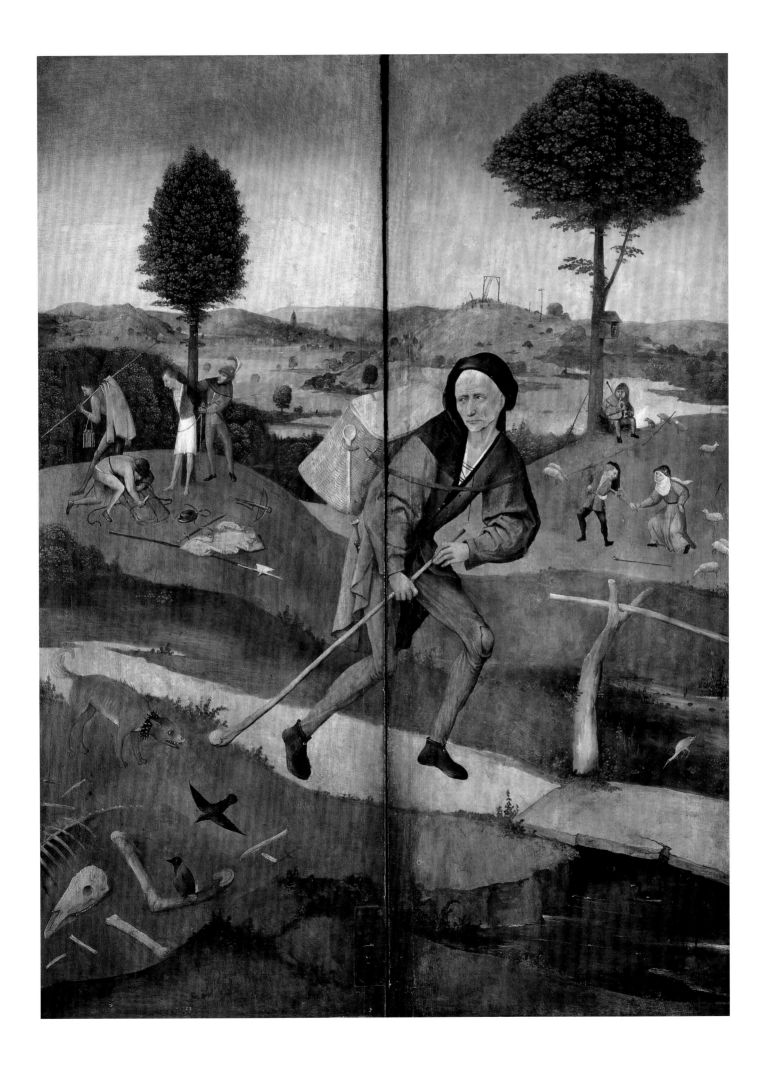

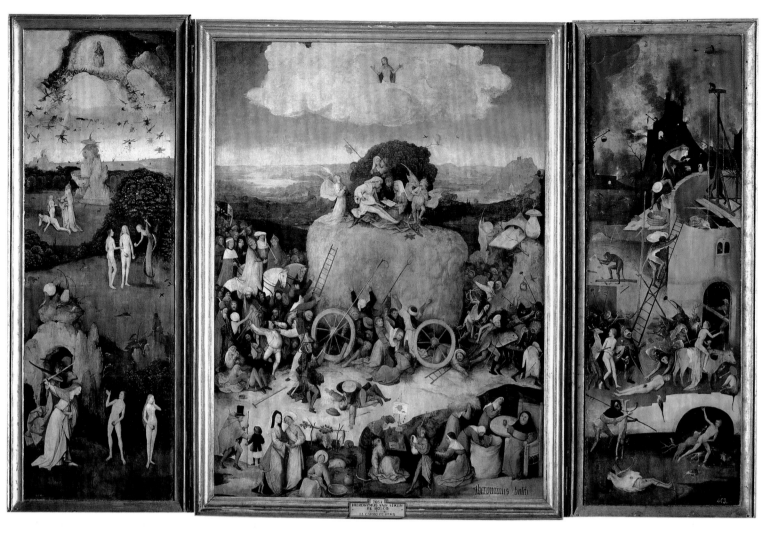

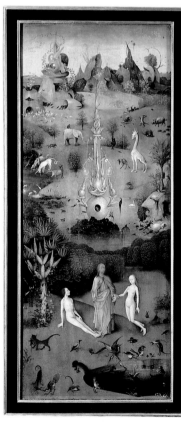
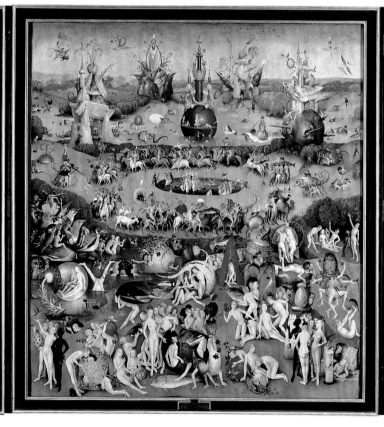

Egon Schiele, Lucian Freud and Georg Baselitz.

Hieronymus Bosch left to posterity no signed self-portraits. A drawing, now in Arras, long believed to represent him was made after his death, and the inscription was pasted in even later.[20] Like Dürer, however, Bosch did sign – ostentatiously – many of his paintings. The central panel of his triptych sometimes called the *Hay Wain* displays a prominent signature. Whatever their symbolic intentions, these and other signed works by this painter advertised the agency of their maker. Bosch boasts of his originality in the one autograph text of which we can be fairly sure. This enigmatic drawing, which goes under the title *The Trees Have Ears and the Field Has Eyes* (fig.42), bears the motto 'most miserable is the mind who uses always invented things, never inventing anything himself'. The drawing itself is a sort of self-portrait *in malo*. By way of an underlying proverb it pictures how the wise man, knowing he is seen and heard from all sides (the ears and eyes), keeps silent. Mobbed by magpies, the morally ambiguous owl stands for the ego self-isolated from a malicious social world. The tree itself probably puns the word 'Bosch' ('forest' in Dutch), indicating both the artist and the place, his hometown of 's-Hertogenbosch, from which he took his name. Practising what he preaches, Bosch conceals the egoism that his highly inventive drawing also boasts.

Ego appears under negative signs in Bosch. The outer shutters of the so-called *Hay Wain* portray the self as a pedlar wandering through the sinful world (fig.43). The saleable trinkets in his backpack signify his attachment to material things. Swung open, so that the image of ego (the pedlar) splits down the middle, the

painting, now a triptych, unmasks how, lured by things, humanity receives nothing but hay, and hell beyond that (fig.44). Bosch's earliest commentators identified the hay as an emblem of nothingness. Flanked by paradise and hell, the hay marks the present moment of its display: a mobile centre between fixed historical ultimates. It represents both the object of desire *and* the desiring subject whose 'flesh is grass'. On the exterior shutters, and thus concealing the cosmic trap, Bosch documents life from within, from the ego's perspective. Everyman marches in step with the hay his world covers. But threatened from behind by murderous highwaymen and by a snarling dog, he looks backward, ignoring the dangers that lie ahead (note the cracked footbridge in front and the gallows above). The ego is a de-centred centre. Accordingly, it spans a literal gap in its physical support: again, the shutters open to hay's flammable nothingness. Already split within himself by desire and fear, the ego turns back on itself. The cause of its own avariciousness, the ego *turns on* itself. It is its own true enemy, as it was in Paradise.[21] Inside, the ego is empty: a box of hay.

Bosch can represent the ego as an object – a body marching forward while gazing back – because it desires objects. The pedlar's wares stand for what he has and is, just as the hay is both world and flesh. The ego and its objects are not separate. The flow of one into another makes life appear to move forward, giving life its apparent mobility. This fluidity of person and thing has its most famous expression in the so-called 'Treeman'. The motif makes its most famous appearance in the Hell panel of the *Garden of Earthly Delights* (fig.45), where it closes off the triptych's pessimistic storyline. But

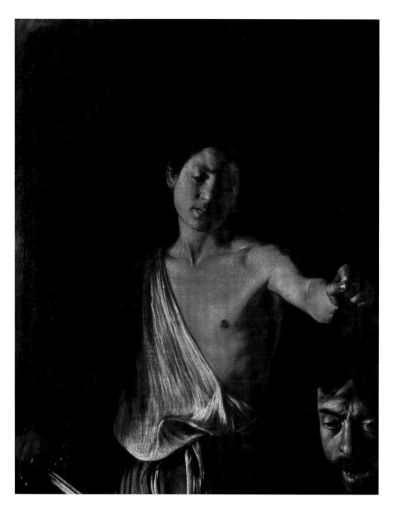

Fig.47
**Michelangelo Merisi da Caravaggio
(1571–1610)**
David with the Head of Goliath,
1605–6
Oil on canvas, 1250 x 1010mm
(49 x 40")
Galleria Borghese, Rome

Fig.48
**Arnulf Rainer
(b.1929)**
Over-Painting Totem, 1983
Oil on photograph, 1030 x 730mm
(40½ x 28¾")
Museum Kunst Palast, Düsseldorf

it appears isolated for easier study in an autonomous drawing by Bosch's hand (fig.46). Punning again on Bosch's name, the Treeman turns back upon itself to reveal the nothingness inside him. Whether or not the face that gazes backwards is a likeness of Bosch, as some scholars have suggested, or whether, as a more generalised visage of 'man', the entire figure demonstrates why self-portraiture, for Bosch, must needs be oblique. The ego is perpetually undone by its striving, including the desire to see or know oneself. Folded back upon his own body, the self appears as a hellish enclosure, indeed as 'hell' itself in its etymological derivation from 'hole'. I would note that, in the *Garden of Earthly Delights*, the Treeman looks back, through a strange and estranging world of carnal activity, towards Adam in Paradise. Adam's face looks like the Treeman's, as do many of the faces of the men in the central 'garden' scene – perhaps not because they are the same person, but because, all stemming from Adam, they (we) are Adam's inheritors.

Here we may think we reach self-portraiture's absolute Other, a knotty fantasy of everything that the self wishes it were not. Yet from its very beginning as an historical phenomenon, self-portrait painting located self within a condition of abject or evil. In his *Last Judgement* fresco in the Sistine Chapel, Michelangelo portrayed himself as the flayed skin of St Bartholomew (fig.3), probably as an appeal for redemption from the flesh, perhaps also as symbolic penance for artistic ambition, since Apollo flayed Marsyas alive for challenging divine artistry.[22] Caravaggio made a more obvious confession when he gave his own features to the giant's ghastly visage in his canvas *David with the Head of Goliath* in Rome (fig.47).[23]

It is possible that Giorgione's *David and Goliath* of *c*.1509 portrays the artist as the giant and not as David, as Giorgio Vasari contended.[24] Certainly Cristofano Allori, working under Caravaggio's influence, cast himself in the role of Holofernes in his *Judith* of 1613 (cat.7).[25] Veronese and Palma Vecchio may have done the same in their Judiths in Vienna and Florence respectively. Like Manuel's drawing, these pictures cast the artist as victim of women's power, whether vicious or virtuous. In line with a tradition of love poetry, they conflate self-pity with self-reflection and posit the over-filled ego as a consequence of failure rather than success. In light of such works, modern experiments in defaced or evacuated self-portraits seem less exceptional. Whereas self-portraiture in its heroic mode celebrated what art – and human creativity – could achieve, these likenesses *in malo* testify to our limits as agency and as body. In doing so, however, painting evinces yet again its evidential force.

The quest for originality, in the sense both of constituting an origin and of engendering novel creations, has long been staged as a journey into solipsism and death. Melancholic and estranged, the artistic ego, turned inward and against itself, becomes the object of personal and social *sacrifice*: personal sacrifice, through single-minded devotion to its calling; and social sacrifice, due to its being perennially misunderstood. 'Cry out, art, and weep loudly for thyself!' reads the inscription on a stylistically vanguard German altarpiece painted in 1432: 'No one wants you any more, woe is me.'[26] In contemporary practice, the imagined scapegoat of the sacrifice is less the artist himself than a certain idea of art. In vandalising their own effigies, artists attack the art tradition itself; defacing their likeness, they scandalise entrenched ideas *about* likeness. When Arnulf Rainer, in the 1960s, defaced his photographic likeness with strokes of paint (fig.48), or when Gerhard Richter blurred the outlines of his still-wet effigy (cat.58), their target was not their own *person*. Personhood had not been proposed by the underlying images that they defaced. As simulacra of simulacra (re-reproduced photographs), these were evacuated and impersonal before the attack. Iconoclasm now targets the false idol of art itself: the beautiful picture.

Self-portrait painting has always been both direct and oblique: direct in proposing the artist as the ultimate subject of art, but oblique in evidencing the impossibility of that proposal. We glimpse this impasse in Dürer's 1500 likeness, where his active right hand, unrepresentable in the act of painting, disappears below the lower framing edge. The artist makes this ineluctable incompleteness visible by allowing the two-ply cuff of his sleeve to be glimpsed where his hand disappears. The origin of painting, the artist seems to say, remains unpaintable even here, in this emblem of origination. Painting's model, self-portraiture is also painting's mystery.

1 On the artist's oeuvre as a 'distributed person' see Gell 1998, pp.232–58.
2 Lorne Campbell, *Renaissance Portraits: European Portrait-Painting in the 14th, 15th and 16th Centuries* (Yale University Press, New Haven, 1990), p.215.
3 Koerner 1993, pp.203–23 and *passim*.
4 *On Painting*, trans. John R. Spencer, rev. edn, (Yale University Press, New Haven, 1966), p.63.
5 *Critique of Judgment*, trans. Werner S. Pluhar (Hackett Publishing Co., Indianapolis, 1987), p.46.
6 On this point, see especially Hans Belting, *Bild-Anthropologie. Entwürfe für eine Bildwissenschaft* (Wilhelm Fink Verlag, Munich, 2001), pp.115–42.
7 Nicolas of Cusa, *Idiota de mente* 62.10-19, in *Philosophisch-theologische Werke*, ed. Ernst Hoffman *et al.* (n.p., Hamburg, 2002), vol.2, p.15.
8 Jasper Hopkins, *Nicholas of Cusa's Dialectical Mysticism: Text, Translation and Interpretative Study of De Visione Dei*, 2nd edn (Banning Press, Minneapolis, 1988).
9 'A good painter is inwardly full of figures,' wrote Dürer, 'And were it possible for him to live forever, he would have from his inward ideas, whereof Plato writes, always something new to pour forth through his work' (Albrecht Dürer, *Schriftlicher Nachlaß*, ed. Hans Rupprich [Union, Berlin, 1956–69], vol.2, p.109, also pp.112 and 113).
10 Sigmund Freud, 'On Narcissism: An Introduction', in *Standard Edition of the Complete Psychological Works*, ed. and trans. James Strachey *et al.* (Hogarth Press, London, 1953–74), vol.14, pp.84–8.
11 In the family chronicle, Dürer writes that his father sought to launch his children into the world with greatest 'breeding' so that they might be 'pleasing in the sight both of God and man.' 'My father took a special liking for me because that I was diligent I was in the practice of learning.' The father, along with 'God and man', survey the artist's formation precisely as super-ego. Torment came from those jealous of his distinction. Apprenticed to Michael Wolgemut, 'I had to suffer a lot from his lads' (Dürer, *Schriftlicher Nachlaß*, vol.1, p.30).
12 The Christomorphic aspect of the self-portrait was noted early on by painters, but first described by Moritz Thausing, *Dürer* (Seemann, Leipzig, 1884), pp.355–65.
13 Koerner 1993, pp.80–126 and *passim*.
14 Joseph Leo Koerner, 'Albrecht Dürer: A Sixteenth-Century Influenza', in *Albrecht Dürer and His Legacy: The Graphic Work of a Renaissance Artist*, ed. G. Bartrum (exh. cat., British Museum, London, 2002), pp.18–38.
15 *Niklaus Manuel Deutsch. Maler, Dichter, Staatsmann*, ed. Cäsar Menz and Hugo Wagner (exh. cat., Kunstmuseum, Bern, 1979), no.159.
16 Joseph Leo Koerner, 'The Fortunes of Dürer's *Nemesis*' in *Fortuna*, ed. W. Haug and B. Wachinger (Niemeyer, Tübingen, 1995), pp.260–1.
17 Koerner 1993, pp.437–47.
18 Yvonne Owens, 'Vessels of Evil/Vessels of Light: Representations of Feminine Physiology and the Gendering of Witchcraft in the *Malleus Maleficarum* and the Art of Hans Baldung Grien', MA Thesis (University of York, 2003), pp.65–9.
19 Dürer, *Schriftlicher Nachlaß*, vol.1, p.131.
20 The drawing is part of the *Recueil d'Arras* – a large collection of portraits of illustrious people; see Peter Gerlach, 'Het portret von Jeroen Bosch', *Brabantia* 23 (1974), pp.163–9.
21 See Judith Butler, *Psychic Life of Power: Theories of Subjection* (Stanford University Press, Stanford, 1997), pp.3–4, 168–9.
22 Edgar Wind, *Pagan Mysteries in the Renaissance* (Abrams, New York, 1968), pp.186–9.
23 See most recently Avigdor Posèq, 'Caravaggio's Self Portrait as the Beheaded Goliath', *Konsthistorik Tidskrift* 3 (1990), pp.169–82.
24 John Shearman, 'Cristofano Allori's "Judith"', *Burlington Magazine* 121 (1979), p.9.
25 Ibid., pp.3–9.
26 The inscription appears on Lukas Moser's Magdalen Altarpiece in Tiefenbronn; see Alfred Stange, *Kritisches Verzeichnis der deutschen Tafelbilder vor Dürer* (Bruckmann, Munich, 1970), vol.2, pp.120–1, no.553.

Overleaf Salvator Rosa, *Self-portrait* (cat.18, detail)

SELECTED WORKS

Jan van Eyck
(c.1390–1441)

Portrait of a Man (Self-portrait?), 1433
Oil on wood, 260 x 190mm (10¼ x 7½")
Inscribed on frame (top): ᴀᴧᴄ.ɪхн.хᴀɴ.
(bottom): ᴊᴏнᴇꜱ.ᴅᴇ.ᴇʏᴄᴋ.ᴍᴇ.ꜰᴇᴄɪᴛ.ᴀɴᴏ.ᴍ°
ᴄᴄᴄᴄ°.33°.21.ᴏᴄᴛᴏʙʀɪꜱ [*As I can / Jan van
Eyck made me on 21 October 1433*]
The National Gallery, London
London only

Jan van Eyck's *Portrait of a Man* was first described as a self-portrait in 1655[1] although this view was not unanimous and the identification remains tentative.[2] The inscription at the top of the frame has been cited as strong evidence for recognising the sitter as the famous Flemish artist. The phrase ᴀᴧᴄ.ɪхн.хᴀɴ. (*Als ich kan:* 'As I can') is thought to be a pun on Van Eyck's surname (ɪᴄн/ᴇʏᴄᴋ ['I/Eyck']) and occupies the position usually reserved for the name of the sitter – which is otherwise absent from the work.

Van Eyck's technical contribution to the development of oil painting made possible the precise optical effects and mirror-like polish that make this portrait so lifelike, for example the effects of the two-toned stubble or the capillaries on the white surface of the left eye. Through his control of the medium, Van Eyck becomes ineffably present in the image, if not through his physical likeness, then through the way in which he alone has the skill to render invisible the mark of each brushstroke. The inscription 'Jan van Eyck made me' along the lower edge of the frame in abbreviated Latin emphasises the creation of the work and points to the pictorial field

as not just a portrait of a man, but also a man-made painting. Furthermore, the inscription is not actually carved on the frame, but painted in *trompe l'œil,* so that the words were literally produced by the painter's artifice. The phrase also draws a comparison between the creation of a portrait and a performance in a mirror, where the self is simultaneously seen as the creator ('ᴇʏᴄᴋ': the person making the image) and the subject ('ᴍᴇ': the image reflected in the mirror).

The variation of focus between the two eyes suggests that Van Eyck may, in fact, have used a mirror to create this image: his right eye is slightly blurred around the edges, appearing to be only passively engaged in sight, while the outline of the left eye is clearly delineated and focused on a specific object. This effect probably resulted from the artist observing himself in the mirror: when viewing oneself from an angle, both eyes cannot be seen simultaneously.[3]

Van Eyck apparently depicted himself elsewhere in his own work: he seems to be reflected in the mirror in the *Arnofini Marriage* (1434; National Gallery, London) and in the shield of St George in *The*

Madonna of Canon van der Paele (1436; Musée Communal des Beaux-Arts, Bruges). The linguistic connection in this later picture between the Flemish words *schild* (shield) and *schilder* (painter) is significant, because it implies that Van Eyck conceived of his paintings as self-reflective objects. While it can never be known for certain if the *Portrait of a Man* depicts Van Eyck, it is nevertheless an early example of a work conceived in the context of self-reference and self-awareness. ɴʟ

1 1655 inventory of Alathea Talbot, widow of Thomas Howard, Earl of Arundel (1585–1646), '*ritratto di Gio:van Eyck de mano sua*'. (Campbell 1998), pp.212, 217.
2 In 1618 the Antwerp art dealer Peeter Stevens (1590–1668) named the portrait as of the '*Hertoch van Barlaumont*'. This identification is supported in Dieter Jansen, 'Jan van Eycks Selbstbildnis – der Mann mit dem roten Turban und der sogenannte Tymotheos der Londoner National Gallery', *Pantheon* 47 (1989), pp.36–48.
3 Campbell 1998, p.216. Cf. Van Eyck's *Cardinal Nicola Albergati* (c.1432; Kunsthistorisches Museum, Vienna) and *Margaret van Eyck, the Artist's Wife* (1439; Stedelijk Museum voor Schone Kunsten, Bruges), where the subject is viewed head-on and the eyes are uniformly defined.

Literature
P.V. Calster, 'Of Beardless Painters and Red Chaperons: A Fifteenth-Century Whodunit', *Zeitschrift für Kunstgeschichte* 4 (2003), pp.465–92; Lorne Campbell, 'Portrait of a Man (Self Portrait?)', *National Gallery Catalogues: The Fifteenth Century Netherlandish Paintings* (National Gallery Publications, London, 1998), pp.212–17.

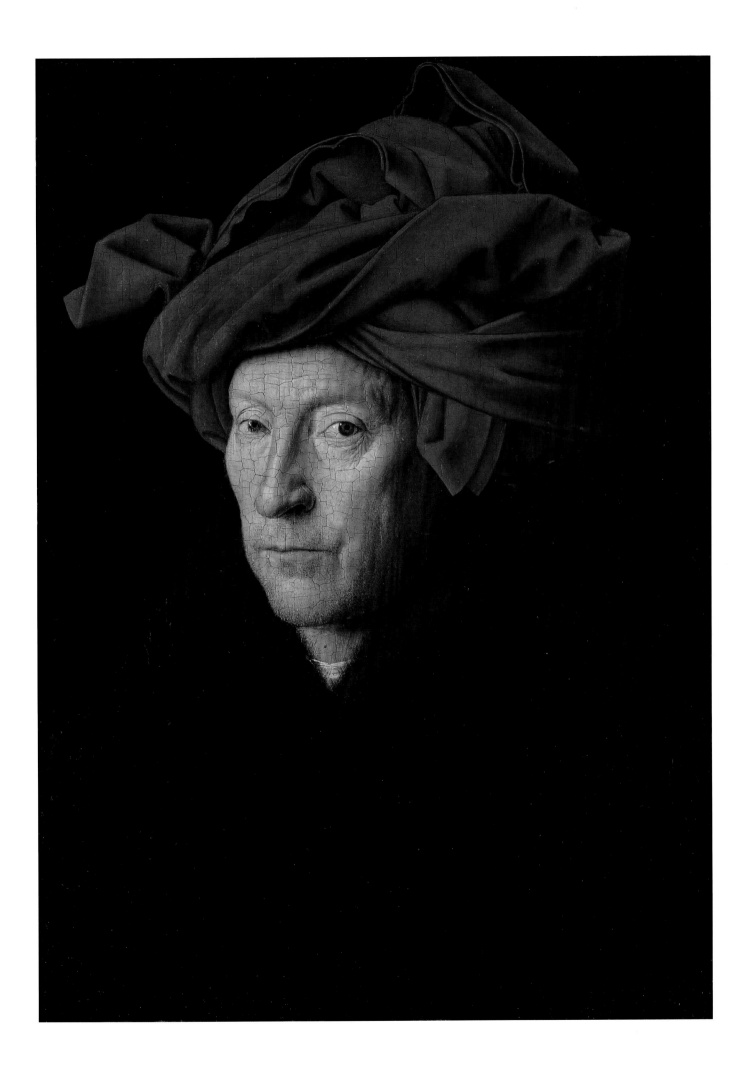

Talis erat facie Gerlachus Flicci: ipsa Londinia quãdo Pictor Vrbe fuit
Hanc is ex speculo p charis pixit amici. Dei obitu possint quo meminisse sui.

ANNO 1554

Strangwish, this strangely, depictedis One prisoner, for thother, hath done this
Gerlin, hath garnisht, for his delight This woork whiche you se, before youre sight.

ANNO 1554

2

Gerlach Flicke
(c.1495–1558)

*Gerlach Flicke with Henry Strangwish
(or Stangways)*, 1554
Diptych, oil on paper or vellum laid on oak
panel, 88 x 119mm (3½ x 4⅝")
Inscribed (both panels): ANNO 1554;
(left): TALIS ERAT FACIE GERLACHUS FLICIº:
IPSA LONDINIA QUÂNDO PICTOR URVE
FUIT/HANCIS EX SPECULO P CHARIS PÎXIT
AMICI. POST OBITÛ POSSINT QUO MEMINIS_E
SUI [*Such was the face of Gerlach Flicke when
he was Painter in the City of London. This he
himself painted from a mirror for his dear
friends. That they might have something by
which to remember him after his death*]; (right):
STRANGWISH, THUS STRANGELY, DEPICTED IS
ONE PRISONER, FOR THOTHER, HATH DONE
THIS/GERLIN, HATH GARNISHT, FOR HIS
DELIGHT, THIS WOORCK WHICHE YOU SE,
BEFORE YOURE SIGHT
National Portrait Gallery, London

This intriguing work in miniature is the
earliest known self-portrait in oil produced
in England. Its painter, Gerlach Flicke, came
from Osnabrück in Germany and by 1545–6
was working as a portrait painter in
England, although fewer than a dozen of his
paintings are yet known. His full-scale
Thomas Cranmer (1545) is displayed at the
National Portrait Gallery. It can be inferred
from his will that Flicke was a Catholic and
married to an Englishwoman; like Holbein,
he may have left his homeland because of
the disruption to artistic production caused
by the Protestant Reformation and related
attacks on religious imagery.[1] His compan-
ion here, Henry Strangwish, a member of a
distinguished West Country family, was
apparently a gentleman privateer notorious
as 'the Pirate' or 'Red Rover' and described
as 'rough and shaggy with a red chestnut
mane of hair'.[2] This painting was apparently
produced when both men were in prison,
perhaps in connection with Wyatt's
Rebellion of 1554. The Latin inscription
above Flicke's head implies that he may have
been facing a death sentence.[3]

The inscription above Strangwish's head,
in English, suggests that the two men were
also captives of representation, and that
there is a symbolic exchange between them,
'One prisoner for thother'. The figures are
set within separate frames but against the
same expensive-looking, blue background
that, together with the gold calligraphy and
diptych format – normally used for religious
images – imbues the work with the precious
aura of a devotional work. Indeed, Flicke's
inscription states that inspiring the
remembrance of those who love him after
his death is the motivation for his own
portrait 'painted from a mirror for his dear
friends'. One of these intimates was clearly
Strangwish: the two figures appear like
offsets or mirror images, both turned
slightly towards the centre as if in
acknowledgement of each other's presence;
when the diptych is closed they come face to
face and touch. The greying painter with his
neatly trimmed hair and fine blackwork
collar and the much younger man with
leonine features and flowing locks are thus
represented in accordance with humanist
ideals of friendship, which claim that true
friends are alter egos and that the dialogue
between them enhances the virtue of each
individual.[4]

Flicke holds an artist's palette while
Strangwish is portrayed with a lute, an
aristocratic instrument associated with love
and the attribute of Hearing, one of the five
senses; Strangwish's inscription invokes the
sense of Sight in the appreciation of Flicke's
'woorck' – work that is alluded to by the
palette in his own portrait. Music was one
of the seven Liberal Arts; thus the visual
parallel between the lute and the palette also
implicitly raises the status of painting from
a manual craft to a gentlemanly pursuit.[5]
LC/JW

1 Mary Hervey, 'Notes on a Tudor Painter: Gerlach Flicke – I',
Burlington Magazine 17 (May 1910), pp.71–2; Mary Hervey,
'Notes on a Tudor Painter: Gerlach Flicke – II', *Burlington
Magazine* 17 (June 1910), p.149.
2 Other suggested spellings are Strangways, Strangwise or
Stranguyshe: see the anonymous note, 'Gerlach Flicke's Lost
Diptych Portrait', *Connoisseur* 45 (1916), p.163.
3 Ibid. See also Hervey 1910 (II), p.147.
4 On Flicke's birthdate, Hearn 1995, p.120. On the
relationships between friendship, virtue and art, especially
portraiture, Bomford 2004, esp. pp.237–52.
5 Leslie Korrick, 'Lomazzo's *Trattato … de la pittura* and
Galilei's *Fronimo*: Picturing Music and Sounding Images in
1584' in McIver 2003, pp.193–209. For the significance of the
lute see also Pieter Fischer, *Music in Paintings of the Low
Countries in the Sixteenth and Seventeenth Centuries* (Swets &
Zeitlinger, Amsterdam, 1975), pp.33, 52, 54–5.

Literature
Karen Hearn (ed.), *Dynasties: Painting in Tudor and Jacobean
England 1530–1630* (exh. cat., Tate Gallery, London, 1995);
Katherine A. McIver (ed.), *Art and Music in the Early Modern
Period* (University of Alabama Press, Tuscaloosa, 2003);
Bomford 2004; Strong 1969.

3

Alessandro Allori
(1535–1607)

Self-portrait, c.1555
Oil on panel, 600 x 470mm (23⅝ x 18¼")
Galleria degli Uffizi – Collezione degli
Autoritratti – Firenze

This self-portrait is one of the earliest representations of the painter in the act of painting, rather than in the honorific pose of a gentleman or as a protagonist or bystander within a larger scene.[1] Allori is portrayed 'observing himself observing himself in the mirror',[2] a figure of advancing self-awareness captured in the space between reflection and execution, the delicately held brush an arrow linking the substantial body with a painting that remains hidden from view. The composition circles between eyes and hands, a fragmentary palette and a complete face, highlighting the intimacy of the space and enclosing the quiet, self-reflective gaze.

An accomplished portraitist and narrative painter, Allori ultimately became court painter to the Medici. The pictorial style and the sitter's youth in this self-portrait suggest that it heralded the Florentine artist's arrival in Rome in 1554, at the age of nearly twenty, where he established his credentials by studying classical antiquity and the works of Michelangelo. Allori was the adopted son and pupil of the leading Florentine mannerist and court painter Agnolo Bronzino (1503–72) and while contemporaries claimed that 'every painter paints himself' in the literal sense that the faces he painted were modelled upon his own,[3] Allori adopted the wide face, round eyes, elongated nose and chin dimple characteristic of the physiognomies in his master's work. He also emulated Bronzino's refined handling of surface and colour, positioning of the figure and use of shadow to sculpt the face. The Florentine artistic genealogy is acknowledged in the portrait of Allori beside Bronzino and the latter's own teacher and guardian, Jacopo da Pontormo (1494–1556), in Bronzino's *Martyrdom of St Lawrence* fresco (1569; San Lorenzo, Florence).[4]

Alessandro Allori declared his artistic emancipation through the new iconography of the painter in action. His own son, Cristofano, chose an equally innovative and ingenious form of self-portrayal (cat.7). The working artist depicted in an unrefined costume is unusual and daring because manual labour was considered ignoble and artists were concerned to assert their credentials as gentlemanly practitioners of a liberal art, rather than mere craftsmen. However, Allori's is a highly sophisticated characterisation that, while celebrating the physical application of paint, also emphasises the phase of intense mental and spiritual concentration in which the artist 'seeks the perfection of design and invention'.[5] The viewer is drawn into a process of physical and spiritual self-reflection through the direct equivalence between what he or she sees and the artist's mirror image. Yet the highly fashioned representation accessible to the viewer is hinged to a self-image that cannot be seen and remains a work in progress. The mood is devotional. Allori's idealised and feminised face, contemplative expression and blue cap and robe are reminiscent of the Virgin Mary, the 'Mirror without Stain' and the legendary subject of a miraculous portrait by the first Christian painter, Saint Luke (cf. cat.4). But if the artist is working to produce a resemblance of Mary, the perfect model of natural virtue, he also refers to divine agency by recalling the active, pointing gesture of the angel of the Annunciation. AH/JW

1 Identified in A. Matteoli, 'La Ritrattistica del Bronzino nel "Limbo"', *Commentari* 20, no.3 (1969), pp.281–316.
2 Woods-Marsden 1998, p.229.
3 Kemp 1976; Zöllner 1992, pp.137–60.
4 Fresco from the Charterhouse at Galluzo, San Lorenzo, dated to 1565–9. E. Pilliod, *Pontormo Bronzino Allori: A Genealogy of Florentine Art* (Yale University Press, New Haven and London, 2001), p.256 n.84.
5 Vasari (ed. Milanesi) 1906, VII, p.607: 'cercare la perfezione del disegno ed invenzione'.

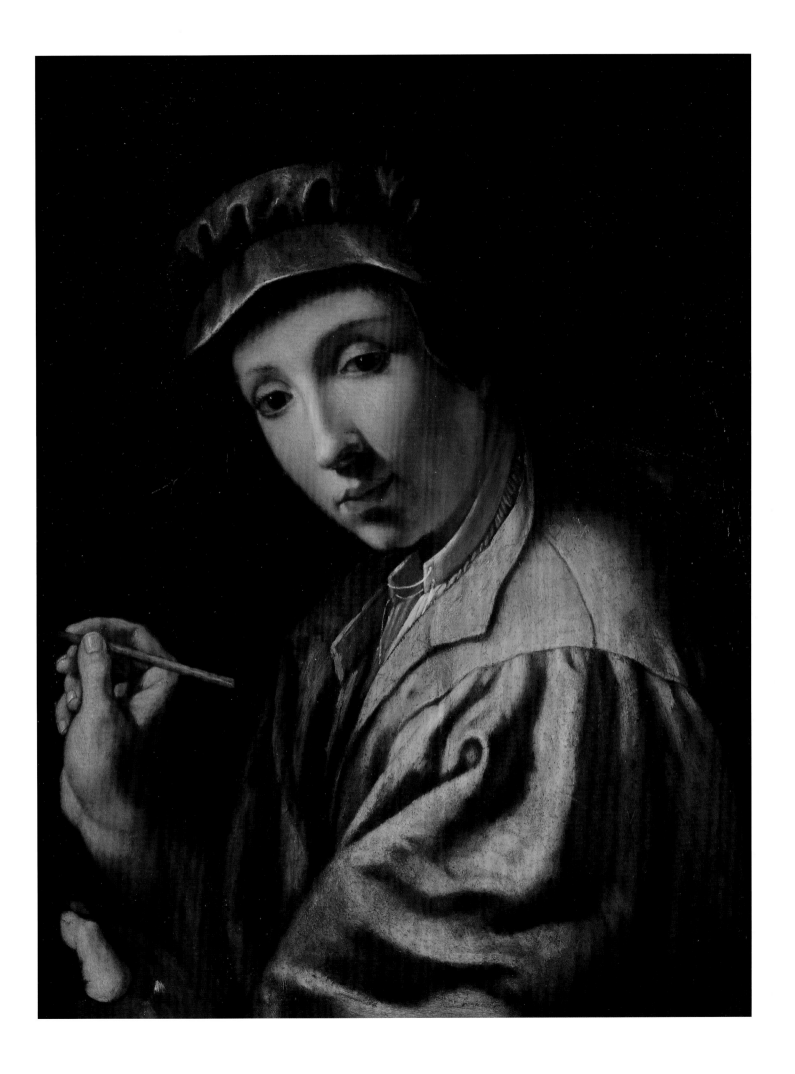

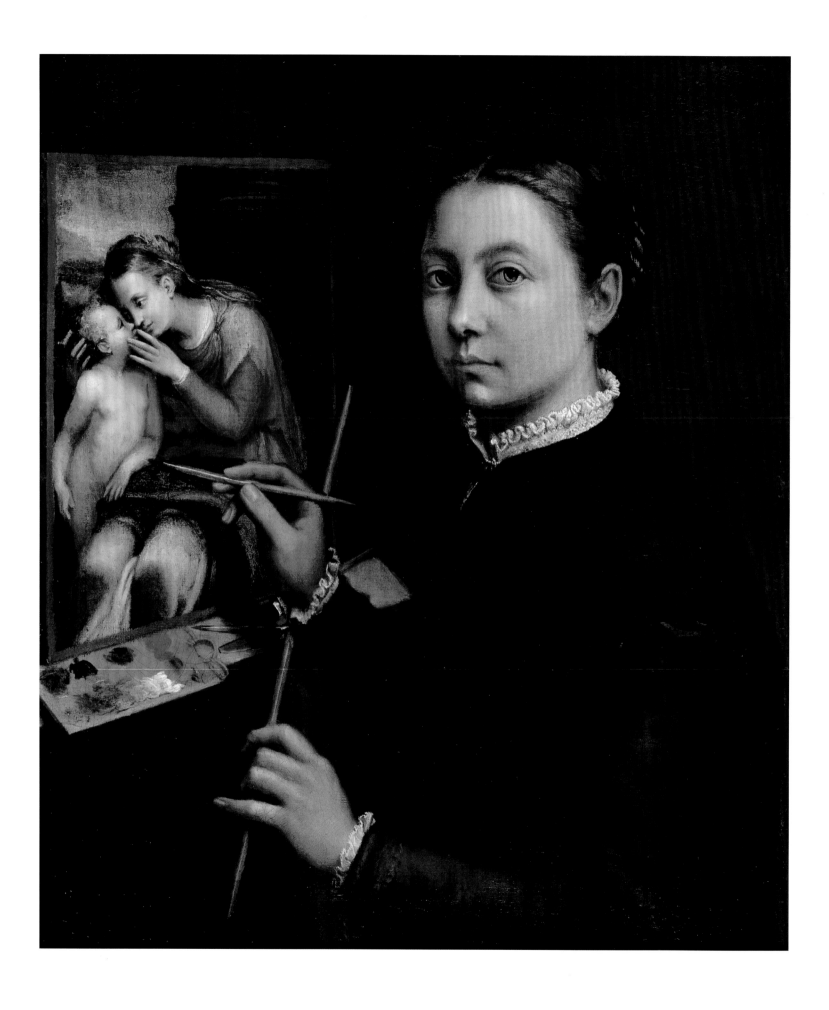

4
Sofonisba Anguissola (c.1532–1625)

Self-portrait at the Easel Painting a Devotional Panel, 1556
Oil on canvas, 660 x 570mm (26 x 22½")
Muzeum-Zamek, Lancut, Poland

Sofonisba Anguissola was an exceptional woman. In 1559 she was appointed to a prestigious position as a portraitist at the court of Europe's most powerful monarch, Philip II of Spain, and in 1568 she received unusual praise in Giorgio Vasari's immensely influential *Lives of the Artists*.[1] The eldest of six daughters of a minor nobleman in the provincial Italian city of Cremona, Anguissola's artistic talent was fostered by her father in the hope that she would attract a wealthy patron or husband. Trained by local masters, she became an important model for other female painters, including Lavinia Fontana (cat.5). She painted more self-portraits than any other artist between Dürer (1471–1528) and Rembrandt (1606–69), of which the majority, including the present work, were produced in Cremona before her departure for Spain.

During the Renaissance it was almost literally inconceivable for a woman to become an elite artist, in that Aristotle's account of sexual reproduction, in which the man was regarded as the sole efficient cause, was a paradigm for the creative process. It was believed that as inert matter, woman lacked an inherent capacity to generate form in life and in art.[2] If a woman did enter the realm of painting, female portraiture was considered an appropriate genre as it was domestic in scale, compatible with a life of feminine refinement and virtue and regarded by some as an act of mindless reproduction.

Anguissola produced several self-portraits to be sent as gifts to prospective patrons as she could not respectably enter into competition with men for paid commissions. The present work is understandable in this context of self-promotion. Like all her Cremonese self-portraits, it conformed to the ideal female courtier described by Baldassare Castiglione: 'she should always dress herself correctly, and wear clothes that do not seem vain and frivolous'.[3] The modest black gown, lace collar and cuffs, absence of jewellery and simple hairstyle preclude any suggestion of easy virtue.

This self-portrait is one of the earliest surviving works to depict the artist in the act of painting, as subject and object, author and model. In her ingenious reworking of the legend of St Luke the Evangelist, thought to have painted the first portrait of the Virgin,[4] Anguissola not only took on the masculine role of St Luke but also exploited the traditional symbolic connection between the Virgin Mary and an immaculate mirror. By showing herself as if turning towards a mirror situated at the threshold of representation, the artist claims to be engaged in perpetual contemplation of a Virgin/mirror in which she sees her *own* reflection. Indeed, her imitation of this natural sign of supreme feminine virtue produces not a likeness but the lovely painting of the Virgin and Child on the easel. Balancing social expectations, humanist wit and artistic skill, this painting is simultaneously a discreet portrait of a virtuous noblewoman and a fundamental challenge to the contemporary belief that women lacked an inherent capacity to create. GF/JW

1 Giorgio Vasari, *The Lives of the Artists,* ed. Julia Conaway Bondanella & Peter Bondanella (Oxford University Press, Oxford, 1991), p.343.
2 Jacobs 1994, pp.74–101.
3 Castiglione [1528] 1967, p.211.
4 Woods-Marsden, 1998, p.204.

Literature
Sylvia Ferino-Pagden and Maria Kusche, *Sofonisba Anguissola: A Renaissance Woman* (exh. cat., National Museum of Women in the Arts, Washington DC, 1995); Ilya Perlingieri, *Sofonisba Anguissola: The first great woman artist of the Renaissance* (Rizzoli, New York, 1992).

5
Lavinia Fontana
(1552–1614)

Self-portrait at the Clavichord with a Servant,
1577
Oil on canvas, 270 x 240mm (10⅝ x 9½")
Inscribed (upper left corner): *Lavinia Virgo Prosperi Fontane / Filia Ex Speculo Imaginem/ Oris Sui Expressit Anno / MDLXXVII [Lavinia, Virgin, Daughter of Prospero Fontana depicted herself from a mirror in the year 1577]*
Accademia Nazionale di San Luca, Rome

Lavinia Fontana was one of the most renowned female artists of her time. Born in Bologna and trained by her father, Prospero Fontana, in 1577 she married Gian Paolo Zappi, a former fellow pupil of Prospero from a wealthy, noble family. This self-portrait was probably connected with her wedding, since Bolognese brides favoured red, and it may well have been a gift to Lavinia's future father-in-law, Severo Zappi, who wrote to his wife from Bologna in February 1577: 'I am bringing [home] ... two portraits of [Lavinia] which very much please me.'[1] However, an autograph copy in the Uffizi collection of self-portraits suggests that the image was meant for a wider public too, serving as self-advertisement, a demonstration of Fontana's artistic skill and virtuosity at the beginning of her career.[2]

The inscription underlines the traditional link between virginity and the 'Mirror without Stain' to guarantee a technically and morally spotless image. Sofonisba Anguissola (c.1532–1625; cat.4), upon whom Fontana consciously modelled herself, inscribed her miniature *Self-portrait* (c.1555; Museum of Fine Arts, Boston) in a similar way. The respectable lineage and chaste virtue that made such women eligible for an elite marriage are mirrored in the beauty of their portraits. The mirror-image not only provides a perfect likeness, but demonstrates an advantage enjoyed by

female portraitists with female subjects: the avoidance of the threat to feminine virtue posed by facing a masculine artist. Fontana personally benefited from this, becoming the favoured portraitist of Bolognese noble-women before moving to Rome in 1604.

Fontana was well versed in arts and letters – records list her as *dotoressa*[3] – and the portrait is an impressive display of her talents. Music was a noble accomplishment that in Castiglione's *Book of the Courtier* (1528) was considered suited to women and placed alongside painting. The two are visually linked in Fontana's composition, where the A-shape formed by the soundboard of the clavichord echoes that of the empty easel, set in a brightly illuminated perspective space. Positioned close to her head, almost touching her hair, the easel seems to occupy her thoughts, while her hands make beautiful music. Music's patron saint, Cecilia, was often depicted in the sixteenth century with a keyboard: she controlled the seductive associations of music, asking God to keep her soul and body without stain when she was being led to the house of her betrothed, to the sound of musical instruments.[4]

Music had a secure position as a liberal art and like poetry, to which it was closely connected, helped to enhance the status of painting. Here the maidservant holding the score augments the authority of her

mistress. The choice between the two arts, which is explicit in Angelica Kauffmann's *Self-portrait Hesitating between the Arts of Music and Painting* (fig.56), is resolved by Fontana's centrally placed body, linking foreground and background. Music made the hand an adaptable 'instrument' rather than a tool of manual labour and Fontana's delicately crafted hands demonstrate her virtuosity, while her elaborately painted dress reveals a desire to *fare bella figura*, like the Bolognese ladies whose portraits she later painted. This concern with outward show does not diminish her art though – rather the opposite. Fontana reiterates Castiglione's claim that appearance is inseparable from depth: her skill lies in her display, in knowing how to fashion herself virtuously.[5] EP/JW

1 Maria Teresa Cantaro, *Lavinia Fontana Bolognese 'pittore singolare', 1552 – 1614* (Jandi Sapi Editori, Milan, 1989), pp.302–3 and Caroline P. Murphy, *Lavinia Fontana: a painter and her patrons in sixteenth-century Bologna* (Yale University Press, New Haven and London, 2003), pp.38ff.
2 Cantaro 1989, pp.72–4.
3 Katherine A. McIver, 'Lavinia Fontana's *Self-portrait Making Music*', *Woman's Art Journal*, 1998, p.3.
4 Castiglione [1528] 1967, pp.94–7. The clavichord was an instrument deemed suitable for young women; the iconography echoes Anguissola's *Self-portrait at the Keyboard with Maidservant* (late 1550s; Spencer Collection, Althorp, Northamptonshire). On Cecilia: James Hall, *Dictionary of Subjects and Symbols in Art* (John Murray, London, 1974), p.60.
5 Castiglione [1528] 1967, pp.94–7; P. Burke, *The fortunes of The Courtier. The European reception of Castiglione's* Cortegiano (Polity, Cambridge, 1995), pp.27–8, 30–31.

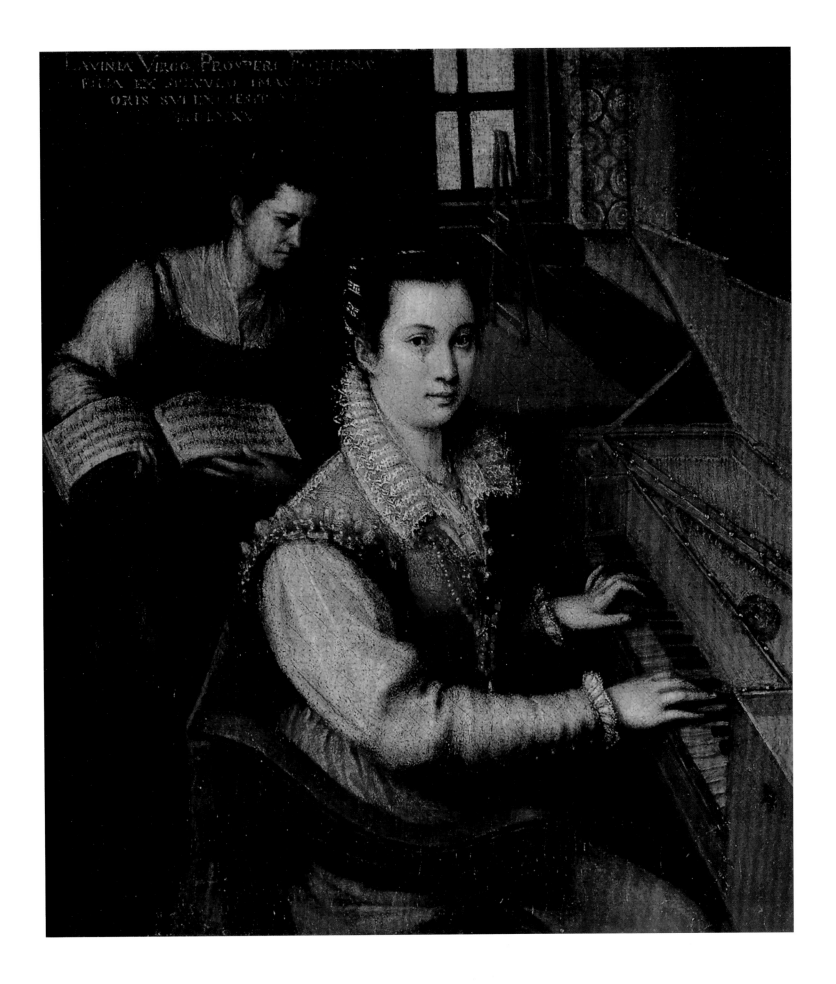

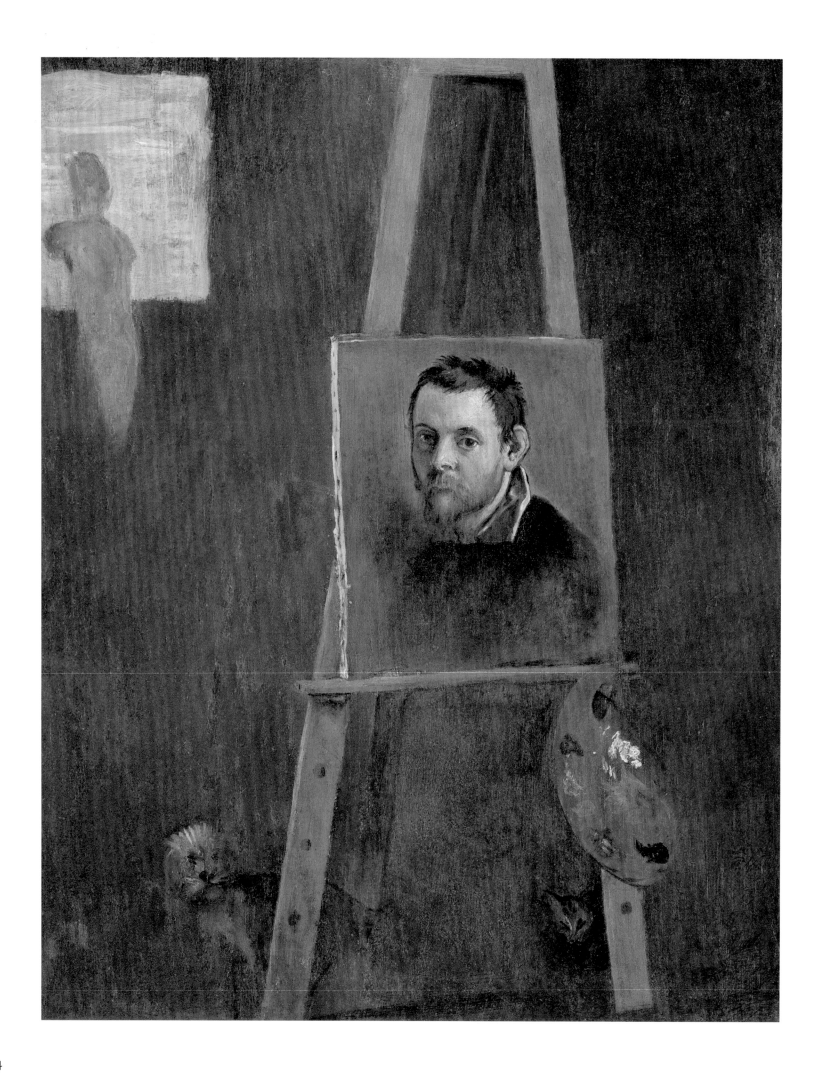

Fig. 49

Annibale Carracci
(1560–1609)

Self-portrait on an Easel in a Workshop, c.1605
Oil on wood, 370 x 320mm (14⅛ x 12⅝")
Galleria degli Uffizi – Collezione degli
Autoritratti – Firenze

Fig.49
Annibale Carracci
Preparatory drawing
Pen and brown ink, 245 x 180 mm
(9⅝ x 7")
Her Majesty Queen Elizabeth II

Heralded as the restorer of an ideal art based on nature, Annibale Carracci's crowning achievement was the vast Farnese ceiling in Rome. His small self-portrait, a version of which is now in the Hermitage Museum, St Petersburg, was given by the writer on art Giovanni Bellori to Leopoldo de' Medici in 1673/4 to hang in his renowned collection of self-portraits in the Uffizi. There is no evidence to suggest that it was commissioned; indeed, its idiosyncrasies and intimate character indicate the opposite. The date is uncertain – some place it in Annibale's last, melancholic years – but the sitter looks relatively young (he left Bologna for Rome in his mid-thirties) and the picture is more characteristic of his earlier experiments with caricature and genre than his relatively idealised and classicising later work.[1]

The son of a tailor, Carracci is said to have believed that 'the finest thing is to be content with one's own station, recognise one's own place, and not start taking on grand airs beyond what was warranted by one's own natural circumstances'. To Michelangelo's claim that 'we paint with our brain, not with our hands' he apparently responded, 'we painters have to speak with our hands'.[2] His *Self-portrait on an Easel* encourages the viewer to see beyond the conventional presentation of the artist as a gentleman who is a stranger to manual work by exploring the physical underpinnings of painting. In the upper register of his preparatory drawing in the Royal Collection at Windsor (fig.49) there is a conventional self-portrait in which an elegant cape hides the artist's hand (compare cat.9), whereas in *Self-portrait on an Easel* the artist is represented in working attire, his hands cut off by the edge of the painting. Transposed onto canvas and placed on an easel, the artist's image has been torn from his body, subverting the conception of painting as an unmediated mirror of reality. Carracci is present only at one remove, in a painting within his painting, framed by the scenario of production: the artist is both in his work and elsewhere, leaving only a material trace for the spectator to interpret.[3] The palette, which is not present in the preparatory drawing, acts as a personal signature: the artist's missing hands are responsible for the materialisation of the self-portrait through the act of transferring pigment from one flat surface to another.

The textural brushstroke is evocative of Venetian 'rough' painting; however, the handling of the features is relatively precise and the centrally placed eye implies insight into a truth beyond superficial appearances.

Peeking from behind one leg of the easel is a dog, a symbol of fidelity whose inquisitive look resembles the face of the artist. Whereas in Gumpp's *Self-portrait* (cat.19) the dog and cat fight, here overt action has been suppressed: the creative process is over and the artist has left the studio to adopt a contemplative position alongside the viewer.

We are prevented from imagining that the artist is fully embodied in this work and the ragged edge of the unframed canvas highlights the limits of the illusion (compare cat.3). The picture nevertheless evokes an artist of the utmost distinction: Carracci here rejects a socially sanctioned role, embracing a figurative death by removing his living body, in the form of a naturalistic portrait, from the painting in order to look dispassionately at the nature of his art. GF/JW

1 Beverly Louise Brown, *The Genius of Rome* (exh. cat., Royal Academy of Arts, London, 2001), p.158.
2 Anne Summerscale, *Malvasia's Life of the Carracci* (Pennsylvania State University Press, Pennsylvania, 2000), p.88; Giovanni Battista Agucchi, 'Treatise on Painting' in *Italy in the Baroque. Selected readings,* ed. and trans. Brendan Dooley (Garland, New York, 1995), p.434. See also Woods-Marsden 1998, pp.4, 244–5.
3 Stoichita 1997, pp.199, 212–15.

7
Cristofano Allori
(1577–1621)

Judith with the Head of Holofernes, 1613
Oil on canvas, 1204 x 1003mm (48 x 40")
Inscribed (lower right): *Hoc Cristofori Allorii/*
Bronzinii opere picture / hactenus invicta pene /
Vincitur Anno 1613 [*In this work of Cristoforus*
Allorius Bronzinius, painting,
so far unconquered, is virtually conquered,
in the year 1613][1]
Lent by Her Majesty the Queen

Filippo Baldinucci's *Notizie dei Professori del Disegno* (Florence, 1681) characterised Cristofano Allori as a melancholic, brooding libertine, his turbulent life marked by debauchery and an insatiable sexual appetite. Having 'played, danced and rhymed very proficiently'[2] he later joined a religious brotherhood in an attempt to reform. Cristofano was taught by his father Alessandro (cat.3) before entering the studio of Gregorio Pagani (1558–1605) and working alongside Ludovico Cardi – 'Il Cigoli' (1559–1613). He associated with Artemisia Gentileschi (cat.14) and became a follower of Caravaggio in Rome.

This celebrated composition, of which the Royal Collection work is the primary example, was commissioned by the prominent Florentine Cardinal Alessandro Orsini.[3] It represents a scene from the Biblical Apocrypha in which the beautiful and pious Jewish widow Judith of Bethulia, accompanied by her maid, Abra, ventures into the Assyrian camp on the pretext of seducing the general, Holofernes; at the climactic moment she seizes his sword and beheads him with two strokes. According to Baldinucci, the model for Judith was a girl known as 'La Mazzafirra', with whom Allori was enamoured, although he obtained 'nothing but misery from the liaison'.[4] Here he portrays himself in the guise of Holofernes and his lover's mother as the maidservant. The double narrative – biblical

and autobiographical – was recognised by the contemporary poet Giambattista Marino in 1619 and romanticised by John Keats two hundred years later in his epic poem, *La Belle Dame sans Merci*.

Allori engages, in the most psychologically compelling terms, with the possibilities for self-revelation in combining autobiography with role-play, introspection with spectacle. He is a 'masked author'[5] who, by assuming the role of a character, projects himself into his work while also remaining 'behind' it. The mask is most obviously the ghastly face of Holofernes, and the inscription, located close to this decapitated but still suffering head, states that painting has been 'virtually conquered'. Yet from the perspective of the viewer, the painter and his medium are not the *victims* but the *creators* of the scene, so that the luminous, gorgeously attired Judith, whom Baldinucci described as the most beautiful thing in the work, could equally be the 'conquered' figure of painting. Judith's impassive gaze at the viewer (who was originally the artist himself) refuses to admit defeat – she, the beloved and unattainable other, has been conquered only *virtually*. And yet she is not, as a sign of virtual conquest, really so different from the symbolic presence of the artist in the work of art. As a captive captor, she stands in the position of a painter at work, observing him/herself in the mirror and gesturing towards a canvas (cf. cat.14).

The firm grip on the hair makes Allori's head Judith's own, and the delicate rendering of the texture of his hair between the fingers of his mistress accentuates the eroticism of this central, challenging gesture. Life and death, the subject and object of the painting, are united in a violent, unyielding and never-ending embrace.
SC/JW

1 Translated in Shearman, 1979, p.5. Cristofano's father, Alessandro, was a nephew of the painter Bronzino; both Alessandro and Cristofano often referred to themselves as 'Bronzino', evoking their noble artistic ancestry.
2 Baldinucci, *Notizie dei professori del disegno da Cimabue in qua...*(Studio per edizioni scelte, Florence, 1974), 7 vols, III, p.726: '*un giovane tutto conversazioni, tutta galanteria, bravissimo nel suono, nel ballo, nella rima piacevole, ed in soma uno de' più bizzarri...*'.
3 John Shearman, *The Early Italian Pictures in the Collection of her Majesty the Queen* (Cambridge University Press, Cambridge, 1983), pp.7–8; *Cristofano Allori 1577-1621* (exh. cat., Palazzo Pitti, Florence, 1984), p.78.
4 Elena Ciletti, *Patriarchal Ideology in the Renaissance Iconography of Judith*, in M. Migiel and J. Schiesari (eds), *Refiguring Woman: Perspectives on Gender and the Italian Renaissance* (Cornell University Press, Ithaca, 1991), p.41. Baldinucci was particularly interested in this work and is thus likely to have been well-informed about it. He owned the painted *modello* for the head of Abra and a preparatory drawing for the painting itself (Shearman 1979, p.3). Mina Gregori, 'Note su Cristofano Allori', *Scritti di Storia dell'Arte in onore di Ugo Procacci*, ed Maria Grazia Ciardi Duprè Dal Poggetto and Paolo Dal Poggetto (Electa, Milan, 1977), vol.II, p.522; McCorquodale 1979, p.17.
5 Stoichita 1997, pp.201–5.

Literature
John Shearman, 'Cristofano Allori's "Judith"', *Burlington Magazine* 121, no.910 (January 1979), pp.2–10; Charles McCorquodale, *Painting in Florence 1600–1700* (exh. cat., Royal Academy of Arts, London, 1979); Giuseppe Cantelli and Giulietta Chelazzi Dini, *Disegni e Bozzetti di Cristofano Allori* (exh. cat., Palazzo Strozzi, Florence, 1974).

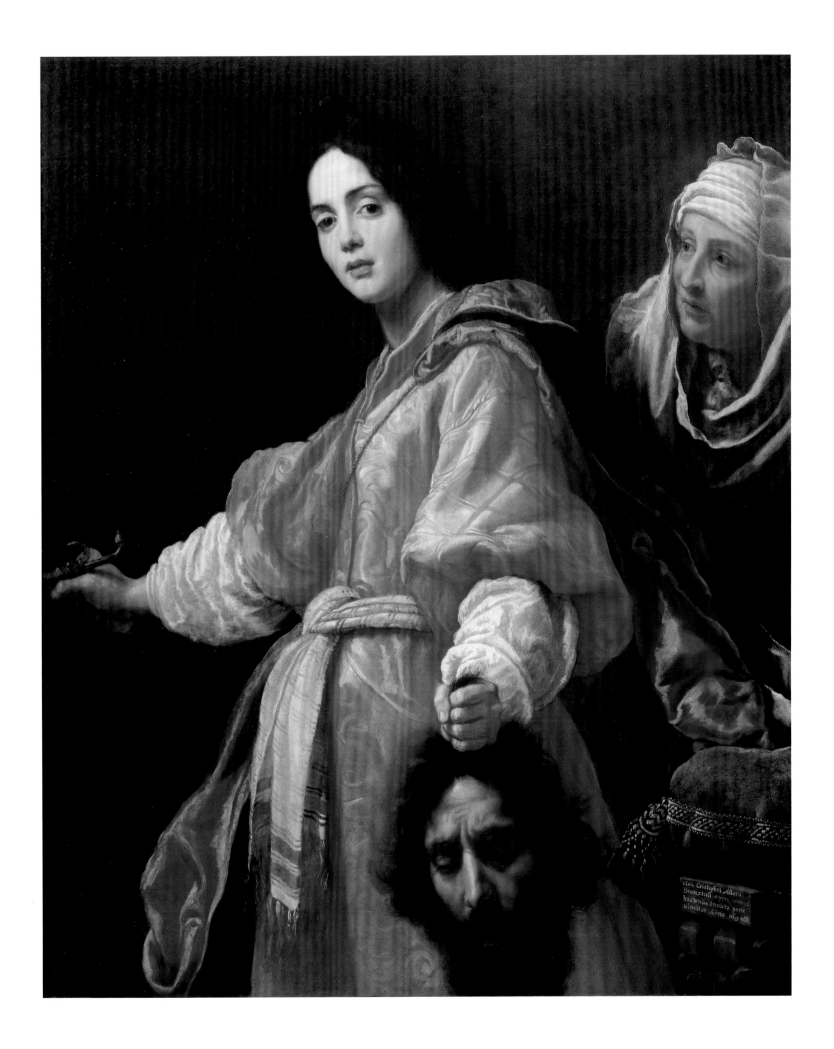

Jacob Jordaens
(1593–1678)

*The Family of the Artist, c.*1621
Oil on canvas, 1810 x 1870mm
(71¼ x 73⅝")
Museo Nacional del Prado, Madrid

Jacob Jordaens enjoyed a prolific and profitable career in his native Antwerp. Strongly influenced by Rubens, his work is characterised by decorative surfaces, abundance of flesh and burlesque humour. This picture is one of three early self-portraits in which Jordaens appears within a kinship group.[1] It shows the artist with his wife, Catharina van Noort (seated) and their first child, Elizabeth, born in 1617. In the centre stands an anonymous figure, presumably a maidservant. The picture is dated on the basis of Elizabeth's apparent age and may have been painted to commemorate her father's inauguration in 1621 as the Dean of the Antwerp Guild of St Luke.[2] Strikingly restrained, the painting is loosely modelled on Rubens's *Self-portrait with Isabella Brant* (*c.*1610, Alte Pinakothek, Munich).

The picture plays fruitfully on analogies between family likeness and artistic imitation, between biological reproduction and artistic creativity, between microcosm and macrocosm. Simultaneously naturalistic and allegorical, it proposes a loving, productive marriage between the material world and the realms of imagination and desire. This relationship is played out in the marital theme of the painting: Jordaens's wife, Catharina, was the daughter of his esteemed teacher, Adam van Noort. Thus his love for his wife and his artistic skill have the same root and come, as it were, from the same seed.

The artist boldly adopts a full-length pose, distinguishing his position as head of his own family, no longer surrounded by numerous relatives or future in-laws as in the previous two self-portraits. His gentlemanly stance, omitting any reference to palette and brushes, also distances creativity from manual craft. The artist's authority is professional as well as domestic, and these two spheres are intimately bound together in a garden that is a naturalistic yet ideal domain of love. The lute, played by Jordaens in his previous two self-portraits, is now held by his side: no longer a means to seduce, but rather to harmonise and regulate. The lute was a refined instrument, considered suitable both for sacred and secular music, although Jordaens was happy to show himself elsewhere playing 'vulgar' pipes.[3] Winding vine leaves behind the artist represent the twining of lovers' souls; at his foot is a dog, a symbol of loyalty and fidelity. The parrot, perched next to a Cupid fountain, stands for chaste love but also for imitation, a central theme of the painting.[4] Jordaens emphasises young Elizabeth's physical likeness to her mother through pose and lighting, while her basket of fruit and apple mimic, parrot-fashion, the maidservant's attributes. This beautiful maid transcends any distinction between natural reality and an abstract, imagined ideal. As a servant she confirms the family's elite status but, with her red dress and overflowing basket, she is also a personification of fertile Nature.[5] Elizabeth, the fruit of the love of Jordaens and his wife Catharina, and herself a future marriage prospect, echoes this theme of fertility. The maid is pivotal yet in the background, suggesting a connection, in nature, between surface and depth, domestic concord and the harmony of the cosmos.[6] EP/JW

1 The two other pictures are *Self-portrait with parents, brothers and sisters* (*c.*1615, Hermitage Museum, St Petersburg) and *Self-portrait with the Van Noort family* (*c.*1615, Staatliche Museum, Kassel).
2 Compare David Teniers II's *Portrait of the Painter and his Family on the Terrace of His Château* (*c.*1645, Staatliche Museum, Berlin), which commemorates his election as Dean of the Guild of St Luke in Antwerp. The artist is also shown playing a musical instrument (a violoncello); perhaps a link was drawn with the 'orchestration' the Dean's role required.
3 A.P. de Mirimonde, 'Les sujets de musique chez Jacob Jordaens', *Jaarboek van Het Koninklijk Museum voor Schone Kunsten, Antwerp* (Koninklijk Museum voor Schone Kunsten, Antwerp, 1969), p.204.
4 Devisscher *et al.* 1993, p.118.
5 J.B. Bedaux, 'Fruit and fertility: Fruit symbolism in Netherlandish portraiture of the 16th and 17th centuries', *Simiolus* 17 (1987), pp.150–68; Eddy de Jongh, 'Grape symbolism in paintings of the 16th and 17th centuries', *Simiolus* 7 (1974), pp.166–91.
6 Ross Smith 1982, p.148.

Literature
Pieter Fischer, *Music in Paintings of the Low Countries in the 16th and 17th centuries* (Swets & Zeitlinger, Amsterdam, 1975); Hans Devisscher, Nora de Poorter and Roger Adolf d'Hulst, *Jacob Jordaens (1593–1678)*, vol.I: *Paintings and Tapestries* (exh. cat., Koninklijk Museum voor Schone Kunsten, Antwerp, 1993); Matías Díaz Padrón, *El siglo de Rubens en El Museo del Prado, Catálogo Razonado de Pintura Flamenco del Siglo XVII*, vol.I (Editorial Prensa Ibérica, Museo del Prado, 1995), pp.628–31.

9
Peter Paul Rubens
(1577–1640)

Self-portrait, 1623
Oil on canvas, 860 x 620mm (33⅞ x 24⅜")
National Gallery of Australia
Sydney only

Rubens was the elite artist par excellence: skilled and learned, prolific and versatile, a man of virtue, prestige and wealth. Raised and trained in Antwerp, in 1608 he returned to his home town from an eight-year stay in Italy to participate in the restoration of the Catholic Church after the Protestant Reformation and destruction of religious images. The following year he was appointed principal painter to his Hapsburg sovereigns, Albert and Isabella.

Rubens was able to work on a monumental scale, producing vivid and dramatic pictures that imbued religious and historical subjects with life and appealed to the mind and spirit through the senses. By the 1620s, when this self-portrait was painted, his work was valued internationally and his services were in demand in the princely courts and the Catholic Church throughout Western Europe. Sir Thomas Rose, a diplomat, remarked that Rubens 'had grown so rich by his profession that he appeared everywhere not like a painter but a great cavalier'.[1]

This picture is an autograph example of the artist's most widely disseminated self-portrait. It is unusual in that it is one of only four compositions depicting Rubens alone: he seems to have preferred to characterise himself as motivated to work by love – rather than money or honour – by showing himself in the company of intimates, as in his self-portrait with his wife Isabella Brant in a honeysuckle bower (*c*.1610; Alte Pinakothek, Munich), or the self-portrait with humanist friends known as *The Four Philosophers* (*c*.1611–12; Pitti Palace, Florence).[2] Nevertheless, in 1623 Charles, Prince of Wales, requested Rubens's 'owne pourtrait', which was to be placed in 'the Princes Gallery'.[3] This picture, on panel, entered the Royal Collection, where it remains,[4] while the

version of the composition exhibited here, painted on canvas, stayed in Rubens's possession until 1628. In June 1630 it was in France, in the collection of the artist's friend and correspondent, the renowned humanist scholar Nicolas Claude Fabri de Peiresc (1580–1637). In the same year Paulus Pontius produced for Rubens an engraving after the picture, an early example of an artist marketing his own image through the modern technology of print. The composition was the foundation of all his later self-portraits, the stable iconography perhaps articulating the artist's commitment to the virtue of constancy, which was highly valued in humanist circles influenced by Stoic philosophy.[5]

Such a gracious image of the artist would have made an appropriate gift within both the dynastic court and the humanist republic of letters, manifesting the links between the elite artist and these established spheres of virtue. It avoids explicit reference to the working painter, concealing the hands as befits the image of a perfect gentleman. However, knowledgeable and sophisticated viewers, such as Peiresc and the Prince of Wales, would have appreciated Rubens's own hand in a performance of supreme artistic virtuosity. The sweeping hat-brim links a vibrant 'Venetian' sky with deep shadows in the rock, situating the head in a dynamic psychological realm.[6] Bold, dark swathes of drapery set off the subject's pellucid skin and contrast with the exquisitely refined brushwork in the lace collar and calligraphic curls of hair and moustache. The focus of the composition is the central right eye, which gives the artist the aloof, acute look of a sovereign. A glimpse of gold at the neck refers not only to the gold chain that was the traditional

reward of the court artist, acting as a subtle hint to potential patrons, but also implies the consummate artist's capacity to transform his humble materials into representations of value. This seemingly modest work is a subtle claim to mastery; it is not surprising that Rembrandt adopted it as a model for his ambitious, gentlemanly self-portraits of the 1630s (cf. cat.16a).

FS/JW

1 Sir Thomas Rose, quoted in C. White, *Peter Paul Rubens: Man and Artist* (Yale University Press, London and New Haven, 1987), p.73.
2 Schama 1999, p.295; Bomford 2004, pp.229–58.
3 M. Rooses and C. Reulens, *Correspondance de Rubens et documents épistolaires concernant sa vie et ses oeuvres*, vol.III (Veuve de Backer, Antwerp, 1887–1909), p.134.
4 C. Collins Baker, *Catalogue of the Principal Pictures in the Royal Collection at Windsor Castle* (Constable, London, 1937), p.275. The inscription, *Petrus Paullus Rubens / Se ipsa manu expressit / A.D. MDCXXIII / Ætatis suae XLV*, explicitly claims the self-portrait to be by the artist's own hand, perhaps to allay a recent controversy about the extent of his participation in a *Lion Hunt* intended to be presented to the Prince. *The Letters of Peter Paul Rubens* trans. and ed. Ruth Saunders Magurn (Northwestern University Press, Evanston, Illinois, 1991), pp.76–7, 446.
5 Cf. Rubens's *Self-portrait* (*c*.1628–30; Rubenshuis, Antwerp) and *Self-portrait* (*c*.1638–40; Kunsthistorisches Museum, Vienna). On the relationship between the painting and the engraving, Vlieghe 1987, no.135. On the engraving as means of marketing the artist's image, Jaffé 1983, p.19. On Rubens and constancy: Müller-Hofstede 1992, pp.365–405.
6 D. Jaffé, *Rubens and the Italian Renaissance* (exh. cat., Australian National Gallery, Canberra, 1992), p.152.

Literature
D. Jaffé, *Rubens' Self-Portrait in Focus* (exh. cat., Australian National Gallery, Canberra, 1988); M. Jaffé, 'Rubens to himself: The portraits sent to Charles I and N.C.- Fabri De Peiresc', in *Rubens e Firenze*, ed. M. Gregori (La Nuova Italia, Florence, 1983), pp.19–32; Hans Vlieghe, *Rubens' portraits of identified sitters painted in Antwerp. Corpus Rubenianum Ludwig Burchard* pt XIX, vol.2 (H. Miller, London, 1987), no.135; Justus Müller-Hofstede, 'Rubens und das Constantia-Ideal. Das Selbstbildnis von 1623', in *Der Künstler über sich in seinem Werk. Internationales Symposium der Bibliotheca Hertziana Rom 1989*, ed. Matthias Winner (Weinheim, VCH Acta Humaniora, 1992), pp.365–405.

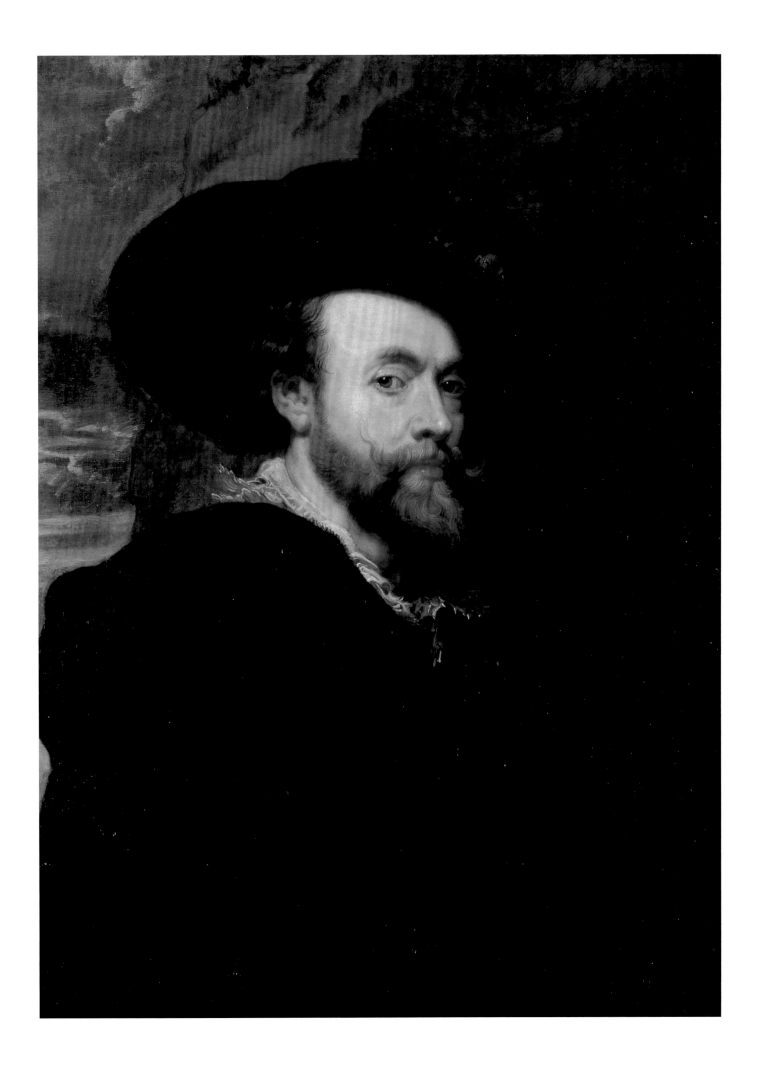

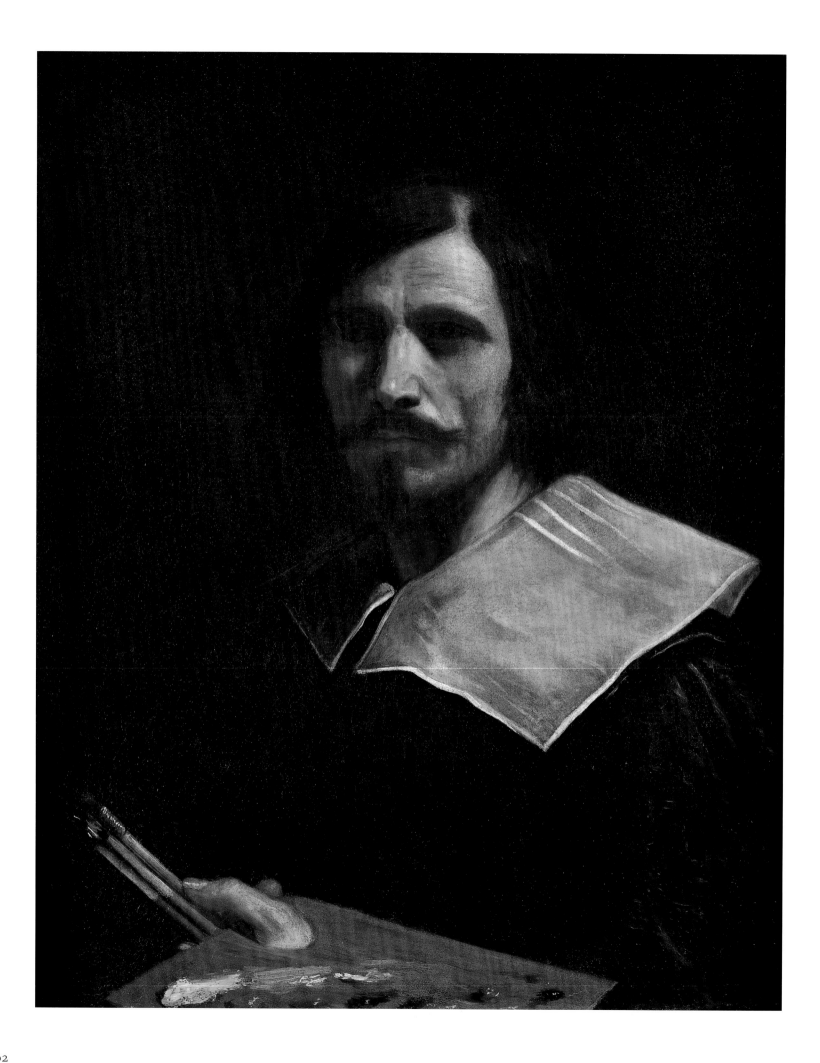

Guercino
(Giovanni Francesco Barbieri)
(1591–1666)

*Self-portrait, c.*1624–6
Oil on canvas, 641 x 521mm (257¼ x 20½")
Private Collection, courtesy
Richard L. Feigen & Co.
Sydney only

The nickname Guercino means 'squinter' but this did not prevent Barbieri from making an extremely successful career, producing mainly devotional and history paintings for the Catholic and city elites of his native Emilia in northern Italy. Born in Cento, a small town between Ferrara and Bologna, his early work utilised the pictorial language of rugged naturalism and strong tonalities characteristic of his region. In 1621 one of his patrons was elected Pope Gregory XV and immediately summoned him to Rome with the promise of great commissions. Although Gregory's death in 1623 soon put an end to these opportunities, back in Cento the experience of Rome fundamentally changed Guercino's work as he absorbed the lighter-toned, more classicising approach of painters fashionable in the papal city and practiced by his great Bolognese rival, Guido Reni. Guercino spent the remainder of his career in Cento and, after Reni's death in 1642, as the principal painter in Bologna. His meticulous account book, recording payments for all his commissions from 1629 until his death, reveals a systematic and businesslike exploitation of his prolific talent.

Guercino seems to have painted very few self-portraits, although there are two presumed images of him in the Medici collection in the Uffizi.[1] This painting was identified from an old copy in the Louvre;[2] the style and the apparent age of the figure (in his mid-thirties) suggest a date in the mid-1620s, soon after Guercino had returned to Cento from Rome. It is not known whether the picture had a formal purpose, but Christ's death at the age of thirty-three encouraged people to personal reflection on their achievements at about this age (cf. cat.16a). It is a work of deceptive simplicity, using the restricted palette of black, white, red and yellow that, according to Pliny the Elder, Apelles and other ancient Greek artists used to produce their masterpieces.[3] Guercino has made the squint from which he took his name into a sign of creative individuality: artfully placed shadows across his eyes obscure the physical imperfection of his sight, turning the characteristic, penetrating gaze of self-portraiture inwards into interiorised self-examination (cf. fig.50). The hands are clasped, almost as if in prayer.

The loaded palette and brushes situate this meditative moment during a pause in the process of painting, defining self-reflection – and its representation – as a hiatus in the constant, lived interplay between ideas and execution (cf. cat.3).[4] Process and change are implied by the smears of pigment on the palette, play of light and shadow across the face and open, slightly sketchy facture of the wood, flesh and hair, which is traceable back to the late work of Titian (fig.6). By contrast, the crisply focused edge of the plain collar stills the movement and, sharply outlined in white, highlights the artist's command of the brush. Set at right angles to the rectangular palette, the collar perfectly offsets its messy incompleteness. Guercino's reputation rests not only on his painting but his draughtsmanship and his wonderful drawings provide a parallel to this self-portrait. Both display an ongoing, spontaneous process of revision and development combined with consummate, self-conscious control. JW

1 Mina Gregori, *Uffizi e Pitti: i dipinti, gli artisti, le scuole* (Librinoderni, Florence, 1979), cats A434, A435, p.892.
2 Luigi Salerno, *I dipinti del Guercino* (U. Bozzi, Rome, 1988), pp.5 and 7, fig.2.
3 Jacob Isager, *Pliny on art and society: the Elder Pliny's chapters on the history of art* (Routledge, London, 1992)
4 Marin 1995, p.205.

Literature
D. Mahon, Massimo Pulini, Vittorio Sgarbi (eds), *Guercino: poesia e sentimento nella pittura del '600* (exh. cat., Palazzo Reale, Milan, 2003–4; d'Agostino, Milan, 2003).

Judith Leyster
(1609–60)

*Self-portrait, c.*1630
Oil on canvas, 746 x 653mm (29⅜ x 25¾")
National Gallery of Art, Washington DC, Gift
of Mr and Mrs Robert Woods Bliss

A contemporary praised Judith Leyster as a 'lodestar' or 'leading star' of her hometown of Haarlem, but in the following centuries her work was subsumed under the name of Frans Hals (*c.*1581–1666), who may have been her master.[1] In 1893, a painting supposedly by Hals was discovered to contain Leyster's star monogram: in 1926 it was sold once again as her own *Self-portrait.*[2] Unlike many women artists of her time, Leyster did not benefit from an artistic family or elevated birth; her father, originally a weaver, later owned a brewery named 'The Leyster'. He was bankrupt by 1625, when his daughter was still only sixteen years old. By 1629 she was signing her own works. She painted what would sell rather than what was womanly: some portraits and still lives but mostly 'modern' images of music, drinking, children and revellers in the manner of Hals. This, her only known self-portrait, was perhaps her admission piece to the Haarlem Guild of St Luke; or it may have been kept in her studio to show off her skills to prospective customers. Its light-hearted, casual mood is characteristic of her work. Indeed, the laughing fiddler depicted on the easel is also a motif in her *Merry Company* of 1620 (Private Collection, Netherlands), as if advertising her wares. Leyster's own facial type, too, is echoed in the faces of her women, personalising her production for

the market and substantiating the claim that artists invested their works with their own likeness.[3]

Leyster is posed in a studio, as though interrupted by a visitor towards whom she turns, smiling in acknowledgement as if about to speak.[4] She is youthful and exquisitely dressed, her finely painted collar, cuffs and headdress making her portrait as elegant as any client might wish for. Her graceful right hand, prominently displayed, accords with this refined image. Comically juxtaposed to all this finery are the working painter and the bawdy image she is more roughly painting. Connecting painter and picture is one of an array of eighteen brushes, apparently accidentally pointing to the fiddler's groin.

Infra-red photography has shown that the music-making figure was painted over an earlier portrait of Leyster herself, an act of masking that provides a material metaphor for the element of masquerade in the artist's persona.[5] Although her forcefulness and resourcefulness emerge clearly from the documents relating to her participation in the male-dominated Guild of St Luke, Leyster may also have produced works in Hals's studio, under his name, and she collaborated with her future husband, Jan Mienszoon Molenaer (1610–68). After her marriage to this pugnacious character in

1636 she largely abandoned independent painting for a domestic role. The strutting, theatrical, bawdy musician on the easel, playing a bow across a curvaceous viol with the same skill and wit as the artist wields the pointed brush, can be recognised as an alter ego, a mirror image, of the painter portrayed: he even looks like her. Painting is not real life: but Leyster's artistry in this self-portrait acknowledges and makes light of the conditions of her existence, living on her wit and charm and, when occasion demanded, assuming a masculine role.
EE/JW

1 T. Schrevelius, *Harlemias: Of, de eerst stichting der stad Haarlem* (Haarlem, 1648), p.290. For biography: Hofrichter 1989.
2 Christie, Manson & Woods, London, 16 April 1926, no.115.
3 Cf., and for further literature, J. Woodall, p.28 n.6 above.
4 This seemingly spontaneous pose was apparently an invention of Frans Hals; see Welu *et al.* 1993, pp.163–4. Cf. Berger 2000, pp.171–96 and *passim.*
5 For the infra-red image see www.nga.gov/education/classroom/self_portraits/act_leyster.htm.

Literature
J. Welu *et al.* (ed.), *Judith Leyster: A Dutch Master and her World* (exh. cat., Frans Halsmuseum, Haarlem and the Worcester Art Museum, Worcester, MA; Yale University Press, New Haven and London, 1993); Frima Fox Hofrichter, *Judith Leyster: A Woman Painter in Holland's Golden Age* (Davaco, Doornspijk, 1989); Arthur K. Wheelock, Jr., 'The Art Historian in the Laboratory: Examinations ... of the 17th-Century Dutch Painting', in *The Age of Rembrandt: Studies in 17th-Century Dutch Painting* (Pennsylvania State University, Pittsburgh, 1988), ed. Roland E. Fleischer and Susan Scott Munshower, pp.214–45, figs 9-19, 9-20, 9-21.

Anthony van Dyck
(1599–1641)

Sir Endymion Porter and van Dyck, c.1635
Oil on canvas, 1190 x 1440mm
(46⅞ x 56¾")
Museo Nacional del Prado, Madrid
London only

Sir Anthony van Dyck was a superb and profoundly influential portraitist who made his name depicting the elite of his native Antwerp and of Genoa, finally becoming principal painter at the court of Charles I of England in 1632. He began painting young, and after his apprenticeship was one of Rubens's leading assistants. During a six-year stay in Italy, from 1621 to 1627, he imbued himself with the painterly and colouristic sensibility of Titian. Van Dyck's self-portraits and his *Iconography* (1632–41), a series of print portraits of elite men of which the majority depict Antwerp artists, attest to his intense interest in the honour and virtue of his profession. His oeuvre also includes religious, historical and mythological subjects such as the poetic *Rinaldo and Armida* of 1629 (Baltimore Museum of Art), which was acquired for Charles I by Sir Endymion Porter, the figure who accompanies van Dyck in this self-portrait.

Porter was a courtier par excellence, whom Charles admired 'for his general learning, brave stile, sweet temper, great experience, travels and modern languages'.[1] Raised in the household of the Count Duke Olivares in Spain, he subsequently used his cultural knowledge and linguistic skills to act as an agent for the Stuart monarchy on diplomatic missions and in acquiring works of art – and artists. The self-portrait shows

the artist as the alter ego of this cultural mediator; it may have been either a gift from van Dyck to Porter or a commissioned work.

Porter is highlighted in the painting, dressed in white satin and strongly lit. However, the two figures share the pictorial space equally and there is a complementary relationship between outside and inside, bright, stylish display and a dark, even melancholic interiority. The reciprocal movement within the composition is enhanced by the unusual oval frame, which creates a pictorial field of two intersecting circles. At the heart of the painting is the rock upon which the two figures rest their hands, a sign of their friendship: the material connection between the two men is thus rendered honorific.[2]

According to Erasmus, 'Friendship is equality. A friend is a second self', and a personal intimacy analogous to friendship was already regarded as the basis of the best portraiture.[3] However, friendship was also a means of self-enhancement whereby the subject perfected himself in the mirror of his friend's virtues.[4] Van Dyck here translates the expansive and egalitarian interpretation of humanist friendship of his master, Rubens (compare his *Justus Lipsius and his Pupils*, c.1611–12; Palazzo Pitti, Florence; *Self-portrait with Mantuan Friends*, c.1600–7[?]; Wallraf-Richartz-Museum,

Cologne) to the more overtly competitive courtly arena. The hierarchical yet reciprocal relationship between the two parties in van Dyck's work is even more explicit in a related composition, the *Self-portrait with a Sunflower* of c.1633 (fig.20), where a golden chain links the artist symbolically to a sovereign source of patronage and favour of which he is both the creature and the creator.[5] LC/JW

1 Anthony À. Wood, *Athenæ Oxonienses: an exact history of all the writers and bishops who have had their education in the … University of Oxford, from … 1500, to the author's death in November 1695 ; to which are added, the Fasti, or annals, of the said University* (printed for R. Knaplock, D. Midwinter, and J. Tonson, London, 1721), vol.2, p.1.
2 Christopher Brown and Hans Vlieghe et al., *Van Dyck 1599–1641* (exh. cat., Koninklijk Museum Voor Schone Kunsten Antwerp and Royal Academy of Arts, London, 1999), p.30.
3 Desiderius Erasmus, *Adagiorum Opus Des. Erasmi Roterodami, ex Postrema Autoris Recognitioni …* (Sebastianus Gryphius, Lyons, 1556), cols 18–19.
4 On the relationships between friendship, virtue and art, especially portraiture, see Bomford 2004, pp.229–58, esp. pp.237–52.
5 Brown and Vlieghe, 1999, p.29. On the gold chain: H. Perry Chapman, *Rembrandt's Self-Portraits: A Study in Seventeenth -Century Identity* (Princeton University Press, Princeton, 1990)

Literature
Susan J. Barnes, Nora de Poorter, Oliver Millar, Horst Vey, *Van Dyck: A Complete Catalogue of the Paintings* (Yale University Press, London and New Haven, 2004; Matías Díaz Padrón and Aída Padrón Mérida, *El siglo de Rubens en el Museo del Prado. Catálogo razonado de pintura flamenca del siglo XVII* vol.1(Prensa Ibérica, Barcelona, 1995); Emilie E.S. Gordenker, *Anthony Van Dyck (1599–1641) and the Representation of Dress in Seventeenth-Century Portraiture* (Brepols Publishers n.v., Turnhout, 2001).

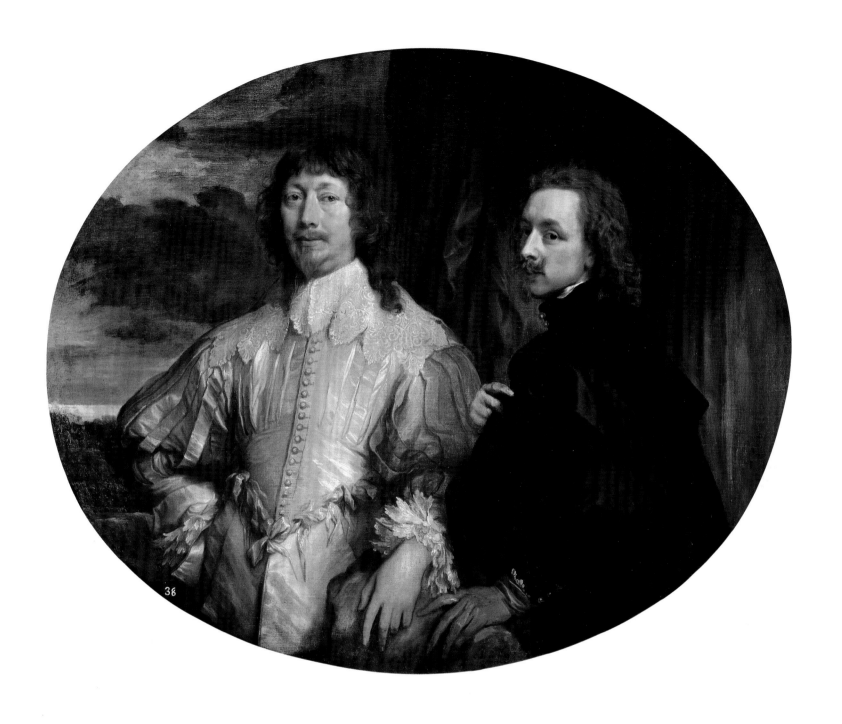

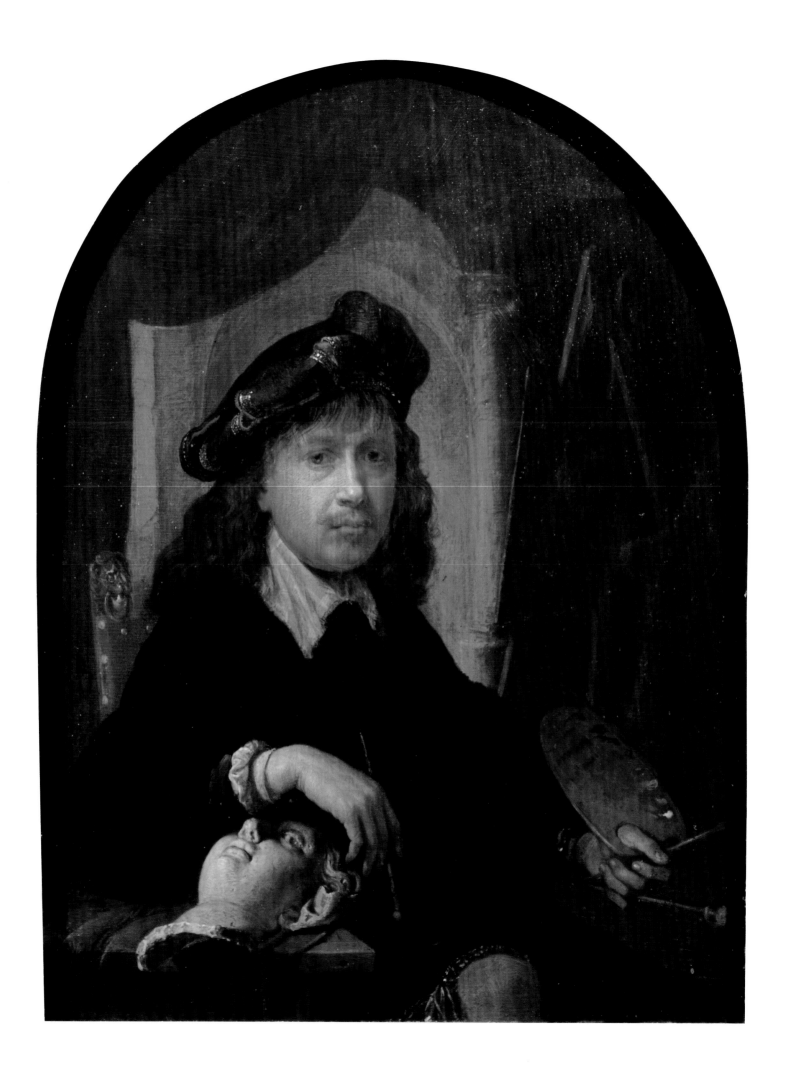

13

Gerrit Dou
(1613–75)

Self-portrait, 1635–8
Oil on panel, 185 x 140mm (7⅛ x 5½")
Cheltenham Art Gallery and Museum

During his life Gerrit Dou completed approximately twelve self-portraits, this being one of the earliest examples. His interest in painting his own likeness may have resulted from studying with Rembrandt (see cat.16), one of the masters of self-portraiture, while the exquisite detailing of his small paintings was probably the result of his earlier training as a glass engraver. In this *Self-portrait* Dou is not depicted in the act of painting but rather at rest, perhaps waiting for the dust to settle, as he was said to do before beginning work.[1] In his left hand are a palette, a paintbrush and a maulstick; in his right, loosely held, is another unused brush, the tip of which is curiously large considering that Joachim von Sandart, visiting Dou's studio around 1640, describes his paintbrush as being 'scarcely larger than a fingernail'.[2] While Dou precisely represents the textures of his silk cuff and the silver embroidery of his beret, accentuating their luminous qualities through the application of many layers of varnish, he pays far less attention to creating an accurate illusion of space behind the figure. For example, the close proximity of the easel to the column results in an impractical working space. This unsuccessful attempt at spatial articulation

is a common feature throughout Dou's oeuvre and may, in fact, be a result of his overriding preoccupation with creating convincing illusions of textures and surfaces.[3]

In the foreground a plaster cast is carefully positioned with its cavity exposed to the viewer, suggesting a connection to a mask, the symbol of Pittura (cf. fig.11).[4] The image of Dou and the 'mask' are physically and formally related: the arch of Dou's hand over the sculpted head mimics the architectural curve of the niche above the artist's face. This 'emblematic' relationship raises the issue of whether portraits in general serve as representations of physical likeness, or as constructed façades that employ signs of reference in order to convey meaning, and, essentially, *create* identity. Here Dou appears to be manipulating his own image by emulating the appearance of his teacher, Rembrandt, who was also well known for playing various roles in his self-portraits.[5] Dou's wavy, amber-coloured hair, artist's beret, and wispy moustache are evocative of Rembrandt's *Self-portrait* of 1640 (cat.16a), but Dou's pose is less expressive than Rembrandt's. While they both lean on wooden surfaces, Dou recedes from the viewer, in contrast to the forthright

positioning of Rembrandt's arm with ruffled sleeve, which threatens to break through the threshold of the illusion. Dou's lack of expressive gesture is also reflected in his brushwork: in contrast to Rembrandt's rough late style of painting, through which his physical application of paint is discernable on the surface, Dou's compulsive tendency to build up thin, even layers of paint, concealing each stroke in the process, suggests a desire to create a picture that contains no mark of its actual creator. It is only surfaces: Dou is not revealing himself; he is creating a mask. NL

1 *Joachim von Sandrart's Academie der Bau-, Bild- und Mahlerey-Künste von 1675*, ed. A.R. Poltzer (G. Hirth's Verlag, Munich, 1925), pp. 195–6. Sandrart also states that Dou would sit silently in his chair and wait for the dust in the room to settle before starting to paint. Baer 2000, pp.14, 39.
2 Quoted in Hollander 2002, p.68.
3 Ibid. p.69.
4 Cesare Ripa, *Iconologia, overo Descrittione d'Imagini delle Virtv, Vitij, Affetti, Passioni humane, Corpi celesti, Mondo e sue parti* (Padua, Pietro Paolo Tozzi, 1611), pp.429–30.
5 Perry Chapman 1990, pp.12–21.

Literature
Ronni Baer, *Gerrit Dou 1613–1675: Master Painter in the Age of Rembrandt*, ed. Arthur K. Wheelock, Jr. (exh. cat., National Gallery of Art, Washington DC, 2000); Ivan Gaskell, 'Gerrit Dou, his Patrons and the Art of Painting', *Oxford Art Journal* 5 (1982), pp.15–23; Martha Hollander, *An Entrance for the Eyes: Space and Meaning in Seventeenth-Century Dutch Art* (Berkeley, University of California Press, 2002).

Artemisia Gentileschi
(1593–1652)

*Self-portrait as the Allegory of Painting
(Self-portrait as La Pittura)*, 1638–9
Oil on canvas, 965 x 737mm (39 x 29")
Inscribed: A.G.F. [*Artemisia Gentileschi fecit*]
Lent by Her Majesty the Queen

Artemisia Gentileschi was among the first female artists in Europe recognised for painting large-scale narrative scenes rather than portraits. Born in Rome in 1593, she was trained in the workshop of her father, Orazio (1563–1639), a friend and follower of Caravaggio. When she was nineteen Artemisia famously accused Orazio's associate, Agostino Tassi (*c*.1580–1644), of rape; he was convicted in the ensuing trial.[1] Artemisia's subsequent pictures with female protagonists in traditional stories of rape and vengeance exemplify in an unusual way the aphorism 'every artist paints himself [*sic*]'. Gentileschi spent her successful artistic career in Florence, Naples, Rome and London. It is uncertain where her *Self-portrait* was painted but it became part of the collection of Charles I of England. Sold following his execution in 1649, it was recovered by the Crown during the Restoration.[2]

Although painted in her mid-forties, Gentileschi here assumes the guise of a youthful Pittura, the female personification of Painting. Cesare Ripa's *Iconologia*, a hugely influential iconographic dictionary first published in Rome in 1593, described Pittura with 'garments of changing colours, a golden chain with a pendant mask ... and unruly locks of hair symbolizing the divine frenzy of the artistic temperament' (fig.11).[3] Vasari had depicted Pittura with similar

attributes in 1542.

By adopting this pictorial vocabulary Gentileschi identified herself directly with Painting, rather than positing her as a separate model or subject. The woman artist could thus visually unify the ideal concept and its individual embodiment, subverting contemporary ideas of creative virtue in which the work of art resulted from an implicitly masculine intellect or spirit acting upon passive, implicitly feminine, matter.[4] Gentileschi underlined her claims to the status of a virtuosa through her skilful handling of the oil medium and the deceptively simple pictorial conception (an oblique view of her own head would have required an ingenious arrangement of mirrors). Poised holding a brush to the canvas, the artist is caught in a moment of 'divine frenzy' in which inspiration is inseparable from its active expression. In contrast to Cristofano Allori's self-portrait as the decapitated Holofernes (cat.7), Gentileschi's head and hands are smoothly connected by a formal arc that integrates the intellectual and material aspects of her art.

In terms of composition, the sturdy body of Artemisia/Pittura dominates the picture. Her physicality and energy are emphasised by the earthy tones, dramatic lighting and angled pose, her chest exposed and sleeves pushed up to the elbows to reveal a powerful forearm and right hand. The averted face

and engagement in strenuous manual work do not fit easily into the established way of affirming the artist's elevated status in society, through a self-assertive gaze and repression of references to physical labour. Yet the compelling visual connections between the face and hands manifest the link – through the body – between inspired imagination and work of art. Gentileschi acknowledges her 'hand' in this bold assertion of the material, implicitly feminine basis of creativity by placing the acronym A.G.F. in the centre below her palette. Nowhere is her aplomb more explicit than in the evocation of her name: *Arte-mi-sia*, or 'Let art be for me'.[5] SC/JW

1 R. Ward Bissell, 'Artemisia Gentileschi – A new Documented Chronology', *Art Bulletin* 50, no.2 (June 1968), pp.153–65; Mary D. Garrard, *Artemisia Gentileschi* (Princeton University Press, Princeton, 1989), app. B, pp.403–87.
2 Michael Levey, 'Notes on the Royal Collection: Artemisia Gentileschi's "Self Portrait" at Hampton Court', *Burlington Magazine* 104 (February 1962), pp.79–81; Ward Bissell 1999, pp.272–5.
3 Garrard 1989, p.355; Cesare Ripa, *Iconologia* [Rome, 1603], ed. Erna Mandowsky (Georg Olms Verlag, Hildesheim and New York, 1970), pp.367–8.
4 Jacobs 1997, chap.3.
5 Christensen and Mann 2001, p.278.

Literature
Keith Christensen and Judith Mann, *Orazio and Artemisia Gentileschi* (exh. cat., Metropolitan Museum of Art New, York, 2001); R. Ward Bissell, *Artemisia Gentileschi and the Authority of Art: A Critical Reading and Catalogue Raisonné* (Penn State University Press, Pennsylvania, 1999); Mary D. Garrard, *Artemisia Gentileschi* (Princeton University Press, Princeton, 1989).

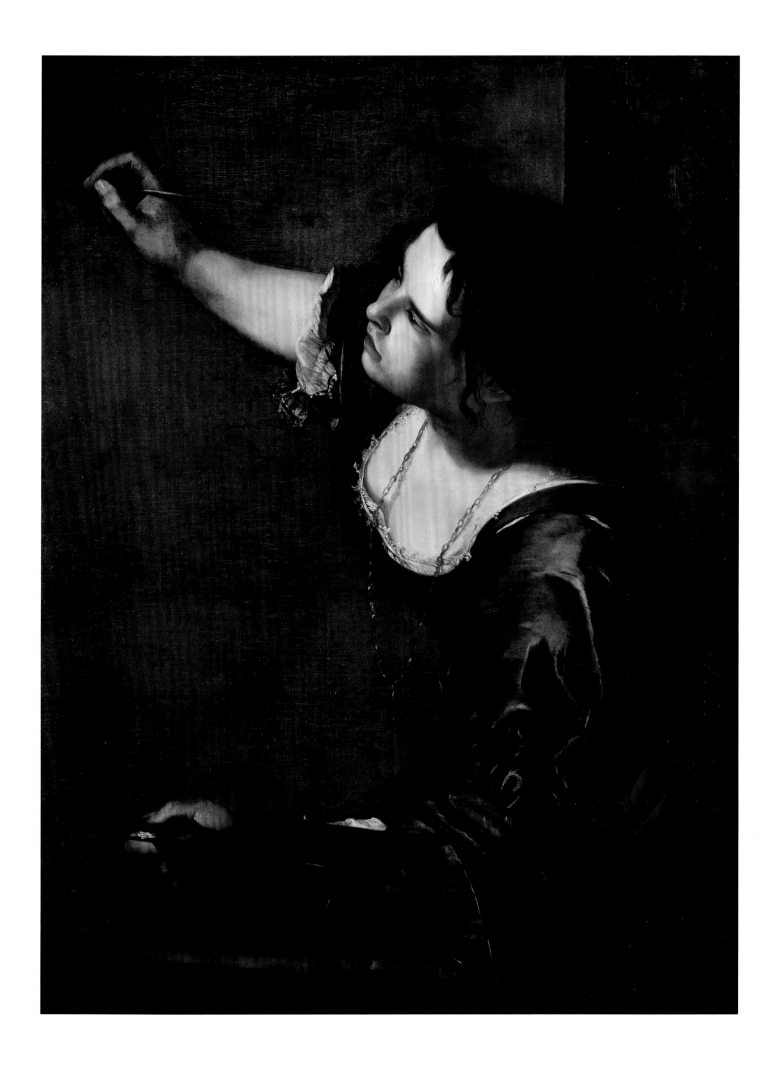

15

Pieter-Jacobsz van Laer
(1599–c.1642)

Self-portrait, 1638–9
Oil on canvas, 788 x 1128mm (31 x 44⅜")
Inscribed (on manuscript bottom left):
P. v Laer
Private Collection, New York

Pieter van Laer was the leading light of the 'Bentveughels' or 'Birds of a Feather', a band of Northern European artists in Rome whose intention was to challenge the establishment. He worked in Rome between 1625 and 1637, making his living from small-scale pictures that showed the city's street-life rather than contributing to her great monuments. On his initiation to the Bentveughels, van Laer was given the nickname '*Il Bamboccio*', meaning 'big child' or 'clumsy doll', a reference to his physical abnormality: he apparently had a malformed spine and very short torso in comparison to the length of his legs. His little pictures, which were sold in open markets rather than commissioned, were called '*bambocciate*' – and the numerous artists who imitated van Laer became known as 'Bamboccianti'.[1]

Although the term '*bambiocciate*' could be understood to imply that the figures in these low-life paintings resembled van Laer's own misshapen body, none of van Laer's self-portraits emphasises physical deformity. In this self-portrait his face is recognisable by its characteristic handlebar moustache, which is also a feature of an engraved portrait in his biography published by his friend Joachim von Sandrart in 1675.[2] The painting itself is believed to date from around 1639, when van Laer had returned to his native Haarlem. The artist shows himself surrounded by occult paraphernalia such as the inverted skull, a book inscribed with a pentagram and mysterious symbols, and a type of knife used in sorcery.[3] Alchemists and necromancers were still potent figures at this period, treading the fine line between the distrust of others who suspected them of deceit and their own powerful desire to unravel the ultimate mysteries of life and attain command of nature itself. Although Vasari condemned artists who practised alchemy, there were clear parallels in their capacity to conquer or manipulate nature and transform base matter into something of value.[4]

Van Laer here seems to be invoking the mock encomium, a classical literary genre in which ignoble things are praised. Especially popular in the Low Countries, ironic paradox justified the Bentveughels' commitment to low subject matter and a disreputable lifestyle rather than elevated standards.[5] This self-portrait rejects the honourable self-representation epitomised by Rubens (cat.9) and wittily replaces the artist at work (cat.3) with a practicing magician. It also mockingly turns a respectable Netherlandish genre, the vanitas still life, into a sinister scene of sorcery. However, the joke turns into a nightmare at the appearance of the skeletal claws on the right, summoned, it seems, by the musical round for *three* voices (which implies the presence of a singer in addition to the artist and the viewer). It has recently been argued that the harmony of this music contradicts its explicit claim to invoke the devil and is linked, rather, to the Bentveughels' Bacchic initiation ceremonies – celebrations of drunken excess justified by ideas of creative madness and poetic inspiration founded in ecstatic worship of the nature god Bacchus.[6] This self-portrait oscillates between laughter and horror as the game turns into reality, the illusion suddenly becomes actual, and vice-versa. The artist, his mouth opened in a scream that can be heard only by viewers complicit in the drama, is eternally petrified by the grotesque realisation that perpetual life involves the embrace of death. JD/JW

1 The Bentveughels were also known as the *Schildersbent* ('painters' clique'). Van Laer left Haarlem in 1642, but his death date is unknown. G.J. Hoogewerff, *De Bentveughels* (M. Nijhoff, The Hague 1952); W. Thompson, '"Pigmei Pizzicano di Gigante": The encounter between Netherlandish and Italian Artists in seventeenth century Rome' (unpublished PhD Thesis, Johns Hopkins University, 1997); J.Verberne, 'The Bentvueghels in Rome (1620/21-1720)', in *Drawn to Warmth: seventeenth-century Dutch Artists in Italy* (exh.cat., Rijksmuseum Amsterdam, 2001), ed. P. Schatborn, pp.22–3.
2 *Joachim von Sandrart's Academie der Bau-, Bild- und Mahlerey-Künste von 1675*, ed. A.R. Peltzer (G. Hirth's Verlag, Munich, 1925), p.201, as *Pieter de Laar alias Bambot Harlemensis*.
3 Briganti *et al.* 1983, p.59; Levine and Mai 1991, p.201; Wind 1998, p.118 n.51.
4 Wittkower and Wittkower 1963, pp.84–8; Smith 2004, pp.129–42.
5 D. Levine, 'The art of the Bamboccianti' (unpublished PhD Thesis, Princeton University, 1984), pp.39–48; D. Levine, 'The Bentvueghels: "Bande Académique"', in M. A. Lavin (ed.), *IL 60: Essays Honoring Irving Lavin on his Sixtieth Birthday* (Italica Press, New York, 1990), pp.207–25.
6 G. Normand, 'Pieter van Laer's Self-Portrait in the Richard L. Feigen Collection, New York' (unpublished MA Dissertation, Courtauld Institute of Art, London, 2004), pp.12–15. See also T. Kren, 'Chi non vuol Baccho: Roeland van Laer's burlesque painting about Dutch artist's in Rome', *Simiolus* 11 (1980), pp.63–80; D. Levine, 'Pieter van Laer's *Artists' Tavern*: An Ironic Commentary on Art', *Holländische Genremalerei im 17. Jahrhundert: Symposium Berlin 1984, Jahrbuch Preussicher Kulturbesitz* IV (1987), pp.169–91.

Literature
G. Briganti, L. Laureati and L. Trezzani, *I Bamboccianti: pittori della vita quotidiana a Roma nel Seicento* (U. Bozzi, Rome, 1983); D. Levine and E. Mai, eds, *I Bamboccianti: niederländische Malerrebellen im Rom des Barock* (exh. cat., Wallraf-Richartz-Museum, Cologne, 1991 and Centraal Museum, Utrecht, 1991–2), pp.199–200; B. Wind, *A Foul and Pestilent Congregation: Images of 'freaks' in Baroque Art* (Ashgate, Aldershot, 1998).

16a
Rembrandt Harmensz. van Rijn (1606–69)

Self-portrait at 34, 1640
Oil on canvas, 1020 x 800mm
(40⅛ x 31½")
Signed and dated bottom right: *Rembrandt f. 1640*; inscribed: *Conterfeycel* [*Portrait*]
The National Gallery, London
London only

Fig.50
Raphael
(1483–1520)
Portrait of Baldassare Castiglione, 1514–15
Oil on canvas, 820 x 670mm (32 x 26⅜")
Musée du Louvre, Paris

Fig. 50

Rembrandt is one of the outstanding artists of the Western artistic tradition. Born and educated in Leiden, he became an independent master in 1626 and by 1640 had built a successful career in Amsterdam. As well as painting in oils, he was an extraordinary draughtsman and printmaker. He is perhaps most celebrated for having made over seventy self-portraits in different media throughout his life. Furthermore, his self-portraits were copied and imitated by his pupils and fellow artists; the distinctive features and style of 'a Rembrandt' became representative of the quintessential artist, even when not actually painted by the artist himself. This distinguished work, apparently not commissioned, is the culmination of a series of autograph self-portraits from the 1630s in which Rembrandt portrays himself as an affluent and successful gentleman like Rubens (cat.9), rather than a working artist.

Unlike self-portraits in his later style (cat.16b), this work is painted in a smooth and meticulous technique, producing an intensely naturalistic and lifelike image.[1] Rembrandt's characteristic palette of earth colours is used with supreme virtuosity to create subtle effects of light, texture and surface. The rich velvets and furs and the glimpse of gold sparkling on the cap proclaim the figure's wealth. The costume, however, is not contemporary: it combines elements of sixteenth-century portraits, particularly those believed to depict Rembrandt's predecessor from his home town, Lucas van Leyden.[2]

The self-portrait is used here to elevate the role of the artist by reference to both Northern and Italian pictorial traditions. For example, the half-length composition and arched format (altered from the original rectangle, possibly by Rembrandt himself) are reminiscent of Lucas and other early sixteenth-century Northern artists. Rembrandt's pose, with his right arm resting on a balustrade, is strikingly similar to the *Self-portrait* of 1498 (Museo del Prado, Madrid) by Albrecht Dürer, who was similarly a painter and printmaker and deeply revered in the Netherlands. Dürer also represents himself as a gentleman rather than a working painter.[3]

There is also a clear allusion in Rembrandt's 1640 work to Raphael's portrait of Baldassare Castiglione (1514–15; fig.50), which Rembrandt sketched at an auction in Amsterdam on 9 April 1639. In addition there are similarities in pose and attitude to Titian's *Portrait of a Man* (c.1510; National Gallery, London), long believed to represent the Italian poet Ariosto, which was once in the possession of Alfonso Lopez, the buyer of the Raphael. By referring to these two works by Raphael and Titian, Rembrandt was modelling himself on different kinds of gentlemen. Raphael was described as 'a Prince more than a Painter' because his virtuous character was equal to his artistic skill; Castiglione was the author of the highly influential *Book of the Courtier* (1528), a publication concerned with the cultivation of the virtuoso gentleman.[4] This book has been described as 'emblematic of

Renaissance self-fashioning, the attitude that viewed the formation of the self as an artful, conscious process'.[5] Similarly, for Rembrandt the self-portrait becomes a performative space where the self is consciously created through reflection of and on another. It is noticeable that Rembrandt's picture is a mirror image of Raphael's *Castiglione*, which implicitly establishes a reflective dialogue between the two masterpieces: just as the mirror was seen as a transformative tool,[6] here the mirror-like portrait holds the power to transform, becoming the means whereby Rembrandt can perfect his courtly image and not only emulate but surpass his predecessors. FS/JW

1 C. Brown *et al.*, *Art in the Making: Rembrandt* (exh. cat., National Gallery, London, 1988), pp.82–4.
2 White and Buvelot 1999, p.44; cf. Chapman 1990, p.72 and p.156 n.67.
3 Rembrandt possibly saw Dürer's painting in 1636; V. Manuth, 'Rembrandt and the Artist's self-portrait: tradition and reception', in White and Buvelot 1999, p.44.
4 C. Brown, *Second Sight. Titian: Portrait of a Man, Rembrandt: Self-Portrait at the Age of 34* (exh. booklet, National Gallery, London, 1980); Chapman 1990, pp.73–4, quoting Karel van Mander's *Het Schilder-boek* of 1604. Castiglione's *Il Cortegiano* was not translated into Dutch until 1662 but it was available in the original Italian, French and English. For a modern English translation see Castiglione [1528] 1967.
5 Chapman 1990, p.73.
6 H. Berger Jnr., *Fictions of the Pose*. S. Melchior-Bonnet, *The Mirror. A History*, trans. K.H. Jewett, preface by Jean Delumeau (London and New York, Routledge, 2001), p.157, chap.6, *passim*.

Literature
Chapman 1990; White and Buvelot 1999.

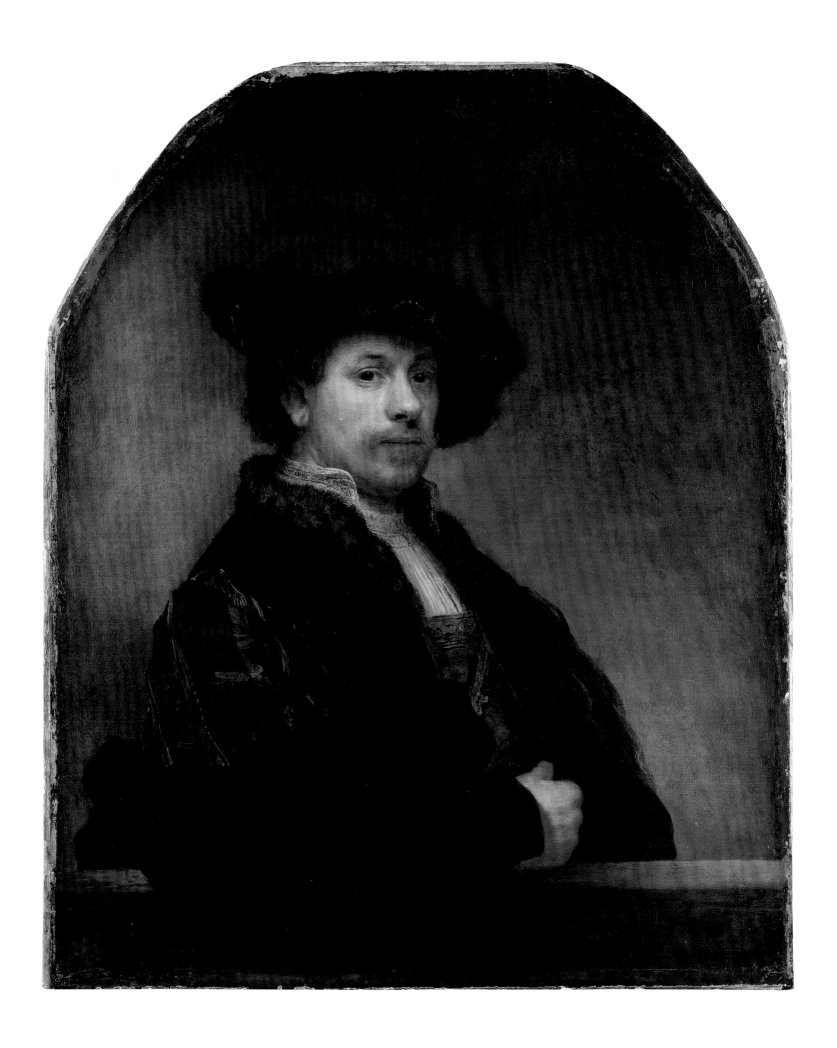

16b

Rembrandt Harmensz. van Rijn
(studio of)

Rembrandt (1660s)
Oil on canvas, 765 x 616mm (30⅛ x 24¼")
Felton Bequest, 1933
National Gallery of Victoria, Melbourne
Sydney only

A 'self-portrait' of one artist by another seems a contradiction in terms, unless it is a copy. Yet stylistic and technical examination has indicated that this painting and two others are original works painted in Rembrandt's studio that deploy the conventions of self-portraiture but were not by Rembrandt himself.[1] Rembrandt painted many variations on his different self-images and this picture resembles, but does not repeat, his self-portrait at the easel of 1660 in the Louvre, Paris. The canvas comes from the same bolt as an accepted painting, the *Flora* in the Metropolitan Museum, New York, and it is executed on a kind of ground that was particular to Rembrandt's workshop. The style is evocative of Rembrandt's late manner, the bulbous nose, shadowed eyes and working apparel instantly recognisable, and the pose and gaze seem to refer to a mirror. However, Rembrandt himself was not directly responsible for producing the picture; the flesh tones are cruder, the drawing not as assured and the brushstrokes not so fluent and differentiated as in uncontested works.

Such workshop 'self-portraits' probably served similar functions to the free paraphrases of Rembrandt's other paintings which were produced by his pupils: as part of the training process and a source of income. Yet they also fundamentally challenge our desire to see in self-portraits an authentic encounter with the artist through the medium and metaphor of the mirror. All the signs of self-portraiture are there, but the 'real' artist does not stand 'behind' them. This absence is particularly disturbing in relation to Rembrandt, because we associate his name, and particularly his late, rough style, with the sincerity and insight attributable to the true artist. Instead, the existence of such pseudo self-portraits supports Alpers's argument that in his later career Rembrandt astutely took advantage of the unprecedentedly free market of seventeenth-century Amsterdam to promote the authority and authenticity of the artist in an unconventional way.[2] Rather than the pose and polish of a courtly gentleman he marketed renderings of his distinctive, plebeian features and working habit in a rough manner of painting that referred to embodied skill and had an aura of individuality, although it was not always autograph. The numerous 'Rembrandts' that emerged from his workshop thus became embodiments of the artist for a commercial market, whether or not they were physically produced by the master himself.[3] JW

1 For example, Staatsgalerie, Stuttgaart; Fogg Art Museum, Cambridge MA. Ernst van de Wetering, 'Thirty Years of the Rembrandt Research Project: The Tension between Science and Connoisseurship in Evaluating Art' IFAR *Journal* 4, no.2 (2001).
2 Svetlana Alpers, *Rembrandt's Enterprise. The Studio and the Market* (University of Chicago, Chicago and London, 1988), esp. pp.115–21.
3 Manuth 1999.

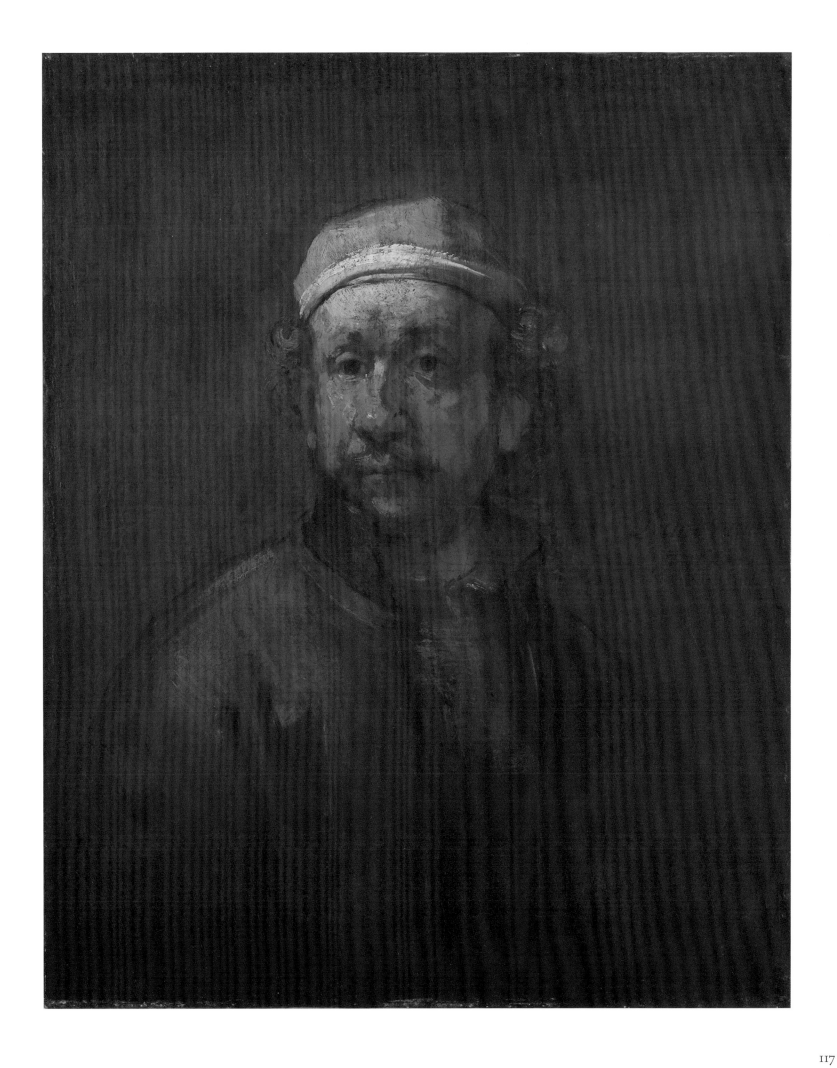

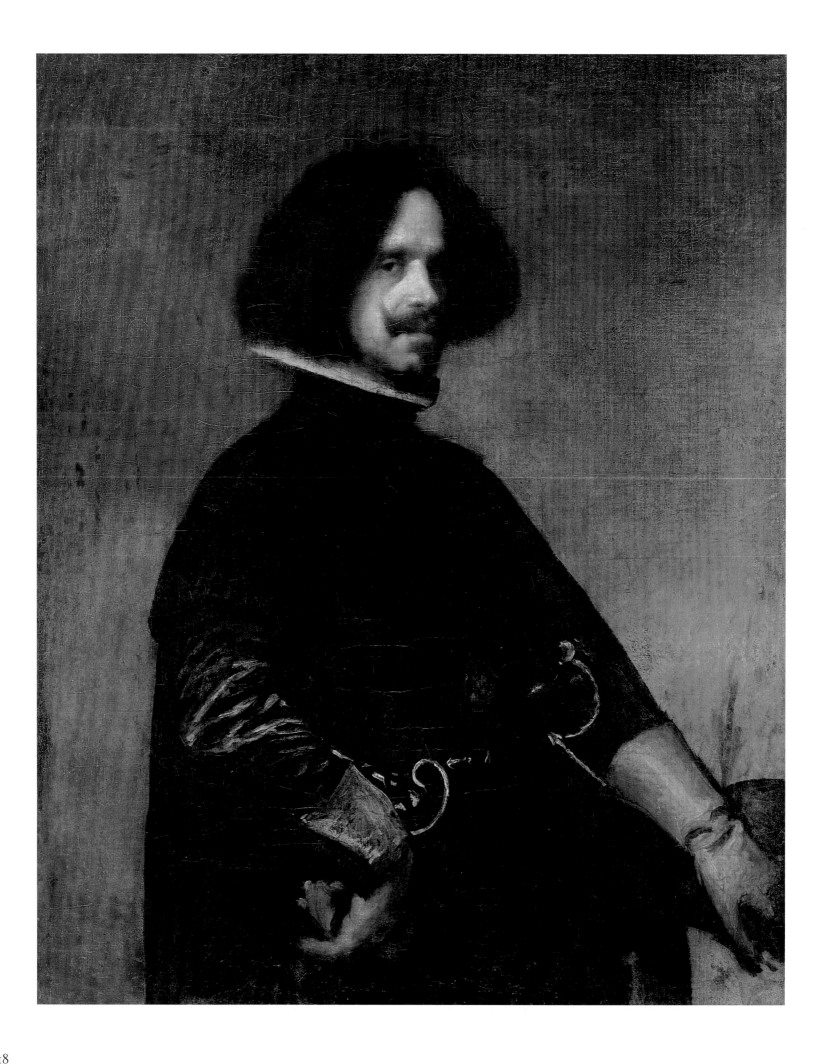

Diego Rodríguez de Silva y Velázquez (1599–1660)

Self-portrait, c.1645
Oil on canvas, 1035 x 825 mm (40¾ x 32½")
Galleria degli Uffizi – Collezione degli Autoritratti – Firenze

Painted at the age of about forty-five, this self-portrait conveys the ambition and drive for distinction that motivated Velázquez's long career as courtier and principal painter to Philip IV of Spain. Nothing is known of the commission; the picture was first recorded in the famous Medici collection of self-portraits in 1690.[1] It is one of many self-portraits attributed to Velázquez, of which the most significant is *Las Meninas* (*The Maids of Honour*, 1656–7; fig.15), in which the painter's portrayal of himself with members of the royal family plays in various ways on the relationship between artistry and sovereignty.[2]

Whereas in *Las Meninas* Velázquez appears with brushes and palette standing before an enormous canvas, here there is no explicit acknowledgement of the artist's profession. Instead, we are presented with a man of the court celebrating his honoured status as Royal Chamberlain.[3] The gesture of his right hand draws attention to the keys of that office attached to his belt; the sword and difficult pose, with foreshortened, bent right arm, is associated with portraits of men whose martial virtue justified their membership of the hereditary nobility.[4] Known to have coveted a knighthood, Velázquez was finally admitted into the Order of Santiago in 1659, the year before his death. The Order's emblem, a red cross, is just visible on his chest: it was probably added later, as it was in *Las Meninas*, but because the military and the court were aristocratic preserves, depiction as a shining example of a courtly knight is in itself a claim to a title of nobility.

Rubens, who met Velázquez at the Spanish court in 1628–9, also exploited the established tradition of self-portraiture as a nobleman (cat.9). Indeed, the early modern court has been located as a principal site for the emergence of the artist as a model of individuality.[5] According to the Roman painter Federico Zuccaro (1540–1609), artists should 'display the fine manners that fit them to negotiate with princes and gentlemen and be seen and flattered by them'.[6] However, such self-portraits, just as much as more explicitly theatrical self-presentations, are performances in which the artist plays various roles: the courtier, the gentleman, the nobleman, the military officer, the diplomat and politician. These fictions all involve the removal of explicit reference to manual labour and monetary profit, since the man of virtue engages in intellectually based activity and is motivated by his own free will, not the desire for gain.

The brightest features of this painting are the head and the hand, physical metaphors for the distinction between painting's intellectual and mechanical status. Indeed, the head is almost separated from the body by the single brushstroke that defines the edge of the white collar. The virtuoso handling, which is profoundly influenced by Titian, has also been related to Baldassare Castiglione's courtly ideal of *sprezzatura*: the easy nonchalance that conceals the effort involved. Contemporaries recognised, however, that this naturalistic effect depended on a particular, distanced viewing position; the physical marks and blotches involved in producing such an illusion were clearly visible from close up. The unpolished, sometimes even apparently unfinished brushwork constituting the noble artist thus becomes a demonstration of the transformative 'work' of art. AH/JW

1 M. Gregori, ed., *Uffizi e Pitt: i dipinti gli artisti le scuole* (Librinoderni, Florence, 2000), cat.791, p.613; ibid., *Uffizi e Pitt: i dipinti gli artisti le scuole* (Librinoderni, Florence, 1979), cat.A991, p.1032. Cosimo da Castiglione reputedly bought the picture in Spain in 1689.
2 For the attribution, J. López-Rey and A.L. Mayer, *Velázquez: a catalogue raisonné of his oeuvre* (Faber and Faber, London, 1963), cats 172–84, pp.182–5, pls 228–33.
3 *Ayuda de camera ad honorem*. J.M. White, *Diego Velázquez: Painter and Courtier* (Hamish Hamilton, London, 1969), pp.xxi–xxii. Velázquez was also architect, decorator, and director of royal ceremonies.
4 J. Brown, *Velázquez: Painter and Courtier* (Yale University Press, New Haven, 1986), pp.52–6.
5 Warnke 1993, p.117; Woods-Marsen 1998, p.15.
6 F. Zuccaro, *Scritti d'arte* (Leo S. Olschki, Florence, 1961), p.158.

Literature
J. Brown, *Velázquez: Painter and Courtier* (Yale University Press, New Haven, 1986); S.L. Stratton-Pruitt (ed.), *The Cambridge Companion to Velázquez* (Cambridge University Press, Cambridge, 2002).

18
Salvator Rosa
(1615–73)

*Self-portrait, c.*1645
Oil on canvas, 1163 x 940mm (45¾ x 37")
Inscribed: AUT TACE / AUT LOQVERE MELIORA / SILENTIO [*Keep silent unless your speech is better than silence*]
The National Gallery, London

Fig.51
Salvator Rosa
Lucrezia as Poetry, 1640–1
Oil on canvas, 1040 x 910mm (41 x 35⅞")
Wadsworth Atheneum
Museum of Art, Hartford, CT

Fig. 51

Salvator Rosa was a man of many talents and great ambition. Trained in Naples, he became a painter of marine and battle scenes, wild landscapes peopled with hermits or bandits and visions of demons and witches. He was also an accomplished poet, actor, satirist and musician. In 1640, after a period in Rome, he moved to Florence where he became friends with the poet Giovanni Battista Ricciardi (1623–86) and his house was the centre of an artistic and humanistic circle called the '*Accademia dei Percossi*' (loosely 'the Agitators'). Rosa developed a particular interest in Stoic philosophy, which taught that man's supreme goal is to live in harmony with nature, freeing himself from all material desires and sensual passions in the pursuit of virtue. The visual and verbal arts are thought to instil virtue through a morally directed appeal to the senses of sight and hearing. This self-portrait promotes an image of a melancholic, even taciturn outsider, self-consciously engaged with death and immortality.[1]

Rosa's monumental figure is dramatically silhouetted against an open sky, a traveller poised within a turbulent landscape. The artist's distinctive swarthy looks are recognisable from his other self-portraits; his clothing and the motto, derived from the Greek thinker Pythagoras, position him as a philosopher.[2] Rosa's Latin dictum refers explicitly to the rule of silence in the School of Pythagoras and the philosopher's wise retention of speech.[3] The words, inscribed on a slab that is at once commemorative and reminiscent of a painter's prepared panel, oblige the artist-philosopher to speak only if he can overcome a silence that ultimately implies death. A pendant picture of a standing woman holding a pen and book (fig.51) is believed to represent Rosa's mistress, Lucrezia Paolina, in the guise of Poetry. As in Angelica Kauffmann's self-portrait of 1782 (cat.26), the pairing of the two subjects alludes to the humanist parallel between painting and the liberal art of poetry. In this context, the maxim 'Keep silent unless your speech is better than silence' relates to the classical axiom 'painting is mute poetry, poetry a speaking picture'.[4]

However, in contrast to Kauffmann's self-portrait, the mood of *Lucrezia as Poetry* is dark. Her sallow complexion, challenging expression and ragged, disarrayed clothing identify Rosa's alter ego and pictorial model with 'low life' (cf. Caravaggio's *Sick Bacchus, c.*1593–4; fig.13). Her loose hair and tangled headdress characterise the inspiration of Poetry in terms of divine frenzy rather than rhetorical rules and, in conjunction with her malevolent face, give her a witch-like or Medusan aspect.[5] Both she and the artist transfix their viewers, reducing them to silence with an intransigent stare.

Rosa was in fact rather loquacious. In his satire *Pittura* (1650) he played the role of a moral philosopher, asserting the lofty aims and subjects of painting and scorning the low-life work of the northern Bamboccianti such as Pieter van Laer (cat.15). In this portrait, such high-mindedness and allegory are, perhaps ironically, combined with a taste for melodrama and the macabre to create a figure possessing intellectual ambition worthy of Poussin and a dramatic naturalism and rebelliousness inherited from Caravaggio. JD/JW

1 For the identification as a self-portrait: Roworth 1988, pp.106–9; Roworth 1989, pp.138–9; Scott 1995, pp.71–3.
2 Cf. *Diogenes* by the Naples-based painter Juseppe de Ribera (1591–1652) (Private Collection, see N. Spinosa, *Ribera*, Naples 2003, p.303, cat.no. A171); for the inscription see Leuscher 1994, pp.278–9.
3 Leuschner 1994, p.282; Roworth 1989, p.141.
4 C. Baker and T. Henry, *The National Gallery Complete Illustrated Catalogue* (London, National Gallery, 2001), p.583; Lee 1967, pp.3–9; Roworth 1989, p.140.
5 C. Ripa, *Iconologia*, Rome, 1603, p.177; Mary D. Garrard 1989, p.355.

Literature
W.W. Roworth, '*Pictor Succensor': A study of Salvator Rosa as Satirist, Cynic, and Painter* (Garland, New York and London, 1978), pp.258–9; E. Leuschner, 'The Pythagorean Inscription on Rosa's London "Self-Portrait"', *Journal of the Warburg and Courtauld Institutes* 57 (1994), pp.278–83; J. Scott, *Salvator Rosa. His Life and Times* (Yale University Press, New Haven and London, 1995).

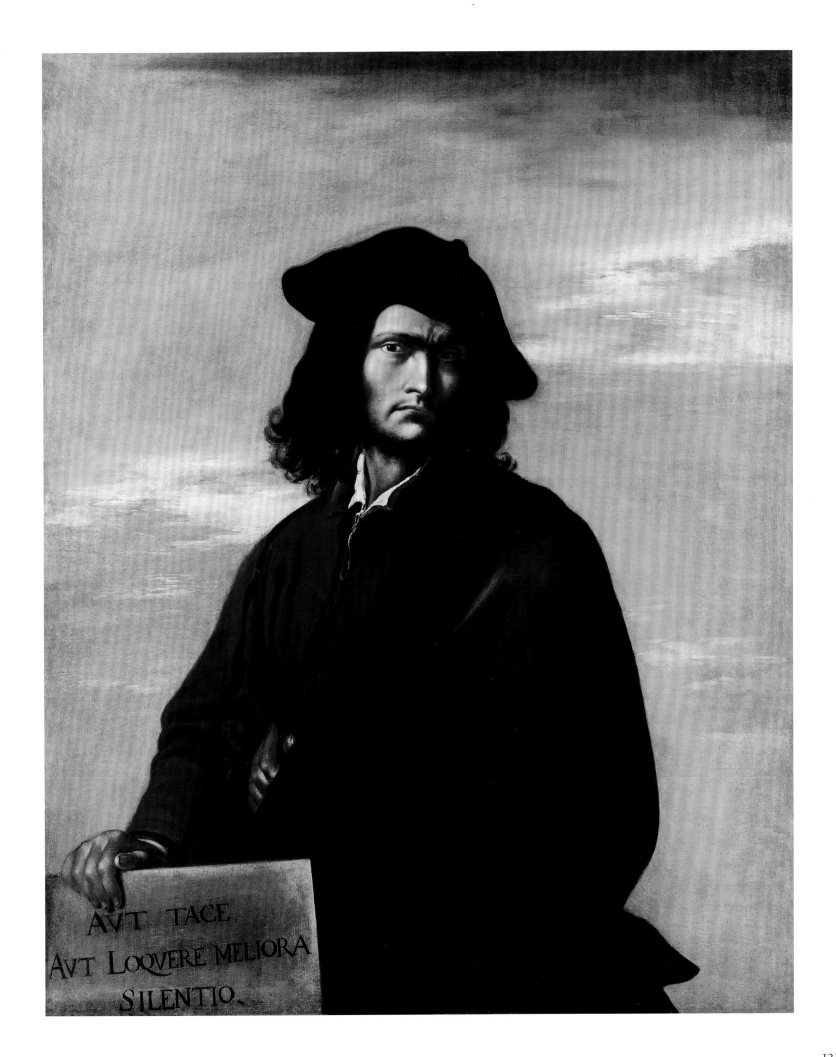

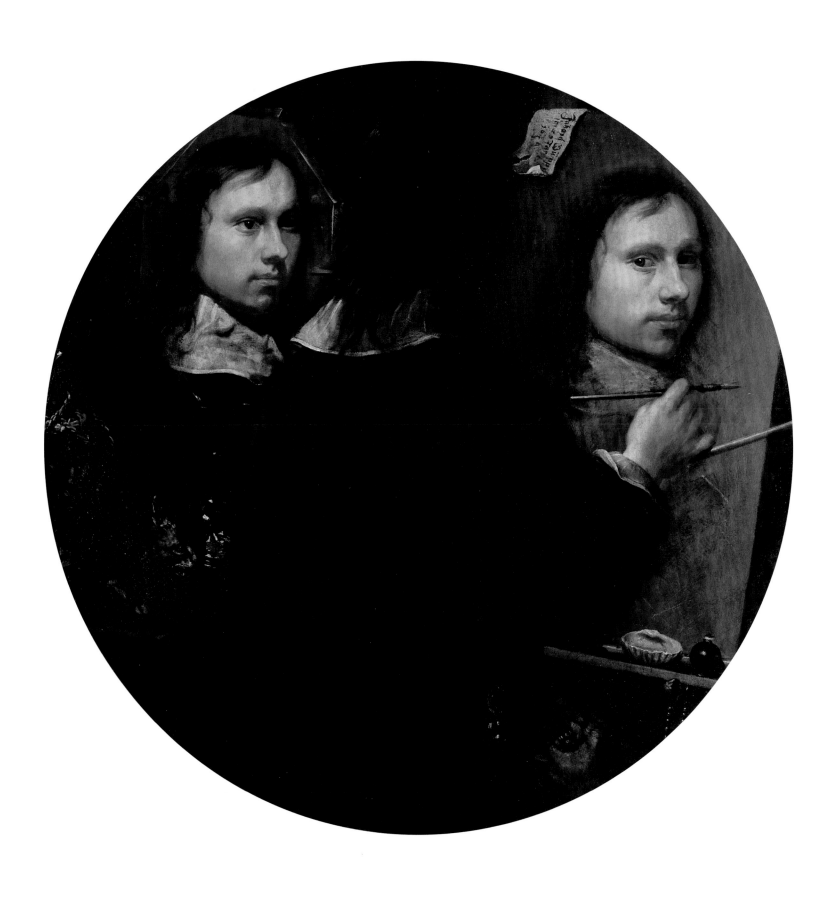

19
Johannes Gumpp (?)

Self-portrait, 1646
Oil on canvas, 885 x 890mm (34⅞ x 35")
Inscribed: *Johannes Gumpp im 20 Jare 1646(?)*
[*Johannes Gumpp in his twentieth year, 1646*]
Galleria degli Uffizi – Collezione degli
Autoritratti – Firenze

There is a mystery in this self-portrait. The inscription, written in Germanic script on the *trompe l'œil* piece of paper that is draped over the top of the canvas, gives the artist's name, Johannes Gumpp, his age – twenty – and a partially legible date, which could read either 1646 or 1659.[1] The surname on this *cartellino* has prompted scholars to associate the painter with the Austrian Gumpp family of artists but neither Johann Anton Gumpp (1654–1719) nor Johannes Baptist Gumpp (1651–1728) were aged twenty at either of the possible dates in the inscription. However, their brother, the painter Franz Gumpp, reportedly died aged twenty-four in 1663, in Florence where the *Self-portrait* remains today; this would have made him twenty years old in 1659.[1] While, according to the date in the painting, it seems more likely that Franz is the author of the *Self-portrait*, it is clear that the first name on the *cartellino* reads Johannes. Thus it is difficult to be certain which member of the Gumpp family painted this work.

Considering the ambiguity surrounding the identity of the artist, it is fitting that this self-portrait discloses the artist's face only through a reflection, in a mirror to his left and on a painted canvas to the right. Positioned with his back to the viewer, the 'real' face of Gumpp remains concealed. Depicted not in the act of painting, but rather of looking, this image illustrates the process by which a self-portrait is created: from the artist to a mirror, and then from the reflection to the canvas. Triply visible, Gumpp depicts himself in different forms: the reflected self, the painted self and the 'real' self. At first glance the artist appears to be using the mirror to paint an exact image of his reflection; however, not everything is what it seems. Although the image *we* see in the mirror closely matches the portrait in progress, the depicted artist would see a very different reflection. In relation to the sight lines, the pupils reflected in the mirror are placed in the centre of the eyes, while in the portrait they are focused to one side. In other

words, the artist would not be seeing an angled view of himself in the mirror: he would, rather, be viewing his face straight on. He is therefore transposing onto the canvas not what *he* observes in the mirror, but what the external viewer sees. This mirror is not, therefore, a symbol of truth, but a sign of deceit. The manipulation of various angles and perspectives invalidates the documentary aspect of production, and instead dramatises the disparate nature of identity and self-knowledge: of seeing oneself and being seen, of knowing oneself and being known. In this painting, the self is constructed as relative to the point of view of another.[2] NL

1 Rave 1960, p.31.
2 Cf. Melchior-Bonnet 2001, pp.166–8.

Literature
Paul Ortwin Rave, 'Das Selbstbidnis des Johannes Gumpp in den Uffizien', *Pantheon* 18, no.1 (1960), pp.28–31.

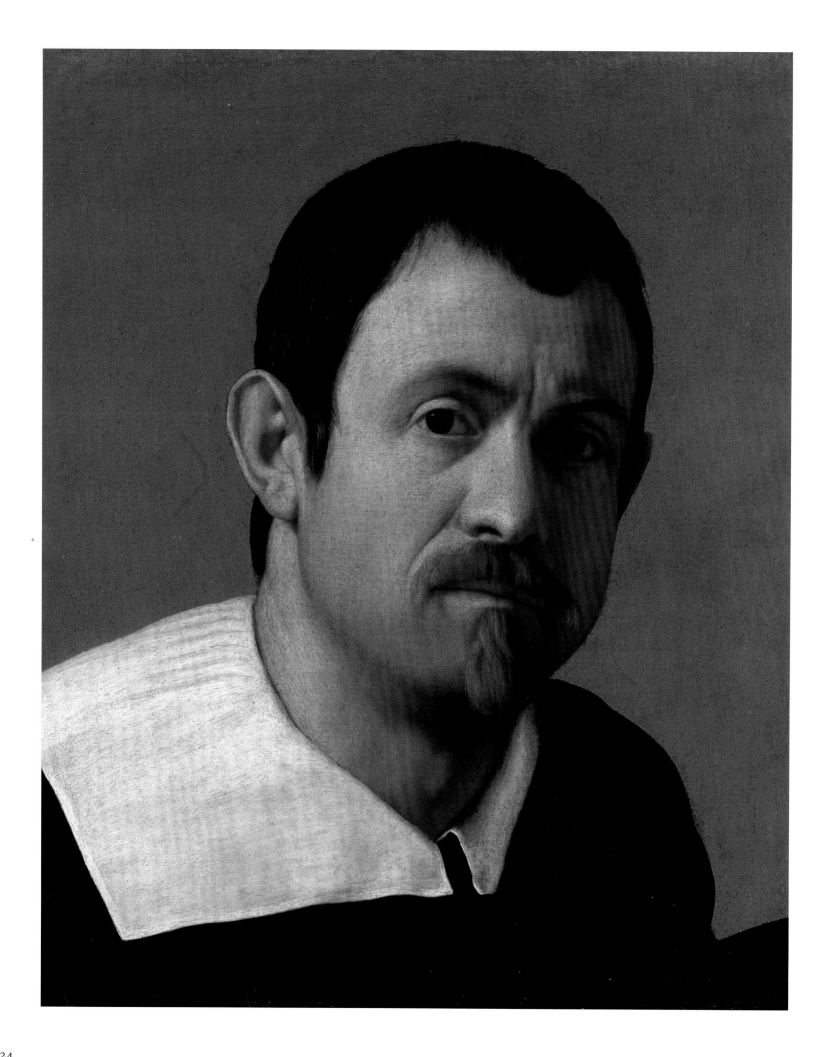

20
Sassoferrato
(Giovanni Battista Salvi)
(1609–85)

*Self-portrait, c.*1650
Oil on canvas, 380 x 325mm (15 x 12¾")
Galleria degli Uffizi – Collezione degli
Autoritratti – Firenze

Fig.52
Raphael
(1483–1520)
*Self-portrait, c.*1506
Oil on wood, 450 x 330mm (17¾ x 13")
Galleria degli Uffizi – Collezione degli
Autoritratti – Firenze

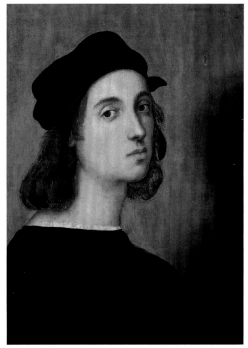

Fig. 52

Giovanni Battista Salvi is more commonly known by the name of his native town, Sassoferrato, in Italy. He was famous in his lifetime, working on commission and also producing multiple versions of the same compositions for pilgrims; his immaculate images of the Virgin at Prayer cloaked in saturated ultramarine blue remain archetypal devotional images. However, he has attracted little attention from art historians, partly because his work seems to hark back to the religious art of the previous century, particularly to Raphael. This self-portrait was commissioned on behalf of Duke Cosimo III de' Medici, to join the Uffizi collection of self-portraits.

The unblemished mirror, imagined here between model and spectator, symbolises the purity of the Virgin. By reflecting on his appearance in this mirror, Sassoferrato visualised an inner, spiritual persona.[1] His intense gaze and furrowed brow indicate profound and concentrated meditation, and oil paint's potential to produce a mirror-like finish has been exploited to suggest that the image we see is true. By removing all traces of brushwork and excluding his hands, Sassoferrato's physical role as a maker has been suppressed in favour of the tradition

of the *acheiropoetas*: an icon whose mythical origin was divine.[2]

In this unassuming but arresting painting Sassoferrato thus assimilated his own persona to the character of his oeuvre as a whole. The use of his trademark blue evokes not only his own staple images of the Virgin, but a tradition reaching back to the medieval aesthetic in which the 'virtue' of natural, divinely created materials was valued alongside the skill of the artist who worked them into a magical illusion. Raphael's *Self-portrait* of *c.*1506 (fig.52) already hung in the Medici collection[3] and Sassoferrato's devotion to this supreme master of religious art is perhaps evident in the modest dress, simple composition, centrally positioned eye and high finish common to both works.[4]

A comparison can also be made three centuries on with the self-portrait of Edward Hopper (cat.41), in which the artist similarly appears as a character within his own created world. In fact, the contradictory subjectivity represented by Sassoferrato is quite unlike that of a devout Christian before the sixteenth-century Protestant reformation and iconoclasm split the world in two. Surrounded by ultramarine blue, the

artist is situated in a place, or a space, at once infinite and immediate, backward-looking and startlingly modern. The white, gently receding plane of the large collar both creates and negates an illusion of space, linking the lifelike figure with the abstraction beyond. Like Alessandro Allori's self-portrait (cat.3) a century earlier, the figure is idealised and the extreme close-up view of the head and shoulders challenges the boundaries of representation, yet the directness of the expression, enamel-like finish and intense colour also conjure up an almost photographic effect. The central left eye fixes and appraises an external object of attention, but the shadowy right side of the figure recedes into the blue, drawing us into the mystery of interiority and bringing Sassoferrato inexorably into the 'modern' world of his contemporary, Rembrandt.

GF/JW

1 Melchior-Bonnet 2001, esp. p.105.
2 Koerner 1993, chap.5, pp.80–6; Woods-Marsden 1998, p.4. The painting looks as if it has been cut down.
3 This *Self-portrait*, attributed to Raphael, belonged to Cardinal Leopoldo de' Medici (1617–75).
4 Francis Russell, 'Sassoferrato and his Sources: A Study of Seicento Allegiance', *Burlington Magazine* 119, no.895 (October 1977), pp.694–700

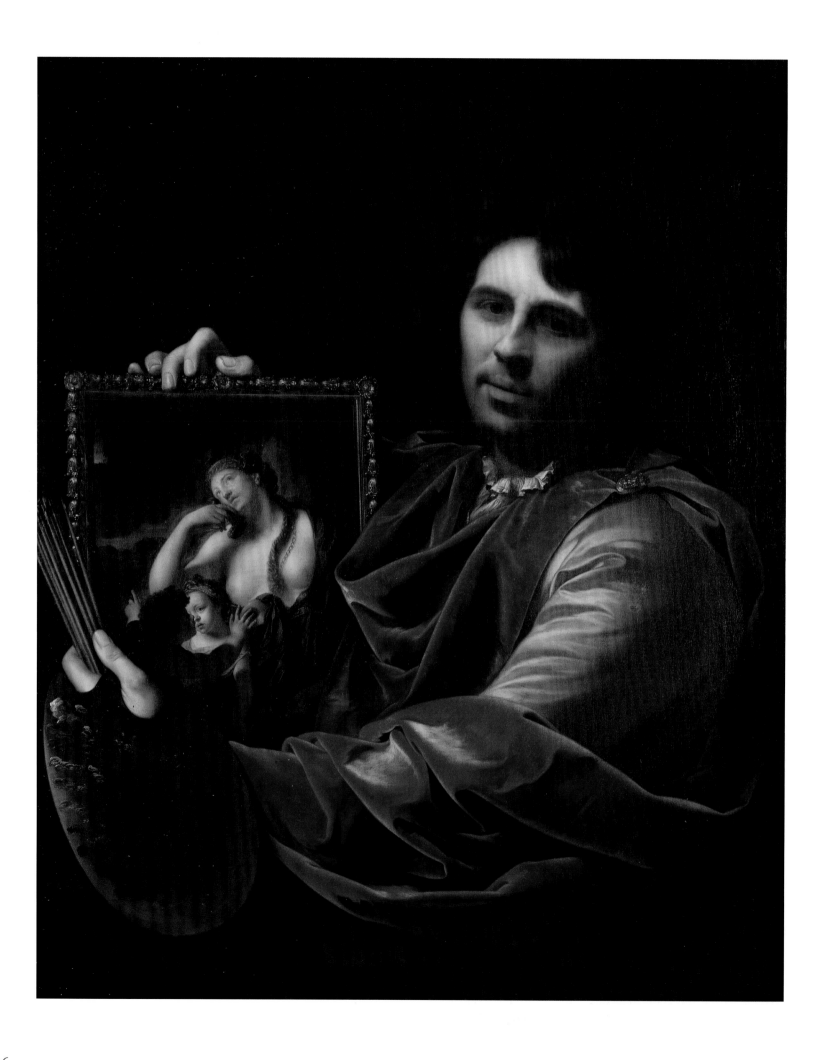

Fig. 53

21

Adriaen van der Werff
(1659–1722)

Self-portrait with Wife and Daughter, 1697
Oil on canvas, 890 x 730mm (35 x 28¾")
Inscribed: *Adr" vand' Werff fec. An° 1697*
Galleria degli Uffizi – Collezione degli
Autoritratti – Firenze

Fig.53
Adriaen van der Werff
Self-portrait, 1699
Oil on canvas, 810 x 655mm (31½ x 25½")
Rijksmuseum, Amsterdam

In 1718 Adriaen van der Werff was described as 'the greatest Dutch painter of all time'.[1] This self-portrait apparently formed part of his first commission for the Elector Palatine, Johann Wilhelm van der Pfalz, on being appointed his court artist in 1696. The picture was subsequently delivered to the Elector's father-in-law, Cosimo de' Medici III, probably as a gift, and was incorporated into the famous Medici collection of self-portraits assembled from the sixteenth century onwards.[2]

The artist is shown cradling a picture of a woman and child, with a third, back-turned figure partly obscuring the child's face. The mask worn round the neck of the woman identifies her as Pittura, the personification of painting (cf. cats 13, 14). In Cesare Ripa's *Iconologia*, a hugely influential iconographic guide published in Dutch in 1644, Pittura's attributes include a mask and a palette (see fig.11). In van der Werff's self-portrait the mask is contained within the framed, classicising allegory, while the palette belongs to the 'true' picture of the artist. The female figure also refers to the painter's wife, Margareta Rees, and the child to their daughter Maria, born in 1692. Netherlandish artists frequently depicted themselves in the company of their spouses, sometimes with their children; in another version of this self-portrait made two years later (Rijskmuseum, Amsterdam; fig.53) the

artist carries a portrait of his wife and daughter, who bear a strong resemblance to the pair in the earlier picture. Thus the female figure is at once van der Werff's domestic muse, or natural inspiration, and a manifestation of his cultivated imagination. The child is a product of the union between these two foundations of artistic creativity.

A contemporary Netherlandish aphorism claimed that 'Art is born of love',[3] and in van de Werff's self-portrait Pittura is reminiscent of figures of Venus elsewhere in his oeuvre. The red swathes of drapery emphasise the painting's amorous mood. However, love does not preclude other interests: Seneca had identified profit and honour or fame alongside love as motivations for the artist.[4] While the central claim of the image is that art is generated from personal desire, it also celebrates van de Werff's lucrative court appointment and advertises his mastery of Netherlandish naturalism and Italianate allegory. Furthermore, it manages to incorporate both a paired and a double portrait. Other self-portraits in the Medici collection similarly show the sitter holding a picture within a picture: Cosimo de' Medici may have sought self-portraits that exemplified the artist's special skills.[5]

By framing the lovely figure of Pittura with a lifelike scene Van der Werff marries allegory and naturalism in a single image.

The artful placement of the drapery, mask and child's arm seem to cross the threshold between the reality of the painter's presence and the allegorical portrait linking husband and wife together. Similarly, one cannot be certain to which 'picture' the second child truly belongs: perhaps a personification of the Love of Art, he appears to be pushing away Pittura's mask. If truth and honesty are the marks of love, then Art has no place for simulation and deceit. EP/JW

1 Arnold Houbraken, *De Groote Schouburgh der Nederlantsche Konstschilders en Schilderessen* (Amsterdam, 1721, repr. Leiter-Nypels, Maastricht, 1953), p.390; Jakob Rosenberg, Seymour Slive and E.H. Ter Kuile, *Dutch Art and Architecture 1600–1800* (Yale University Press, New Haven, 1977), p.358.
2 Berti 1979, p.1027; Henk T. van Teen, 'Tuscan visitors for Adriaen, van der Werff', *Mercury 2* (1985), pp.29–35; Langedijk 1992, p.198.
3 '*Liefde baart const*'. Jongh 1986, pp.57–9, 276; Joanna Woodall, 'Love is in the Air. *Amor* as motivation and message in seventeenth-century Netherlandish painting', *Art History* 19, no.2 (1996), p.220; Langedijk 1992, p.198.
4 Bob Haak, *The Golden Age: Dutch Painters of the Seventeenth Century* (Thames and Hudson, London, 1984), p.35; *Seneca on Benefits, translated by Thomas Lodge* (The Temple Classics, London, 1899), p.75.
5 Langedijk 1992, pp.xvii–xxvii and p.88.

Literature
Albert Blankert (ed.), *Dutch Classicism in Seventeenth-Century Painting* (exh. cat., Museum Boijmans Van Beuningen, Rotterdam, 2000); Barbara Gaehtgens, *Adriaen van der Werff, 1659–1722* (Deutscher Kunstnerlag, Munich, 1987); Peter Hecht, *De Hollandse fijnschilders Van Gerard Dou tot Adriaen Van der Werff* (exh. cat., Rijksmuseum, Amsterdam, 1989).

22
Joshua Reynolds
(1723–92)

*Self-portrait, c.*1747–9
Oil on canvas,635 x 743mm (25 x 29¼")
National Portrait Gallery, London

Fig.54
Rembrandt Harmensz. van Rijn
(1606–69)
Self-portrait as a Young Man, 1628
Oil on panel, 226 x 187 mm (9 x 7⅜")
Rijksmuseum, Amsterdam

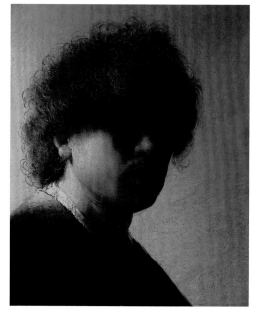

Fig. 54

In 1818 Sir Joshua Reynolds's pupil James Northcote used this *Self-portrait* as the frontispiece for his biography of the painter.[1] Reynolds, the leading artist of his day, was renowned for his portraits of elite members of society. After training and working in London he went to Italy in 1749 to study the Old Masters, returning in 1752 to promote the 'Grand Style' of painting. He was a founder and the first President of the Royal Academy, and between 1769 and 1790 delivered his celebrated annual 'Discourses' on academic principles. A prolific self-portraitist, his output was comparable to that of his predecessor, Rembrandt (cat.16a).

Reynolds probably painted this self-portrait shortly before he left for Italy at the age of about twenty-five. The 'landscape' orientation of the support is remarkable, yet the canvas has apparently not been cut down. The artist is depicted in fashionable colours, and garments adapted for work by turning down the collar and shortening the sleeves.[2] In his later self-portraits Reynolds tends to emphasise his role as an academic; this is the only certain one in which he represents himself with the tools of his trade, including his hand-mirror-shaped palette.[3] Arguably, the studio setting results in 'a rejection of artifice, and ... a sober, realistic approach' characteristic of English

art of the 1740s.[4] However, the hand raised over the eyes signifies more than a simple directness of vision: it produces effects of chiaroscuro that, together with the predominantly earthy palette and closely worked paint surface, reveal an interest in works by Rembrandt, especially his *Self-portrait as a Young Man* of *c.*1628 (fig.54). Rembrandt's self-portrait, painted more than a century before Reynolds's, has been interpreted in terms of interiority and introspection: the shaded eyes suggest the melancholic temperament that in the seventeenth-century was associated with artistic creativity. Reynolds imitates the intensity of Rembrandt's gaze but turns it towards the light, emphasising clarity of vision and looking outwards as if to discover inspiration in the mirror and beyond. The shading of the eyes has thus become simultaneously 'a practical and a visionary gesture'.[5]

In 1814 William Hazlitt claimed that 'Rembrandt was the painter of all others whom Sir Joshua Reynolds most resembled ... and borrowed most'.[6] This is evident in his paintings, his writings and his collections of etchings and drawings. He was also influenced by Jonathan Richardson's *Essay on the Theory of Painting,* which described Rembrandt as a true genius

and recommended him to young artists for his composition and use of chiaroscuro. Reynolds considered the study of the Old Masters as 'the best kind of wealth' for an artist, whereby he might 'find certain niceties of expression are capable of being executed, which otherwise we might suppose beyond the reach of art'.[7] FS/JW

1 J. Northcote, *The Life of Sir Joshua Reynolds,* 2 vols (London, 1818), frontispiece.
2 See Postle 2005. For the clothing, Aileen Ribiero in *Reynolds,* ed. N.Penny (exh. cat., Royal Academy of Arts, London, 1980), p.175.
3 David Mannings, *Sir Joshua Reynolds: A Complete Catalogue of his Paintings* (Yale University Press, New Haven and London, 2000), p.46. A *Self-Portrait Painting before an Easel* of *c.*1772, formerly in the collection of the Ismay family, is mentioned in C. White *et al., Rembrandt in Eighteenth Century England* (Yale Center for British Art, New Haven, 1983), p.36.
4 D. Mannings, 'The Sources and Development of Reynolds' Pre-Italian style', *Burlington Magazine* 117 (April 1975), p.214; Mannings 2000, p.46.
5 Mannings 1975, p.219. On Rembrandt, Chapman 1990, p.26; White and Buvelot 1999, pp.95–6.
6 White *et al.* 1983, pp.4, 11 and n.37 citing William Hazlitt, 'The character of Sir Joshua Reynolds', *The Champion,* 30 October and 6 November 1814. Chapman 1990, p.26.
7 J. Richardson, *An Essay on the Theory of Painting,* 2nd edn (A. Bettesworth, London, 1725), p.141; White *et al.* 1983, p.33.

Literature
J. Reynolds, *Discourses on Art,* ed. R. Wark (Yale University Press, London and New Haven, 1975); Martin Postle (ed.), *Joshua Reynolds: the creation of celebrity* (exh. cat., Tate Gallery, London, 2005).

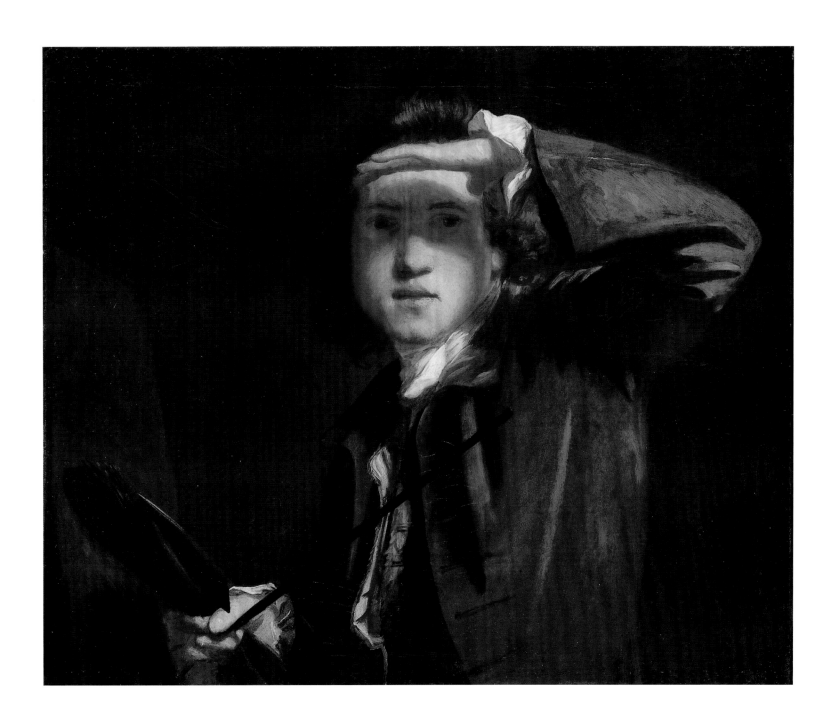

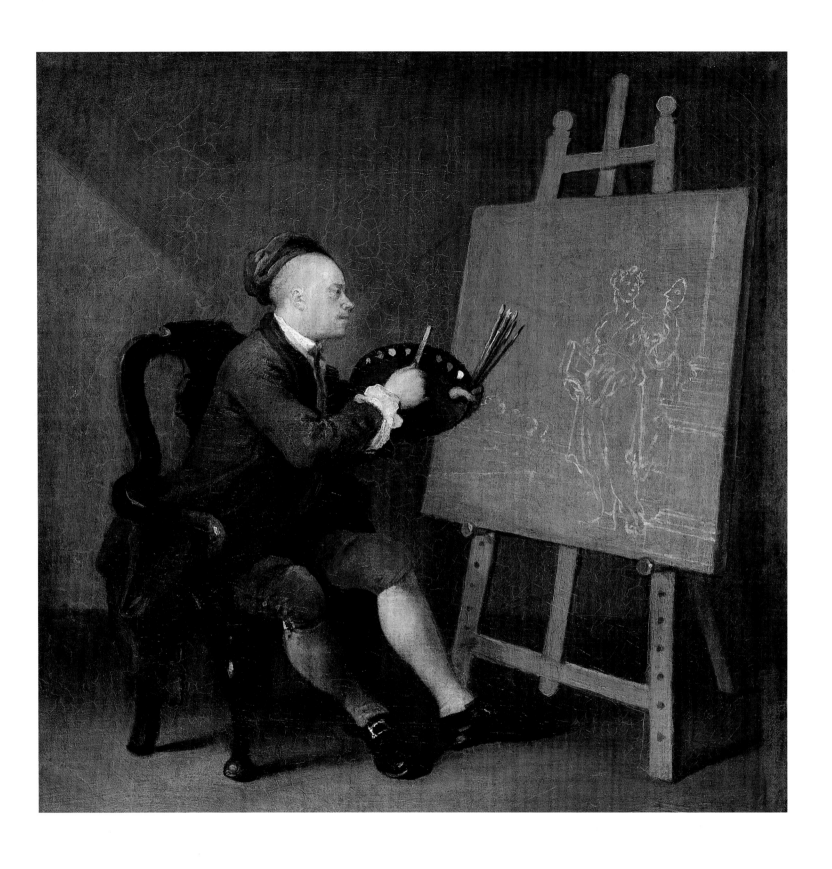

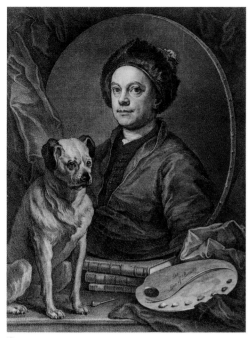

Fig. 55

23
William Hogarth
(1697–1764)

Self-portrait, c.1757
Oil on canvas, 451 x 425mm (15½ x 14¾")
National Portrait Gallery, London

Fig.55
William Hogarth
Self-portrait with a Pug Dog (Tramp), 1759
Engraving, 368 x 268 mm (14½ x 10⅜")
National Portrait Gallery, London

Like one of the characters in his own pictorial narratives, William Hogarth developed from unpromising beginnings into eighteenth-century England's most original and successful designer and marketer of genre prints, only to die a disappointed man. The son of a shopkeeper mother and a schoolmaster father whose business ventures failed, leading to bankruptcy and imprisonment, Hogarth was apprenticed to a silversmith before trying his luck as an independent engraver. Inspired by the artist Sir James Thornhill to become a painter, he attended Thornhill's Free Art Academy in Covent Garden and eventually married his master's daughter. He achieved success with his moral or comic 'histories', such as *A Rake's Progress* (1732–4; Sir John Soane's Museum, London), which satirised contemporary life and from which he produced engravings. A victim of print piracy, he was influential in passing the Copyright Act in 1735 and helped found the St Martin's Lane Academy for young artists. Although he was a ferocious social commentator and a self-confessedly pugnacious character, as his witty inclusion of a pug dog in his self-portrait of 1745 reveals (cf. fig.55), Hogarth aspired to recognition by the Establishment. In 1753 he published a theoretical treatise entitled *The Analysis of Beauty* and in 1757, the year in

which this self-portrait was begun, he was appointed Sergeant-Painter to King George II. The painting apparently originally had a pendant of Hogarth's wife.[1]

The small picture looks at first glance like a modest genre scene: an artist in his studio absorbed in his work, with none of the self-assertion typical of self-portraiture. On the canvas, sketched out in white, is Thalia, the Muse of comedy, holding her mask and a book.[2] The picture is in fact a work of high artifice in which the elements of painting – artist, palette and canvas – are represented in the manner best calculated to display them to the viewer. The proportions of the composition are planned according to mathematical rules and the sinuous curve of the chair arm is reminiscent of the serpentine line advocated in *The Analysis of Beauty*. Even the priority given to red and white on the palette seems to allude to Hogarth's aesthetic principles.[3] The artist, although ostensibly unaware of our presence, is like an actor on stage, playing out bold claims for his art that belie the picture's modest size and appearance.

One such claim is for the ennoblement of comic history which, according to the artistic hierarchy of the day, was denied the status of 'high' art. The drawing of Thalia reveals the elevated allegorical design beneath Hogarth's comic genre scenes:

indeed, the mask allies Thalia with the figure of Pittura herself (cf. fig.11). This *Self-portrait* was the model for an engraving of 1758 celebrating the artist's appointment as the King's Painter.[4] Like Hogarth's other paintings, it was thus the basis of a design whose authorship was recognised by copyright law. In the print the intellectual ambitions of the seemingly humble subject are made explicit, emphasised by the introduction of a book propped against the foot of the easel, displaying the first plate of the *Analysis of Beauty*. Hogarth also 'improved' the *Self-portrait* itself: X-ray analysis reveals substantial alterations to the composition, including the obliteration of a pug relieving himself against a couple of paintings.[5] EE/JW

1 John Kerslake, *The National Portrait Gallery. Early Georgian Portraits* (2 vols, HMSO, London, 1977), vol.1, no.289, esp. p.145.
2 Ronald Paulson, *Hogarth: His Life, Art and Times* (Yale University Press, New Haven and London, 1971), vol.2, pp.259–62.
3 Matthew Craske, *William Hogarth* (Princeton University Press, Princeton NJ, 2000).
4 Joseph Burke and Colin Caldwell, *Hogarth: The Complete Engravings* (Thames & Hudson, London, 1968), p.243.
5 Kerslake 1977, vol.1, p.146; vol.2, p.400.

Literature
William Hogarth, *Analysis of Beauty*, ed. R. Paulson (Yale University Press, New Haven and London, 1997).

24

Johann Zoffany
(1733–1810)

*Self-portrait (with Hourglass and Skull), c.*1776
Oil on panel, 875 x 770mm (34½ x 30⅜")
Inscription: ARS LONGA, VITA BREVIS
Galleria degli Uffizi – Collezione degli
Autoritratti – Firenze

Johann Joseph Zauffaly, alias John Zoffany, arrived in London from his native Germany around 1760, speaking no English. Born near Frankfurt, the son of a court cabinet-maker and architect, he spent his early career as an historical and decorative painter. In England he made his reputation through conversation pieces and theatrical portraits for the actor-manager David Garrick; he was elected to the Royal Academy in the late 1760s. In 1772 Queen Charlotte sent him to Florence to paint the Tribuna of the Uffizi Gallery. His royal connection enabled him to move in the highest circles and as a result of successful self-promotion he adopted a luxurious lifestyle.[1] It is not surprising, therefore, that he wanted his image to be incorporated into the Uffizi's famous self-portrait collection: having discarded two previous versions, he gave this final painting to Grand Duke Pietro Leopoldo in 1778.[2]

In November 1775 Sir Joshua Reynolds had given a self-portrait to the Uffizi to mark his election to the Reale Accademia delle Belle Arti in Florence. Zoffany was involved in the acquisition of this painting and he may have felt challenged by Reynolds.[3] However, his self-portrait does not compete directly with Reynolds's work: its strong vanitas theme dramatises his own personal situation. After the death of his estranged first wife, and soon after his arrival in Florence, the painter had married a 15-year-old girl. They had a son who died at just

sixteen months, after falling down a flight of stairs. According to a contemporary, Zoffany was completely devastated by the tragedy and 'in order to drown his thoughts, he overworked himself, which brought on the first attack of paralysis, when he lost the use of his limbs, and for some time his senses'.[4]

Tension between Zoffany's worldly pursuits and his devout Catholic faith apparently contributed to his breakdown.[5] In this self-portrait he represents himself in a luxurious fur-lined coat with the hermit St Antony the Great tempted (by the Three Graces) in the picture behind him and an *écorché* statue standing before him like a secular crucifix. The hourglass acts as a lamp illuminating the ambiguous inscription ARS LONGA, VITA BREVIS: art bestows a kind of immortality, despite the brevity of human life; yet life is too short to learn this difficult craft. Together the book, the palette and the *écorché* statue refer to an academic education in art. The painter's smile, echoed by the grinning skull, may well allude to the Greek philosopher Democritus who, after brooding on humanity's fate, ultimately laughed at human folly and used satire to warn people against madness. A combination of a laughing painter and symbols of death also evokes Zeuxis, the Greek artist renowned in academic circles for his 'noble selection' from the five most beautiful women he could find. Yet Zeuxis had another side: the aged painter died laughing, engaged in what

must have been a naturalistic representation of an ugly old woman.[6] These exemplars – Democritus and the aged Zeuxis – found meaning in a tragic world not through classical techniques of idealisation but by means of an ironic and witty perspective on the world as it is. JD/JW

1 Pressly 1987, p.91; Lady Victoria Manners and Dr G.C. Williamson, *Johan Zoffany, R.A. His Life and Work* (John Lane, London and New York, 1920), pp.48–52; Jane Turner (ed.), *The Grove Dictionary of Art* (Oxford University Press, Oxford, 1996), vol.33, pp.692–5.
2 Berti 1979, p.1042; Webster *et al.* 1971, cat.67 (n.p.); *Il Neoclassicismo in Italia da Tiepolo a Canova*, ed. F. Mazzocca *et al.* (exh. cat., Palazzo Reale, Milan, 2002), cat.VI.16, p.157, p.448.
3 Pressly 1987, p.92 n.11.
4 C.L.H. Papendiek, *Court and Private Life in the Time of Queen Charlotte: Being the Journals of Mrs. Papendiek, Assistant Keeper of the Wardrobe and Reader to Her Majesty*, ed. Mrs. Vernon Delves Broughton (Bentley and Son, London, 1887), I, pp.86–7; R. Paulson, *Emblem and Expression: Meaning in English Art of the Eighteenth Century* (Thames & Hudson, London, 1975), pp.145–6.
5 Pressly 1987, p.92; Manners and Williamson 1920, p.15.
6 Pressly 1987, pp.94–6; On Democritus, A.Blankert, 'Heraclitus en Democritus, in het bijzonder in de Nederlandse kunst van de 17de eeuw', *Nederlands Kunsthistorisch Jaarboek* 18 (1967), pp.31–123. On connections between melancholy (even insanity) and creativity, Wittkower and Wittkower 1963, chap.5, esp. pp.98–108. Manners and Williamson (1920), pp.127–8 interpreted the smile as simply 'Benevolence coupled with some smug self-satisfaction'.

Literature
M. Webster, A.M. Crino and M.M. Mosco (eds), *Firenze e l'Inghilterra, rapporti artistici e culturali dal XVI al XX secolo* (exh. cat., Palazzo Pitti, Florence, 1971); W.L. Pressly, 'Genius Unveiled: The Self-Portraits of Johan Zoffany', *Art Bulletin* 64 (1987), pp.86–99.

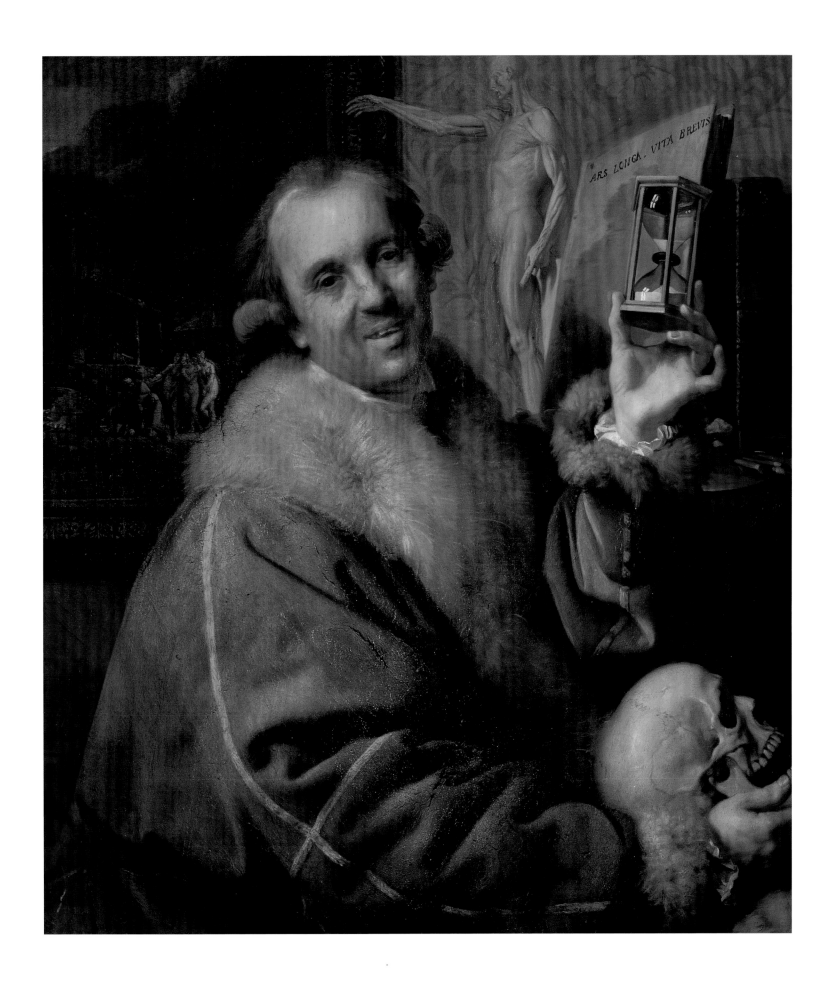

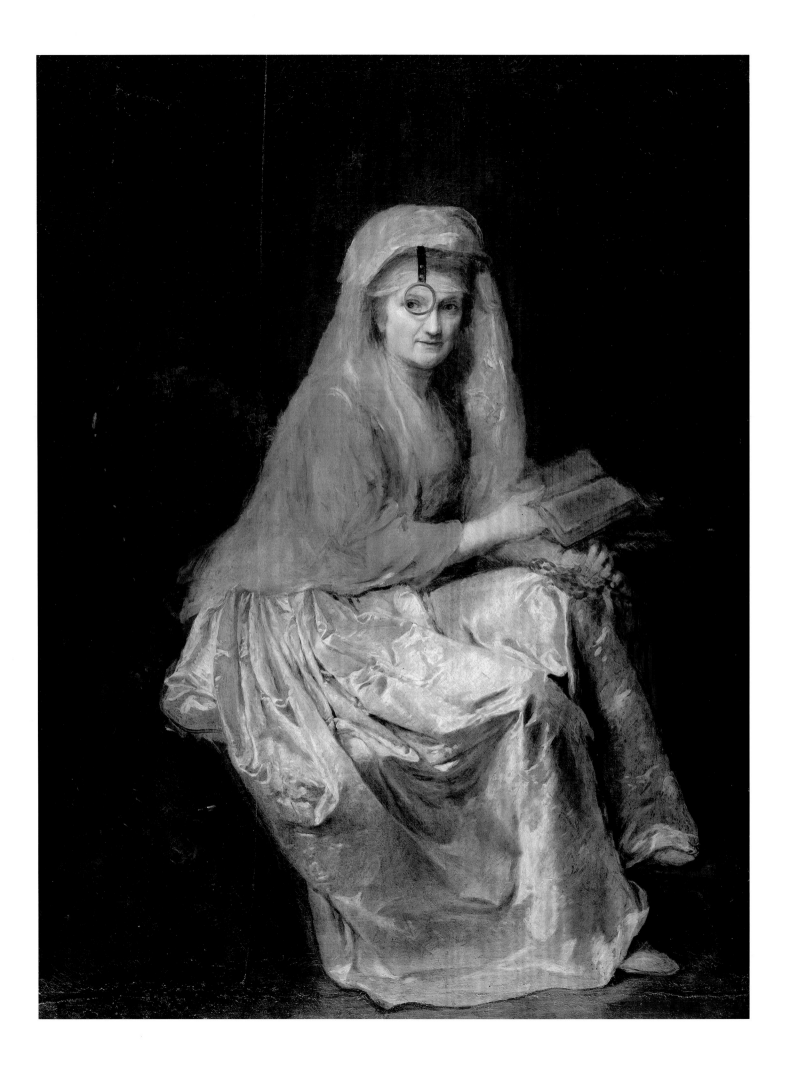

25

Anna Dorothea Therbusch-Lisiewska
(c.1721–82)

Self-portrait, c.1776–7
Oil on canvas, 1510 x 1150mm
(59½ x 45¼")
Staatliche Museen zu Berlin, Gemäldegalerie
London only

Anna Dorothea Therbusch-Lisiewska was born in Berlin to a Polish family of artists. Initially trained by her father, she married in 1742. She did not seriously pursue her artistic career for nearly two decades, although during this period she began her lifelong interest in self-portraiture.[1] In the 1760s and 1770s she travelled widely, leaving family responsibilities behind to concentrate on her painting and quickly gaining a reputation as a portraitist at the courts of the Count of Württemburg in Stuttgart and the Elector Palatine of the Rhine in Mannheim. In 1762 she was admitted to the Stuttgart Kunstakademie and in 1767 to the Académie Royale in Paris. On her return to Berlin in 1769, she was employed by King Frederick II of Prussia and Catherine II, Empress of Russia, as well as portraying senior figures in the city.

Therbusch was noted for her virtuosity in oils. Indeed, her submission to the Académie Royale was initially rejected on the grounds that she could not have worked alone, because the daring strokes and beautiful colouring must have been the work of a man.[2] She was also criticised for disregarding acceptable feminine artistic practice – for example, by painting the male nude. Her preference for a realist mode of (self)-portraiture that resisted the contemporary emphasis upon idealisation and beauty adds an aesthetic dimension to Diderot's remark: 'One thing I know, is that on receiving Mme Therbusch, the Academy cannot be suspected of having submitted to the rule of beauty, so powerful in France, for the new academician is neither very young nor very pretty.'[3]

Like a number of female artists (cats 4, 26, 27), Therbusch used self-portraiture to dramatise the connection between her position as a woman and her art. Between 1750 and her death in 1782 she painted at least twelve self-portraits, often depicting herself as a working painter. This image, apparently painted in her last years,[4] takes a radical stance: while her younger contemporaries represented feminine virtue primarily through idealising youthful beauty, Therbusch presents herself as a matriarch of about sixty. The fine detail in the face and the dress is characteristic of her late portraiture, while the rest of the painting is freely rendered, giving the picture a sketch-like appearance.

The artist is posed looking up from reading a book, the shimmering skirt and diaphanous veil demonstrating her artistic skill. The fantastic suspended monocle, an accessory that she adopted after the death of her husband in 1772, has been related to her status as a widow: it was certainly not a fashion item, and from a practical perspective could have been replaced by spectacles.[5] Yet the monocle became a feature of Therbusch's self-portraiture. As a prosthesis it acknowledges weakened vision and implied mortality, but it also frames, multiplies, magnifies (and slightly displaces) the gaze. Therbusch's use of the monocle thus both assumes and questions the potency of the artist's vision, commenting on the central eye characteristic of self-portraiture (cf. cat.18).[6] And, as with Reynolds's *Self-portrait* (cat.22), the object of looking is uncertain; is this contraption a help or a hindrance in the process of self-reflection? AH/JW

1 Pomeroy et al. 2003, p.171; Küster, Katharina and Beatrice Scherzer, *Der Freie Blick: Anna Dorothea Therbusch und Ludovike Simanowitz, Zwei Porträtmalerinnen des 18 Jahrhunderts; Katalog zur Ausstellung des Städtisches Museums Ludwigsburg* (Kehrer, Heidelberg, 2003), p.17; Berckenhagen 1987, pp.118–30.
2 J.G. Meusel, 'Lebensumstände de im Jahr 1782 in Berlin verstroben Madame Therbusch', *Miscellaneen artistischen Inhalts* 3, no.xvii (1783), p.267. Therbusch took successful legal action in defence of her authorship: Pomeroy et al. 2003, p.171.
3 Denis Diderot, *Salons* (Clarendon Press, Oxford, 1767), p.34.
4 Cf. Borzello 1998, p.72, where the painting is dated 1762.
5 P.D.R. Greeff, *Katalog einer Bilderausstellung zur Geschichte der Brille im Auftrage des Vorstandes des XIII. Internationalen Opthalmologischen Kongresses zu Amsterdam* (A.E. d'Oliveira, Amsterdam, 1929); and A. Vitols, *Dictionnaire des Lunettes: Historique et symbolique d'un object culturel* (Editions Bonneton, Paris, 1994), p.162.
6 Derrida 1993, p.45; Koerner 1993, pp.127–38.

Literature
Ekhart Berckenhagen, 'Anna Dorothea Therbusch', *Zeitschrift des Deutschen Vereins für Kunstwissenschaft* 41 (1987), pp.118–30; Henning Bock et al., *Gemäldegalerie Berlin: Gesamtverzeichnis*, ed. Rainald Grosshans (Staatliche Museen zu Berlin, Preussischer Kulturbesitz, Berlin, 1996); Tanja Wöhle, 'Anna Dorothea Therbusch', *Deutsche Frauen der Frühen Neuzeit*, eds K. Merkel and H. Wunder (Wissenschaftliche Buchgesellschaft, Darmstadt, 2000).

Angelica Kauffmann
(1741–1807)

The Artist in the Character of Design
Listening to the Inspiration of Poetry, 1782
Oil on canvas, diam. 612mm (24")
Inscribed (top): *For George Bowles Esq.*
English Heritage, Kenwood
(The Ernest Edward Cook Bequest
Presented by the National Art-Collections Fund)
London only

Fig.56
Angelica Kauffmann
Self-portrait Hesitating between the
Arts of Music and Painting, 1791
Oil on canvas, 1470 x 2160mm (58 x 85")
The St Oswald Collection, Nostell Priory
(The National Trust)

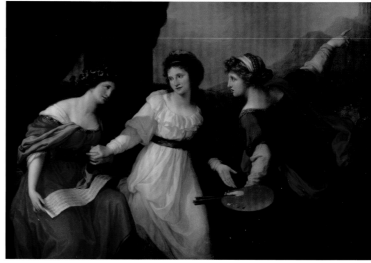

Fig. 56

Angelica Kauffmann's contemporary James Boswell described her as 'musician, paintress, modest, amiable'.[1] She was also acute, audacious and resourceful. Born in the Swiss Tyrol, precociously talented both musically and artistically, she was trained by her father, a professional painter, and spent her early career with him as a copyist of Old Master paintings in Italy. She made her name in 1764 with a portrait of the celebrated German writer on art, J.J. Winckelmann, and subsequently travelled to England, where she became a sought-after society portraitist and designer of decorative scenes for elite interiors and objets d'art. Exceptionally for a woman, she penetrated the elevated, male-dominated genre of history painting and was a founder member of the Royal Academy, where she exhibited from 1769 until 1797. In 1781 she married the Italian artist Antonio Zucchi and settled with him in Rome.[2]

Like her contemporary Vigée-Lebrun (cat.27) and predecessor Anguissola (cat.4), Kauffmann painted numerous self-portraits as a means of defining and advertising her special position as a woman artist. She recorded this picture, a hybrid of allegory and self-portraiture, in her Memorandum of Paintings as follows:

At Rome 6th November 1782. For Mr. Bowles of London circular picture of two English feet consisting of two figures representing poetry embracing painting who is listening eagerly to the suggestions of Poetry, given by the artist to the above name because the figure representing painting is the portrait of herself Angelica Kauffmann.[3]

Two figures in classically inspired dress are seated against columns in an idealised landscape – a timeless, perfected world. The figure of Poetry, clad in a flame-coloured garment, leans toward Painting in a pure white dress, represented with stylus and portfolio. Kauffmann was actually forty-one when this picture was painted, while Poetry was apparently modelled on her friend Maria Hadfield (1759–1838), who married the miniaturist and connoisseur Richard Cosway in 1781. A contemporary reported that 'we have now in Rome a Miss Hadfield who studies painting. She plays very fairly on the Harpsichord, and sings and composes music very finely and will be another Angelica'.[4] The two figures function as alter egos, attesting to Kauffmann's knowledge of the humanist concept of friends as 'second selves' (cf. cat.2).[5] The composition also alludes to the Horatian topos '*Ut pictura poesis*' ('as painting, so poetry'), which justified painting's claim to elevation by analogy with the liberal art of poetry.[6] However, the idyllic mood and characterisation of poetry as an inspiring passion moves beyond classicising precepts into a lyrical realm, closely associated with Kauffmann's other talent, music: Poetry is accompanied by a lyre and a laurel crown, linking the two arts represented in loving harmony. A decade later, in a major work entitled *Self-portrait Hesitating between the Arts of Music and Painting* (fig.56), Kauffmann dramatised the relationship by placing herself allusively in the position of a Hercules choosing between the paths of vice and virtue. Both pictures are allegories of the artist's exceptional talents; the latter also moralises her youthful decision to give precedence to a career in painting over her love of music. LC/JW

1 Rideal 2001, p.36.
2 Winckelmann's portrait is in the Kunsthaus, Zurich. For Kauffmann's biography see Roworth 1992, pp.190–2.
3 Bowles was one of Kauffmann's chief patrons. The oval shape and classical allusions are also a compliment to his taste for this format and style. See Lady Victoria Manners and Dr G.C. Williamson, *Angelica Kauffmann, R.A. Her life and her works* (Bodley Head, London, 1924), p.43; Dr G.C. Williamson, *Angelica Kauffmann RA her life and works* (Richard Clay & Sons, Ltd., Suffolk, 1924), p.143.
4 James Northolt in Dorothy M. Mayer, *Angelica Kauffmann, R.A., 1741–1807* (Colin Smithe, Gerrards Cross, 1972), p.95.
5 'Verum etiam amicum qui intuetur, tamquam exemplar aliquod intuetur sui' (Cicero, *De Amicitia* vi.23), *Cicero De Senectute, De Amicitia, De Divinatione*, trans. W.A. Falconer (William Heinemann, London and G.P. Putnam's Sons, New York, 1922), p.133; Bomford 2000, pp.169–82.
6 Lee 1967; *Angelica Kauffmann e Roma* (exh. cat., Academia Nazionale di San Luca, Instituto Nazionale per la grafica, Roma, 1998), p.142.

Literature
Bryant, Julius, *Kenwood: Paintings in the Iveagh Bequest* (New Haven and London, Yale University Press, 2003); Roworth, Wendy Wassyng (ed.), *Angelica Kauffmann: A Continental Artist in Georgian England* (London, Reaktion Books, 1992).

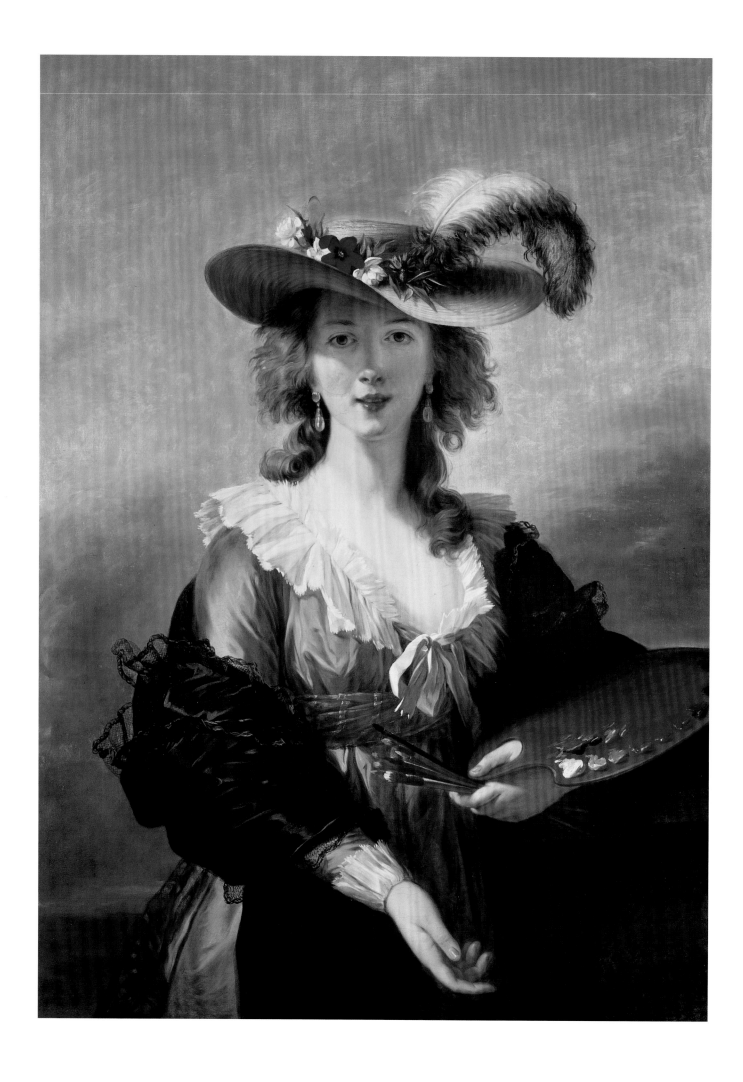

Elisabeth-Louise Vigée-Lebrun (1755–1842)

Self-portrait in a Straw Hat, after 1782
Oil on canvas, 978 x 705mm (38½ x 27½")
The National Gallery, London

Elisabeth Vigée-Lebrun was beautiful, intelligent and resourceful. The daughter of a portraitist in pastels, she was professionally trained in oils and at fifteen began to support her family by her work.[1] Like Sofonisba Anguissola (cat.4), she specialised in female portraiture but, in contrast to her predecessor, charm and desirability were explicit themes of her paintings. In *ancien régime* France she was a socialite, patronised by Marie Antoinette, who in 1783 secured her entry into the Académie Royale against considerable opposition. She escaped Paris just before the Revolution and spent eleven successful years in various European capitals before her return to Paris in 1801. Her output was prodigious – she apparently produced around eight hundred paintings – and in 1835 she published her autobiography, *Souvenirs.*[2]

Vigée-Lebrun used self-portraiture to advertise and exemplify her work as a woman artist, disseminating her image through autograph replicas. *Self-portrait in a Straw Hat* is one of over twenty known self-portraits, all characterised by the freshness, attractiveness and seeming naturalness for which her work was renowned. The picture is based on Rubens's *Le Chapeau de Paille* of c.1622–5 (fig.27) which now also hangs in the National Gallery, London, and which Vigée-Lebrun herself encountered on a trip to the Low Countries in 1781:

This admirable painting represents one of Rubens's wives [*sic*] ... it charmed and inspired me to the point at which I made my own portrait in Brussels, searching for the same effect. I therefore painted myself with a straw hat on my head, a feather and a garland of wild flowers, my palette in my hand. When it was exhibited at the *Salon,* I admit that it added greatly to my reputation.[3]

Vigée-Lebrun's technical interest in Rubens's picture lay in the play of direct and indirect light, and her own *Self-portrait* is in this respect an experiment on the effects achievable in oil.[4] Her visual homage to a supposed portrait of Rubens's wife also acknowledged her artistic allegiance to this painter – indeed, she herself became known as 'Madame Rubens'. More subversively, she also plays the role of the master himself.[5]

Rubens's legacy in France had been channelled through the debate at the turn of the century between the *Rubénistes*, who celebrated the visual effects of colour as an integral part of lifelike imitation, and the *Poussinistes*, who emphasised painting's appeal to the mind through form, design and its literary dimension. In *Self-portrait in a Straw Hat* Vigée-Lebrun recognised and exploited the implications of these gendered oppositions by turning herself into a personification of both the inventive painter and natural painting.[6] This is a witty, secular

reinterpretation of the Virgin Mary's identification with desirable feminine nature and its perfect imitation through art. The figure holds a palette with a selection of colours at the ready, and their artful use is realised in the flowers decorating her hat. Daubs of colour on the tips of her brushes project forward, challenging the boundary between the materiality and the magical illusions of 'Madame Painting'. SC/JW

1 P. Conisbee, *Painting in Eighteenth-Century France* (Phaidon, Oxford, 1981), p.137.
2 Nochlin and Sutherland Harris 1984, pp.190–4.
3 Vigée-Lebrun 1984 edn, pp.75–6. *Le Chapeau de Paille* was mistakenly believed to portray Rubens's second wife, Helena Fourment; in fact, it probably represents her sister, Susanna Lunden. *Self-portrait in a Straw Hat* was exhibited in Paris in 1782 at the Salon de la Correspondance.
4 Ibid. p.75: '... son grande effet réside dans les deux differents lumières que donnent le simple jour et le lueur du soleil, ainsi les chairs sont au soleil ... peut-être faut-il être peintre pour juger tout le merité d'execution qu'a déployé Rubens ...'.
5 Goodden 1997, p.111; Sheriff 1996, pp. 210–11.
6 Cf. J. Lichtenstein, 'Making Up Representation: The Risks of Femininity', *Representations* 20 (autumn 1987), p.84.

Literature
Linda Nochlin and Ann Sutherland Harris, *Women Artists 1550–1950* (exh. cat.; Los Angeles County Museum of Art, 1984); Mary D. Sheriff, *The Exceptional Woman. Elisabeth Vigée-Lebrun and the Cultural Politics of Art* (University of Chicago Press, Chicago and London, 1966); Elisabeth Vigée-Lebrun, *Souvenirs,* 2 vols (Édition feministe de Claudine Herrmann, Paris, 1984); Angela Goodden, *The Sweetness of Life: A biography of Elisabeth Louise Vigée-Lebrun* (André Deutsch, London, 1997).

28
Victor Emil Janssen
(1807–1845)

*Self-portrait at the Easel, c.*1829
Oil on paper on canvas, 566 x 327mm
(22¼ x 12⅞")
Hamburger Kunsthalle
London only

This work by Hamburg-born artist Victor Emil Janssen is widely regarded as an icon of Romantic self-portraiture. Janssen belonged to the circle of the Nazarenes, a group of German Romantic painters named for their archaic style of dress who at one point formed a quasi-monastic community. The Nazarenes famously admired the 'clean line' and 'simple faith' of medieval and early Renaissance artists. They idealised Albrecht Dürer as a God-fearing craftsman in medieval Germany, and the Italian quattrocento artists (before Raphael) as the embodiments of authentic religious and literary feeling. In 1811 Friedrich Overbeck and the Nazarenes were joined in Rome by Peter von Cornelius. Born in Düsseldorf, Cornelius would later become Janssen's teacher.

Crown Prince Ludwig of Bavaria met the Nazarene painters in Rome in 1818 when they were living in an abandoned monastery and wearing biblical attire, long hair and sandals. Prince Ludwig declared that Peter von Cornelius was 'the new Dürer' and invited him to Munich, appointing him Director of the Munich Royal Academy of Art, where Janssen later studied.

In this self-portrait the artist is twenty-two years of age. Stripped to the waist, he pivots between the image in the mirror and that on his barely suggested easel. This pictorial device of the 'hinged canvas' coincides with the right edge of the picture frame. This was a convention of self-portraiture used by Alessandro Allori (cat.3) and Artemisia Gentileschi (cat.14), surviving into the late twentieth century in the work of

Leon Kossoff (cat.55), for example. Andreas Beyer argues that Janssen's canvas can be read as a 'broadsheet with theses on painting': he represents the whole gamut of artistic genres here: nude, portrait, interior, drapery study, still life and arguably even history painting.[1] The latter is represented by his role-playing as a half-naked, Christ-like figure, echoing paintings of the Passion or scenes of Christian martyrdom. Janssen and the Nazarenes admired Dürer's Christ-like *Self-portrait* of 1500 (fig.36) in which the artist idealised his own likeness.

Yet Janssen's naked torso and backward glance, the bed in the background and the shirt knotted around his waist like a loincloth, all suggest that this was a private rather than a publicly conceived self-portrait. Painted on paper and only later transferred to canvas, the work remained in the artist's possession until his death. His intimate self-depiction acknowledges a counter-tradition that began with Dürer's nude self-portraits in which the artist reflects critically upon his own corporeality (see Joseph Koerner, p.74 above). Commentators have noted Janssen's unhealthy-looking, deliberately 'unclassical' body with its stoop-shouldered pose, jutting belly and curved back, and the suggestive melancholy of his almost morbid gaze.[2] It is significant that Janssen modelled for portraits by other artists, yet these reveal a conventionally attractive young man rather than the sorrowful consumptive portrayed here.

The Romantic spirit informed the work of a whole generation of self-portrait artists in Germany, and the Nazarenes showed a

particular preoccupation with solitude and inner feelings, according to Hans Joachim Neidhart: 'All that counts is the face, the mirror of the soul'.[3] But Janssen's focus in the present work is equally upon the depiction of the artist's body, the embodiment of an idealised, martyr-like and suffering creativity: 'In this intensely private studio scene, intended purely as an instrument of self-knowledge, Janssen has tuned a pitiless eye upon himself. With clinical acuteness the young man shows himself … with the hollow chest and rounded back of a man under threat of tuberculosis … Janssen's self-interrogation places him in a tradition that runs from Albrecht Dürer to Otto Dix.'[4]

The Nazarene-style foreground scatter of violets and heather, and the box of paints also have a symbolic meaning, alluding to the brevity of life and the longevity of art. Given the artist's demise in the prime of his life, a mythology has grown up around this image. UP

1 Beyer 2003, p.298
2 Sebastien Giesen, *In Blickfield: Victor Emil Janssen, Selbstbildnis vor der Staffelei* (Hamburg, 2001) cited in Beyer 2003, pp.298, 401; Thea Vignau-Wilber, *Deutscher Romantiker: Bildthemen der Zeit von 1800 bis 1850* (exh. cat., Bayerischen Staatsgemäldesammlungen und der Kunthalle der Hypo-Kulturstiftung, Munich, 1985), p.34.
3 Hans Joachim Neidhart, in Hartley 1994, p.285.
4 Ibid.

Literature
Beyer 2003; Keith Hartley, ed., *The Romantic Spirit in German Art 1790–1990* (exh. cat., Scottish National Gallery of Modern Art, Edinburgh, Hayward Gallery, London, and Oktagon Verlag, Stuttgart, 1994).

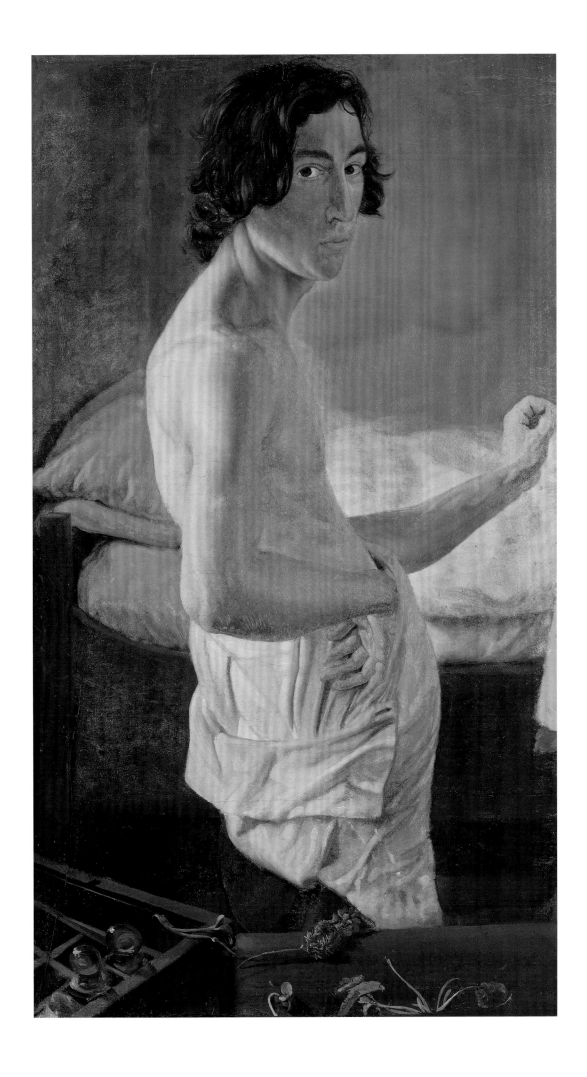

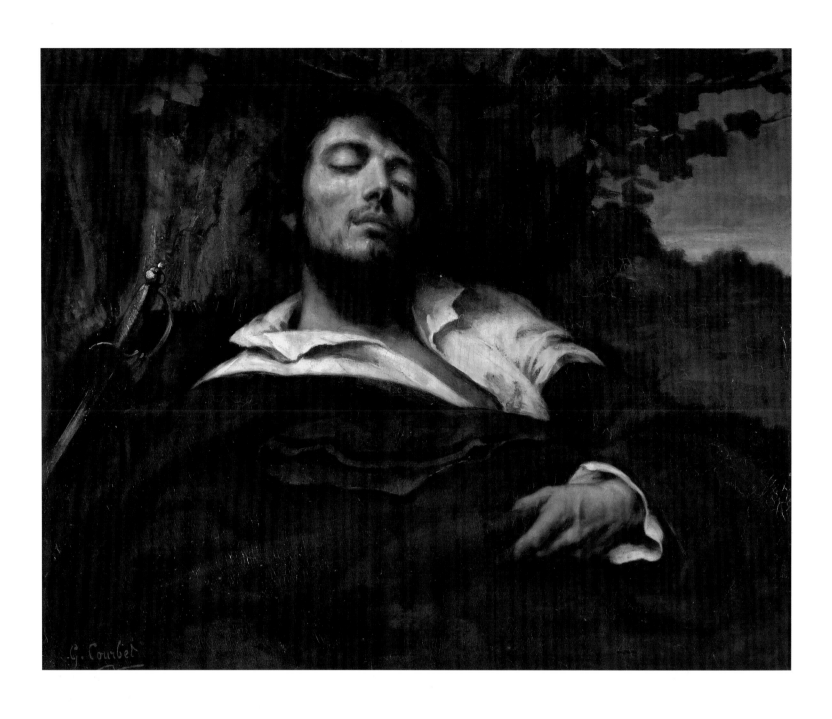

Gustave Courbet
(1819–77)

*Portrait of the Artist called The Wounded Man
(L'homme blessé)*, 1844–54
Oil on canvas, 815 x 975mm (32⅛ x 38⅛")
Paris, Musée d'Orsay
London only

Courbet's development as a mature painter and a political radical coincided with momentous events in France during the Revolutionary Government of 1848–51 and its replacement by the Empire of Napoleon III. He identified strongly with the revolution in 1848, and in later years he held important posts in the short and ill-fated Commune of 1871–2. When the Commune failed he was arrested, imprisoned for six months and fined 500 francs.

He is best known for his central role in the Realist Movement, an important political force in those troubled years. The Realist circle gathered at the Brasserie Andler, which came to be known as the 'Temple of Realism'; the group included Courbet's influential colleagues Charles Baudelaire, Pierre Proudhon and Jules Champfleury, and his cousin and childhood friend Max Buchon. It was at the Brasserie that the term 'Realism' was first coined to describe not only a style of art and literature which presented life as it was, but also a philosophy committed to contemporary social issues.

Courbet's painting style looked back to the painterly tradition of Rembrandt rather than to the smooth illusionism of many salon painters such as Bouguereau or even Ingres. He used impasto and the palette knife to create a painterly equivalent for aspects of the material world, rather than imitate superficial appearance. For example, when Courbet paints water it is slippery, with varnish added to the paint, while slabs of thick paint recall the craggy surface of the rocky landscape near the artist's home at Ornans. This understanding of earthy, tactile realism as distinct from seamless visual imitation was fundamental to the evolution of modern painting.

Courbet gives his subjects a palpable presence: we can almost smell works like *The Trout* (1872; Kunsthaus, Zurich) and we can certainly feel its texture in a way that is impossible with a photograph. Similarly, his famous nudes give a real sense of actual presence: it is as if Courbet creates the sensation of the thing,[1] providing a direct physical sensation and thereby weakening the boundary between the representational surface and the object conjured from the paint itself.

As a young man he painted many self-portraits in which he experimented with rendering states of consciousness from reverie to extreme existential angst, as in *The Man Made Mad with Fear* (fig.12).[2] In these early works he deliberately exceeds the frame, suggesting that the figure might slip through the glossy surface as if it were Alice's mirror. Michael Fried points out that the figure of the artist in his great allegorical painting *The Studio* (1855; Musée D'Orsay, Paris) sits so close to the canvas that he is virtually merging with it; the space between the artist and the landscape which he depicts himself painting is so compressed that his legs seem to be sliding into the composition before him.[3]

Courbet also often shows himself with eyes closed or drooping, as if slipping into reverie. Fried considers this a precondition for visual and imaginative absorption that facilitates the passage from the world about us to the world we sense beyond the pictorial surface. *The Wounded Man* is one such picture. The prostrate figure is painted very close to the pictorial surface and exceeds the frame: in fact, the bottom half of the body seems to extend into the space of the viewer. The subject's eyes are closed as if he has swooned from the loss of blood that appears on his wounded chest, reinforcing the effect of the figure sliding down and out of the pictorial field. AB

1 This idea of conveying the sensation of the thing figures strongly in later painting (for example the portraits by Bacon and Freud in this catalogue).
2 See p.33 above.
3 Fried 1990, pp.158–61.

**Edgar Degas
(1834–1917)**

*Self-portrait, c.*1863
Oil on canvas, 925 x 665mm (36⅜ x 26⅛")
Calouste Gulbenkian Museum, Lisbon
London only

As a young man Degas took advantage of his family's prosperity to travel widely, spending several years in Italy rigorously preparing himself for the exacting career of an artist. His family was important to him, and his first portraits were of family members. From his student years Degas saw himself primarily as a figure painter aspiring to master the most demanding, historically ambitious tradition of art. In 1858 his father wrote, 'You have a splendid career ahead of you, do not be discouraged ... portraiture will be one of the finest jewels in your crown'.[1]

Although this painting represents Degas relatively early in his career, at around thirty years of age and some ten years before he became an important figure in the Impressionist movement, the 1860s was the last decade in which he produced any self-portraits. Painted in *c.*1863, this Romantic image is almost identical to a photograph of the artist taken in 1862, now in the Bibliothèque Nationale in Paris. A friend described him thus: 'On the short side ... the head powerful, the expression quizzical ... the eyes bright, sly, questioning, deep set under high-arched brows'.[2] In this elegantly urbane three-quarter-length self-portrait Degas presents himself as a young dandy in a dark coat, white shirt and black cravat, holding a silk hat and chamois gloves (a

discreet homage to Titian). He also recalls the aristocratic figures by van Dyck he had admired in Italy by representing himself as a gentleman of leisure, worldly and self-assured. His body is nonchalantly turned at an angle to the picture plane, his face apparently responding to the spectator. Originally Degas had drawn the top hat closer to him: the painted outline is still visible.[3] Moving the hat further out allows his face and body to command the space and our attention more effectively, as he tips his hat in a spontaneous salute, politely acknowledging our presence.

The setting is an interior, but a window reveals landscape and sky in the Renaissance tradition. Although the rich brown tones lend a sombre note of seriousness and tradition to this youthful self-image, Degas' presentation of himself is completely modern. He is the embodiment of Baudelaire's cosmopolitan *'flaneur'* (urban idler), his pose, dress, gesture and facial expression conveying sophisticated detachment as well as the teasing mobility of social encounters in the modern world. Degas saluting us is a public image of the artist as he would like to be seen: aloof, ironic, proud and self-possessed, the modern incarnation of the Renaissance tradition of the gentleman artist.

Not private or confessional, the painting also raises the question of what does a person's outward appearance signify? With sitters conceived as actors, the viewer as audience, does the metaphor of the picture as a kind of theatre of modern life apply here? According to Edmond Duranty, a realist writer with whom Degas was friendly in the 1860s, the modern portraitists' approach is as follows: 'What we want is the special note of the modern individual, in his clothes, amid his social habits, at home or in the street'; as for social standing, 'physiognomy will tell us for sure that here is a well behaved man'.[4] UP

1 Auguste Degas in a letter to his son, 11 November 1858 quoted in Gordon and Forge 1988, p.87.
2 Paul Lafond in a reminiscence published in 1918, quoted Gordon and Forge 1988, p.17.
3 Rona Goffen, *Museums Discovered: The Calouste Gulbenkian Museum* (New York, Woodbine Books, 1982), p.186.
4 Gordon and Forge 1988, pp.94–5. Duranty published his famous pamphlet on modern painting, *La Nouvelle Peinture*, in 1876, much of it written with Degas' work in mind. See e.g. John Rewald, *The History of Impressioninsm* (Museum of Modern Art, New York, 1973), p.376; Reff 1976, p.9.

Literature
P.A. Lemoisne, *Degas et son œuvre*, 4 vols (Arts et Metiers Graphiques, Paris, 1946); Theodore Reff, *Degas: the Artist's Mind* (Metropolitan Museum of Art/Harper & Row, New York, 1976); Denys Sutton, *Edgar Degas: Life and Work* (Rizzoli, New York, 1986).

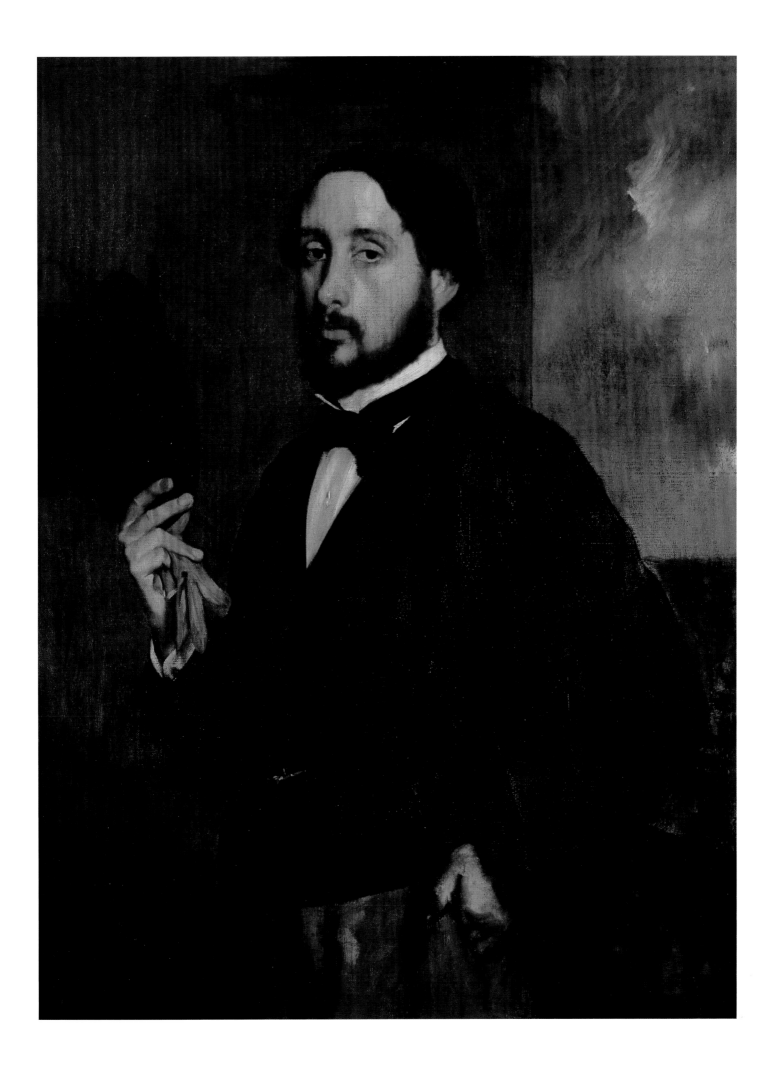

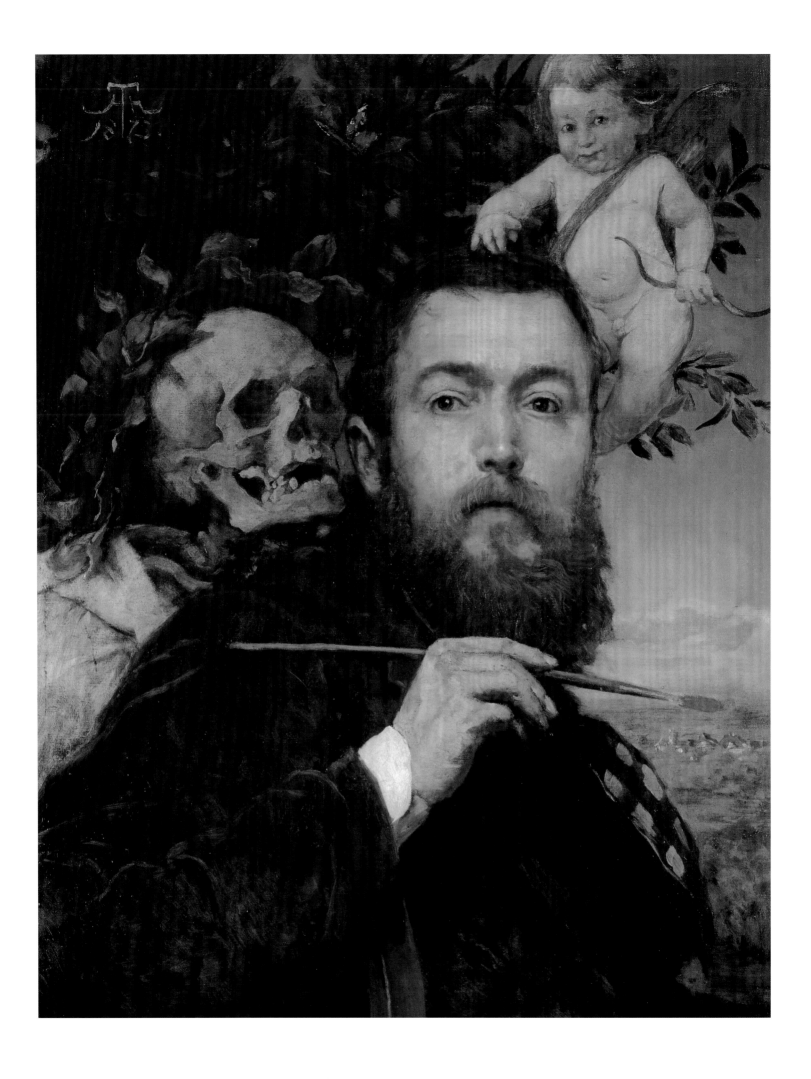

31
Hans Thoma
(1839–1924)
Self-portrait with Love and Death, 1875
Oil on canvas, 725 x 585mm (28½ x 23")
Staatliche Kunsthalle Karlsruhe
London only

After early studies in Karlsruhe and Düsseldorf, German artist Hans Thoma went to Paris in 1868, where he was strongly influenced by Gustave Courbet (cat.29). Thoma later wrote to a friend, 'Seeing his pictures I had the impression that I might have painted them myself; I felt myself free of the shackles of the Academy'.[1] Subsequently Thoma's landscapes and figure subjects demonstrated greater directness of observation, solidity of form and sensitivity to specific conditions of light. In 1870 he moved to Munich and formed a friendship with the Swiss-born Late Romantic, proto-Symbolist painter Arnold Böcklin. In 1874 he visited Italy for the first time, an experience that reinforced his growing interest in mythology and symbolism, especially in the work of the Italophile Böcklin.

This allegorical self-portrait of 1875 echoes Böcklin's *Self-portrait with Death the Fiddler* (1872; Nationalgalerie, Berlin). Imagery of death and music had a strong personal association for Böcklin, resulting in an 'inspiration picture' which portrayed the artist as a creative genius communing with his macabre muse. The classical tradition typically conferred the role of artistic inspiration to gentler feminine images of the Muses or Venus (see Angelica Kauffmann, cat.26, for example). Thoma's symbolism, however, tempers Böcklin's darker, more melancholy vision, countering the threat of death with the ideal of love. So the grotesque, laurel-wreathed skeleton whispering in his right ear is contrasted with the playful cupid who floats on his left side, one hand stroking his hair, the other holding a golden bow, its arrow already released. Thoma's figure, although painted in the studio, appears to be bathed in sunshine, evoking the warmer climate of the classical south. The flying cherub representing love in this painting echoes the ubiquitous putti in the frescoes of Italian Renaissance classicist Andrea Mantegna.

The strongest motif is the artist's face as it turns to fix the viewer with a tranquil yet intense stare. Thoma compels our gaze to answer his, emphasising the immobile frontality of the artist's pose, the vertical of his body and face counterbalanced by the long, red-tipped brush he wields as his gesture aligns itself to the distant horizon. Thoma, like Alessandro Allori (cat.3), is alluding to the conceit of 'mirroring' in self-portraiture. Depicting himself interrupted, looking into a mirror to check the accuracy of the mark he is about to make with his brush, Thoma is poised to paint the canvas we are looking at, just outside the edge of the picture's frame.

Böcklin's example first motivated Thoma to look to Renaissance art for inspiration, and he continued to look there for guidance as a craftsman and student of painting techniques; his ambitions finally crystallised as a 'painter-poet'. The hallmarks of his figure paintings in the 1880s and 1890s were mythological and allegorical references, finely observed physiognomies, rich colour, taut linearity, iconic composition and decorative framing.[2] His interest in decorative and floral patterns, particularly on the picture frame, anticipated the Jugendstil of around 1900. UP

1 Hans Thoma letter to Georg Gerland quoted in Ulrich Finke, *German Painting: From Romanticism to Expressionism* (London, Thames & Hudson, 1974). p.146.
2 See his *Self-portrait* of 1880 in the Museum Georg Schäfer, Schweinfurt (catalogue 2002, p.259).

Literature
Jane Turner (ed.), *The Grove Dictionary of Art* (Oxford University Press, Oxford, 1996), vol.30, E. Ruhmer, 'Hans Thoma', pp.739–40.

Paul Cézanne
(1830–1906)

*Self-portrait, c.*1880
Oil on canvas, 336 x 260mm (13¼ x 10¼")
The National Gallery, London

Paul Cézanne was the forerunner and prime inspiration for a new kind of modernist classicism that came into being during the decade before the First World War. Following the revelation of Cézanne's first one-man exhibition at Ambroise Vollard's gallery in Paris in 1895, his influence over the younger generation of artists grew all-pervasive. Matisse and Picasso were his most renowned acolytes. 'Cézanne, you see, is a sort of God of painting', Henri Matisse exclaimed.[1] 'Cézanne! He was like the father of us all. It was he who protected us', added Picasso.[2]

Cézanne's achievements in portraiture were emulated in such modernist landmarks as Picasso's *Portrait of Gertrude Stein* (1906; Metropolitan Museum of Art, New York) and Matisse's *Portrait of Madame Matisse* (1913; Hermitage Museum, Leningrad); his self-portraits influenced those of Paula Modersohn-Becker (cat.38) and Derain (cat.37), and, directly or indirectly, his example informed the whole approach to painting taken by artists such as Leon Kossoff (cat.55) and Lucian Freud (cat.50).

Lawrence Gowing gave a very good description of what seems to have been the enduring legacy of Cézannism in modern art: 'Cézanne was the first man in the [Impressionist] group, perhaps the first man in history, to realize the necessity for the manner in which paint is handled to build up a homogeneous and consistent pictorial structure. This is the invention of *forme* in

the French modernist sense – meaning the condition of paint that constitutes the pictorial structure. It is the discovery of an intrinsic structure inherent in the medium and the material.'[3]

The intent, dispassionate character confronting the viewer in this self-portrait is in notable contrast to the wild-haired, gimlet-eyed bohemian Cézanne had depicted in earlier self-portraits. As Roger Fry noted of this work, 'His eyes no longer flash out a menace; he is no longer interested in what effect he may produce in others; all his energy is concentrated in that alert, investigating gaze'.[4] Indeed, the impression of intelligence radiating from the artist's brow is very striking. This is one of Cézanne's most celebrated self-portraits, and has come to exemplify his classic style.

Although the picture is quite small, Cézanne invests it with a sense of density and monumentality. He has maximised the tension of the curve of his bald dome by flexing it against the massive opposing curve of the shoulder, and the ensuing visual tension is offset by, and released through, the looser curve of the shirt front. The rough-hewn blockiness of the image is echoed in miniature by rugged, square brushstrokes and reinforced by the sombre, rocky colouration.

Distortions in the wallpaper pattern alert us to Cézanne's quest for visual order and synthesis. The pattern has been edited down to only what is strictly useful to the composition. The diamond motifs and their

interconnecting struts have been enlarged, diminished, emphasised, softened and frayed, or eliminated entirely; the diamond shape has served Cézanne as a subtle means of connecting the foreground and background. The pointed shadows of the ear and the eye socket, the bridge of the nose, the zigzag of the lapel, the lines of the moustache and beard, the individual diagonal brushstrokes and diamond-shaped clusters of brushstrokes all become implicated with the wallpaper pattern, and vice-versa. Despite the painting's overall appearance of simplicity and sobriety, its colour structure is complex and dynamic. Cézanne creates a balanced, harmonious composition by inventing intricate, ingenious systems of correspondence: in his own words, 'The whole thing is to put in as much rapport as possible'.[5] TM

1 Henri Matisse, 'Entretien avec Jacques Guenne' (1925) in *Écrits et propos sur l'art*, ed. Dominique Fourcade (Hermann, Paris, 1992), p.84.
2 Pablo Picasso, quoted in Brassaï, *Conversations avec Picasso* (Gallimard, Paris, 1997), p.125.
3 Lawrence Gowing, 'The Early Work of Paul Cézanne', in *Cézanne, The Early Years 1859–1872* (Royal Academy of Arts, London, 1988), p.10.
4 Roger Fry, *Cézanne: A Study of His Development* (University Press, Chicago, 1989 [1927]), pp.53–4. Roger Fry painted a famous copy of this self-portrait, now in the Courtauld Institute, London. There is also a drawing based on it by Juan Gris: see: John Rewald, *The Paintings of Paul Cézanne, A Catalogue Raisonné*, 2 vols (Abrams, New York, 1996), vol.2, p.321.
5 Cézanne, letter to his son, 14 August 1906, in Paul Cézanne, *Correspondence*, ed. John Rewald (Bernard Grasset, Paris, 1978), p.321. There is a drawing in the Cincinnati Art Museum, *Self-portrait and apple* (Chappuis 406), that relates directly to this painting. In it, a system of visual rhymes based on the curves of the apple substitutes for the diamond motif.

Sabine Lepsius
(1864–1942)

Self-portrait, 1885
Oil on canvas, 840 x 635mm (33⅛ x 25")
Staatliche Museen zu Berlin,
Nationalgalerie

Born in Berlin in 1864, the only daughter of Gustav and Franziska Graef, who both trained as painters, Lepsius first studied in Berlin under Carl Gussow. She was twenty years old when she entered Gussow's school for women artists, receiving her early training in this atelier, with about sixty other female students, between 1884 and 1886. She later wrote of Gussow that 'one could not learn anything from him but craft, but nobody taught this as well as he'.[1] This self-portrait, completed when Lepsius was just twenty-one and still working under her maiden name, was her first significant painting. It was clearly intended to function as a manifesto image of the artist in her new professional identity as a painter – which in the 1880s was still an unconventional ambition for a bourgeois woman.

Lepsius represents herself standing, half-length, holding the traditional painter's attribute of a palette. The focus of her quietly dressed and posed figure is a gracefully inclined head, an unsmiling but sensuously half-open mouth and heavy-lidded, half-closed eyes. Gustave Courbet's self-portraits also feature closed or half-closed eyes (see cat.29): his shadowed, unfocused eyes and sensuous lips can be interestingly compared with Lepsius's romantic self-depiction here.

On more than one occasion Lepsius posed for her father as a shepherd boy, and was photographed striking jaunty attitudes, her hair tucked up in her hat.[2] She was proud of her ability to disguise herself as a boy, even venturing out on the streets in trousers, properly accompanied by her maid, to covertly indulge the freedoms usually denied to women of her class. Her boyish hairstyle here is uncommon for a woman at this period: thus she hints at a desire to play at being a boy and to throw off the constraints imposed on women in contemporary society.

A male role model for her self-depiction here may have been Caravaggio's *Saint Matthew with the Angel* (1602), a work formerly in the Kaiser Friedrich Museum, Berlin (destroyed in 1945), where Lepsius probably knew it well: the pose, lighting and facial features of Caravaggio's androgynous inspiring angel are echoed in her ambitious self-conception as the inspired and inspiring artist/muse of her own portrait.[3]

Dorgerloh records the enthusiasm with which Lepsius embraced male disguises, especially the role of the Italian shepherd boy, invoking one of the most enduring artist myths: that of Giotto, the humble shepherd boy who was discovered to be an artist-genius.[4] Her father gratifyingly signalled his acceptance of Sabine as artist and equal by displaying her self-portrait in the foyer of his studio. In 1892 she married Reinhold Lepsius, also a painter. She continued to work as an artist after her marriage and the birth of her children: her last work, another self-portrait, was a direct, unromantic depiction of the artist in old age, painted in 1941, the year before her death.

UP

1 Lepsius quoted in Dorgerloh 2003, p. 65 (trans. Arnaldo Buch, Sydney).
2 Two photographs labelled 'Sabine Graef als Hirtenknabe', taken on the balcony of her parents' apartment in the 1880s, are reproduced in op. cit. p.76.
3 Op. cit. p.75. In a letter to Reinhold Lepsius of February 1892 Sabine writes that she dressed as a man for a masquerade ball, and 'natürlich sah ich sehr echt aus und für einen Jungen ordentlich hubsch'.
4 See op. cit. pp.71–2.

Literature
Dorgerloh 2003, pp.61–85.

Vincent van Gogh
(1853–90)

Self-portrait with Felt Hat, 1888
Oil on canvas, 440 x 375mm (17⅜ x 14¾")
Van Gogh Museum, Amsterdam
(Vincent van Gogh Foundation)

'What impassions me most, much, much more than all the rest of my work is the portrait, the modern portrait.'[1] Vincent van Gogh is to the modern portrait what his countryman Rembrandt van Rijn (cat.16a) was to the Old Master tradition. The legend of his tragic, solitary personality resonates through his self-portraits and feeds the immense fame of his art and reputation as chief 'martyr' of modernism.[2] In his quest to become a modern artist, van Gogh moved to Paris in 1886–8. Lacking the funds to pay for models, he resorted to self-portraiture, painting himself more than twenty times over the next two years.

Living with his art dealer brother, Theo, in Montmartre and taking life-drawing classes at Fernand Cormon's atelier in 1886, in his earliest self-portraits van Gogh maintained the dark mahogany tones of Rembrandt's work which he now studied in the Louvre. Over the next two years he increasingly used himself as the model for experiments in his 'anti-academic' painting techniques associated with Impressionism, which he equated with a more sincere or truthful way of working. He explained his new method thus: 'Instead of trying to reproduce exactly what I have before my eyes I use colour arbitrarily to express myself forcibly.' Completed over the winter of 1887–8, *Self-portrait with Felt Hat* is one of the last he painted in Paris. Flaunting a vibrantly prismatic palette and energised brushmarks, this work alludes to Cézanne and the Impressionists as well as to

Rembrandt, who were the touchstones of his mature identity as the creator of a visual language emphatically of its time.

Van Gogh's Parisian self-portraits show the artist in many moods and guises. In all his portraits clothing exerts a special power: certain hats, jackets, even old pairs of shoes compel his images. Hats signify class and occupation and imply something of the wearer's personality. Here he wears a hat belonging to Theo: he appears as a contemporary urban dweller, not as an artist holding the tools of his trade or wearing the painter's straw hat or peasant smock of his other portraits from this series. Theo reported that Vincent was so changed in Paris that his mother would not recognise him: new clothes, trimmed beard – he had even visited a dentist – suggesting a new sense of identity grounded in his profession and a new optimism regarding his potential to 'produce and to be something'.[3]

However, his early hopes for achieving professional success in the city had evaporated by the time he painted this work: 'When I left Paris seriously sick at heart and in body, and nearly an alcoholic because of my rising fury at my strength failing me – then I shut myself up within myself.' His face records the tension of his intense self-scrutiny. Yet van Gogh's self-portraits (like Rembrandt's before him, cf. cat.16a) hide private concerns as often as they mirror them: his face a painted mask, pierced by red-rimmed, green-flecked eyes.[4] The vibrant 'halo' of energy pulsing around him

betokens his persistent faith in the exceptional destiny of artists and his conviction that a portrait can penetrate the soul, where the camera cannot reach. He said he wanted to give his portraits 'that something of the eternal which the halo used to symbolise'.

His style of execution – a staccato frenzy of hatched brushstrokes – is now regarded as the defining aspect of his art. The jagged brushwork introduces a discordant energy into his self-portraits. It is as if he sought in the resistance offered by his materials (the rough-textured, absorbent canvas that soaked up the medium and made applying the paint difficult) a physical expression of the inherent difficulties of existence, as well as those of defining and fixing his identity in art. He later wrote to Theo from the asylum of St Remy: 'It is difficult to know yourself, but it isn't easy to paint yourself either.'

UP

1 Artist quotes all from Van Gogh Letters, by permission of the Van Gogh Foundation.
2 Picasso said that van Gogh was his 'patron saint in painting. Because of his paintings which were so tied to life. All at once radiance and suffering' (quoted in Helene Parmelin, *Voyage en Picasso* (Christian Bourois Editeur, Paris, 1994), p.29.
3 Theo's letter to their mother (July 1886) see Dorn 2000, p.83.
4 See George T. M. Shackelford, 'Van Gogh in Paris', in Dorn 2000, pp.87–125.

Literature
Dorn 2000; J. Hulsker, *The New Complete Van Gogh: Paintings, Drawings, Sketches. Revised and Enlarged Edition of the Catalogue Raisonné of the Works of Vincent van Gogh* (J.M. Meulenhoff, Amsterdam, 1996); Van Gogh 1958.

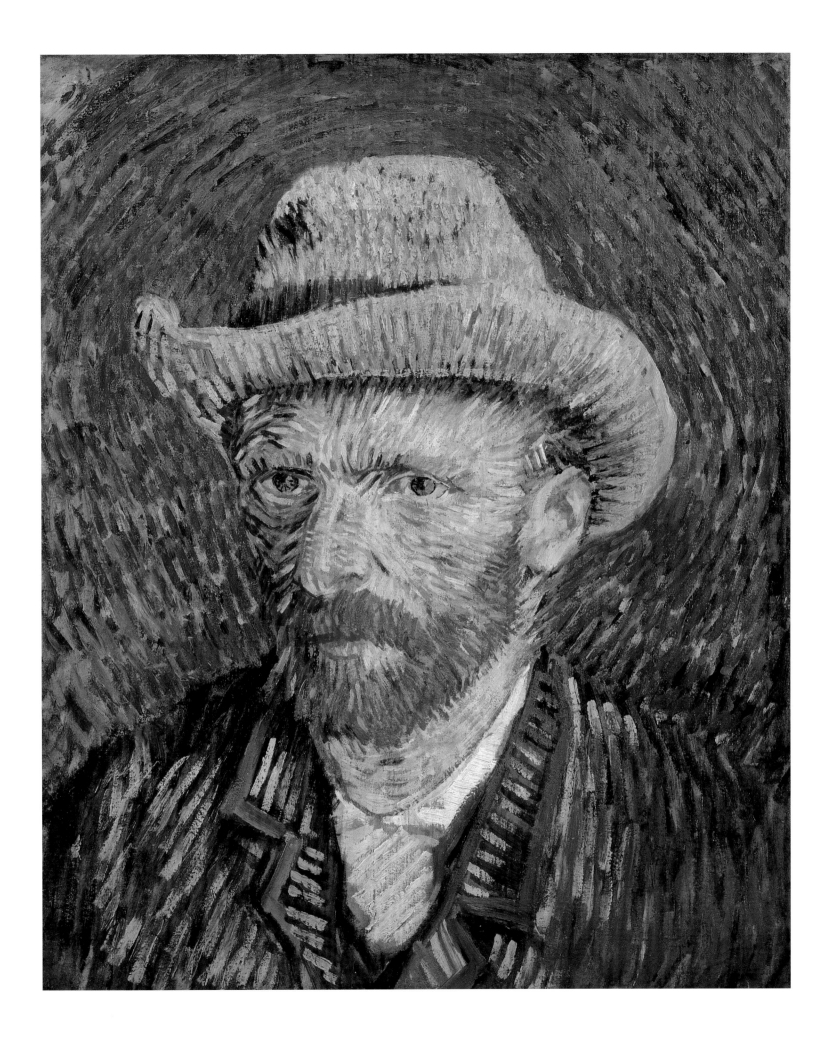

153

35

James McNeill Whistler
(1834–1903)

*Gold and Brown: Self-portrait, c.*1896–8
Oil on canvas, 624 x 465mm
(24½ x 18¼")
National Gallery of Art, Washington DC,
Gift of Edith Stuyvesant Gerry

American-born James McNeill Whistler was trained in France but based in England for most of his working life. His famous painting *Arrangement in Grey and Black: Portrait of the Painter's Mother* (1871; Musée d'Orsay, Paris), familiarly known as 'Whistler's Mother', has been compared with the work of Velázquez for its unusual technique: the pigment is scraped, rubbed or wiped away in parts to reveal the canvas-weave. At first audiences were puzzled, for this was the first portrait Whistler exhibited as an 'arrangement' of colours (at the Royal Academy of Arts, London, in 1872); but by 1884 the French symbolist writer and critic Joris-Karl Huysmans wrote of its mysterious power, 'the compatibility of the grey and truly inky black'.[1] In 1891 it was the first work acquired from the artist for the French State (for the Musée du Luxembourg), and in 1892 the flamboyant American was awarded the Légion d'Honneur – its ribbon appears in this self-portrait, a bright spot of red on his otherwise dark clothing emerging from the sombre shadows.

Whistler's instinct for delicacy of touch, shadowy depths and richly nuanced silences characterises his late self-portraits. In the mid-1890s, when this work was painted, he was working on three half-length self-portraits in his Fitzroy Street studio (this one and two related studies) and one full-length, *Brown and Gold* (1895–1900); all but the present work are now in the Hunterian Gallery, Glasgow. This was the most harrowing period of the artist's life: his wife, Beatrice ('Trixie'), was fatally ill. She died in May 1896, leaving him distraught: 'The days are filled with dragging work … and the

nights are not filled with sleep', he wrote.[2]

The present work is, according to his sister-in-law, the portrait 'Whistler wanted to be remembered by'. In dark-toned Rembrandtesque painting he reveals the inner as well as the outer man: the face and hands emerge, loosely brushed, almost ghostly, under a dim and moody light; turning to look in the mirror, Whistler has an air of 'searching self-scrutiny'.[3] His tremulous expression is weary and melancholy, the rim of his 'trademark' monocle just catching the light, his eyelids drooping. But his carriage is still proudly upright: Whistler presents himself to his public as a man who has mellowed, an artist of substance and gravity, but still a man who was a dandy all his life, always concerned with presenting a stylish impression. Arthur Symons recalls the artist at this time:

I never saw anyone so feverishly alive as this little, old man, with his bright withered cheeks, over which the skin was drawn tightly, his darting eyes … his bitter and subtle mouth, and above all, his exquisite hands, never at rest. He had the most sensitive fingers I have ever seen, long, thin, bony, wrinkled, every finger alive to the tips, like the fingers of a mesmerist. He was proud of his hands, and they were never out of sight … If ever a painter had a painter's hands it was Whistler.[4]

Yet in spite of his carefully cultivated impression of fluency, his lightning wit and dandyish affectations, Whistler did not find painting easy. In 1896 an artist friend,

Walter Savage Landor, a regular observer in the Fitzroy Street studio, wrote:

few realized that no man ever had so much difficulty … He gradually got to absolute perfection in his pictures after an immense amount of labour, doing and undoing until every part of the picture was exactly as he wished. He knew quite well when things were wrong … That is why, when he felt that his vision could not distinguish any more how defects could be remedied, he placed the pictures face to the wall for months before he would work on them again.[5]

Whistler required endless sittings before he was satisfied that he had captured a sitter's true likeness and character: in private he was always less confident than his public image projected. His deep-rooted self-doubt and the searching, experimental nature of his art combine in his late self-portraits to reveal Whistler as one of the most fascinating and complex figures in nineteenth-century painting. UP

1 Huysmans, *La Revue Independent*, 1884, quoted in Dorment 1994, p.143.
2 Whistler to William Heinemann, 1899: Dorment 1994, cat.205, p.285.
3 Dorment, op. cit. p.284.
4 A. Symons, 'Whistler and Manet', in *From Toulouse-Lautrec to Rodin* (1968), quoted in Weintraub 1974, p.424: 'At Whitehall Court dinners Arthur Symons saw a Whistler now ravaged by age, in his sixty-third year but looking much older.'
5 Landor's reminiscences from A.H. Savage Landor, *Everywhere* (1924), quoted in Weintrub 1974, p.427.

Literature
Richard Dorment and M.F. Macdonald, *James McNeill Whistler* (Tate, London, 1994); Stanley Weintraub, *Whistler: A Biography* (Weybright & Talley, New York, 1974).

36

Lovis Corinth
(1858–1925)

Self-portrait with Model, 1903
Oil on canvas, 1210 x 890mm (47⅝ x 35")
Kunsthaus, Zürich

Corinth studied at Königsberg, Munich and Antwerp academies before finally moving to the Académie Julien in Paris in 1884. In Antwerp he formed a great admiration for the painting of Rubens, Jordaens and Rembrandt. Many of his later paintings hark back to Rubens and even when he is at his most academic (revealing the influence of his teacher, the well-known academic painter Adolphe-William Bouguereau) he reveals a freshness of paint quality that has its roots in this tradition. While in Munich he saw works by Barbizon masters, including Courbet.[1]

In 1887 Corinth returned to Königsberg, and from there moved for a while to Berlin. At that time the Berlin Academy of Art dominated the official art scene and was hostile to the modern tendencies Corinth had encountered in France. In the early 1890s he experimented with various styles in works such as his *Portrait of Benno Becker* (1892; Von der Haydt Museum, Wuppertal), which is a little like Manet's portrait of Zola, while his *In the Slaughterhouse* (1893; Staatsgalerie, Stuttgart) exhibits an expressive brushwork that matches the gestural freedom of many of his later paintings. Painted the following year, his *Fishermen's cemetery at Nidden* (Staatsgemaldesammlungen, Munich) adopts an International Impressionist style. In Berlin Corinth would have encountered works by artists such as Arnold Böcklin, Hans Thoma and Max Klinger, contributing to his use of symbolism, particularly in his graphic works.

Corinth was a prolific self-portrait artist with no fewer than forty-two recorded paintings of himself, as well as many drawings and prints. In nearly all of these he adopts a theatrical role, often incorporating the use of elaborate costume, a favourite being the armour of a medieval knight that he kept in his studio. Sometimes he uses the role of the knight in an explicit reference to Rubens and Arnold Böcklin, such as when he poses as Perseus in his *Perseus and Andromeda* (1900; Schäfer collection, Schweinfurt) after Rubens's *Perseus Liberating Andromeda* (1640; Prado, Madrid) or Böcklin's *Angelica and the Dragon* (1873; Alte Nationalgalerie, Berlin). In one self-portrait Corinth poses with a skeleton, creating a vanitas image in the manner of Böcklin.[2] He often appears with wine glass in hand, sometimes his wife Charlotte's bare breast in the other and his clothes loosened in true Bacchic style, and in other works he actually dresses up as Bacchus, with grapes over his ears. These portraits all suggest a bohemian lifestyle and bacchic inspiration for Corinth's creativity.

In the present self-portrait Corinth stands in a sober, protective role, with Charlotte turning away from us and seeking comfort from her husband, while also gently supporting him. She is positioned between the artist and the canvas that replaces the mirror: the band at the base of the composition, with its motif of winged figures, may be read as the frame of the mirror. Corinth looks over Charlotte's shoulder at their reflection in the mirror and beyond, to meet the eyes of the viewer. He holds his palette in the hand that protectively enfolds her naked shoulder, while his other hand is poised to continue applying paint to the plane that is both mirror and canvas. AB

1 Horst Uhr, *Lovis Corinth* (University of California Press, Berkeley, CA, 1990), pp.28–39.
2 These relations are brought out well in the focus publication by Sigrid Bertuleir, *Lovis Corinth, Der Sieger: zum Gamalde 'Perseus und Andromeda'* 1900 (Museum Georg Schafer, Schweinfurt, 2004).

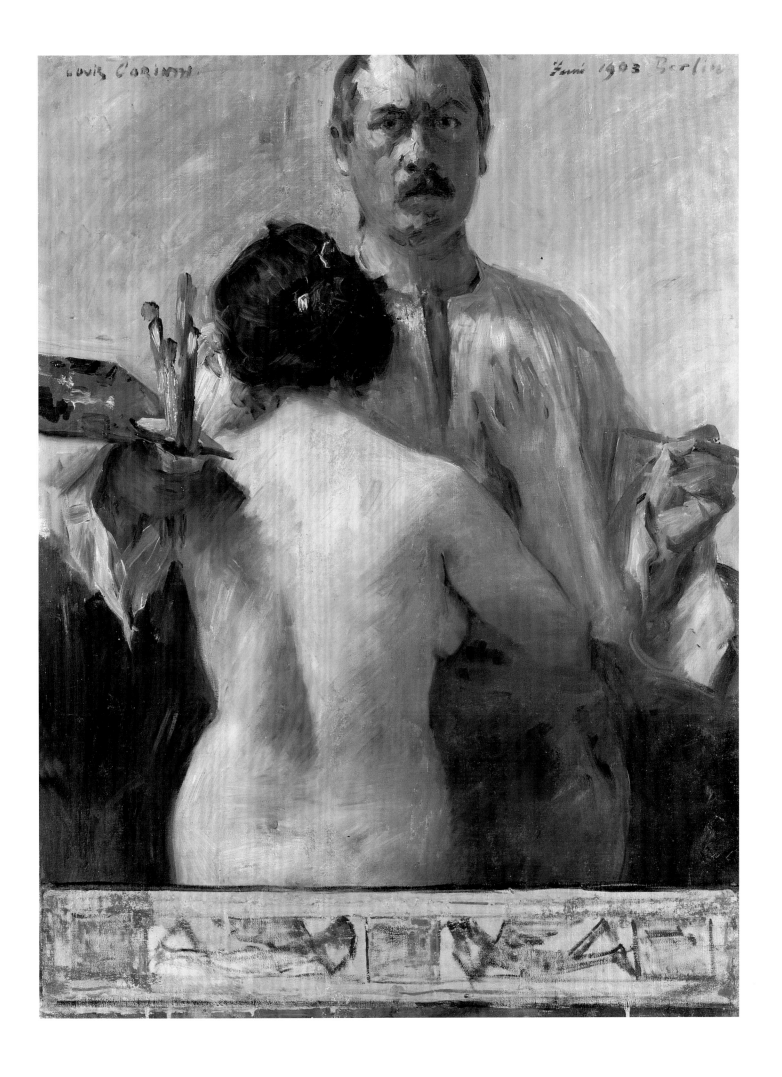

37
André Derain
(1880–1954)

*Self-portrait in studio, c.*1903
Oil on canvas, 422 x 346mm (16⅝x 13⅝")
Purchased 1981, National Gallery of Australia
Sydney only

André Derain was a complex and elusive character who frequently changed his style. His early career and avant-garde reputation reflected his shifting attraction towards the twin polarities of modern art of his time: Matisse and Picasso. Derain first came to prominence in 1905, as a member of the Fauve group led by Matisse. From 1907, through his friendship with Picasso, he turned towards Cubism, reinforcing his long-standing interest in primitive art.

As a very young man Derain painted with Maurice de Vlaminck at Chatou, a small town on the Seine just outside Paris. Legend has it that they met in 1900, on a train that had derailed. Together they rented a disused restaurant as a studio on the Ile de Chatou, and painted the local landscape. Vlaminck had no formal art training, but attacked his paintings with a ferocity and reckless spontaneity that captivated Derain. While studying art in Paris, Derain registered to copy at the Louvre and also painted from life at Camillo's Academy. Matisse attended some classes there and was intrigued by the silently watchful 18-year-old Derain: 'he interested me ... we began to talk'. Matisse was at this time heavily influenced by Cézanne's bathers, executing his nudes in bold slabs of crimson, green and purple paint.[1]

In March 1901 an exhibition of van Gogh paintings opened at Bernheim-Jeune's gallery on the rue Laffitte. Derain was excited by the work and introduced Vlaminck to Matisse there. Matisse initially mocked Vlaminck's reputation as a 'big-mouth and bad hat' type, but was impressed by the paintings he saw when he visited their studio.[2] Derain and Vlaminck were experimenting with electric reds. Matisse, who had learnt to trust his instincts, was reassured to discover that two younger men had independently reached the same point. Later that year Derain was called up for three years of compulsory military service. He wrote many letters to Vlaminck reporting his frustration at leaving Paris for the boredom and brutalisation of life in barracks at Commercy. These letters show his love of books and intellectual problems, and his approach to art based on intuitive, individual sensations, with views on unity, intuition and primitivism close to Matisse's.

His *Self-portrait in studio* was painted during this period of military service, probably while Derain was on leave in Chatou.[3] Using staccato, angular shapes, he rapidly indicates the main features of the figure and ground. A zigzag of black and green defines the painter's face. There is a startling alternation of bold tonal contrasts and even bolder slashes of primary colour, applied in impastoed streaks. Looking into a mirror, Derain records himself actively at work (in mirror-image): dramatically extending his left hand, he holds the paint-smeared palette in his right. The darker half of his body forms a diagonal axis around which the pictorial structure pivots. Legs apart, he accents his unstable stance with a vivid slash of vermilion, drawing attention to the dynamism of his matador-like painting action. His energetic technique and determined self-representation define his artistic identity as a 'combative' modernist – rather than the combat soldier dictated by fate.[4]

From their initial meeting Derain and Matisse had 'responded to an answering boldness in each other'. Anticipating Fauvism, their cursory, abbreviated pictures erupt with colour. This early self-portrait heralds Derain's ambitions as a painter: as he wrote to Vlaminck, 'I believe the Realist period is over... we have only just begun ... Apart from van Gogh's abstract pictures, I believe that colour and lines are enough ... to enable us to discover a simpler form of composition.'[5] UP

1 Their teacher, Carrière, is supposed to have asked Matisse: 'what would you do if you had a parrot to paint?' Matisse replied: 'But I haven't got a parrot.' See Hilary Spurling, *The Unknown Matisse* (Hamish Hamilton, London, 1998), p.195: Matisse on meeting Derain.
2 Op. cit. p.223.
3 Because of his military service, the dating of Derain's early works is uncertain, but this painting is generally thought to have been completed in 1903. See Lloyd and Desmond 1992, p.92.
4 Judi Freeman points out typical aspects of his later style that are already present here: 'the progression from blues to oranges to reds visible on his palette' that would reappear in later Fauve works (1995, p.58).
5 Derain letter to Vlaminck October 1901, quoted in Gaston Diehl, *Derain* (The Uffici Press, Milan, n.d.), p.25.

Literature
Michael Lloyd and Michael Desmond, *European and American Paintings and Sculptures 1870–1970 in the Australian National Gallery* (National Gallery of Australia, Canberra, 1992), p.92; Judi Freeman, *Fauves* (The Art Gallery of New South Wales, Sydney, 1995); Denys Sutton, *André Derain* (Phaidon Press, London, 1959); Maurice Vlaminck (ed.), *Lettres à Vlaminck* (Paris, 1955).

38
Paula Modersohn-Becker
(1876–1907)

Self-portrait, 1906
Oil on cardboard, 457 x 297mm (18 x 11⅝")
Haubrich Collection, Museum Ludwig,
Cologne
London only

Paula Modersohn-Becker began her career in 1898, joining a Barbizon-style artist colony at Worpswede near Bremen where she took her first drawing lessons. She married another Worpsweder painter, Otto Modersohn, in 1901. Disillusioned by the lack of freedom and stimulation of married life in Worpswede, she escaped for increasing periods to Paris, which she called 'the world'. For a year before her death she settled in a small studio on the avenue du Maine, where she wrote to her estranged husband on 27 February 1906, 'I begin my life'.[1] He later followed her to Paris and persuaded her to return to Worpswede with him in the spring of 1907. That November she died of an embolism after the birth of her first child, when she was just thirty-one.

In the last two years of her life Modersohn-Becker made her boldest strides towards an original artistic identity, even painting nude self-portraits (possibly the first ever painted by a woman artist). A self-portrait from 1906, *Self-portrait with Amber Necklace* (Kunstmuseum, Basel), in which she depicted herself nude with a flower between her breasts, is highly symbolic and admired for its lapidary colour and strongly planar structure. She had absorbed the lessons of French modernism to emerge as one of the most advanced artists of her day. Her most striking works, apart from her self-portraits, are her mother and child images.

Paris changed her. Influenced and stimulated by her discoveries – such as the Roman-Egyptian mummy portraits from

Fayum in the Louvre, visits to dealer galleries such as Vollard's (where she encountered the work of Cézanne, van Gogh and Gauguin), through her visits to the studios of contemporary painters Vuillard and Denis, and meeting the sculptor Maillol – she was encouraged to seek permanence, structural clarity and monumentality in her art.

In 1906, when she painted this self-portrait, Modersohn-Becker wrote optimistically from Paris to her sister, 'I'm going to be something – I am experiencing the most intense, happiest time of my life'.[2] She produced a number of powerful self-portraits during this year, characteristically treating her face as a mask, highlighting her large, almond-shaped eyes and simplifying and enlarging the broad planes of her nose, forehead and cheekbones, rendered as interlocking surfaces of dense colour.[3] Framed by the twin simplified arcs of her severely parted brown hair, Modersohn-Becker's oval face and intense, dispassionate gaze call to mind the portraits of Cézanne (cf. cat.32), her technique echoing the pasty, thickly impastoed surfaces characteristic of some of his early works.[4] Furthermore, with its dominant, dark, staring eyes, Modersohn-Becker's portrait has something of the memorial gravity of the Fayum portraits in the Louvre,[5] and its primitivism and sculptural simplicity can also be compared to Picasso's portrait of Gertrude Stein (1906; Metropolitan Museum of Art, New York) and images influenced by Iberian sculpture he painted in Paris in the same year. Modersohn-Becker was also aware of

Matisse's work: the patches of colour that mark her face here recall Matisse's notorious Fauve portrait, *Woman with a Hat* (Museum of Modern Art, San Francisco, bequest of Elise S. Haas) of 1905.

Throughout her brief but productive career, Paula Modersohn-Becker painted herself in many moods and guises: for her, the question 'how do I look?' engaged an inherent need for self-definition and a search for her own style, her resilience and independence. As Rainer Maria Rilke wrote in his *Requiem for a Friend*, a year after her untimely death, she depicted bowls, women, children and herself, 'moulded from inside, into the shapes of their existence'.[6] UP

1 Busch and von Reinken 1990, pp.386, 542–3; see also her letter to Rilke of 17 February 1906: 'I am not Modersohn and I am not Paula Becker anymore either. I am Me and I hope to become Me more and more' (p.384).
2 May 1906 letter to Milly Rohland-Becker, Busch and von Reinken 1990, p.395.
3 As in many of her self-portraits, she wears an amber necklace here: she seems to have favoured such earthily natural jewellery with its folk associations.
4 Letter to Clara Rilke-Westhoff, October 1907: 'I think and thought much about Cézanne ... he was one of three or four powerful artists who affected me like a thunderstorm ... Do you remember what we saw at Vollard in 1900? And then, during ... my last stay in Paris, those astonishing early paintings of his at the Galerie Pellerin' (see Busch and von Reinken 1990, p.425).
5 Busch identified the influence of Coptic mummy portraits from Fayum on her last self-portrait on panel, *Self-portrait with Camellia Branch* (1907; Museum Folkwang Essen). See G. Busch et al. (eds), *Paula Modersohn-Becker: Zum Hundertsten Geburtstag* (exh. cat., Kunsthalle, Bremen, 1976).
6 Rilke also writes here: 'I'll remember you as you placed yourself within the mirror, deep within and far from us all...'.

Literature
G. Busch and L. von Reinken (eds), *Paula Modersohn-Becker: The Letters and Journals*, trans. A. Wensinger and C. Hoey (Northwestern University Press, Evanston, IL, 1990); G. Perry *Paula Modersohn-Becker: Her Life and Work* (The Women's Press, London, 1979); E. Oppler, 'Paula Modersohn-Becker: Some Facts and Legends', *Art Journal* 35, no.4 (1976), pp.364–9.

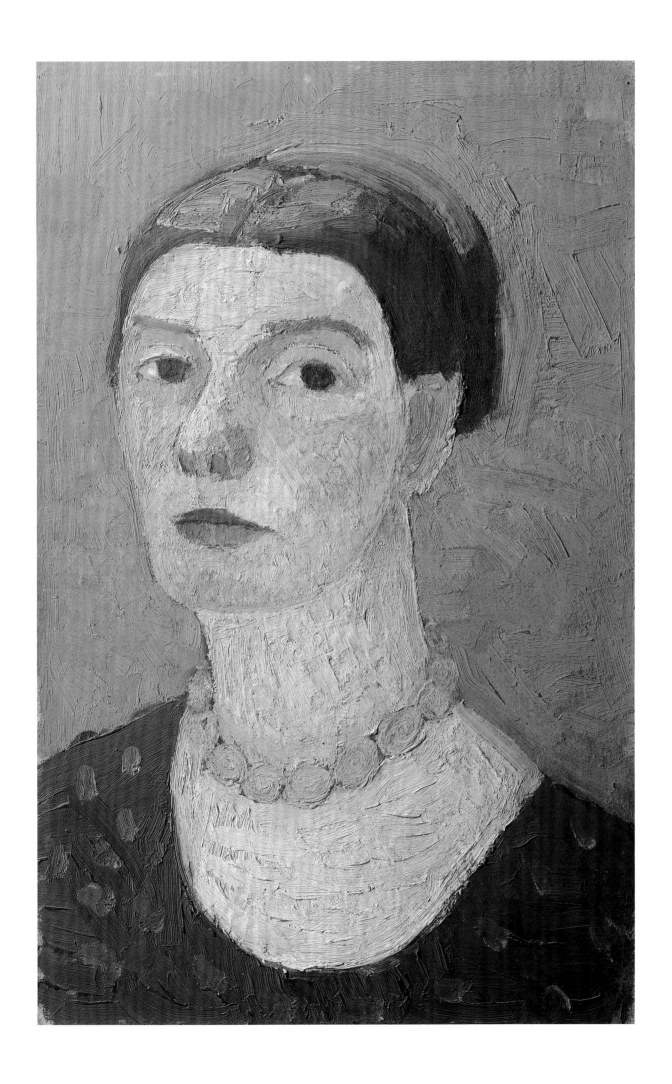

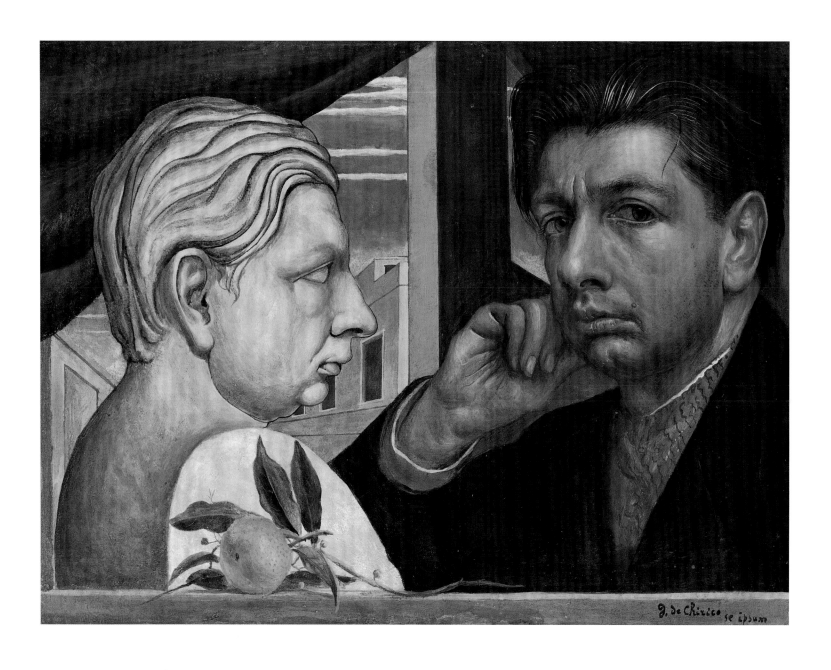

39
Giorgio de Chirico
(1888–1978)

*Self-portrait, c.*1922
Oil on canvas, 384 x 510mm (15⅛ x 20⅛")
Toledo Museum of Art, Purchased with
funds from the Libbey Endowment,
Gift of Edward Drummond Libbey
London only

As a young man de Chirico studied at the Munich Academy where he was strongly influenced by Max Klinger and the Symbolist painter Arnold Böcklin.[1] Born of Italian parents in Greece, where he spent his early years, de Chirico returned to his homeland in 1915 as a result of the First World War. He was very much an urban dweller and his most successful early works were painted around the subject of the city. He returned regularly to certain stock images, often representing actual buildings, objects and scenes remembered from his youth, such as steam engines cutting a swathe through urban landscapes, towers, empty squares, colonnades, and lone sculptures. He first showed his stark, deserted cityscapes, which became known as '*Pittura metafisica*', in Paris in 1911; they were met with enthusiasm by such members of the art world as Picasso and Paul Eluard.

De Chirico's work seemed at first to be a form of modernism; yet the Surrealists later embraced him as a precursor to their work, until he turned violently against them and all modern art. The metaphysical quality of his paintings arises from their simplification and the absence of people and daily life: his canvases are more like spaces awaiting population by memories, whose effect can easily be associated with notions of alienation in the modern world. De Chirico seemed to have a very different view of his place in the world from other people's, and perhaps because of his failure to win favour with the avant-garde he claimed to be a classical painter and wrote vicious diatribes condemning everything in modern art.

After about 1918 he turned increasingly to classical themes, often copying the work of Old Masters such as Rubens and Titian; he later even began systematically copying his own early work. He produced a series of catalogues raisonnés with volumes for each decade, in each of which the works are virtually identical to those in the previous one. This may be interpreted as a reaction against the modernist rhetoric of originality – indeed, several post-modern appropriationists have taken de Chirico as a very early precursor for their project.[2]

This self-portrait is fascinating for its pictorial references. The artist has inscribed '*se ipsum*' below his signature – that is, '[de Chirico] himself'. He is posed in the reverse manner of Baldassare Castiglione, the gentleman in Titian's famous *Portrait of a Man (Ariosto)* (*c.*1512; National Gallery, London) so often referred to by Western artists. The inscription is written across the bottom of the composition, as if on a window ledge. Here there is also a small still-life group, possibly a classical reference to the skilled illusions of the Greek painter Zeuxis, who tempted the birds to his painted grapes. Facing the artist is a sculpted bust of himself, the truncated shoulder catching the light to create a highlighted frame for the still life. The inclusion of a sculpture in the composition is a common theme for de Chirico, dating from his metaphysical paintings before 1918. In the present painting the use of the stone bust of the artist doubles the self-portrait, perhaps suggesting the notion of reflection underlying the Narcissus myth. The real de Chirico 'himself' regards the stone image of himself, suggesting layers of representation and undermining the concept of an authentic likenss. The cityscape glimpsed in the background refers back to de Chirico's earlier metaphysical works. AB

1 Robert Hughes, 'Giorgio de Chirico', in *Nothing If Not Critical: Selected Essays on Art and Artists* (Alfred A. Knopf, New York, 1990), pp.160–4.
2 Notably in Australia, Imants Tillers not only quotes de Chirico's compositions and style, but is an enthusiastic collector of information on the artist, to the point of being the pre-eminent de Chirico scholar in Australia. Tillers also owns the sets of catalogues raisonnés referred to above. In the early 1980s in London several artists graduating from the Royal College of Art, e.g. Graham Crowley and Tim Jones, show de Chirico's influence in their work.

Suzanne Valadon
(1865–1938)

The Blue Room (La chambre bleue), 1923
Oil on canvas, 900 x 1160mm (35⅜ x 45⅝")
Centre Georges Pompidou, Paris.
Musée national d'art moderne

Suzanne Valadon's remarkable life placed her outside the boundaries of bourgeois respectability. Born Marie-Clémentine Valadon in a small French village, the illegitimate daughter of a domestic labourer, she became an artist's model in Montmartre during the 1880s, her face and body immortalised in a number of significant works.[1] Valadon's fearlessly independent, vivacious intelligence contributed to her appeal as a model. She was very much the modern woman, a feature of her independent spirit as an artist: 'I paint with the stubbornness I need for living, and I've found that all painters who love their art do the same.'[2]

Dissatisfied with the passive role of model, Valadon was determined to be an artist, learning her craft by observing male artists at work in the studios where she posed. She produced her first self-portrait in 1883, aged eighteen and already the mother of an illegitimate son, Maurice Utrillo (whose later reputation as an artist would for a time overshadow her own). Her portrait, in pastel, was signed 'Suzanne Valadon', the professional name she adopted to signify her newly acquired identity; she continued to work as 'Maria' when posing. Embracing shifting identities, as an actress switches roles, she was the first to combine successfully the careers of model and painter.

Degas was one of her earliest important patrons, and purchased some of her drawings from the 1894 Salon de la Société Nationale des Beaux-Arts in Paris. Valadon's participation in this exhibition was remarkable for many reasons: she was completely untrained, she was a woman, and the female nude was the subject of her art – something no respectable bourgeois woman painter would have attempted.

Indeed, she and Modersohn-Becker (cat.38) were two of the first women artists to portray the female nude; both also painted nude self-portraits. Clearly Valadon's friendship with Degas influenced the direction of her work. He called her his 'terrible Maria', taught her to etch and paint, and permitted her to work in his studio. Like Degas, Valadon was interested in the unguarded moment: her subjects are not idealised, eroticised, timeless icons of femininity. Firmly outlined with an abrupt, edgy line ('drawn like a saw', Degas commented), these self-possessed characters contrast with and implicitly challenge the conventional representation of the nude.[3]

First shown at the Autumn Salon of 1923, *The Blue Room* is one of Valadon's best known and most characteristic works. The painting alludes to Manet's *Olympia* (1865; Musée d'Orsay, Paris) and the tradition of the *odalisque* in French art from Ingres to Matisse.[4] It also commemorates her career as an artist's model and her time as a circus performer, and harks back to the sexually free, bohemian lifestyle of a liberated woman, which she had maintained for decades. This is not a straightforward 'mirror portrait', but rather a type of 'role-playing' work, representing a glamorous ideal of her dual nature as model and independent creator. It contrasts with her later self-portrait, such as those painted after the breakdown of her long-term relationship with André Utter (she had previously celebrated their love as Adam and Eve in a daring portrait of 1910): by 1931 she was depicting herself in a starkly realistic fashion, neither desirable nor glamorous, but dispassionately reflected in a mirror, bare-breasted and alone at the age of sixty-five (see *Self-portrait with Bare Breasts*, 1931; Collection Bernadeau, Paris).

In the current work, unselfconsciously relaxed on the studio couch, Valadon slouches across richly ornamental blue draperies, wearing trousers and defiantly smoking, a fashionably dark helmet of hair confirming her sexual ambiguity and louche style. Preoccupied with her own thoughts, she disdains the spectator's gaze or anticipated criticisms: her body is frankly thickening with age, her breasts no longer firm under the pink slip, her shoulders inscribing a meatier silhouette than that of Manet's Olympia. She chooses to share her bed not with a cat or an admirer's posy, but with a pair of brightly coloured books in an exploitation of intense colours reminiscent of van Gogh, Gauguin or Matisse. In this allegorical self-portrait and manifesto picture, Valadon shows herself to be interested in a decorative aesthetic but definitely not in a decorative femininity.

UP

1 These include Pierre Puvis de Chavannes, *The Sacred Wood* (1884–6; Palais des Arts, Lyon); Auguste Renoir, *The Bathers* (1884–7; Philadelphia Museum of Art); Henri de Toulouse-Lautrec, *Young Woman at a Table, 'Poudre de riz'* (1887, Van Gogh Museum, Amsterdam).
2 Valadon quoted in Peter de Polnay, *Enfant Terrible: The Life and Work of Maurice Utrillo* (New York, William Morrow & Co., 1969), p.190.
3 Degas quoted by Rosemary Betterton, 'How do women look? The female nude in the work of Suzanne Valadon', in Hilary Robinson (ed.), *Visibly Female: Feminism and Art Today* (London, Camden Press, 1987), p.266.
4 Literally a 'slave' or 'concubine', in Western art the *odalisque* was part of Orientalist tradition depicting eroticised and idealised exotic Eastern women of the harem. Cf. Ingres, *La Grand Odalisque* (1814) and Delacroix *Women of Algiers* (1832), both in the Louvre, Paris. Matisse painted a series of *odalisques* in the 1920s (see Jack Cowart and Dominique Fourcade, *Henri Matisse: The Early Years in Nice 1916–1930* [National Gallery of Art, Washington DC, 1986] p.31).

Literature
Rosinsky 1994; Rose 1998; Patricia Matthews, 'Returning the Gaze: Diverse Representations of the Nude in the Art of Suzanne Valadon', *Art Bulletin* 73 (September 1991).

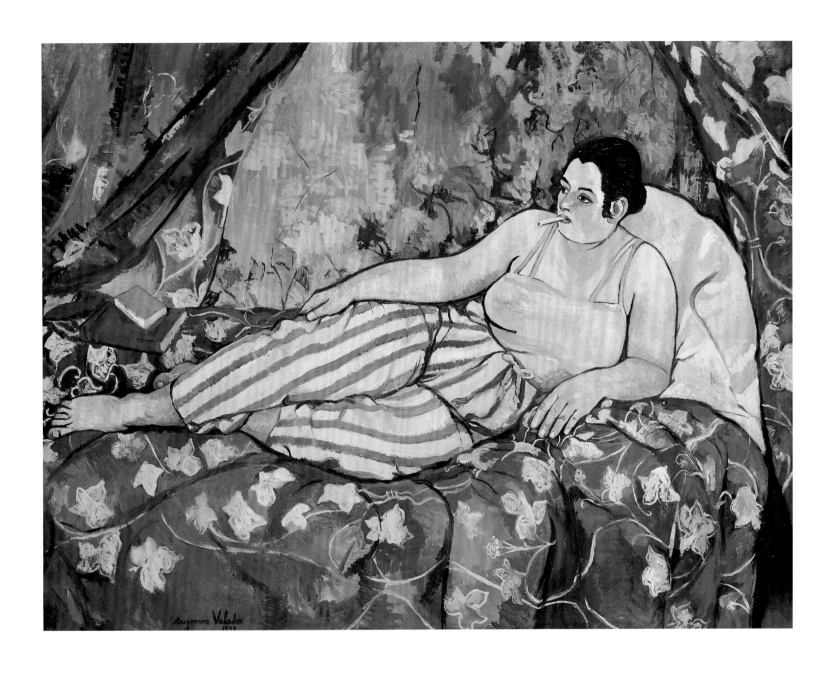

165

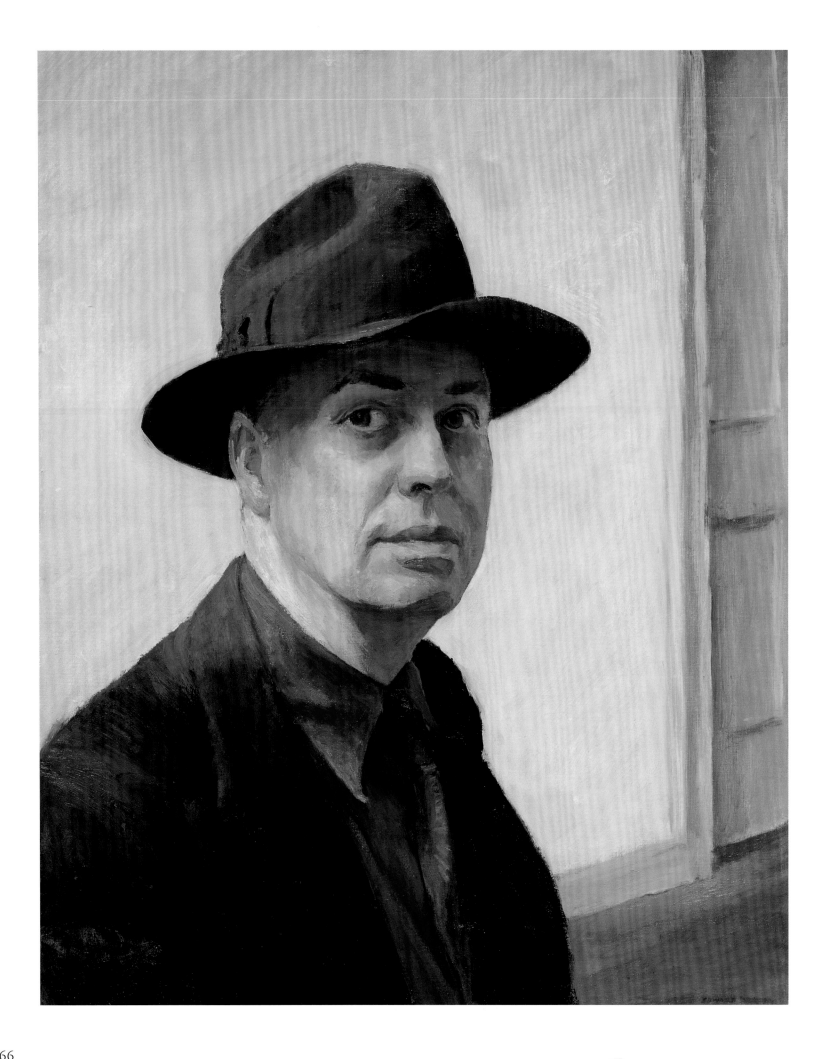

41
Edward Hopper
(1882–1968)

Self-portrait, 1925–30
Oil on canvas, 641 x 524mm
(25¼ x 20⅝")
Whitney Museum of American Art,
New York, Josephine N. Hopper Bequest

Certain paintings by Hopper have become modern icons of America. The artist, who worked for sixteen years as a freelance illustrator, only found an audience for his paintings after he had almost given up hope, in his mid-forties, as we see him here. He produced several self-portraits between 1900 and 1923, sketching, painting and etching his own features, partly for lack of another model. This is the first oil self-portrait in his mature style. He presents himself as a reserved, self-contained, introspective, unpretentiously dressed figure with wary eyes and a determined chin; interestingly, he does not directly identify himself as an artist.

From the time he left the New York School of Art in 1906, Hopper absorbed a range of European and American influences from Manet, Degas and Eakins to the Ash Can School and the American 'realists'. His imagination was also shaped by watching movies, going to the theatre and reading, all of which activities feature in his paintings. The distinctively modern and filmic qualities of his starkly presented imagery were already apparent in such works as *House by the Railroad* (1925), which secured his early reputation and was the first painting to enter the collection of the Museum of Modern Art, New York, in 1930.

Years later, Hopper was delighted to read in the *New York Evening Post* that Alfred Hitchcock credited the painting as his inspiration for the house in the film *Psycho* (1960).[1]

In his work Hopper reveals himself to be a subtle painter of everyday subjects whose key strategy was 'alienation by light'.[2] He conceived his urban interiors and their very particular arrangements of lighting as metaphors for his inner world of thought. Much of the impact of his art, as in this self-portrait, depends on what is not visible, whether in shadow or left just outside the image. Always interested in architecture, Hopper makes every bare corridor, blank wall or doorway heavy with silence and unspoken meaning.

Hopper and his wife Josephine (who later bequeathed this self-portrait to the Whitney) habitually kept to themselves. In this vein, Hopper's portrait is notable for its stillness, suspended narrative and curious mixture of reticence and confidence. Wearing his hat, ready to go outdoors, he stops to regard himself in the mirror represented by the painting. This does indeed appear to be the image of a man who 'connected to the way in which he observed his own thought processes and feelings as if they belonged to somebody else'.[3] His level

stare is challenging yet withdraws from our appraisal: his body half turned away, the fall of the hat's shadow over his eyes and the angled tilt of his chin suggesting a man calmly taking stock of those who would assess him. His reticence and carefully guarded privacy tease the viewer.

This self-portrait makes an interesting comparison with van Gogh's *Self-portrait with Felt Hat* (cat.34): van Gogh's nervously expressive brushwork clearly contrasts with Hopper's deliberately bland handling. However, both artists shared a strong sense of themselves as outsiders, were oversensitive to the judgements of others and identified the core complexities of their inner life with the creative act, as Hopper summarised it: 'So much of every art is an expression of the subconscious.'[4] UP

1 See Chronology compiled by Polkinhorn and Madden in Wagstaff 2004, p.46.
3 Brian O'Doherty, 'Hopper's Look', in Wagstaff 2004, p.86. O'Doherty adds: 'Since this habit was intrinsic to him, he did not consider it unusual or strange. It was, if anything, completely matter-of-fact.'
4 Hopper quoted op. cit. p.50.

Literature
Levin 1980; Wagstaff 2004.

Christian Schad
(1894–1982)

Self-portrait with Model, 1927
Oil on wood, 760 x 615mm (29⅞ x 24¼")
Private Collection
London only

Christian Schad trained in Munich and his earliest works were expressionist woodcuts. A pacifist, he avoided military service during the Great War, living in Zurich and Geneva between 1915 and 1919. Here he associated with the Dada movement, experimenting with cubist collages and abstracting photography to create his first 'Schado-graphs', cameraless photographs similar to Man Ray's 'Rayographs'. At this time his closest friend, the writer Walter Serner, expressed the disillusion of his age thus: 'Man stands alone … no bridge exists to connect one individual with another; even that of the sexual instinct is a fictitious bond.'[1] It was in the spirit of Serner's provocative lines that Schad later painted this unsettling, fetishistic *Self-portrait with Model*, in Vienna in 1927. This work is famously associated with the style called 'New Objectivity' (*Neue Sachlichkeit*), first identified in a groundbreaking exhibition in Mannheim in 1925.

Schad was not included in the Mannheim exhibition, but his work was shown in a number of later exhibitions devoted to the New Objectivity alongside that of artists such as Otto Dix, Max Beckmann and George Grosz, who depicted the banality of everyday life in Weimar Germany, creating cynical images of hedonism and alienation in the modern city. Many artists had turned away from abstract art forms to embrace new forms of figuration in the 1920s. After Cubism,

Picasso's reversion to a neo-classical style reflected the French '*rappel à l'ordre*' ('call to order'), while in Italy, *Pittura metafisica* painters such as Giorgio de Chirico (cat.39) were reviving Early Renaissance classicism. Schad lived in Naples and Rome between 1920 and 1925, and here, influenced by the works of Raphael and the contemporary artistic scene, he first adopted the 'old master' smoothness, precision of detail and glassy hardness characteristic of his mature style in portraiture.

Regarding this self-portrait, Schad wrote: 'My paintings are in no way illustrative. They are symbolic.'[2] Assembling autobiographical and imaginary fragments from the life around him, he depicts himself frozen, impassive, as 'the cold lover' in a transparent shirt with an opening echoing the scar (*sfreggio*) disfiguring the cheek of the woman reclining behind him.[3] Schad constructed his image like a collage of flat, disparate pieces: the figures do not communicate with each other. The artist is not alone with his palette and brushes but, in an ironic reworking of the Renaissance tradition of the 'inspiration picture', in bed with his model. The skin is carefully rendered through transparent fabric, and details such as the glimpse of red stocking and pert wrist decoration (once glimpsed on a carnival worker) create an ambiguous eroticism. His painting of marmoreal flesh and transparent veiling viewed close up recalls Raphael's famous sixteenth-century

Portrait of a Young Woman (*La Fornarina*, 1520; Galleria Nazionale d'Arte Antica, Rome). But Schad has veiled his own nakedness, not the model's, and turns away from her to face the viewer (or his mirror?).

A narcissus, symbol of vanity, curves towards the artist. The myth of Narcissus, falling in love with his image reflected in a pool and drowning trying to embrace it, has long been cited as an allegory for the power of art to mirror nature and deceive the eye. Here the symbolic white narcissus contrasts with the artificial backdrop of a city at night, which Schad says represents vague longing for bohemian Paris. (He first used this backdrop of Montmartre rooftops in his 1926 portrait of Marcella, his wife; the couple separated while living in Vienna, where this self-portrait was painted.) Above all, Schad's ambiguous self-portrait reveals 'the problem of narcissism' and narcissistic egocentricity: as he himself said, 'no-one is entirely free from narcissicism'.[4] UP

1 Quoted in Michalski 2003, p.41.
2 Quoted in Bezzola 1997, p.114.
3 Schad constructs a psychodrama based around the custom that he discovered while living with his new wife, Marcella, in Naples, of scarring women with the *sfregio* in order to usurp jealous rivals. Michalski 2003, p.45.
4 Bezzola 1997, p.114. Schad continues: 'If you see everything through this mirror from the outset you are warned.'

Literature
S. Michalski, *New Objectivity* (Taschen, Cologne, 2003); Bezzola 1997.

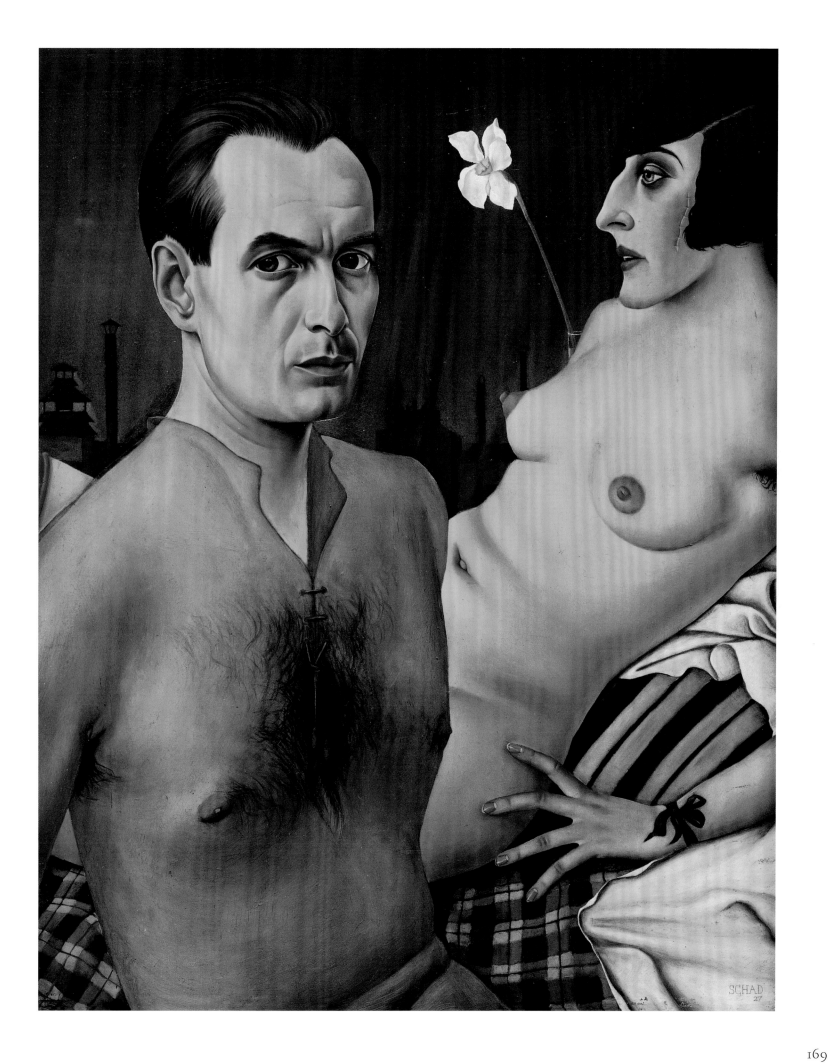

Fig. 57

Fig. 58

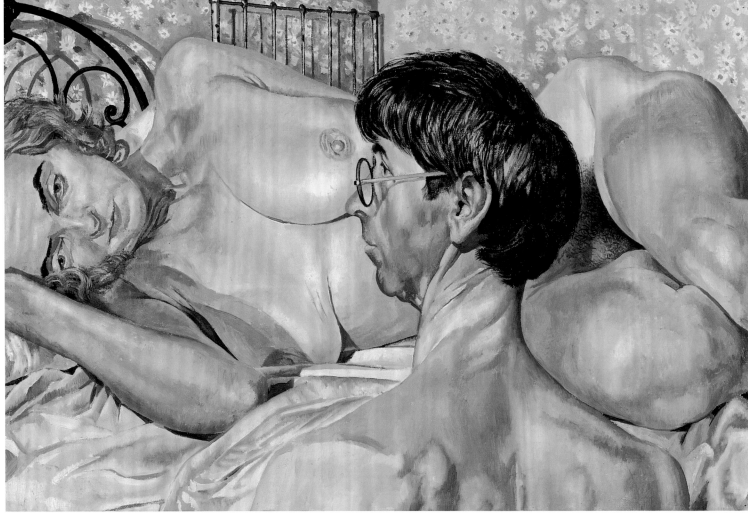

Fig. 59

Fig.57
Stanley Spencer
Self-portrait, 1914
Oil on canvas, 630 x 510mm (24¾ x 20⅛")
Tate, London

Fig.58
Stanley Spencer
Self-portrait, 1959
Oil on canvas, 508 x 406mm (20 x 16")
Tate, London

Fig.59
Stanley Spencer
Self-portrait with Patricia Preece, 1937
Oil on canvas, 610 x 912mm (24 x 36")
Fitzwilliam Museum, Cambridge

43
**Stanley Spencer
(1891–1959)**

*Double Nude Portrait: The Artist and his
Second Wife*, 1937
Oil on canvas, 838 x 937mm (33 x 36⅞")
Tate. Purchased 1974
Not illustrated here

Sir Stanley Spencer sometimes appeared as an outsider caught up in the social and political turmoil in Europe before and during the First World War. Artists in Britain at this time veered between utopian ideals of modernism and a desire to communicate with a wider public which implied a return to realism. Spencer was caught between these two impulses, and his idiosyncratic iconography made him seem eccentric and even primitive to some of his peers.

He studied at the Slade School of Fine Art in London from 1908, where he attended lectures by Roger Fry and learned about post-Impressionism, in particular Gauguin. He also shared Fry's interest in medieval European painting and had a strong attachment to the solid, earthy figures of Giotto. These are the two art-historical strands that most suited his personal narrative aspirations. In his own work he sought to reconcile spiritual with everyday life, locating many of his religious subjects in his home village of Cookham,

Berkshire. He also made several outstanding painted self-portraits, full face to the mirror (see figs 57 and 58).

His experiences during the First World War and the time he spent working in the terrible conditions of field hospitals caused considerable disruption to Spencer's artistic development. When he returned home and resumed his work as an artist, he found the rustic paradise of Cookham hard to recover. In this post-war period he painted religious subjects as well as more explicitly erotic paintings (see fig.59), often with autobiographical content. His *Double Nude Portrait* (included in the exhibition, but not illustrated here), originally known as *The Leg of Mutton Nude*, is possibly the most extraordinary of these works. Spencer destroyed several of these pictures, but he wrapped this one and hid it under his bed where it stayed until his death.

Patricia Preece was Spencer's second wife, although they only stayed together for a short period and may not have consummated

their marriage. He made several explicit paintings of himself with her, none of them more disturbing than *The Leg of Mutton Nude*. His observation of her naked body, and of his own figure crouching over her, explores every blemish and wrinkle of their flesh. The detail is rendered with an unusually rich quality of paintwork for an artist whose palette and technique were often relatively thin and dry.

The conjunction of Spencer's uncompromising view of life and his painterly approach make this painting an important precursor to self-portraits by Francis Bacon and Lucian Freud. It also raises the complex issue of the relationship between autobiography and the self-portrait. Spencer's dream of carnal and spiritual consummation allies him to a bohemian and Bacchic strand within self-portraiture, while the portrayal of the artist in the context of family and friends is given an ironic twist.
AB

Frida Kahlo
(1907–54)

*Self-portrait 'The Frame', c.*1937–8
Oil on aluminium on glass, 285 x 207mm
(11¼ x 8⅛")
Centre Georges Pompidou, Paris.
Musée national d'art moderne

Frida Kahlo began her career as an artist while she was convalescing after a horrific bus accident in Mexico City in 1925. Her pelvis skewered by a steel rod, a leg broken in several places, a foot crushed and her vertebrae severely damaged resulted in her short but eventful life being accompanied by terrible pain. It was only stark determination that prevented her from spending her remaining years as a wheelchair-bound invalid. Although much of her work is celebratory and positive, her mortality, continual pain and twisted body inevitably remain a lifelong focus for her paintings.

Her turbulent marriage to the great Mexican social realist Diego Rivera – both of them committed to progressive politics and to artistic modernism – and her affair with Leon Trotsky were also great influences on Kahlo's life and art. Trotsky stayed in their home from 1937 until 1939, when Diego ended their friendship, ostensibly for political reasons. The cumulation of these extraordinary circumstances have ensured that Kahlo's persona has become inextricably tied to her reputation as an artist; but above all it is her commitment to real life in Mexico that gives her work its particular power. She often dressed in traditional Mexican clothing, which appears in many of her self-portraits, and she adopted a palette and style that owed as much to traditional Mexican *retablo* or ex-voto paintings as it does to European modernism.

This self-portrait was purchased by the Louvre in 1939 from an exhibition of Mexican art at Pierre Collé Gallery, Paris. Frida's work had excellent reviews and was praised by Kandinsky, Picasso and writer André Breton. Breton later wrote the preface for her New York exhibition and claimed her as a surrealist painter, describing her work as being like a 'ribbon around a bomb'.[1] Kahlo, on the other hand, was adamant that she was not surrealist but committed to a realist position in accordance with her socialist views, saying: 'People thought I was a Surrealist. That's not right I have never painted dreams. What I represented was my own reality.'[2]

Painted on aluminium and mounted under glass that has also been painted, this work directly quotes from *retablos* that were often painted on tin sheet, a cheap and readily available material that enhanced bright, cheerful colours. Frida appears in the centre of the panel against a blue field with what seem to be yellow marigolds in her hair. Marigolds are highly significant in Mexican ex-votos and *retablos*, signifying the celebratory side of the Day of the Dead and often made into wreaths or scattered during festivals and public ceremonies. Her image is framed by drapes of fabric often used in *retablos* to enhance their dramatic effect. The space between this painted frame and the outer frame is filled with a mass of flowers and decorative patterning in pink and yellow, colours that signify celebration in Mexican folk art. Standing guard below the image are two plumed birds. Birds have often been associated with the passage of the soul between heaven and earth and, in the case of the dove, with the Holy Spirit. They are also thought to signify the sublimation of erotic desire. Both of these traditional associations would have been important to Kahlo.

There is a typical Mexican ambiguity to this work. It resembles a memorial, with Frida apparently peering at us from beyond the grave, yet is full of the colours of joy, typifying Mexican attitudes to death. The function of the ex-voto is also a form of intercession, a prayer for healing or relief of suffering. AB

1 André Breton, *Surrealism and Painting*, trans. S.W. Taylor (Museum of Fine Art, Boston, 2002), pp.141–4.
2 Isabel Alcantara and Sandra Egnolf, *Frida Kahlo and Diego Rivera* (Prestel Publishing, London and New York, 2004), pp.62–4.

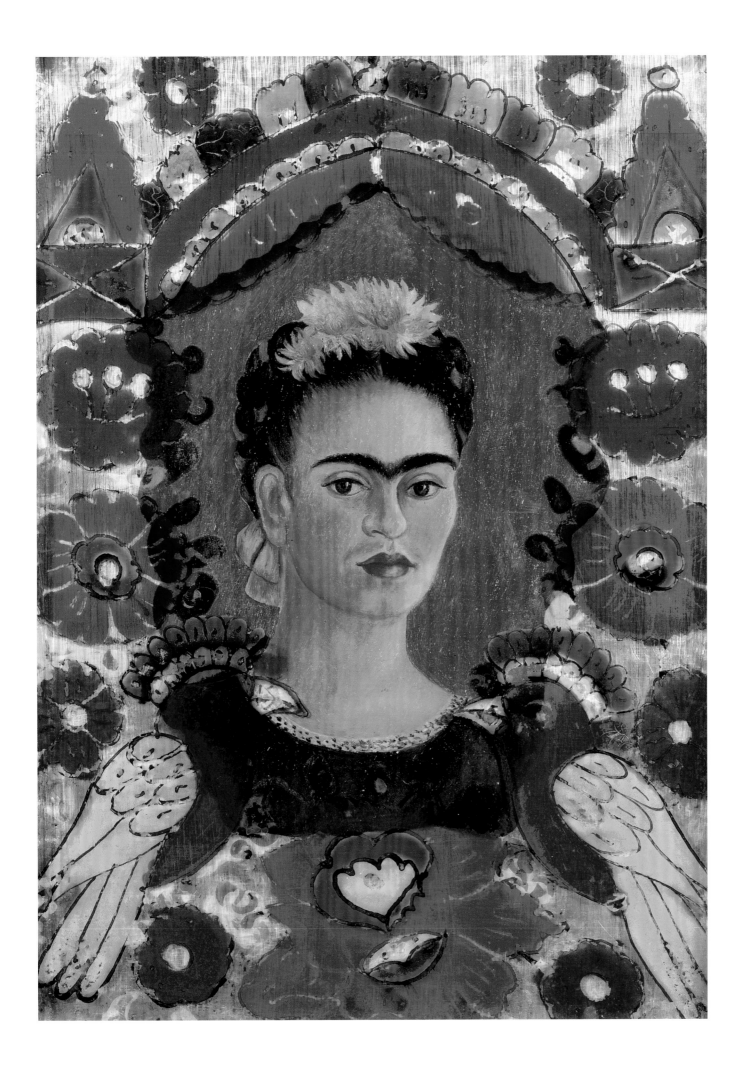

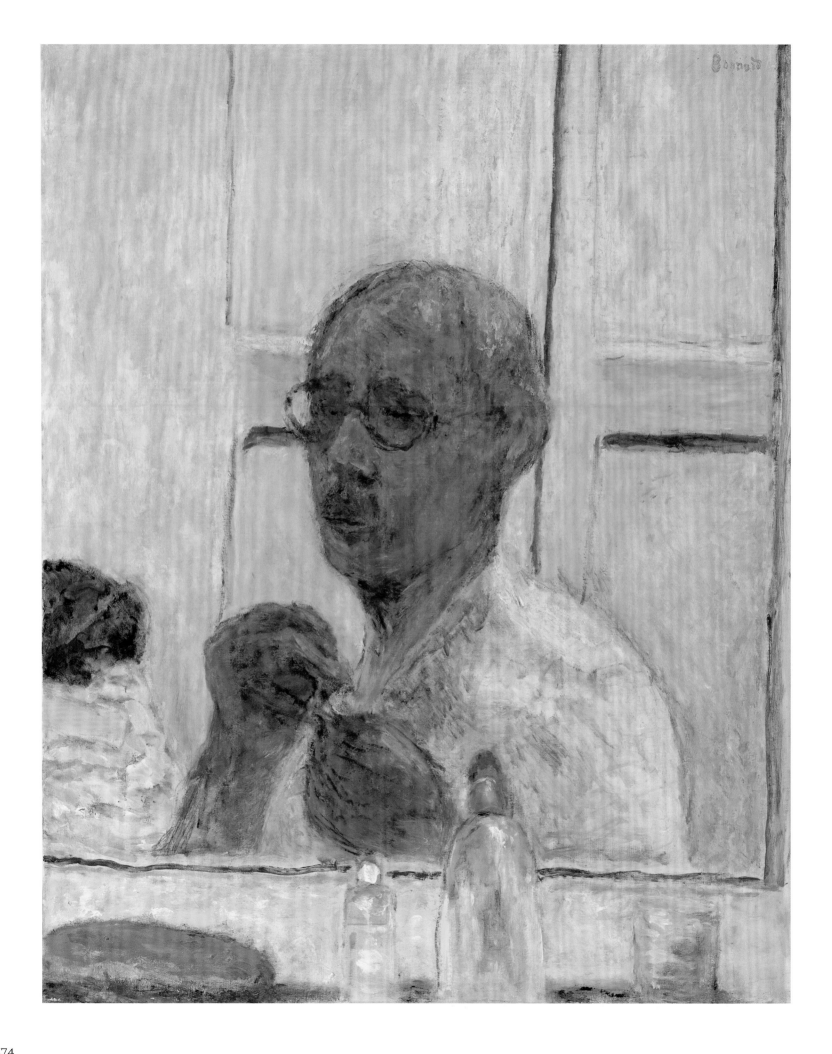

174

45
**Pierre Bonnard
(1867–1947)**

*Self-portrait, c.*1938–40
Oil on canvas, 762 x 610mm (30 x 24")
The Art Gallery of New South Wales.
Purchased 1972

A founder member of the French Nabi movement and a radiant colourist, Pierre Bonnard painted almost a dozen self-portraits, most of them in later life. He very rarely dated these works, the first of which he painted while he was an art student of twenty-two, in 1889 (Private Collection). In the 1930s he developed an interest in depicting himself in front of a mirror; the last in this series is thought to have been completed in 1945, two years before his death.[1]

A self-portrait often implies an artist's direct engagement with a mirror, but unlike the Impressionists, Bonnard did not paint directly from the motif, preferring instead to make drawings, sketches and colour notes and then working up his paintings in the studio. He believed that painters capable of tackling the motif directly were very rare, declaring, 'It is not a matter of painting life. It's a matter of giving life to painting'.[2] Like Matisse, he used colour and decoration to determine the essential qualities of his art. Bonnard admired not only Japanese prints and screens, but also Persian and Indian miniatures, capturing something of their iridescent multiplicity in this self-portrait with its brilliant orchestration of near and far views and its vibrant notes of Indian yellow, ultramarine, emerald green, creamy white and deep, reddish purple. With his eyes half closed behind Ghandi-style glasses, Bonnard cups his hands in a curious

gesture, recalling his 1931 self-portrait known as *The Boxer* (Private Collection). But in this later self-portrait his raised hands conceal the initial occasion of his painting – a fleeting glimpse of his mirrored reflection quickly jotted down in a spontaneous drawing small enough to fit in the palm of one hand. It was that invisible little note-book drawing which blossomed over time into a poignant, almost painfully vulnerable self-portrait that fused pigment, flesh and atmosphere.

Fascinated by the possibilities of mirror reflections, Bonnard exploits them for their tantalisingly oblique glimpses into his private realm. In this self-portrait his pulpy, dark-skinned flesh, severed by the mirror's edge and transfixed by a harsh electric light, is squeezed into the narrow space behind the mirror's reflective surface. Our gaze is thence deflected by myriad smaller reflections and by the glasses that mask his modest gaze.

In his typically indirect, allusive fashion, Bonnard engages the perennial themes of identity and masquerade explored elsewhere in this exhibition. Completed during the increasingly austere and dangerous years of the German Occupation in France, when he was living in Le Cannet near Cannes, this self-portrait echoes his growing sense of personal fragility and impending mortality. In 1930 the Surrealist poet Louis Aragon predicted: 'painting will become an anodyne

amusement for young girls and old provincials'.[3] In a post-Cubist climate some avant-garde critics dismissed Bonnard as old-fashioned and irrelevant. Their attacks had disturbed him and may have prompted the series of probing late self-portraits. In deep concentration, with an undiminished desire to understand and fulfil himself as an artist, Bonnard's self-portraits defied the climate of the times: 'I am working a lot, immersed more and more deeply in this outdated passion for painting. Perhaps with a few others, I am one of its last survivors.'[4]
UP

1 Terrasse called this 'an internal examination of self' which showed an artist who 'lived at a remove from the world, sacrificing all to the passion for art'. See Terrasse 2000, p.108.
2 Angèle Lamotte, 'Le Bouquet de Roses – Propos de Pierre Bonnard recueillis en 1943', *Verve* 5, nos 17–18 (August 1947), n.p. Bonnard continues: '... those [painters] who were able to extricate themselves from it [the motif] had a very personal defence. Faced with the motif, Cézanne had a solid idea of what he wanted to do – taking from nature only what was relevant to his idea.' See also Bonnard 1946 in Antoine Terrasse, 'Les Notes de Bonnard', *Bonnard* (exh. cat., Centre Georges Pompidou, Paris 1984), p.202.
3 Louis Aragon, 'La Peinture au défie', quoted in Terrasse 2000, p.96.
4 Bonnard letter to his nephew, Charles Terrasse, 1933, quoted op. cit. pp.96–7.

Literature
Jorg Zutter (ed.), *Pierre Bonnard: Observing Nature* (National Gallery of Australia, Canberra, 2003); K. Frankel and E. Rosefsky (eds), *Bonnard/Matisse: Letters Between Friends* (Abrams, New York, 1992); Timothy Hyman, *Bonnard* (Thames & Hudson, London, 1998), esp. pp.170–4; Antoine Terrasse, *Bonnard: The Colour of Daily Life*, trans. Laurel Hirsch (London, Thames & Hudson, 2000).

**John N. Robinson
(1912–94)**

*Self-portrait as a Young Man with Mirror,
c.*1940
Oil on canvas, 563 x 511mm (22⅛ x 20⅛")
Robert L. Johnson from The Barnett Aden
Collection, Washington DC

Born in the Washington district of Georgetown, Robinson moved to Anacostia in 1929 with his grandparents who had raised him and his four siblings since the death of their mother when he was eight years old. His new home, across the Anacostia River in south-east Washington, was to become central to his art for the rest of his life. At the age of twelve, while helping his grandfather at work in a garage, he met a chauffeur who introduced him to people who brought him to the attention of members of the African American art community of Washington DC. Despite the fact that he was unable to pay for tuition, Howard University's Art Department Head, James V. Herring, and Professor James A. Porter took Robinson under their wing and gave him artistic instruction while he was still only a teenager.

Robinson became part of Anacostia's 92 per cent African American community with its segregated areas that existed into the late 1950s. This historic neighbourhood, with its vibrancy and strong community ties, was imbued with all the racial and economic problems from which its somewhat troubled reputation derives. Married in 1934,

Robinson had seven children. His artistic inspiration and subject matter came from the area in which he remained for the rest of his life. He painted what was around him: the landscape, and the people with whom he lived, loved and worked. Acclaimed towards the end of his life for its warmth and intimacy, Robinson's art includes portraiture, landscape and some large-scale public works such as church murals. His first of these was *Christ of Gethsemane* at Emmanuel Baptist Church in Anacostia; he did many other religious paintings that were sought after in both south-east and south-west Washington.

This self-portrait can be seen in the post-war context of the newly invigorated desire of black people for real equality in the form of full citizenship, political freedom and self-determination. The high expectations and optimism of this period are reflected here: themes of creativity and introspection are explored using illusion and a *trompe l'œil* effect, reflecting the self-confidence and assertiveness of a young man.[1] It is an honest portrayal of African physiognomy: Robinson's features are portrayed without being either idealised or generalised. His

race is irrefutable, depicted with pride and without arrogance. The mirror in which he examines himself also reflects a self-questioning man surrounded by his studio and his art in the act of establishing and asserting his selfhood.

Robinson worked in a variety of jobs to support his large family, although he never stopped painting, and concentrated fully on his art only after his retirement. It is thought that he had a lean-to at the side or back of his house that he used as a studio, the interior of which appears to be depicted here. Working as a Supervisory Cook for thirty-four years in the famous St Elizabeth Hospital for Mental Health, still a key landmark at the heart of the Anacostia community, Robinson had a characteristically American work and family ethic. Never distinguishing between his art and his life, and using his art to depict his enjoyment of both, he later painted images of his many grandchildren animatedly showing him their own artistic efforts.
HL/SN

1 Richard J. Powell, *Black Art, A Cultural History*
(Thames & Hudson, London, 2002), p.88.

47
Sidney Nolan
(1917–92)

Self-portrait, 1943
Synthetic polymer paint on jute canvas,
610 x 520mm (24 x 20½")
Art Gallery of New South Wales.
Purchased with funds provided by the Art
Gallery Society of New South Wales, 1997

In his early work Sidney Nolan stood out as a dazzlingly original artist.[1] He began his career in Melbourne in 1938 at the age of twenty-one, a largely self-taught but consciously determined innovator. His visual imagination was profoundly affected by the works of Picasso, Cézanne, Rousseau, Matisse and van Gogh that he saw in the 1939 'Herald Exhibition of French and British Contemporary Art' at Melbourne Town Hall. With the outbreak of the Second World War Nolan entered the army as a fledgling abstract painter and was stationed in the flat wheat-growing country of the Wimmera district in western Victoria. He was immediately struck by the 'modern' qualities of the landscape, and inspired to invent a new 'vernacular' modernism based on his Australian context.

Nolan painted this self-portrait in 1943, when he was on military service at Dimboola, aged twenty-six. This was the first time he had depicted himself in the role of artist. Echoes of his life as a soldier and of distant war resonate in the background of this pared-down, boldly flat and frontal image of a masked artist-warrior, grasping a palette like a shield and brushes like spears. It is the image of an iconic outsider and individualist. This early self-portrait framed important conceptual and technical aspects of Nolan's development, heralding his ambition to portray at once the topography and psyche of his country. Like many artist self-portraits, it remained in his personal collection until his death – one of 'Nolan's Nolans'.

Striving for a simple and lucid language that he believed few painters apart from Picasso and Cézanne had achieved, Nolan makes a deliberate reversion to children's art in this self-portrait. His imagery recalls the mask-like faces with striped foreheads painted by so-called 'haptic' children in Viktor Löwenfeld's *The Nature of Creative Activity*, popular with his artist colleagues at the time.[2] Employing selective distortion, exaggeration and symbolic colours to express his feelings about his new surroundings, he eliminates perspective, emphasises the picture surface and 'cuts' in two 'window' landscapes as if they run vertically into the sky on either side of his head, as signs for the Australian landscape: 'pitched in such a high key and so bright that it works in your stomach as well as your eyes ... there is so little to break the vision and the whole landscape appears to surround you everywhere except the particular minute patch that is yourself'.[3]

'Rough as bags' was how Nolan once described his work; indeed, this self-portrait is roughly painted on hessian canvas in ripolin – an oil-based enamel manufactured for use on houses or boats, which Picasso called 'healthy paint'. Nolan wanted his portrait to be recognisably modern, recognisably Australian and at the same time shockingly primitive and new. As the artist and writer Ian Burn astutely observed of Nolan, 'The disarming directness and apparent simplicity of his images mask a struggle to come to terms with what it meant then to be an artist in Australia.'[4] UP

1 Barry Pearce, 'Sidney Nolan', *The Art Gallery of New South Wales Purchase* (Sydney, Art Gallery of New South Wales, 1998), n.p.
2 Viktor Löwenfeld, *The Nature of Creative Activity* (London, Routledge & Kegan Paul, 1939).
3 Nolan quoted in Jane Clark, *Nolan: Landscapes and Legends* (Melbourne, National Gallery of Victoria, 1987), p.54.
4 Ian Burn, *Dialogue: Writings in Art History* (Sydney, Allen & Unwin, 1991), p.75.

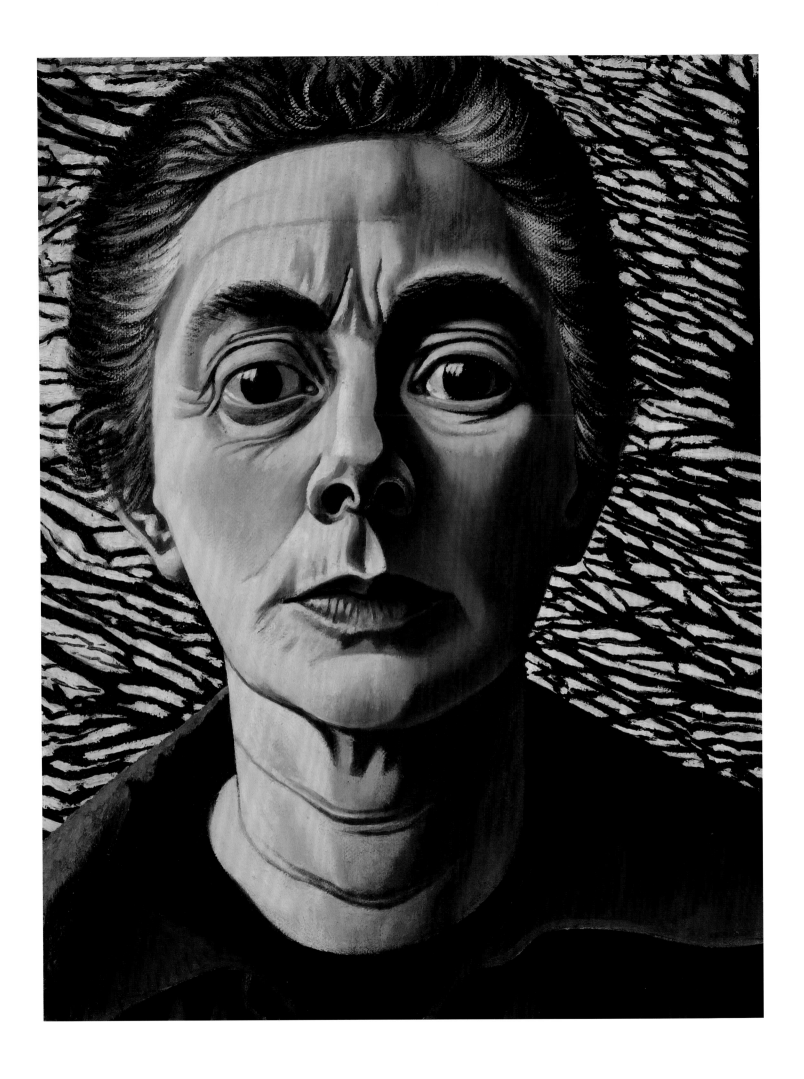

48
**Charley Toorop
(1891–1955)**
*Self-portrait with Winter Branches (Zelfportret
met wintertakken)*, 1944–5
Oil on canvas, 679 x 580mm (26¾ x 22⅞")
Van Abbemuseum, Eindhoven,
The Netherlands

Charley Toorop was born into a family of artists in 1891. The fact that her place in this dynasty was personally important to her is indicated in one of her last and most impressive works: a self-portrait in the company of her son, watched over by a larger than life sculpture of Jan Toorop, her father (*Three Generations*, 1941–50; fig.16 and p.35 above). Although she was self-taught as an artist, Toorop had ample opportunity to learn informally, particularly from her father. She mixed in artistic circles in the Netherlands and beyond, and was by no means a naïve painter. In the early years she experimented with Expressionism and Cubism, but developed a more realistic, highly personal style in the 1930s.[1]

Toorop lived in various parts of the Netherlands and the industrial areas of Belgium; between 1919 and 1921 she regularly spent time in Paris where she associated with Piet Mondrian. While in Belgium she began to work in the manner of Vincent van Gogh and started her evolution towards a form of socialist realism that included scenes of industrial life as well as a number of portraits of mental patients. The war years had a major impact on her and some of her works in the late 1940s have a tougher, sterner quality; her post-war work, however, took a more lyrical turn.

Self-portrait with Winter Branches is one of these commanding later works painted in 1944–5. This portrait is larger than life in every sense of the word. The face nearly fills the frame – indeed, at the top it exceeds it. The effect is of a very close magnifying mirror from which this middle-aged woman stares back at the viewer. All Toorop's self-portraits feature this intense stare, the large, wide-open eyes lustrous with the strain of the fixed gaze. There is an asymmetry between the eyes which also has a slightly unsettling effect. Between the eyebrows the forehead is deeply furrowed with concentration, the face is deeply etched with wrinkles around the mouth and eyes and the swept-back hair implies a businesslike and austere character: in fact, every detail insists on the creative power of this woman. The firm painting technique seemingly sculpts the features out of paint.

The small amount of field remaining behind the figure is filled with a filigree of black lines over white. This might at first be read as an abstraction or wallpaper pattern, but on closer inspection it is a mass of winter branches standing out starkly against the snow. This backdrop seems nonetheless to occupy a very shallow field and has the effect of pushing the head forward even more forcefully towards the picture plane and beyond. It is tempting to feel that this wintry subject matter reflects the harsh circumstances of occupied Holland in the last year of the war; indeed, there is a profound sadness behind the artist's firm gaze. AB

1 Janet Koplos, 'Family Saga', *Art in America* (September 2002).

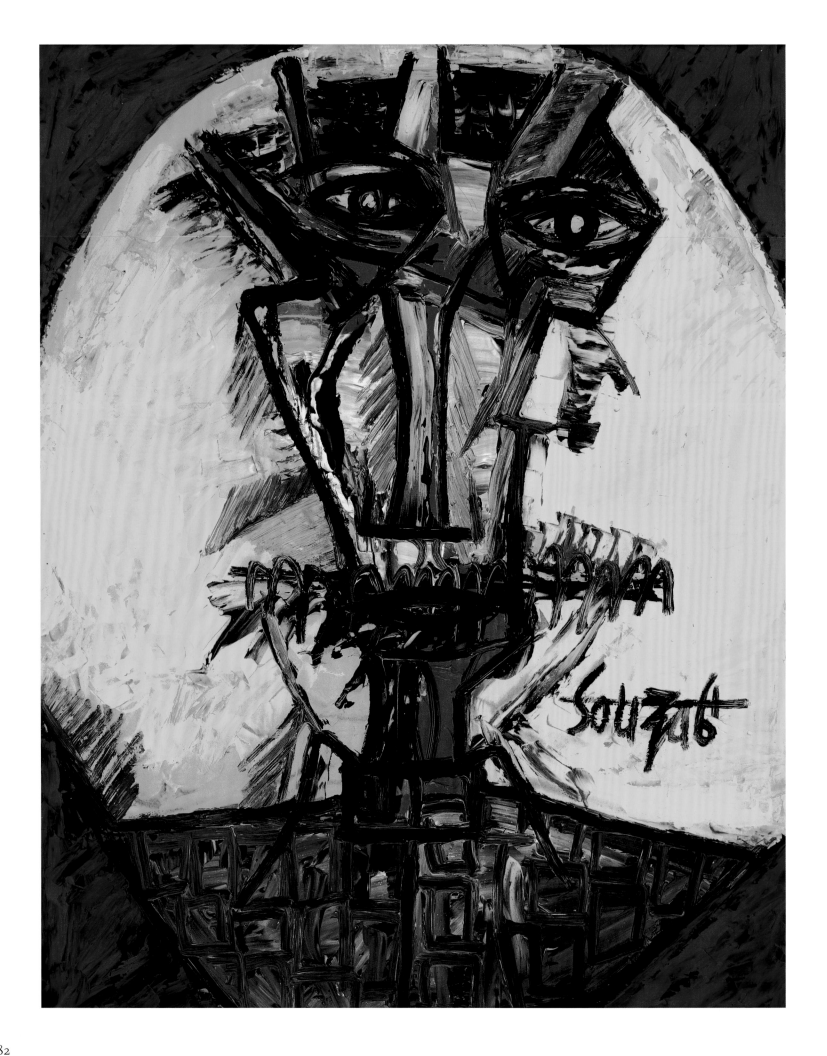

Fig. 60

49
**Francis Newton Souza
(1924–2002)**

Self-portrait, 1961
Oil on board, 760 x 610mm (30 x 24")
Ruth Borchard Collection courtesy of Robert
Travers, Piano Nobile Fine Paintings,
London

Fig.60
Francis Newton Souza
Collage catalogue cover, detail (front
and back), Gallery One, 1962
Cover 277 x 245 mm (10⅞ x 9⅝")
Courtesy of Piano Nobile Fine Paintings,
London

Born in a Catholic enclave in Goa, Souza
moved to Bombay at the age of four. He
studied at the Sir J.J. School of Art but was
expelled in 1945 for his left-wing views.
Arriving in London in 1949 with his
wife, Maria, Souza struggled to achieve
recognition as an artist. He supported
himself largely through his writing,
which has been described, like his art, as
over-the-top, taunting bourgeois prudery,
respectability, racist attitudes and
reactionary artistic trends.[1] It was not until
he had shown his work in Paris that it began
to be accepted in Britain; his first exhibition
in Britain, held at Gallery One, London, in
1955, was critically and financially a success,
reviewed positively by John Berger.

The front cover for the catalogue of
Souza's 1962 one-man exhibition, also at
Gallery One, is a photograph of himself
with a comic, animalistic mouth collaged
over his own (fig.60). Philip Vann suggests
that this kind of self-mockery is also evident
in this self-portrait of 1961, a 'humane and
compassionate picture, at once a graceful
and grotesque vision of self'.[2] This powerful
painting, dominated by vivid primary
colours, is jagged, mournful and humorous.

Like Souza's *Crucifixion* (1959), bought by
the Tate Gallery in 1993, *Self-portrait* is a
critique of traditional historical portraits.
This is apparent in the lopsided oval border
surrounding the glaring figure and the
distorted, Cubist-style disruption of his own
image. In the notes to his 1962 exhibition,
Souza said: 'I have everything to use at my
disposal. I leave discretion, understatement
and discrimination to the finicky and
the lunatic fringe.'[3] Unbound by social
responsibility, he used a supposedly 'inflated
ego' as a 'weapon to deflate the pretensions
and self-deceptions' of others.[4]

'Souza's art is driven by a tension
between opposites'.[5] This, it is suggested,
is because he consistently explored grand
ideologies such as Hinduism and
Catholicism, ideas like narcissism and
humanitarianism and the tensions between
Western and Eastern artistic traditions.
While his art is apparently driven by these
tensions, it does not resolve them: the
power of his work derives from the space it
occupies between irreconcilable opposites.
Despite the political overtones of much of
his art and writing, commenting in relation
to his final solo exhibition, Souza stated that,

'the best I can say about art is that men
would die of boredom without it'.[6]

Ruth Borchard, who collected a number
of self-portraits by contemporary artists,
paid her regular sum of twenty guineas in
1963 for this work. In a letter to Borchard
dated 6 May 1963, Souza states that he
does not think of himself as 'a very good
self-portrait painter even though some
critics think I've got an inflated ego'.[7]

Souza had ten years of successful
exhibitions in England and India, although
he suffered from bouts of alcoholism and
his domestic life went through periods of
strain. Settling in New York in 1967, a move
that may have been influenced by racial
discrimination suffered in London, he
left behind a wife, a mistress and four
daughters. In New York he lived as a recluse,
but never lost his Indian identity. HL/SN

1 Edwin Mullins, *F.N. Souza: An Introduction* (Anthony Blond,
London, 1962).
2 Philip Vann, *Face to Face: British Self-portraits in the Twentieth
Century* (Sansom & Company, Bristol, 2004), p.264.
3 Souza quoted by Vann, op. cit. p.265.
4 Vann, op. cit. p.264
5 M. Harrison, *Transition: The London Art Scene in the Fifties*
(Merrell, London, 2002), p.144.
6 Souza, quoted in *What I See* (New York, 2001).
7 Souza, quoted by Philip Vann, op. cit. p.263.

50
Lucian Freud
(b.1922)

Interior with Hand Mirror (Self-portrait), 1967
Oil on canvas, 255 x 178mm (10 x 7")
Private Collection

Fig.61
Lucian Freud
Naked Man with a Rat, 1977
Oil on canvas, 915 x 915mm (36 x 36")
Art Gallery of Western Australia

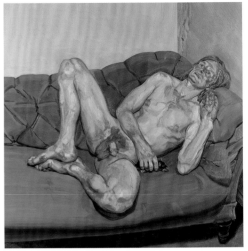

Fig. 61

Lucian Freud, the grandson of the founder of psychoanalysis, was born in Berlin in 1922 and moved to England with his family in 1933 when the Third Reich came to power. In his early paintings and drawings made during the war years he emerged as a strangely compelling young surrealist. After 1945, however, he started his quest for a form of realism. He has dedicated most of his career since then to depicting the human figure, frequently the naked body, most notably of women but also male nudes.

Freud never works with professional models and does not take commissions. His subject matter, like that of Francis Bacon, is always drawn from his circle of close friends and acquaintances, or individuals by whom he finds himself fascinated. His first and second wives and his daughters have often featured in his work, and he has painted a significant number of self-portraits. He says of the autobiographical nature of all his painting: 'It is about my self and my surroundings. I work from people that interest me and that I care about'.[1] In spite of this intimacy, Freud's observations of human imperfection sometimes have a cold, unforgiving quality reminiscent of Otto Dix. Prior to 1956 Freud's painting style was relatively smooth and flat. His imagery was intense but the paint was more appropriate to surrealism than to realism in the painterly tradition of Courbet. In the mid-1950s he

began to introduce an expressive impasto, building up the form with vigorous but carefully applied strokes of thick paint. Francis Bacon spoke about achieving a quality of paint that acted directly on the nervous system and it is just this kind of kinaesthetic quality that Freud now began to access. When we confront the solid, painterly surface of a Freud it is not an illusion of the body we experience but a kind of painterly equivalence, entailing a full sensory engagement: in tracing the form, the viewer's eye follows the gesture of the artist. This is a process that brings the viewer very close to the artist and his subject matter, as if recreating the moment of production with each glance. The boundary between art and life is thus blurred by the replacement of the distancing conventions of academic painting with an emphasis on sensory and emotional engagement.[2] This implied convergence of eye and touch is sometimes emphasised in Freud's work when he draws attention to tactile incidents in the composition; for example, in *Naked Man with a Rat* (fig.61) the naked genitals of the man are juxtaposed with the tail of a rat that he holds in his hand. Draped across the thigh the tail neatly describes the form of the flesh, thus reinforcing the descriptive quality of the paint as well as intensifying an affective reaction to the body.

In this sense Freud is every bit a realist,

so when he makes a self-portrait he is at pains to acknowledge the mediating role of the mirror. He does this either in the image itself or in the title, often using the word 'reflection'. In *Interior with Hand Mirror* the self-portrait is almost secondary to the image of the mirror. The hand-held mirror is propped between the two parts of a sash window so that the handle, which is behind the lower frame, is visibly blurred by the dirty pane of glass. The artist's face fills the oval of the mirror and seems unusually screwed up, with the eyes squinting, possibly from the light coming in from behind the mirror. Although this is a small, apparently simple picture, there seems to have been a considerable amount of scraping out and over-painting, leaving *pentimenti*, or traces of its history, in the painted surface. The area that forms the background to the mirror appears as an ambiguous field of light, but it can be read as reflected light from the wall of the next-door building. This is confirmed by the inclusion of a discrete architectural detail in the lower left quadrant of the field. The otherwise blank surface has been painted again and again, suggesting the struggle of the eyes straining to see against its luminosity. AB

1 Lucian Freud quotes from www.artquotes.net.
2 A. Bond, 'Imagining the void', *Linq magazine* (James Cook University, Queensland) 31, no.2 (October 2004), pp.11–26.

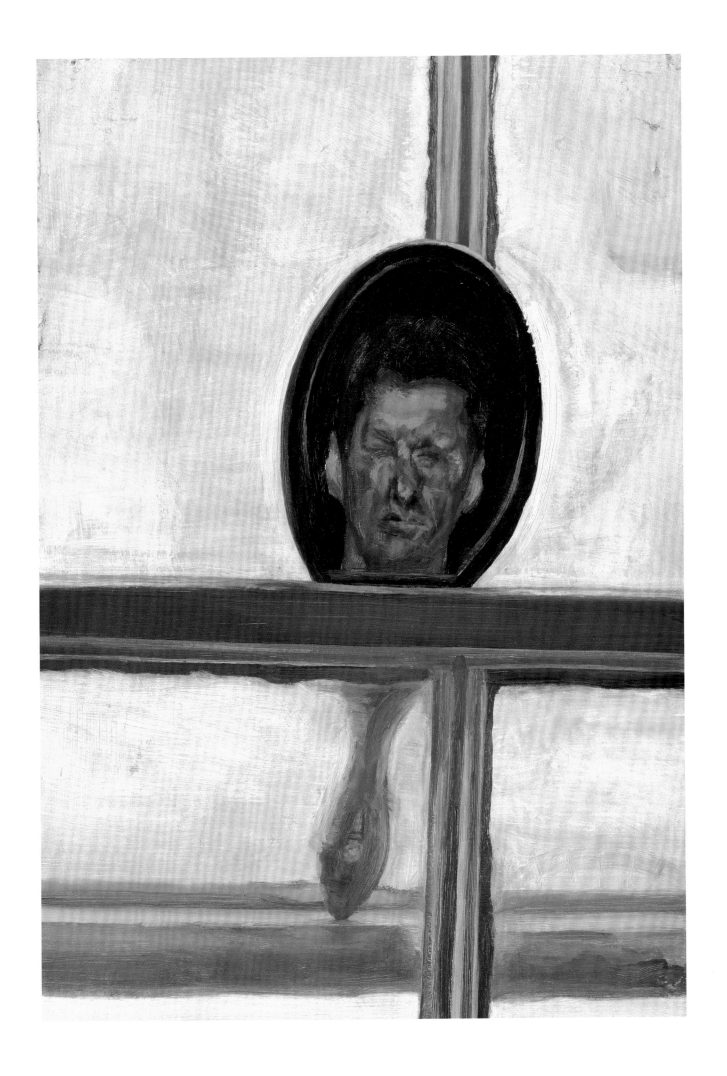

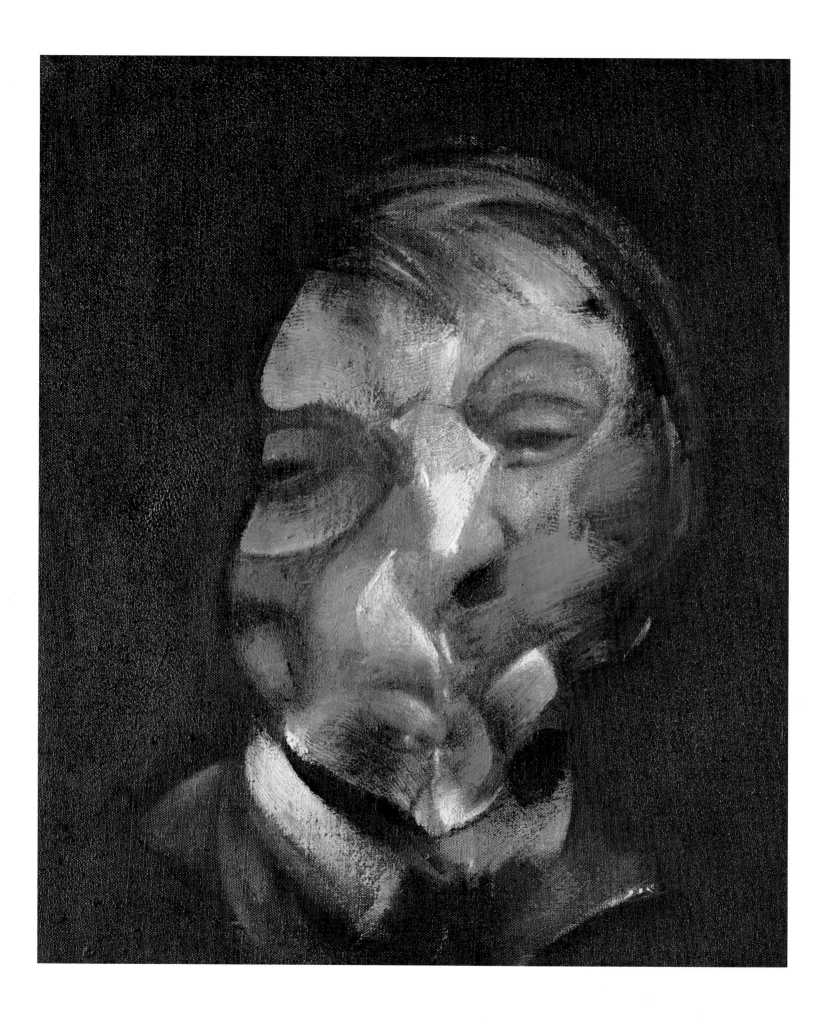

**Francis Bacon
(1909–92)**

Self-portrait, 1971
Oil on canvas, 355 x 305mm (14 x 12")
Centre Georges Pompidou, Paris.
Musée national d'art moderne

Born in Dublin, Francis Bacon arrived in London in 1928 having spent some years in France. In Paris he had worked as a designer making rugs and furniture, and at first continued this practice in London. He was fortunate to find an avuncular lover and mentor in the Australian artist Roy de Maistre, who introduced him to the contemporary artistic scene, not least to Graham Sutherland and to the writer Patrick White. He also introduced Bacon to the Surrealist works by Picasso that had influenced Sutherland.

Encouraged by de Maistre and Sutherland, Bacon took up painting and in 1933 one of his works was reproduced in Herbert Read's book, *Art Now*.[1] Although he had some early limited success, it was not until the mid-1940s that he produced his first substantial body of work. By far the majority of his mature paintings were figure compositions, often including portraits of his close circle of friends and colleagues. He is best known for the dramatic fragmentation of the body and rapid gestures made with a broad brush or applied with a piece of cloth, and occasionally even

splashed directly from the can. Like the surrealists and indeed Duchamp, he was interested in working with chance. It was partly for this reason that he avoided working from life, preferring to collect photographs taken by his friend John Deakin or cut from newspapers and books. He kept this collection of images in his studio, often torn and spattered with paint, awaiting their moment to be transformed in a painting.

For all the expressive gesture and apparent wildness and violence in his imagery, there is always a strong designer's eye behind Bacon's painting. He talked of rescuing paintings from boredom by a last 'violent gesture',[2] yet the animated brushwork of his figures is nearly always isolated against a rich coloured field, like a gem on a velvet cushion. This strong differentiation between figure and field is in a way a reversal of the modernist tendency to integrate the two: in particular, Picasso's Cubist fracturing of the figure had the effect of opening the boundaries between the body and its environment. Many of Bacon's portraits show a Cubist-style cutting and

opening of the figures, but he then closes them off with a flat, hard-edged field.

This self-portrait is a good example of this contradiction. The head seems cut and pulled out of its normal configuration, the mouth savagely distorted as if in a horrible accident, and the chin dislocated. The highlighted left-hand profile, however, is strongly defined and closed off by the dark, flat field. To the right, the distinction is far softer but the animated paint inside the form never escapes into the field. The features are drawn or blotted out by bold brushmarks, yet there is a strange, romantic illusionism lurking behind the mask. Bacon's familiar forelock of grey/black hair falls across his brow in an almost photographic likeness.

This is a painting where the painter's aim seems to have been to project some degree of interiority: it is certainly one where the characteristic painting style of the artist stands in for his presence as strongly as the image itself. AB

1 Herbert Read (ed.), *Art Now* (Faber & Faber, London, 1933).
2 BBC Four Interviews: *Francis Bacon, 1909–1992* (Audio Archive, 23 March 1963), interview with David Sylvester.

52

Georg Baselitz
(b.1938)

Mannlicher Akt – Fingermalerei,
May – July 1973
Oil on canvas,
2510 x 1700mm (98⅞ x 66⅞")
Galerie Thaddaeus Ropac, Salzburg/Paris

Georg Baselitz was born in East Germany but moved to West Berlin to study at the Berlin College for Visual Arts in 1957. Among his peers were painters such as K.H. Hodicke and Berndt Koberling. For this post-war generation, particularly in Berlin, the struggle was to find an authentic German voice that had not been marked or appropriated by the Third Reich. German Expressionism had been vilified by Hitler as decadent art and was therefore ripe for revival. The Expressionists had also taken a political stand against war, as had the Neue Sachlichkeit group, including Christian Schad (cat.42). This aspect of social conscience was initially attractive to Baselitz and his peers.

In 1958 the Berlin College for Visual Arts hosted two influential exhibitions, 'Jackson Pollock' and 'New American Painting'. These exhibitions were to have a major impact on the Expressionism that this young generation of artists were trying to recover: it is possible to detect in their work certain qualities of painting by German Expression-ists such as Ernst Ludwig Kirchner or Emil Nolde, transformed through the influence of Jackson Pollock and Franz Kline. In the early years these new Figurative Expressionists worked against the grain of popular opinion that had become comfortable with politically neutral abstract art and they struggled to keep the underground group alive. Baselitz, together with Eugen Schonebeck, was active in this group which produced such angry manifestos as *Pandemonium*,[1] and led to a feeling of solidarity in adversity, creating an angst that gave their work its edge. The movement initially included an element of political protest in the tradition of Neue Sachlichkeit, with the fracturing of the figure representing a shattered society, but increasingly the images become more personal and abstract. In his later paintings Baselitz insists on the materiality of the medium and the mark, to the point of inverting the fractured figures (as in this self-portrait) to make their content even less accessible.

In the early 1970s Baselitz painted a number of full-length self-portraits that were not only inverted, but also painted with his fingers. In spite of his technique, these paintings are surprisingly representational: the inversion feels rather peculiar, as if the figure is suspended by the feet. These works lack the more brutal fragmentation for which Baselitz would become known in the 1980s – and which makes the inversion seem part of an abstracting process. The violent strokes of the brush are replaced by the sensuality of oil paint, and we can experience the hand of the artist more directly and literally than in other self-portraits: the carefully stroked fingermarks caress the canvas while forming the image of his body. In this way the artist's likeness is presented in complete synchronicity with his stylistic signature and the physical trace of his fingers. AB

1 G. Baselitz, 'Pandemonium Manifesto', in *Art in Theory*, eds C. Harrison and P. Wood (Oxford University Press, Oxford, 1992), pp.621–5.

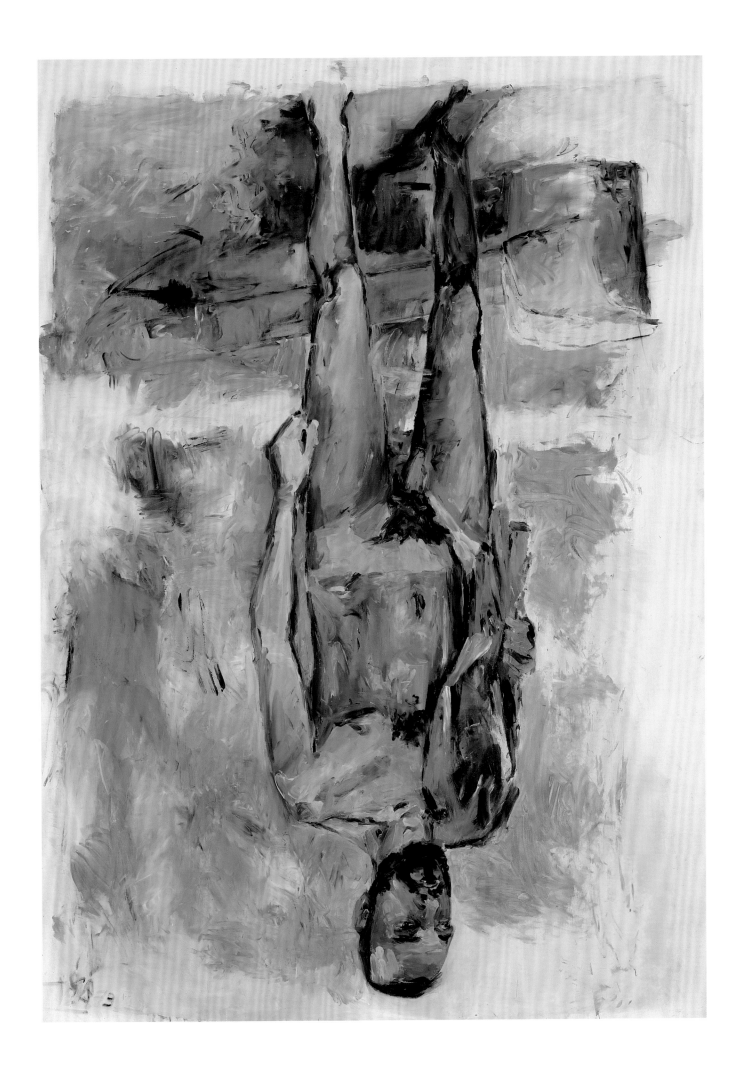

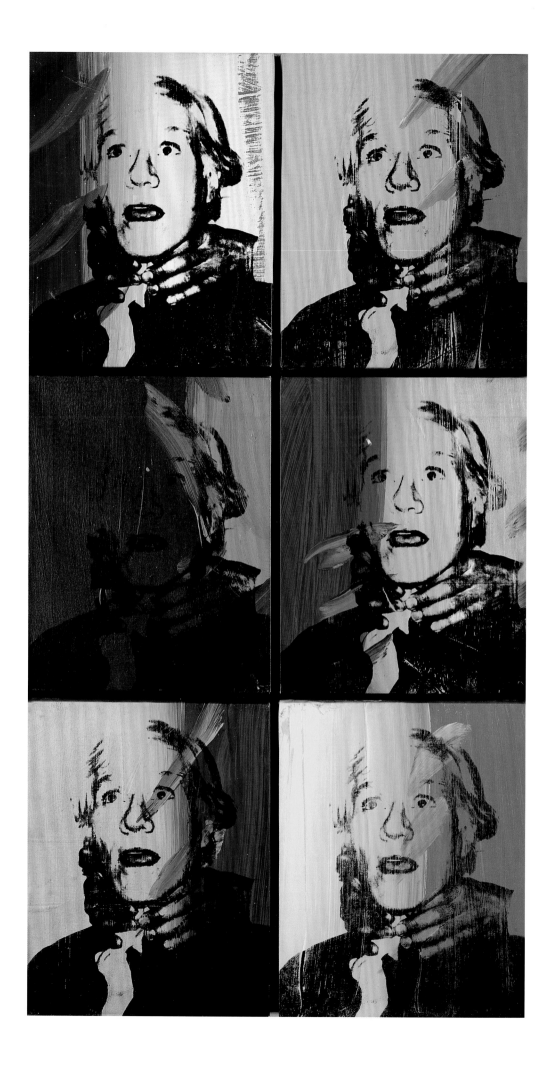

**Andy Warhol
(1928–87)**

Self-portrait (Strangulation), 1978
Acrylic and silkscreen ink on canvas,
six parts, each 406 x 330mm (16 x 13")
Anthony d'Offay, London

Andy Warhol began his artistic life as a commercial artist; when in 1949 he moved to New York from Pittsburgh he soon realised that there was more money to be made in the fine art market. His first efforts as a painter did not produce the instant fame he craved, as galleries in the 1950s were more interested in Abstract Expressionism. However, in the early 1960s, when he developed the idea of representing commercial products and images as serial copies, his career began to take off.

Warhol avoided the aura of the handmade originals, deliberately using cheap imagery such as Polaroids and pictures from photographic booths. He combined glitzy, superficial, even infantile imagery with a projection of his own persona, as synonymous with the qualities of the work. The combination of glossy popular images and the glossy surface image of the artist as celebrity was a huge success once he was launched in the art world. By presenting himself and his work as a readily consumable commodity Warhol actually played into the obsessions of consumer society in the USA.

It was the integration of the artist's life with his product that allowed Warhol to trade on America's fetishisation of celebrity. Both Marcel Duchamp and Joseph Beuys, while very different in style, used similar strategies in creating a mystique around their persona so that whatever they did with their lives became part of their art. This in itself is a form of decentred self-portraiture: the artist becomes the content of the work and whatever he or she does is absorbed into it. Beuys' dictum 'everyone can be an artist' also accorded well with the chaotic participation that seemed to rule in Warhol's famous studio in New York, The Factory.

Warhol's superficial life and trade perfectly mirrored American society, but there was also a very dark side to this world: his series of paintings of disasters, where he serialised images of horrific traffic accidents, and the images of the electric chair and of suicides. Treating these graphic images in the same way as the repetition of soup cans and celebrity faces, he seems to devalue their intensity. The image of a body hanging from a telegraph post after an accident is equally horrible each time it is seen, despite it being treated like wallpaper – possibly all the more so because of the offhand way it is presented. Warhol blocks any possible investigation into his own feelings, yet returns to images of death again and again – such as the skulls and guns that appeared in his work after he was shot and wounded by Valerie Solanis in 1968.

Self-portrait (Strangulation) is a disturbing image of the artist apparently strangling himself. Like many of his portraits, such as those of Marilyn Monroe and Elizabeth Taylor, his likeness is multiplied with six versions of the same photograph that has been transferred by screen-printing and then painted over with deliberate variation. Warhol marks a turning point in the genre of self-portraiture, opening the way for the development of the oblique self-portrait in the manner of Duchamp but also connecting with the theme of mortality that runs through a number of other self-portraits (cf. Johann Zoffany, cat.24; Hans Thoma, cat.31).

AB

Literature
Kynaston McShine, *Andy Warhol: A Retrospective* (exh. cat., Metropolitan Museum of Art, New York, 1989); Andy Warhol, *The Philosophy of Andy Warhol: From A to B and Back Again* (Harcourt Brace Jovanovich, New York, 1975); Nat Finklestein, *Andy Warhol: The Factory Years, 1954–1967* (St Martins Press, New York, 1989); E. Beyeler, G. Frei, P. Gidal and E. Sanders (eds), *Andy Warhol: Series and singles* (exh. cat., Beyeler Museum, Basle, 2000).

54
Marlene Dumas
(b.1953)

This evil is banal (Het kwaad is banaal), 1984
Oil on canvas, 1250 x 1050mm
(49¼ x 41⅜")
Van Abbemuseum, Eindhoven,
The Netherlands

Born in South Africa in 1953, Marlene Dumas grew up under the regime of Apartheid. This made her very aware of issues of social justice and the implications of a political regime that functions through exploitation and physical exclusion. In 1976 she moved to Holland where she studied painting and, later, psychology. Her work today carries traces of her past and of her psychological insights, while her characteristic blurring and staining techniques suggest an approach to representation that is akin to the reading of images into clouds and stains or the interpretation of Rorschach marks.

Dumas is very aware of the problems of the gaze, particularly when the subject is the naked human body; she prefers to work with photographs and avoids using live models. In common with Francis Bacon (cat.51) she has a collection of images from newspapers and magazines for use in her work. Her

painted surfaces may not share the occasional impasto gesture for which Bacon is known, but her juxtaposition of transparency and opacity together with the appearance of accidental effect are very close to his in approach. Like Bacon's, her works have tactile as well as visual impact on the viewer. Her watercolours involve stains that seem as much a trace of the body as the image that those stains suggest. She seems to identify herself with the darker, sexual and seductive sides of humanity. Her images can also be disturbing and even violent, often loaded with ambiguity, sexual tension and anxiety. She withholds resolution of the image to allow spectators to find their own relation to the image and the material resonance of the works.

In 1984 Dumas painted this self-portrait. A strange and disturbing title for a self-portrait, it may be understood, in part at least, to refer to the artist's upbringing in

South Africa. Many of her generation woke up with a rude shock to the realisation that the nature of their normal life with all its privileges was built on the oppression and deaths of others. Perhaps it also alludes to her engagement with the darker rhythms of humanity.

The image is much larger than life and is filled with formal ambiguity and painterly incident. The colour is overheated, particularly the hair which seems almost to be on fire, and the strangely shadowed hand just below her chin. This wild colour contrasts with her more familiar near-monochrome palette. The thin veils of paint over richer impasto are only distinguishable on closer inspection, but they contribute to a mask-like quality and flattening of the face. The eyes, however, shine out as if through holes in this mask in a startling *trompe l'œil* effect. AB

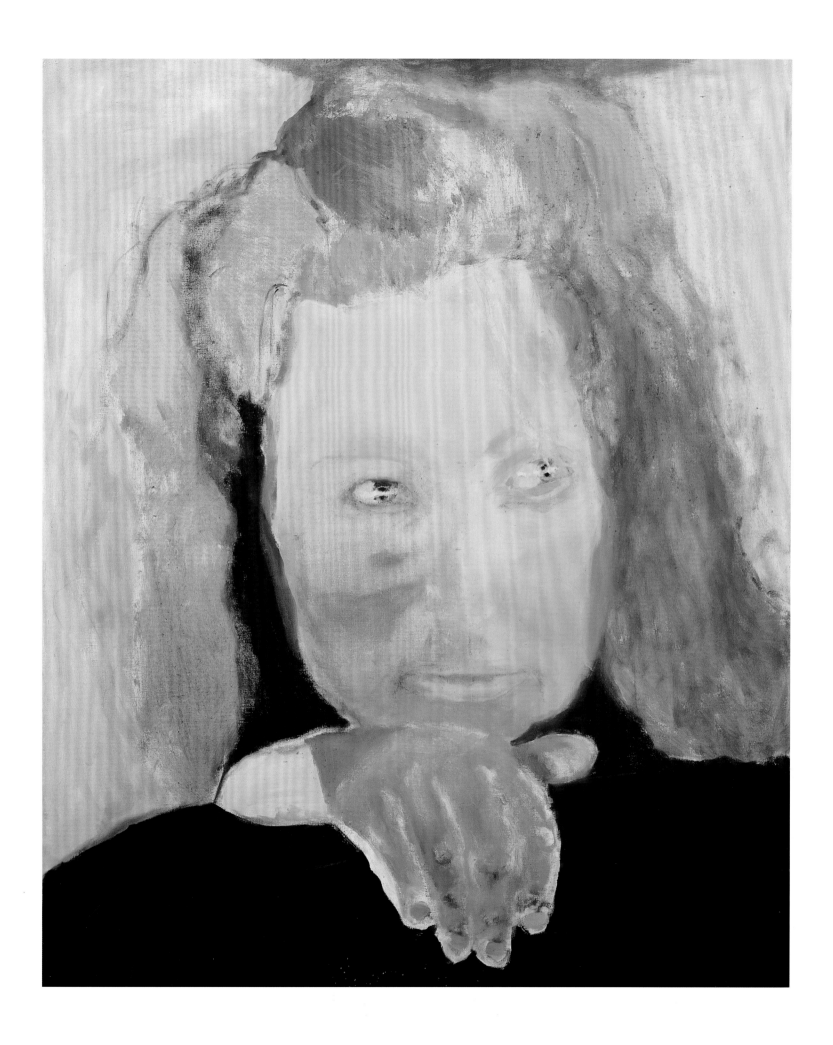

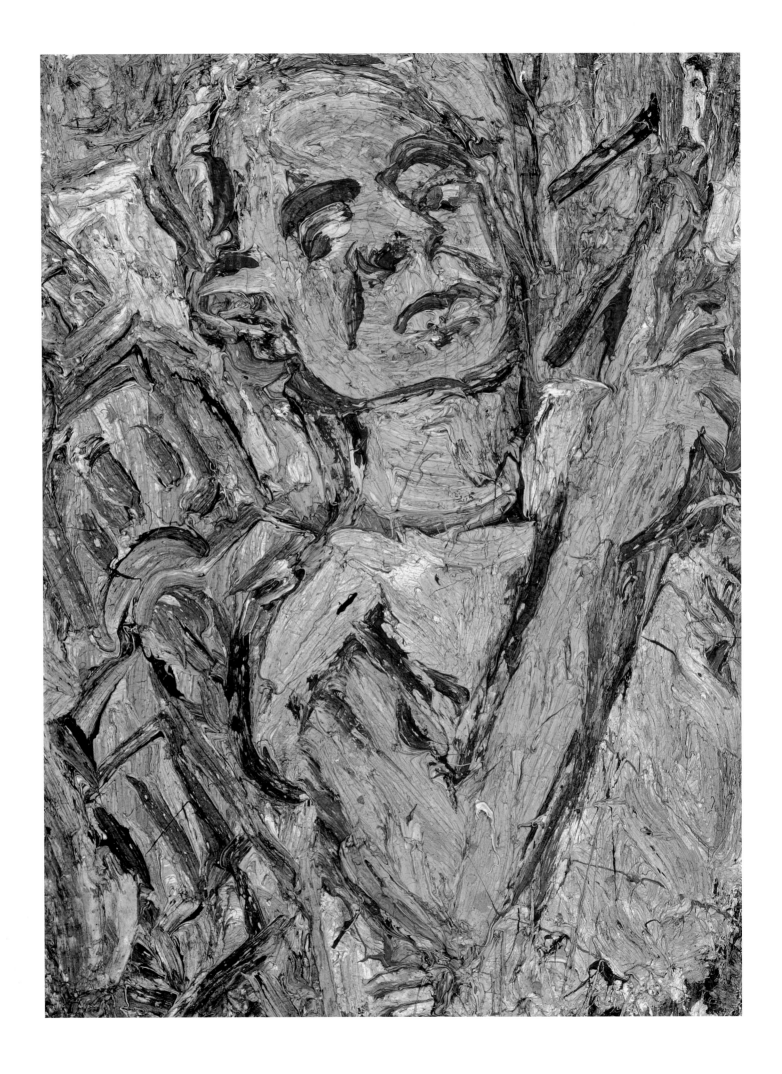

Leon Kossoff
(b.1926)

Self-portrait with Christchurch, 1989
Oil on board, 1540 x 1130mm (60⅝ x 44½")
Private Collection, c/o LA Louver Gallery,
Venice, California

Leon Kossoff was one of the artists who exhibited at London's Beaux Arts Gallery in the 1950s and 1960s along with Frank Auerbach, Lucian Freud, Francis Bacon and John Bratby. They were all painters whose work reflected their immediate environment, their friends and family. Their art seemed at times to be a painterly equivalent of the Angry Young Men of the British theatre in the 1950s, when English culture began a process of critical self-regard, focusing on details of daily life and familiar surroundings, contrasting working-class settings and values with middle-class conventions.[1]

The artist David Bomberg (1890–1957) had a profound influence on Kossoff and Auerbach in particular. Indeed, Bomberg's expressive brushwork and dense colour continues to have echoes in their work half a century later. Walter Sickert was another strong influence, particularly the cloying atmosphere of his urban interiors where his nudes appeared to languish.

It was not until the early 1980s that these artists came to wider attention. Their work challenged the dominance of minimalism and conceptual art that had prevailed in most major international exhibitions of contemporary art in the 1970s. In the next few years many short-lived movements of New Expression-ism or New Figuration came and went. The exception to this has been the influential London artists Freud, Auerbach and Kossoff, all of whose fiercely independent visions have secured them a permanent place in the public imagination.

True to form, in *Self-portrait with Christchurch* Kossoff paints himself in front of the church at Spitalfields, designed by Nicholas Hawksmoor. The figure fills the canvas to the point of exceeding it, his right hand raised with the index finger extended right to the edge. The artist may be in the act of painting on a canvas just out of sight, like Alessandro Allori (cat.3) or Artemisia Gentileschi (cat.14). The paint here is expressively sticky and assertive as oil and pigment: Kossoff seems to find creative energy in the obvious resistance that the material offers to the free movement of his hand. Through the paintwork we experience a strikingly individual trace of the artist's struggle in front of the canvas. AB

1 Anders Kold, 'In the thick of the moment', in *Leon Kossoff: Selected Paintings 1956–2000*, eds Juul Olm and Anders Kold (exh. cat., Louisiana Museum of Modern Art, Denmark, 2004): '[Kossoff's trail] only covers the distance from Wren's St Paul's Cathedral on the banks of the Thames to Hawksmoor's Christ Church a few miles away in East London'.

Richard Hamilton
(b.1922)

Four Self-portraits – 05.3.81, 1990
Oil and Humbrol enamel on Cibachrome
on canvas, four parts, each 755 x 755mm
(29¾ x 29¾")
Anthony d'Offay, London

Richard Hamilton was associated with the Independent Group that formed around the Institute of Contemporary Arts (ICA) in London in 1952. Other notable members were Eduardo Paolozzi and the critic Lawrence Alloway. The group's pioneering work in making installations and mixed media exhibitions anticipated and paved the way for British Pop Art, and may be seen as a precursor for some strands of conceptual art. In 1956 the groundbreaking exhibition 'This is Tomorrow' at the Whitechapel Gallery in London demonstrated the group's pioneering interest in popular and commercial culture. In relation to this exhibition Alloway first articulated the importance of artists balancing their criticism of consumer society with their delight in the aesthetic vitality of its products.

In 1965 Hamilton worked with Marcel Duchamp on the reconstruction of *The Large Glass: The bride stripped bare by her bachelors even* and in 1966 organised the Duchamp retrospective at the Tate Gallery. This first-hand experience made Hamilton very aware of the complexities of Duchamp's thinking and the layered narratives he carefully secreted within his deceptively simple objects.[1] He has continued to collaborate with other artists, including Joseph Beuys and Dieter Roth, clearly continuing the democratic aspects of working with others as he did at the ICA. He has also experimented with new technologies, including highly sophisticated forms of computer manipulation and printing.

Four Self-portraits – 05.3.81 is a typically complex but playful work, following from many different forms of self-portrait made at different stages of his life. It deconstructs the mystique of painting and originality in exchange for a very Duchampian visual conundrum. Hamilton has photographed himself from four slightly different angles in each of the four panels, suggesting the multiple viewpoints of Cubism. He then rephotographed these images through sheets of glass onto which he painted gestural marks. The visual effect of this is very similar to *Mystère*, Clouzot's film about Picasso made in 1956, in which Picasso is filmed painting onto a sheet of glass from behind the glass. Hans Namuth also adopted this technique for his film of Jackson Pollock at work. Thus Hamilton uses a formulation for his own self-portrait to suggest a link with two of the heroes of modernist art. AB

1 Hamilton has written convincingly about this, particularly in the catalogue, edited by Anne d'Harnoncourt and Kynaston McShine (Philadelphia Museum of Art and Museum of Modern Art, New York, 1973).

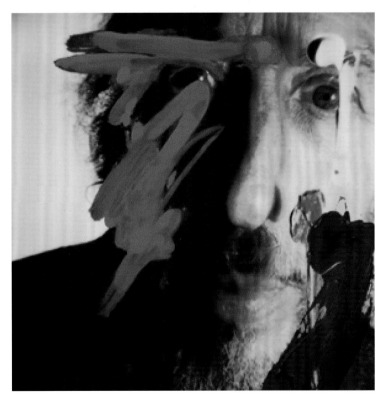

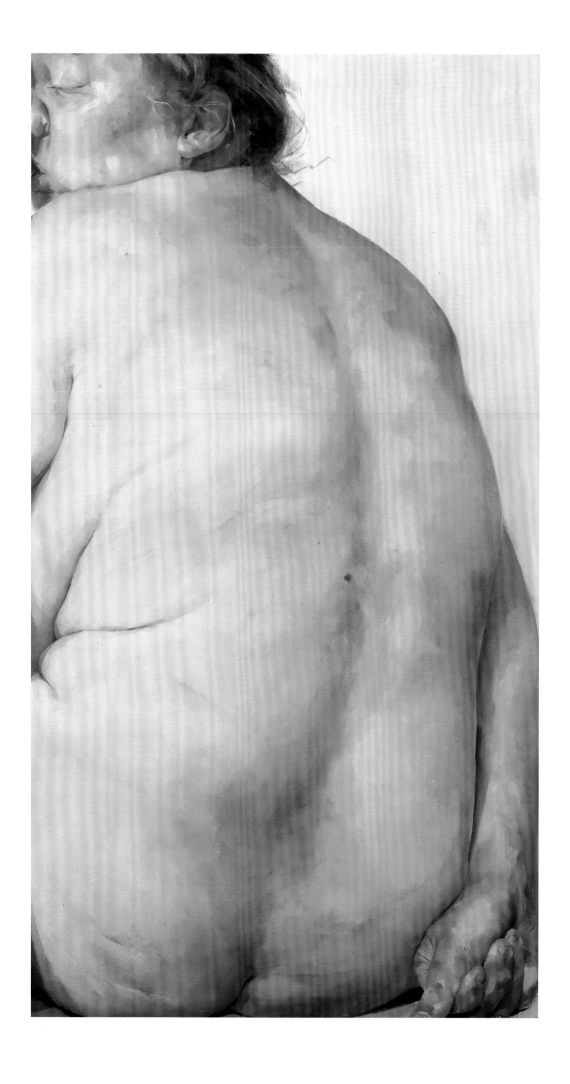

Fig. 62

57
**Jenny Saville
(b.1970)**

Juncture, 1994
Oil on canvas, 2845 x 1676mm
(112⅛ x 66")
Collection of Marguerite & Robert Hoffman

Fig.62
**Ana Mendieta
(1948–85)**
Untitled (cosmetic facial variations), 1972
Digital photograph, 480 x 324mm
(19¼ x 12¾")
Museum of Modern Art, New York

While still a student at Glasgow School of Art in 1992, Jenny Saville's talent was spotted by Charles Saatchi. After purchasing her work he offered Saville an eighteen-month contract to create new works for an exhibition in the Saatchi Gallery in London. It was an instant promotion for a very new artist to the ranks of the famous. In 1994 Saatchi included her in his exhibition 'Young British Artists III' and her career as a 'young brit' or 'YBA' was thus assured. Saville's painting marked a change of direction for Saatchi from the installation art of Damien Hirst or Tracey Emin.

Saville's work prior to 1992 showed various stylistic experiments, although her subject matter was always firmly based on women's bodies. Her *Untitled (girl in the bath)* of *c.*1990 seemed to come closest to Lucian Freud and the 1950s Kitchen Sink School (see cat.50). By the time Saatchi acquired her work she was filling very large canvases with oversized bodies of women. The word 'grotesque' often appears in writings on Saville: Marsha Meskimmon includes her work in an essay entitled 'The Monstrous and the Grotesque' in which she shows how the excessive images by Saville that seem to burst the borders of the normal

body and other similar artists may be employed as a means to cross the boundaries set by the male gaze in reclaiming space for the feminine 'Other'. As Meskimmon writes, 'The word "Monster", and the associated terms "grotesque" and "freak", have a special relationship to notions of representation, rational, scientific knowledge (upon which the structure of oppressive binarism is founded) and the body of woman. Therein lays the potential empowerment of the monstrous and the Grotesque for women's self portraiture'.[1] Later she notes that this artistic and political strategy has the potential to collapse back into a freak show.

The Cuban American artist Ana Mendieta took similar risks in her self-portraits showing her features distorted by being pressed up against glass or forced out of shape inside stockings pulled down over her face, such as her *Untitled (cosmetic facial variations)* of 1972 (fig.62). Saville has more recently made similar photographic self-portraits. The self-portraits of the photographer Jo Spence, made during her battle with cancer, have a painful autobiographical quality: for example, she writes 'Monster' across her body which has

been mutilated by surgery.

Committed to the idea of good painting, Saville has stated: 'I want people to know what it is they're looking at. But at the same time, the closer they get to the painting, it's like going back into childhood. And it's like an abstract piece. It becomes the landscape of the brush marks rather than just sort of an intellectual landscape.' And: 'de Kooning is my main man really, because he just did everything you can do with paint. He reversed it, dripped it, and scraped it. But I want to hold on to a certain amount of reality.'[2]

It is significant that Saville mentions de Kooning, not so much for painterly reasons but because of his notorious mutilation of the female form. Saville's paint quality, although likened to Freud's generous impasto or Courbet's painterly equivalence, is perhaps a little closer to the less spontaneous brushwork of Stanley Spencer (cat.43) or Otto Dix, with its obsessive emphasis on surface incident and human imperfection. AB

1 Marsha Meskimmon, 'The Monstrous and the Grotesque: On the politics of excess in women's self-portraiture', in *Make: The Magazine of Women's Art* (October/November 1996), pp.6–11.
2 Jenny Saville quotes from www.artquotes.com.

58
Gerhard Richter
(b.1932)

Self-portrait, 1996
Oil on linen, 511 x 464mm (20⅛ x 18¼")
The Museum of Modern Art, New York,
Gift of Jo Carole and Ronald S. Lauder
and Committee on Painting and
Sculpture Funds, 1996

Fig.63
Gerhard Richter
Abstract Painting 812, 1994
Oil on canvas, 2500 x 2000 mm
(98½ x 78¾")
Art Gallery of New South Wales

Fig. 63

Richter was born in Dresden in 1932, grew up under the Third Reich and subsequently lived in the Eastern sector. He first studied art at the Kunstakademie in Dresden where he learned to copy realistic and Romantic styles as part of the traditional curriculum. During these years he was isolated from the international avant-garde until he received permission to visit Kassel for the 'Documenta 2' exhibition of Abstract Expressionism in 1959; here he saw works by artists of the New York School for the first time, including Jackson Pollock and Lucio Fontana, which profoundly impressed him. He realised that his form of realism was nothing like as 'actual'[1] as the work of these artists whose material involved both the subject and content of their work. Prompted by this experience Richter moved permanently from the East just before the Berlin Wall was built. From 1961 until 1963 he continued his studies in Düsseldorf where he met Joseph Beuys, whose work was not only political in its engagement with recent German history but also had a very strong material base.

Richter's early paintings were related to Pop Art but with a political edge. His subject matter was often based on newspaper photographs mimicking blurred surveillance images taken from a moving car. Richter's origins in East Germany gave this quality a more personal resonance. The relationship of his painting to photography has remained constant, even though his subject matter has varied from landscape to historical paintings to apparently minimalist abstraction. It is not the accuracy of the image that interests him, but rather the potential for blurring, loss of focus and definition that is produced. When Richter plays with motion he not only suggests the slippage of the artist's hand or the camera lens; by implication he moves the body of the viewer before the work.

His working method includes using photographs of natural forms and rhythms which he often overpaints and rephotographs, creating a slippage between media. In some ways this resonates with the observations Leonardo made of water and wind, which subsequently informed his painterly repertoire. This way of looking is translated into a tradition that is connected to Titian (fig.6) and Velázquez(cat.17), and through Claude Monet to Mark Rothko, partially expressed in the baroque tendency to break the surface of the paint and blur the image to stimulate the viewer's imaginative interpretation. This technique applies to Richter's abstracts (cf. fig.63) as much as it does to his figurative works.

Thus while Richter's self-portrait here has the look of a soft focus photograph, related at one level to the soft focus of Bonnard's self-portrait (cat.45), it does in fact connect to the painterly tradition that defines the likeness of the artist as much through the trace of the hand as it does pictorially. Here he returns stylistically to the Romantic imagery of his youth, although seen from a distance or through a glass darkly. He seems to be wearing what could be an artist's smock; through his large-rimmed glasses he stares out over the viewer's shoulder. The image appears like a photograph seen through many layers of tinted or dusty glass: there is a distancing in this ambiguous depth of field that has viewers screwing up their eyes in an effort to resolve its substance.

AB

1 Often used by European artists, the term 'actual' captures connotations of realist, material, concrete and present.

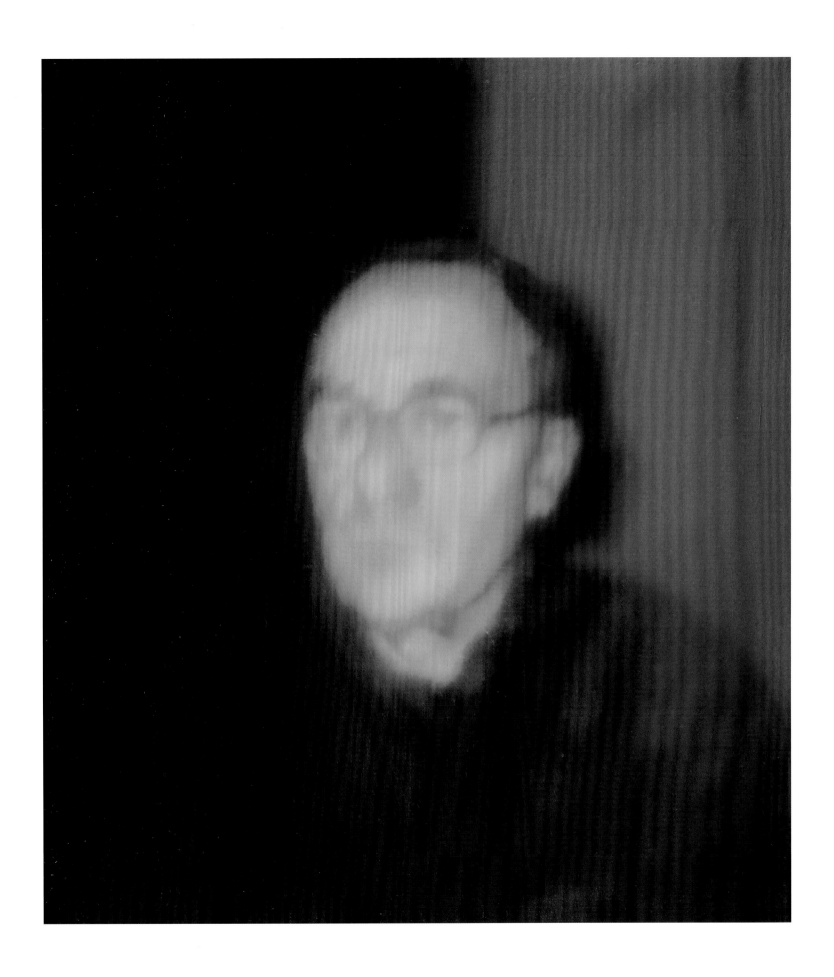

59
Chuck Close
(b. 1940)

Self-portrait, 2005
Oil on canvas,
2756 x 2134mm (108½ x 84")
Private Collection, New York
Not illustrated in final state; images in progress on pp.205–7

Fig.64
Chuck Close
Big Self-portrait, 1967–8
Acrylic on canvas,
2730 x 2120mm (107½ x 83½")
Collection Walker Art Center, Minneapolis;
Art Center Acquisition Fund, 1969

Fig.65
Chuck Close
Self-portrait, 2000–01
Oil on canvas,
2743 x 2130mm (108 x 84")
The Art Supporting Foundation
to SFMOMA

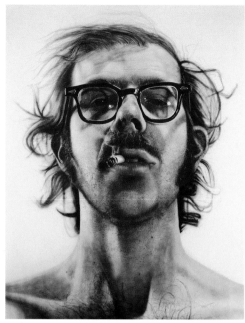

Fig. 64

Chuck Close developed first as an abstract painter. During his studies at the University of Washington in Seattle, Yale University and the Akademie der Bildenden Künste in Vienna, he created principally biomorphic imagery indebted to the paintings of Jackson Pollock, Arshile Gorky and Willem de Kooning. But in 1965, following his return from Vienna, he started making relief constructions and also to work from photographs. By 1967 he had completed the first of a sequence of highly finished and detailed realist paintings, each dramatically enlarged from a photograph, in which colour was set aside and the image rendered entirely in black and white. Each work took many months to paint, being constituted of a grid of more than 100,000 squares. As Close said in 1970, 'I feel a kinship with those artists who have rid themselves of painterly language ... I am also more concerned with the process of transmitting information than in filling out a check-list of the ingredients a portrait painting is supposed to contain'.[1]

Among the early sequence of heads was *Big Self-portrait* (1967–8; fig.64), a 9ft by 7ft, full-face, finely airbrushed, acrylic portrayal of the 27-year-old artist, cigarette in mouth – with tousled, straggly hair, stubble and sprouting chest hair – an iconic image for a rebellious generation. But whereas Chuck

Close was associated by others with the photorealist movement, the artist himself was adamant that his interest was in the combination of system and visual information, rather than in the *trompe l'œil* translation of a particular photograph. The work is therefore as much about *how* to convey an image as about the image itself. In these years Close deliberately chose to make images of his friends or himself, rather than faces that would be known to gallery viewers. 'I am trying not to talk about man's inhumanity to man or other humanist issues, like why somebody is not a nice person or whatever. But ... people's faces are roadmaps of their life to some extent'[2]

Having already made coloured works in acrylics during the 1970s and early 1980s, in 1986 Close returned to the use of oil paint. Following on from works in which the image of a face was conveyed through an assembly of marks other than brush strokes – including shreds of paper and fingerprints – he started to build up the overall painted image in looser units, moving well away from photorealism. After suffering a severe stroke in 1988, which initially paralysed him from the neck down, the artist's ability to make fine brush strokes was radically restricted, and he built his painted images in larger units of coloured paint (see image opposite, fig.65). Like an extreme form of

electronic pixilation, each small square of paint appears abstract itself but builds up to an image fully legible only at a distance.

Chuck Close's self-portraits are a marker of change and continuity over a period of nearly forty years. The photographs he uses are not always concurrent with the period of painting, but they track still a process of self-examination. 'It's a very difficult thing to deal with a nine-foot-high image of yourself ... Anything that is wrong with your face – like your nose is bent a quarter of an inch – when it's nine feet high it's bent four inches, and you can't kid yourself anymore ... I always refer to it as "him" anyhow'.[3] Despite the apparent distancing in the process of painting, Chuck Close's paintings of heads and faces – and his more recent photographic works, including the reworking of the intricately fine detail daguerreotypes – are hugely engaging, his own image with beard and glasses becoming well known worldwide through exhibition and reproduction. SN

At the time of writing the artist is painting a new self-portrait which will be included in the exhibition.

1 Cindy Nemser, 'Chuck Close: Interview with Cindy Nemser', *Artforum* 8, no 5 (January 1970), pp.51–5.
2 Barbaralee Diamonstein, *Inside New York's Art World* (Rizzoli, New York, 1979), p.79.
3 Op. cit., pp.72–3.

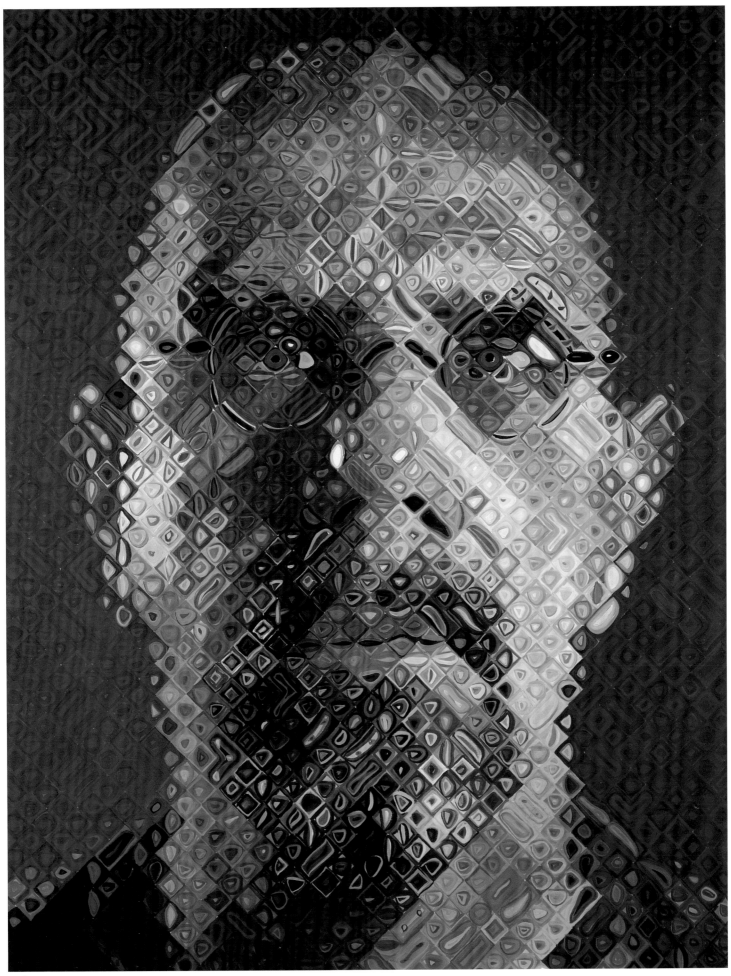

Fig. 65

INTERVIEW WITH CHUCK CLOSE, 6 JULY 2005

Sandy Nairne

SANDY NAIRNE

How did the first self-portrait start?

CHUCK CLOSE

I had done this 22-foot-long reclining nude. I thought the scale was still too small and there were hot spots – the pubic area, the nipples – so I decided I just wanted to get away from that and I wanted it to feel bigger, more like *Gulliver's Travels*: the idea of the Lilliputians crawling over the head of a giant and not even knowing what they were on, stumbling over a beard here and falling through a nostril. I wanted to make it as big as it could be between the floor and ceiling. I was photographing the nude painting and I had film left in the camera so I measured the distance between my face and the camera and I took pictures. The nude was black and white, so I wanted to try and do the same thing with a portrait. Frankly, the fact that it was a self-portrait had more to do with the fact that I was available than anything else.

Over the years, for most solo gallery exhibitions I've tended to do at least one new self-portrait. It's been kind of like a high school lab experiment – watch me age, watch my hair go grey, watch my glasses alter; marking change over time while the image is constant.

SN Did you conceive of them as a series from the beginning?

CC No. I wanted to paint people who weren't well known. And my friends were all unknown. Only later they turned out to be Richard Serra and Phil Glass and Nancy Graves. I wanted *everyman* and *everywoman* – no-one in particular. I certainly didn't want to veer into Andy Warhol's territory of painting superstars. I did that first self-portrait in 1967–8. Sometimes a new one has come because I'm working differently, like when I started watercolours and wanted to do a watercolour of myself. And later the same when I started doing daguerreotype portraits. I didn't do myself in fingerprints or in pulp paper, however. Though now I wish I had.

I'm certainly not aiming to flatter people in my portraits; nor am I trying to make them grotesque. I thought that if I could be really tough on myself, it would be easier to explain to someone else why I didn't end up flattering them. I always thought that in portraying myself I should be as unflattering as with others – wrinkles, warts or whatever – I certainly had that 'grunge' look earlier on, not exactly handsome.

SN Are there ways in which making a painting of your own image is different from when you paint somebody else?

CC In many ways it's very much the same, I refer to 'me' as 'him' often because I have a kind of arm's length distance, especially when spraying little dots. You lose track of what you are doing. It's like any incremental way of working. If you think about a novelist, he can't sit around and worry about the storyline and the narrative the whole time – he'd never be able to do anything because what you have to do is slam one word into the next and you build from these little chunks. You have a vague idea of what you are doing, but you can't be obsessed with it or you'd be crippled. So I am just about as removed and arm's length working on myself as I am with anybody else.

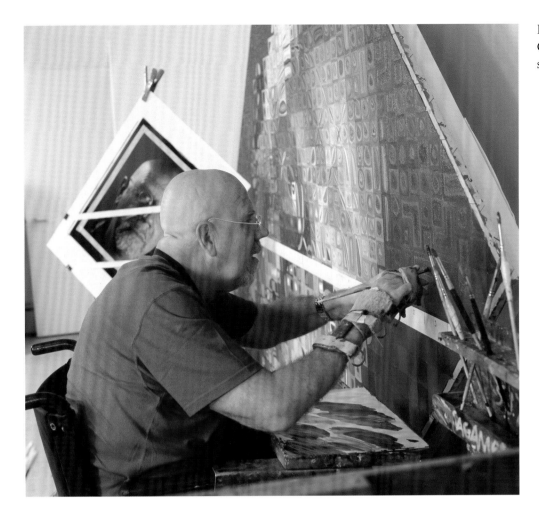

Fig.66
Chuck Close at work on the new
self-portrait, Long Island, 2005

And then of course it sort of clicks in. I come back from lunch or the bathroom and roll back into the studio and, oh my god, I'm making a picture of me. Almost as if I'd forgotten. But I'm maybe the last person to be able to see some of this.

I did a couple of black-and-white portraits that a number of people said were very grim, that looked like I was depressed, or dying, or whatever. I thought, crikey, I don't remember feeling that way, but if I look at them I can see why they might feel that way.

At the same time I do think there is something different about self-portraits and I know that I feel differently about other people's self-portraits. When I go to a museum and I'm spending time with work and I know that it's the image of the artist and how he or she has tried to portray themselves, I look at it in a slightly different way. Also, if I look at a daguerreotype and it's George Sands or something like that, I am more interested in that daguerreotype than I am in Joe Blow the local scientist or something.

SN Are there particular self-portraits by others that have had a strong impact on you?

CC With van Gogh of course, big time. I'm not a big Rembrandt fan, but especially earlier when he was very young, they are so tender. Then the late lumpy ones are amazing. With an artist who isn't even my favourite, like Max Beckmann, I still love his self-portraits. Sometimes something special happens, but I'm not sure what it is, but it can produce an artist's best work.

SN Do you think that your self-portraits give your viewers a particular insight into you as an artist, or indeed into your personality?

CC I've always tried to present the visual information straightforwardly, flat-footedly, without editorial comment. I don't have people in portraits laughing or crying, frowning or smiling particularly. But I always thought that whatever has happened in someone's life, there is evidence embedded in that face. If they have laughed their whole life they have laugh lines. And if they frowned their whole lives they have

furrows. We almost relate to someone in one of these paintings as we would relate to someone that we would meet. You are trying to figure out who the person is; is this a happy person? Or a sad person? Or is this somebody that is snarling at me?

I think this can also happen with my own image and I think that is why I'm so careful to present it so neutrally, so that I'm not bound to get just one reading: that everyone can relate to this image as they would relate to me, or relate to someone else trying to figure out who this person is, as if to make an interview in a sense.

SN Has that changed as you have become well known, as you have become an icon amidst other icons?

CC I now get stopped on the street a lot. I get stopped in museums, or in an airport, or in another country. It's really kind of amazing that I've become so recognisable simply from having done all these self-portraits. Prior to going into the wheelchair, I was six foot three, and I must have been somewhat foreboding and I put people off or they were

hesitant to approach. But the minute I was in a wheelchair, this cut me down to size and now almost anybody is taller than I am. It has made me much more approachable: an odd and wonderful by-product of having done all these self-portraits.

I don't make art as therapy or in a masturbatory way, I make art for other people; I put it out for people. In a sense we are all performing artists, we perform with no audience and then the painting is the frozen evidence that this act took place in the studio. But because they're not in there watching me, the painting has to stand for that. And one of the wild things about having a career is that at first when you are a young artist or student, the only people who relate to your work are people you know, and so they come and look at your work and you pick their brain and try and get them to read the painting for you. Then all of a sudden you have a career and your work is out there and people you *don't* know see your work. People you don't know have a real relationship with you.

Actually it's profoundly moving to be told that your work has urgency or significance by people who feel that they can come up to you on the street. What could be better than that? I guess if they interrupted a meal in a restaurant, I might mind, but even then I don't really care. Because this is why I make this stuff, and to know that people are seeing it all over the world, it's kind of amazing.

SN There's also something particular about your self-portrait works that they position you through the scale of them and their intensity. As a viewer you get the sense that you want to go for the optimum optical position, to get the correct perspective.

CC That's part of this ritual dance that viewers intuit, because people stand at a distance, they go to a middle distance, and then they go close up, trying to find the right place. I guess this is the incremental nature of the work, which clicks in at certain distances. There are thresholds at which certain things happen. But it takes the active participation of the viewer; you don't just walk by these things.

SN As you start, do you have in your mind's eye a sense of what you want the finished self-portrait to look like?

CC Iconographically it's going to look a lot like the source photograph and that's a guarantee in the way I work. I know the story I am going to tell – if we can turn to a writing metaphor – but I don't know the vocabulary. I don't know the syntax. In the pictorial syntax, very much like the written word, you begin to find a certain set of colours. You'll notice on the unfinished areas, that there are marks, almost like notes. These are things that I've thought about while I was working in that area that I jot down. So that when I come to that area in the second pass it will jog my memory as to what it was I saw in the first pass. Don't forget to look at this, don't forget to think about that, or whatever. So I'm making little references, little notes for myself, almost like putting post-it notes all over.

In general there is the first pass and then the second one, and then if it is a diagonal painting I will alter its axis by turning it on another corner so that I am looking at all the squares adjacent to different squares from the first time. That gives me a chance to reassess all the decisions because now the row goes the opposite way. And so that's three passes and then I just work all over and I make the final edit, the final fine-tuning.

SN How do you then know that a self-portrait is finished?

CC Well you could work on it endlessly adjusting this and that, but there is a kind of point at which you risk beating it to death. I try to make the corrections in four or five or six colours. You can keep going but you don't want endlessly to just do it, and it's much more interesting to figure out this is where it is right now, not what else could I have done. It's always wrong before it's right, it's always unacceptable before its acceptable, and incomplete before its complete, which is the fun, game-like quality – you know I have to amuse myself in the studio!

I creep up on the final moment. It's a long slow process and I creep up on it but I know I am getting there and then of course I turn the work to the wall. I turn it to the wall for usually a month to get some distance and then I turn it around and then see about thirty-five huge, ugly sore thumbs sticking out and then I go in and I try and work on those areas.

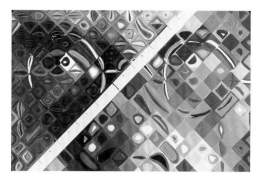

Fig.67
Detail of the new self-portrait, spring 2005

SN In the case of your self-portraits it must be a rather particular kind of editing even when you've become very distanced from it, and you've become 'him' rather than 'me'.

CC Let me tell you what I thought today, for instance. I was rather suntanned in the photograph for this new work and my nose was red. And I'm thinking: oh my god, this is like W.C. Fields, an alcoholic, blood-vessel breaking nose. So I thought momentarily well maybe I won't make it as red. Then I thought, come on, who am I fooling here? And my new right eye, or actually it's my left eye, but the eye on the right of the self-portrait, it's absolutely like a planet exploding apart, and it's broken into four different size comets around an invisible nucleus. There is no centre to the eye. Then one of them appears to have a hole through it, in which you can see orange. So I'm thinking this is really weird, this is not something that will ever read as an eye, so when I stopped for lunch, I sat and I looked at it and I actually went back and made some corrections, but I think I was kind of amazed that I had managed to make this thing look like an eye.

SN Some of the empathy comes for viewers through the fact that we don't all blow our images up but we do all have that same experience of wondering why we look the way we do.

CC In the recent television interview, because I knew the self-portrait was for London, I related a number of things about what I thought was different about American painting from British painting. I was saying that initially I was not very interested in Francis Bacon or Lucian Freud,

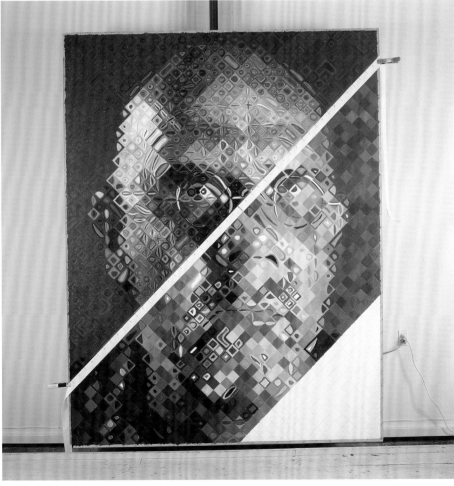

as I didn't think I was a portrait painter. But as I have realised that I am one, then, I began to look at the conventions and traditions of portrait painting and really fell in love with their work. I said that the British painters, like Bacon and Freud, don't have the same commitment to the whole rectangle in the way that American painters do. We have a tradition of all-overness and not making any area more important than another area, whether it's in Jackson Pollock's drips, or De Kooning's 'Excavation' or Frank Stella's black stripes, or in Le Witt. And I don't think I much like Bacon's figure paintings where they are sitting in a big empty room. But I really love his portraits, and the smaller the better because they burst right out to the edge of the painting.

In the small portraits, Bacon really works the whole painting. Freud approaches things differently depending on what he is portraying, with the lumps and bumps on the heavily worked figures, and then the more thinly applied paint, where the floor is almost dashed off with wood grain effect. That's something which I think is really so different and certainly is so foreign to me. I try never to feel any different about an eyeball or a nostril than I do a piece of the background. You've got to trick yourself into that because of course you do care more about the features and they are the things that carry the information that lets us know who the person is, so it's only with the most rigorous self-control that I work to be as nonchalant as I can. So it may be one of the reasons why I work on them on an angle, why I don't walk back. It is a commitment that every square inch will be of equal importance. It fits my recent realisation of how important my grandmother was to me in knitting and crocheting and quilting, the kind of women's work stuff. This is where it is a field, with the same activity everywhere, but in an extraordinary complicated way.

Fig.68
Two partial states of the new self-portrait, studio, Long Island, spring 2005

ACKNOWLEDGEMENTS

The National Portrait Gallery, the Art Gallery of New South Wales, the authors and publishers are grateful to the following institutions and individuals for their help in the preparation of this catalogue and the exhibition that it accompanies.

The living artists whose self-portraits are included in the exhibition: Georg Baselitz, Chuck Close, Marlene Dumas, Lucian Freud, Richard Hamilton, Leon Kossoff, Gerhard Richter and Jenny Saville.

The authors of the catalogue, whose initials are given at the end of each catalogue entry in acknowledgement of authorship, as follows:
AB Anthony Bond
LC Laura Casas
SC Sophie Carr
JD Jephta Dullaart
EE Elizabeth Emerson
GF Georgina French
AH Amanda Herrin
HL Hannah Lake
NL Nicole Lawrence
TM Terence Maloon
SN Sandy Nairne
EP Eugene Pooley
UP Ursula Prunter
FS Francesca Silvester
JW Joanna Woodall

Professor Ludmilla Jordanova, Professor Joseph Koerner and Professor T.J. Clark, who have contributed introductory essays to this book, and those who attended the colloquium in April 2004 in the early stages of this project, particularly Dr Alexander Sturgis and Professor Joanna Woods-Marsden.

Those who gave assistance with loans and research: Don Bacigalupi, Anne Baldassari, Francis Beatty, Christoph Becker, Nicholas Blake QC, Julius Bryant, Brian Clarke, Catherine Clement, Dr Roberto Contini, Felicity Coupland, Elizabeth Cowling, Anthony d'Offay, Jan Debbaut, Sian Ede, John Elderfield, Jeremiah Evarts, William Feaver, Richard Feigen, Gabriele Finaldi, Dr Elisabeth Giese, Adrian Glew, Peter Goulds, Dr Jenns Howoldt, David Jaffé, Frank Kelly, Kasper König, Brigitte Leal, John Leighton, Christopher Lloyd, Ulrich Luckhardt, Caroline Mathieu, Larry Nichols, Lady Mary Nolan, Aly Noordermeer, Antonio Paolucci, Sir Hugh Roberts, Cora Rosavear, Axel Ruger, Rose-Marie San Juan, Charles Saumarez Smith, Katie Scott, David Solkin, Shelley Souza, Unity and Shirin Spencer, Dr Rainer Stamm, Patrizia Tarchi, Dodge Thompson, Annamaria Petrioli Tofani, Robert Travers, Adam Weinberg, Arthur Wheelock, Humphrey Wine and Miguel Zugaza.

At the National Portrait Gallery: Joanna Banham, Pim Baxter, Sophie Clark, Naomi Conway, Tarnya Cooper, Sarah Crompton, Neil Evans, Peter Funnell, John Haywood, Sarah Howgate, Celia Joicey, Catherine MacLeod, Paul Moorhouse, Ruth Müller-Wirth, Lucy Peltz, Kate Phillimore, Liz Rideal, Jonathan Rowbotham, Jude Simmons, Jacob Simon, Kathleen Soriano, Hazel Sutherland and Rosie Wilson. At the Art Gallery of New South Wales: Donna Brett, Edmund Capon, Charlotte Davey, Anne Douglas, Erica Drew, Anne Flanagan, Anna Hayes, Rachel Kiang, Brian Ladd and Ursula Prunster.

The designers of the catalogue, Atelier Works, and Calum Storrie for the design of the exhibition at the National Portrait Gallery.

PICTURE CREDITS

The publisher would like to thank the copyright holders for granting permission to reproduce works illustrated in this book. Locations and lenders are given in the captions, and further acknowledgements to copyright holders are given below. Every effort has been made to contact the holders of copyright material; any omissions are inadvertent, and will be corrected in future editions if the notification is given to the publisher in writing.

Accademia Nazionale di San Luca, Rome cat.5
© ADAGP, Paris and DACS, London 2005 cats 40, 45
© akg-images/Rabatti-Domingie cat.20
Albertina, Wien figs 37, 46
Alte Pinakothek, Munchen fig.36
Courtesy of the Art Gallery & Museum, The Royal Pump Rooms, Royal Leamington Spa, Warwick District Council fig.1
© The Artist (Lucian Freud) fig.7; cat.50
Ashmolean Museum, Oxford figs 28, 29
© Estate of Francis Bacon 2005. All rights reserved, DACS cat.51
© Banco de México Diego Rivera & Frida Kahlo Museums Trust. Av. Cinco de Mayo No.2, Col. Centro, Del Cuauchtémoc 06059, México D.F. Courtesy of Instituto Nacional de Bellas Artes y Literatura, Mexico City cat.44
© Georg Baselitz cat.52
© Museum Bojimans van Beuningen, Rotterdam fig.16
Pinacoteca Nazionale di Bologna courtesy of the Ministero Beni e Att. Culturali fig.12
Galleria Borghese, Rome, Italy/Lauros/Giraudon/Bridgeman Art Library fig.13
Galleria Borghese, Rome, Italy/Bridgeman Art Library fig.47
Pinacoteca di Brera, Milan, Italy/Bridgeman Art Library fig.10
By Permission of the British Library fig.11
© The Trustees of the British Museum figs 39, 40, 41
Courtesy of the Busch-Reisinger Museum, Harvard University Art Museums, Association Fund; Photo Stafford Rick fig.35
© Calouste Gulbenkian Museum, Lisbon cat.30
Cheltenham Art Gallery & Museums, Gloucestershire, UK/Bridgeman Art Library cat.13
© Christian Schad Stiftung Aschaffenburg/VG Bild-Kunst Bonn and DACS, London 2005 cat.42
© Chuck Close, Photo Michael Marfione figs 66–8
© Chuck Close, Collection Walker Art Center, Minneapolis; Art Center Acquisition Fund, 1969 fig.64
© Chuck Close, courtesy Pace Wildenstein/Photo y Ellen Page Wilson, courtesy Pace Wildenstein fig.65
© CNAC/MNAM Dist. RMN, Jacqueline Hyde cat.40
© CNAC/MNAM Dist. RMN, Jean-Claude Planchet, cat.44
© CNAC/MNAM Dist. RMN, Philippe

Migeat, cat.51
© DACS 2005 cats 39, 48
By Permission of the Trustees of Dulwich Picture Gallery fig.26
© Marlene Dumas, Courtesy: Frith Street Gallery cat.54
© Lucian Freud cat.50
© English Heritage Photo Library cat.26
Fitzwilliam Museum, Cambridge fig.59
© bpk Berlin/ Gemäldegalerie, Staatliche Museen zu Berlin. Photo Jörg P. Anders cat.25
Gemäldegalerie der Akademie der bildenden Künste, Wien figs 33, 34
© bpk/Hamburger Kunsthalle, Hamburg, Germany. Elke Walford/Bridgeman Art Library cat.28
© Richard Hamilton 2005. All rights reserved, DACS cat.56
© Leon Kossoff cat.55
Staatliche Kunsthalle Karlsruhe cat.31
© 2005 Kunsthaus, Zürich. All rights reserved cat.36
Kunsthistorisches Museum, Wien oder KHM, Wien fig.4
Kunstmuseum, Basel, Kupferstichkabinett fig.38
Vienna, Österreichische, Nationalbibliotheke fig.4
The Metropolitan Museum of Art, Purchase, The Horace W. Goldsmith Foundation Gift, 1992 (1992.5112) Photograph © 2005 The Metropolitan Museum of Art fig.19
The Minneapolis Institute of Arts, The Ethel Morrison Van Derlip Fund fig.21
Museum Kunst Palast Düsseldorf fig.48
Digital image © 2005, The Museum of Modern Art/Scala, Florence fig.62
© bpk/Nationalgalerie, Staatliche Museen zu Berlin. Jörg P. Anders cat.33
© The National Gallery, London figs 27, 31; cats 1, 16a, 18, 27, 32
© 2004 Board of Trustees, National Gallery of Art, Washington cat.11
© 2005 Board of Trustees, National Gallery of Art, Washington cat.35
National Gallery of Australia cats 9, 37
National Gallery, Norway fig.14
© National Gallery of Victoria, Melbourne cat. 16b
National Gallery in Prague fig.9
National Portrait Gallery, London figs 23, 25, 32, 55; cats 2, 22, 23
© Courtesy the Estate of Sir Sidney Nolan/Bridgeman Art Library cat.47
© Museo Nacional del Prado, Madrid figs 15, 43, 44, 45
© Photographic Archive, Museo Nacional del Prado, Madrid. Fotografía realizada por: José Baztán y Alberto Otero cats 8, 12
Bildarchiv Preussischer Kulturbesitz figs 6, 42
© Private Collection fig.56
Private Collection/Bridgeman Art Library fig.20
© Gerhard Richter cat.58
© Gerhard Richter/photograph: Jenni Carter for AGNSW fig.63
© RMN, Droits réservés fig.30
© RMN, Jean-Giles Berizzi fig.50
© RMN, Hervé Lewandowski fig.22; cat.29
© RMN, Hervé Lewandowski, Paris, Musée

du Louvre fig.5
© Mrs Gladys E. Robinson, wife of deceased artist John N. Robinson, Sr cat.46
The Royal Collection © 2005, Her Majesty Queen Elizabeth II fig.49; cats 7, 14
Museo de la Real Academia de Bellas Artes de San Fernando, Madrid fig.18
Royal Albert Memorial Museum & Art Gallery, Exeter fig.24
© Jenny Saville, Courtesy: Gagosian Gallery cat.57
© Scala, Florence/Courtesy of the Ministero Beni e Att. Culturali fig.5
© 2005, Scala, Florence cat.58
© 1990, Scala, Florence – courtesy of the Ministero Beni e Att. Culturali cats 6, 17, 24
Pinacoteca Nazionale, Siena, courtesy of the Ministero Beni e Att. Culturali. Foto Soprintedeza PSAD Siena & Grosseto fig.17
© Estate of Francis N. Souza/Bridgeman Art Library cat.49
© Rheinisches Bildarchiv Köln cat.38
Rijksmuseum, Amsterdam figs 53, 54
© Estate of Stanley Spencer 2005. All rights reserved. DACS/Tate, London 2005 figs 57, 58
© Estate of Stanley Spencer 2005. All rights reserved. DACS/Fitzwilliam Museum, Cambridge fig.59
Tate, London 2005 cat.42
© Galleria degli Uffizi – Collezione degli Autoritratti – Firenze cat.21
Galleria degli Uffizi, Firenze/Bridgeman Art Library fig.52; cats 3, 19
Van Gogh Museum, Amsterdam (Vincent van Gogh Foundation) cat.34
Vatican Museums and Galleries, Vatican City, Italy/Bridgeman Art Library fig.3
Wadsworth Atheneum Museum of Art, Hartford, CT. The Ella Gallup Sumner and Mary Catlin Sumner Collection Fund fig.51
© The Andy Warhol Foundation for the Visual Arts, Inc./ARS, NY and DACS, London 2005 cat.53
Stiftung Weimarer Klassik und Kunstsammlungen/Museen fig.8
© Whitney Museum of Art, New York cat.41
Museum-Zamek, Lancut, Poland cat.4

BIBLIOGRAPHY

Ades, Dawn, and Andrew Durham, *Francis Bacon* (exh. cat., Tate Gallery London, 1985)

Alcántara, Isabel and Sandra Egnolff, *Frida Kahlo and Diego Riviera* (Prestel Verlag, Munich, 2004)

Alpers, Svetlana, 'Interpretation without representation, or, The Viewing of *Las Meninas*', *Representations* 1 (February 1983), pp.30–42

Auerbach, E., 'Sermo humilis', in *Literary Language and its Public in Late Latin Antiquity and in the Middle Ages* (Princeton University Press, Princeton, 1965), pp.25–66

Autoritratti dagli Uffizi da Andrea del Sarto a Chagall (exh. cat., Accademi di Francia, Rome, and Galleria degli Uffizi, Florence, 1990).

Bazin, Germain, *The Avant-Garde in Painting*, trans. Simon Watson Taylor (Thames & Hudson, London, 1969)

Beckett, Sister Wendy, *Max Beckmann and the Self* (Prestel, New York, 1997)

Bell, Julian (intro.), *Five Hundred Self-portraits* (Phaidon, London, 2000)

Berger, Harry, Jr, *Fictions of the Pose. Rembrandt against the Italian Renaissance* (Stanford University Press, Stanford, 2000)

Bernard, Bruce (ed.), *Vincent by Himself: A Selection of Van Gogh's Paintings and Drawings Together with Extracts from his Letters* (Little, Brown, Boston 1985)

Bernard, Bruce and Derek Birdsall (eds), *Lucian Freud* (Jonathan Cape, London, 1996)

Berti, Luciano, *The Uffizi and the Vasari Corridor*, trans. Rowena Fajardo (Constable, London, 1979)

Beyer, Andreas, *Portraits: A History*, trans. Steven Lindberg (Abrams, New York, 2003)

Bezzola, Tobia, *Christian Schad, 1894–1982* (exh. cat., Kunsthaus Zürich, Städtliche Galerie im Lenbachhaus München and Kunsthalle, Emden, 1997)

Bialostocki, Jan. 'Man and Mirror in Painting: Reality and Transcendence', *Studies in Late Medieval Renaissance Painting in Honor of Millard Meiss*, eds I. Lavin and J. Plummers (New York University Press, New York, 1977), pp.61–72

Biernoff, Suzannah, *Sight and Embodiment in the Middle Ages* (Palgrave Macmillan, New York, 2002)

Bober, T.P., 'Appropriation Contexts: Décor, Furor Bacchicus, Convivium', *Antiquity and its Interpreters*, eds A. Payne, A. Kuttner and R. Smick (Cambridge University Press, Cambridge, 2000)

Bomford, Kate, *The Visual Representation of Friendship amongst Humanists in the Southern Netherlands c.1560–1630* (Ph.D. thesis, London University [Courtauld Institute of Art], 2000)

Bomford, Kate, 'Peter Paul Rubens and the Value of Friendship', in *Nederlands Kunsthistorisch Jaarboek* 54: *Virtue, virtuoso, virtuosity in Netherlandish Art*, eds Jan de Jong, Dulcia Meijers, Mariët Westermann

and Joanna Woodall (Waanders, Zwolle, 2004), pp.229–58

Bonafoux, Pascal, *Les peintres et l'autoportrait: le métier de l'artiste* (Skira, Geneva, 1984)

Bonafoux, Pascal, *L'autoportrait au XXe siècle: Moi je, par soi-même* (exh. cat., Musée du Luxembourg, Paris, 2004)

Borel, France, *Bacon: Portraits and Self-portraits*, intro. Milan Kundera, trans. Ruth Taylor and Linda Asher (Thames & Hudson, London, 1996)

Borzello, Frances, *Seeing Ourselves: Women's Self-portraits* (Thames & Hudson, London, 1998)

Brilliant, Richard, *Portraiture* (Reaktion, London, 1991)

Brooke, Xanthe, *Face to Face : Three Centuries of Artist' Self-portraiture* (exh. cat., Walker Art Gallery, Liverpool, 1994)

Brown, Katherine, *The Painter's Reflection: Self-Portraiture in Renaissance Venice 1458–1625* (Olschki, Florence, 2000)

Bushart, Bruno, Matthias Eberle, and Jens Christian Jensen, *Museum Georg Schäfer, Schweinfurt* (Museum Georg Schäfer, Schweinfurt, 2002)

Cachin, Françoise and Joseph Rishel, *Cézanne* (exh. cat., Philadelphia Museum of Art, Tate Gallery, London, Galeries nationales du Grand Palais, Paris and Musée d'Orsay, Paris, 1995)

Castiglione, Baldassare, *The Book of the Courtier*, trans. George Bull (Penguin, Harmondsworth, 1967). Originally published as *Il Libro del cortegiano* (Aldo Ramaro and Andred d'Asola, Venice, 1528)

Cavalli-Björkman, Görel (ed.), *Face to Face: Portraits from Five Centuries* (Nationalmuseum, Stockholm, 2002)

Chapman, H. Perry, *Rembrandt's Self-Portraits: A Study in Seventeenth-Century Identity* (Princeton University Press, Princeton NJ, 1990)

Cheney, Liana De Girolami, Alicia Craig Faxon and Kathleen Lucy Russo, *Self-portraits by Women Painters* (Ashgate, Aldershot, 2000)

Damisch, H., *The Origin of Perspective*, trans. John Goodman (MIT Press, Cambridge and London, 1995)

Deleuze, Gilles and Felix Guattari, 'Year Zero: Faciality', in *A Thousand Plateaux. Capitalism and Schizophrenia* (Athlone Press, London, 1988), pp.167–91

Derrida, Jacques, *Memoirs of the Blind: The Self-portrait and Other Ruins*, trans. Pascale-Anne Brault and Michael Naas (University of Chicago Press, Chicago and London, 1993)

Dorgerloh, Annette, *Das Künstlerehepaar Lepsius: zur Berliner Porträtmalerei um 1900* (Akademie Verlag, Berlin, 2003)

Dorn, Roland *et al.*, *Van Gogh Face to Face: The Portraits* (exh. cat., Museum of Fine Arts, Boston, Philadelphia Museum of Art and Detroit Institute of Arts, 2000)

Emison, Patricia A., *Creating the 'Divine' Artist: From Dante to Michelangelo* (Brill, Leiden and Boston, 2004)

Faunce, Sarah and Linda Nochlin, *Courbet*

Reconsidered (exh. cat., Minneapolis Institute of Arts and Brooklyn Museum, New York, 1988)

Foucault, Michel, *The Order of Things: An Archaeology of the Human Sciences* (Tavistock, London, 1970)

Foucault, Michel, 'What is an author?', in D. F. Bouchard and S. Simon, trans and ed., *Language, Counter-Memory, Practice: Selected Essays and Interviews* (Cornell University Press, Ithaca, 1977)

Foucault, Michel, 'Technologies of the Self' in *Technologies of the Self: A Seminar with Michel Foucault*, eds L. Martin, H. Gutman and P. Hutton (University of Massachusetts Press, Amherst, 1988)

Fried, Michael, *Absorption and Theatricality: Painting and Beholder in the Age of Diderot* (University of Chicago Press, Chicago, 1988)

Fried, Michael, *Courbet's Realism* (University of Chicago Press, Chicago and London, 1990)

Garrard, Mary, *Artemisia Gentileschi: The Image of the Female Hero in Italian Baroque Art* (Princeton University Press, Princeton, 1989)

Garrard, Mary 'Here's Looking at Me', *Renaissance Quarterly* 67, no.3 (1994), pp.556–622

Gell, Alfred, *Art and Agency: An Anthropological Theory* (Clarendon Press, Oxford, 1998)

Goffman, Erving, *The Presentation of Self in Everyday Life* (Penguin, London, 1990)

Gombrich, E.H. 'The Mask and the Face: The Perception of Physiognomic Likeness in Life and Art', in *The Image and the Eye: further studies in the psychology of pictorial representation* (Phaidon, London, 1982), pp.105–36

Goode, James M., *Contemporary Self-portraits from the James Goode Collection* (National Portrait Gallery, Smithsonian Institution, Washington DC, 1993)

Gordon, Robert and Andrew Forge, *Degas* (Thames & Hudson, London, 1988)

Gowing, Lawrence and Sam Hunter, *Francis Bacon: An Exhibition* (exh. cat., Los Angeles County Museum of Art, Hirshhorn Museum and Sculpture Garden, Washington DC and Museum of Modern Art, New York, 1989)

Graham, J., 'Ut Pictura Poesis', in *The Dictionary of the History of Ideas: Studies of Selected Pivotal Ideas*, ed. P.P Weiner, vol. 4 (Norton, New York, 1973–4), p.466

Herrera, Hayden, *Frida Kahlo: The Paintings* (Bloomsbury, London, 1992)

Hughes, Robert, *Lucian Freud Paintings*, (exh. cat., Hirshhorn Museum and Sculpture Garden, Washington DC, London 1987)

Hyman, Timothy and Patrick Wright (eds) *Stanley Spencer* (exh. cat., Tate Britain, London, Ulster Museum, Belfast and Art Gallery of Ontario, 2001)

Jacobs, Frederika, 'Woman's Capacity to Create: The Unusual Case of Sofonisba Anguissola', *Renaissance Quarterly* 47, no.1

(spring 1994), pp.74–101

Jacobs, Frederika, *Defining the Renaissance Virtuosa* (Cambridge University Press, Cambridge, 1997)

Joachimides, Christos M., Norman Rosenthal, Norman and Wieland Schmied (eds), *German Art in the 20th Century: Painting and Sculpture, 1905–1985* (exh. cat., Staatsgalerie Stuttgart and Royal Academy of Arts, London, 1985)

Jongh, E. de, *Portretten van echt en trouw. Huwelijk en gezin in de Nederlandse kunst van de zeventiende eeuw* (exh. cat. Frans Halsmuseum, Haarlem, 1986, Uitgeverij Waanders, Zwolle, 1986)

Kemp, M., 'Lust for Life: Some thoughts on the reconstruction of Artists' lives in fact and fiction', in *L'Art et les revolutions, XXVe Congres internationale de L'Histoire de l'Art* (1992), p.183

Kemp, M., '"Ogni dipintore dipinge sé": a Neoplatonic Echo in Leonardo's Art Theory', in *Cultural Aspects of the Italian Renaissance: Essays in Honour of Paul Oskar Kristeller*, ed. C. H. Clough (Manchester University Press, Manchester and New York, 1976), pp.311–23

Kemp, S., *Future Face: Image, Identity, Innovation* (Profile Books, London, 2004)

King, Catherine, 'Looking a Sight: Sixteenth Century Portraits of Women Artists', *Zeitschrift für Kunstgeschichte* 3 (1995), pp.381–406

Klinger, L., *The Portrait Collection of Paolo Giovio* (University Microfilms International, Ann Arbor, n.d.)

Koerner, Joseph Leo, *The Moment of Self-Portraiture in German Renaissance Art* (University of Chicago Press, Chicago and London, 1993)

Kristeva, Julia, *Powers of Horror: An Essay on Abjection*, trans. L.S. Roudiez, (Columbia University Press, New York, 1982)

Kriz, E. and O. Kurz, *Legend, Myth and Magic in the Image of the Artist. A Historical Experiment* (Yale University Press, New Haven and London, 1979

Küster, Katharina and Beatrice Scherzer, *Der Freie Blick: Anna Dorothea Therbusch und Ludovike Simanowiz, Zwei Porträtmalerinnen des 18 Jahrhunderts; Katalog zur Ausstellung des Städtisches Museums Ludwigsburg* (Ehrer, Heidelberg, 2003)

Langedijk, K., *Die Selbstbildnisse der Hollandischen und Flämischen Künstler In der Galleria degli Autoritratti der Uffizien in Florenz* (Edizione Medicea, Florence, 1992)

Lee, R. *Ut Pictura Poesis: The Humanistic Theory of Painting* (Norton, New York 1967)

Levey, Michael. *The Painter Depicted: Painters as a Subject in Painting* (Thames & Hudson, New York, 1982)

Levin, Gail, *Edward Hopper: The Art and the Artist* (exh. cat., Hayward Gallery, London and Whitney Museum of American Art, New York, 1980)

Lynch, James B., 'Giovanni Paolo Lomazzo's Self-Portrait in the Brera', *Gazette des*

Beaux-Arts 64 (1964), pp.189–97

McDonald, Ewen (ed.), *AGNSW Collections* (Art Gallery of New South Wales, Sydney, 1994)

Manuth, Volker, 'Rembrandt and the Artist's self portrait: tradition and reception', in White and Buvelot 1999, pp. 40–57

Marin, Louis, 'Topic and Figures of Enunication: It is Myself that I Paint', in *Vision and Textuality*, eds Stephen Melville and Bill Readings (MacMillan Press, Basingstoke and London, 1995), pp.195–214

Mayer, T. and D. Woolf (eds), *The Rhetorics of Life – Writing in Early Modern Europe: forms of biography from Cassandra Fidele to Louis XIV* (University of Michigan Press, Michigan, 1995)

Melchior-Bonnet, Sabine, *The Mirror. A History*, trans. K.H. Jewett, with preface by Jean Delumeau (Routledge, London and New York, 2001)

Meskimmon, Marsha, *The Art of Reflection: Women Artists' Self-Portraiture in the Twentieth Century* (Columbia University Press, New York, 1996)

Miller, Jonathan, *On Reflection* (Yale University Press, New Haven, 1998)

Nancy, Jean-Luc, *Le Regard du Portrait* (Galilée, Paris, 2000)

Painters by Painters (exh. cat., Uffizi, Florence and National Academy of Design, New York, 1988)

Pomeroy, Jordana, Rosalind Blakesley, Vladimir Matveyev and Elizaveta Renne, eds, *An Imperial Collection: Women Artists from the State Hermitage Museum* (Merrell, London, 2003)

Prinz, Wolfram, *Vasaris Sammlung von Künstlerbildnisse: mit einem kritischen Verzeichnisse in der zweiten Ausgabe der Lebensbeschreibungen von 1568* (Verein zur Erhaltung des Kunsthistorischen Institutes in Florenz, Florence, 1966)

Prinz, Wolfram, *Die Sammlung der Selbstbildnisse in der Uffizien* (Mann, Berlin, 1971)

Prinz, Wolfram, 'La collezione degli autoritratti', *Gli Uffizi: Catologo Generale* (Centro Di, Florence, 1979)

Rainbird, Sean (ed.), *Beckmann* (exh. cat., Museum of Modern Art, New York, Tate Modern, London and Centre Georges Pompidou, Paris, 2003)

Raupp, Hans Joachim. *Untersuchungen zu Künstlerbildnis und Künstlerdarstellung in den Niederlanden im 17. Jahrhundert* (Olms, Hildesheim and New York, 1984)

Rideal, Liz, *Mirror, Mirror: Self-portraits by Women Artists* (National Portrait Gallery, London, 2001)

Rocchetta, Giovanni Incisa della, *La collezione dei ritratti dell'accademia di San Luca. Studi e cataloghi* 4 (Accademia nazionale di S Luca, Rome, 1979)

Rose, June, *Suzanne Valadon: The Mistress of Montmartre* (St Martin's Press, New York, 1999)

Rosinsky, Thérèse Diamand, *Suzanne Valadon*

(Universe Series on Women Artists, New York, 1994)

Ross Smith, David, *Masks of Wedlock* (Ann Arbor Press, Michigan, 1982)

Roworth, Wendy Wassyng, 'The Consolations of Friendship: Salvator Rosa's Self-Portrait for Giovanni Battista Ricciardi', *Metropolitan Museum Journal* 23 (1988), pp.103–24

Roworth, Wendy Wassyng, 'Salvator Rosa's Self-Portraits: Some Problems of Identity and Meaning', *The Seventeenth Century* 4 (1989), pp. 117–48

Schama, Simon. *Rembrandt's Eyes* (Allen Lane, London, 1999)

Schneider, Norbert, *The Art of the Portrait: Masterpieces of European Portrait-Painting 1420–1670* (Taschen, Cologne, 1994)

Schulz-Hoffmann, Carla and Judith C. Weiss (eds.), *Max Beckmann: Retrospective* (exh. cat., Haus der Kunst, Munich, Los Angeles County Museum of Art and St Louis Art Museum, St Louis MO, 1984)

Schwarz, Heinrich. 'The Mirror of the Artist and the Mirror of the Devout: Observations on some paintings, drawings and prints of the fifteenth century', *Studies in the History of Art, Dedicated to William E. Suida on his Eightieth Birthday* (Phaidon, London, 1959), pp.90–105

Shackelford, George T.M., *Vincent van Gogh: The Painter and the Portrait* (Universe Publishing, New York, 2000)

Small, Andrew, 'Essays in Self-Portraiture: A Comparison of Technique in the Self-Portraits of Montaigne and Rembrandt', *Renaissance and Baroque Studies and Texts*, ed. Eckhard Bernstein , vol. 19 (Peter Lang, New York, 1996)

Smith, Pamela. H., *The Body of the Artisan: Art and Experience in the Scientific Revolution* (Chicago University Press, Chicago and London, 2004)

Soussloff, C., 'Lives of Poets and Artists in the Renaissance', *Word and Image* 6 (April–June 1990), pp.154–62

Soussloff, C., *The Absolute Artist: The Historiography of a Concept* (University of Minnesota Press, Minneapolis, 1997)

Stanton, D., *The Aristocrat as Art: A Study of the Honnête Homme and the Dandy in 17th and 19th-Century Literature* (Columbia University Press, New York, 1980)

Stoichita, Victor I., *The Self-Aware Image: An Insight into Early Modern Meta-Painting*, trans. Anne-Marie Glasheen (Cambridge University Press, Cambridge and New York, 1997)

Strong, Roy, *The English Icon: Elizabethan & Jacobean Portraiture* (Paul Mellon Association for British Art in association with Routledge & Kegan Paul, London, 1969)

Summers, David, 'ARIA II: The Union of Image and Artist as an Aesthetic Ideal in Renaissance Art', *Artibus et Historiae* 20 (1989), pp.15–31

Szeemann, Harald *et al.*, *Georg Baselitz* (exh. cat., Städtische Kunsthalle, Düsseldorf and

Kunsthaus, Zürich, 1990)

Taussig, Michael T., *Mimesis and Alterity. A particular history of the senses* (Routledge, New York and London, 1993)

Terrasse, Antoine, *Pierre Bonnard, Illustrator: A Catalogue Raisonné*, trans. Jean-Marie Clarke (Abrams, New York, 1989)

Van Gogh, Vincent, *The Complete Letters of Vincent Van Gogh; with reproductions of all the drawings in the correspondence* (Thames & Hudson, London, 1958)

Vasari, Giorgio, *Le vite de'più Eccellenti Pittori, Scultori ed Architetti*, ed. Gaetano Milanesi, 9 vols (2nd edn Sansoni, Florence, 1906)

Wagstaff, Sheena (ed.), *Edward Hopper* (exh. cat., Tate Modern, London, 2004)

Warnke, Martin, *The Court Artist: On the Ancestry of the Modern Artist*, trans David McLintock (Cambridge University Press, Cambridge, 1993)

White, C., and Q. Buvelot (eds), *Rembrandt by Himself* (exh. cat., National Gallery, London, and Royal Cabinet of Paintings, Mauritshuis, The Hague, 1999)

Whitfield, Sarah, *Bonnard*, (exh. cat., Tate Gallery, London and Museum of Modern Art, New York, 1998)

Winner, Matthias, with contributions from O. Bätschmann *et al.*, *Der Künstler über sich in seinem Werk : internationales Symposium der Bibliotheca Hertziana Rom 1989* (VCH Acta Humaniora, Weinheim, 1992)

Wittkower, Rudolf and Margot, *Born under Saturn. The Character and Conduct of Artists: A Documented History from Antiquity to the French Revolution* (Weidenfeld and Nicholson, New York, 1963)

Woodall, Joanna (ed.), *Portraiture: Facing the Subject* (Manchester University Press, Manchester, 1997)

Woods-Marsden, Joanna, *Renaissance Self-Portraiture: The Visual Construction of Identity and the Social Status of the Artist* (Yale University Press, New Haven and London, 1998)

Zöllner, F., '"Ogni pittore dipinge sé": Leonardo da Vinci and "Automimesis"', in *Der Künstler über sich in seinem Werk: Internationales Symposium der Biblioteca Hertziana Rom 1989*, ed. M. Winner (Wiley–VCH, Weinheim, 1992)

Zucker, Wolfgang, M. 'Reflections of Reflections', *The Journal of Aesthetics and Art Criticism* (spring 1962), pp.239–50